L. J. M. DAGUERRE

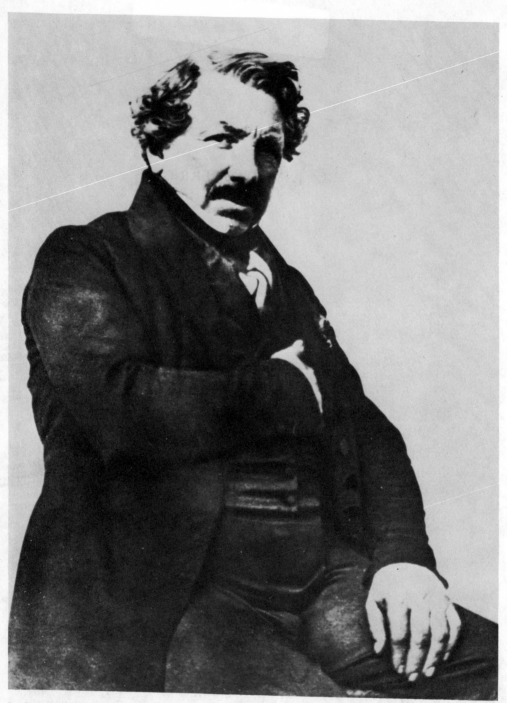

L. J. M. Daguerre. Daguerreotype by E. Thiésson, 1844

L. J. M. DAGUERRE

The History of the Diorama
and the Daguerreotype

BY

HELMUT AND ALISON GERNSHEIM

SECOND REVISED EDITION

DOVER PUBLICATIONS, INC.

New York

Published in Canada by General Publishing Company,
Ltd., 30 Lesmill Road, Don Mills, Toronto, Ontario.
Published in the United Kingdom by Constable and
Company, Ltd., 10 Orange Street, London WC2.

This Dover edition, first published in 1968, is an
unabridged and revised republication of the work originally
published by Martin Secker & Warburg, Limited, London,
in 1956. A new preface has been written by the authors
for this edition.

International Standard Book Number: 0-486-22290-X
Library of Congress Catalog Card Number: 68-8044

Manufactured in the United States of America
DOVER PUBLICATIONS, INC.
180 Varick Street
New York, N.Y. 10014

To
Charles A. Wilson

PREFACE TO THE DOVER EDITION

TWELVE years have elapsed since the first publication of this book in 1955, and the present edition has been brought up to date by including some additional information that has come to light during that period.

The majority of the illustrations in this book are from the Gernsheim Collection, University of Texas, and we wish to express our indebtedness to the Chancellor of the University for permission to publish them, and to Professor John W. Meaney, Curator of the Gernsheim Collection, for his co-operation in making the material available.

We are grateful to Mr Beaumont Newhall, Director of George Eastman House, Rochester, N.Y., for bringing up to date his bibliography of Daguerre manuals which he compiled for the first edition of this book, and for allowing us to draw upon the unique Cromer Collection of Daguerriana at George Eastman House.

It gives us great pleasure to be able to include a number of the finest German daguerreotypes through the courtesy of Herr Fritz Kempe, Director of the Staatliche Landesbildstelle in Hamburg. We are also very appreciative of the generous gesture of Voigtländer & Söhne, Braunschweig, in presenting to the Gernsheim Collection the facsimile daguerreotype camera illustrated in Plate 113. The following institutions and individuals have kindly allowed us to reproduce pictures in their possession:

Besançon Museum 8 (photograph by courtesy of Dr Walter Gernsheim, Florence)
Bibliothèque Nationale, Paris 27
Braun et Cⁱᵉ, Dornach 59
Brown University Library, Providence, R.I. 63
Cincinnati Public Library 70
Conservatoire National des Arts et Métiers, Paris 38 41
Anthony Denney, London 72 83 88 92
George Eastman House, Rochester, N.Y. 1 7 9–11 14 16 26 49 53 55 61
 68 116 facing page 97(a)
Edinburgh Photographic Society 89
Gernsheim Collection, University of Texas 3–6 13 15 17 20–24(a) 28 30 32–35
 39 43–48 50–52 57 65 71 73–76 78–81 84–87 90 91 93–95 108–110
 112–115 facing page 96 page 13 page 21 (a) and (b) facing page 97 (b) page 170
The Louvre, Paris 29

HELMUT AND ALISON GERNSHEIM

Castagnola,
1968

CONTENTS

England – partnership between Niépce and Daguerre – death of Niépce – discovery of development with mercury vapour – Daguerre alters contract with Isidore Niépce – premature announcement of fixing camera images – Hubert's protest – complete success attained – the contract further revised – attempts at commercial exploitation – Arago's patronage of the invention – announcement on 7 January 1839 – rival claims – Bayard – destruction of the Diorama by fire – the French Government grants pensions to the inventors – "From today, painting is dead!" – arrangements with Giroux for manufacture of apparatus.

LIST OF ILLUSTRATIONS

LINE ILLUSTRATIONS

CHRONOLOGY OF DAGUERRE'S LIFE

1787 18 November, born at Cormeilles-en-Parisis.

1792–1801 Educated at the *école publique*, Orléans.

1801 Apprenticed to an architect in Orléans.

1804 Apprenticed to Degotti, chief designer at the Paris Opéra.

c. 1807–1815 Assistant to Pierre Prévost in panorama painting.

1810 10 November, marries Louise Georgina Smith.

1814 Exhibits his first painting at the Salon.

1816–early 1822 Designer at the Théâtre Ambigu-Comique.

1819–early 1822 Designer at the Opéra.

1822 11 July, opens the Diorama, Paris, in partnership with C. M. Bouton.

1823 29 September, opens the Diorama, Regent's Park, London.

1824 10 February, patents (in the name of his brother-in-law) in England the method of exhibiting diorama pictures.

c. 1824 Starts photographic experiments.

1825 10 January, receives Cross of the Legion of Honour.

1826 January, begins correspondence with Nicéphore Niépce, inventor of heliography.

1827 August, first meeting with Niépce.

1829 14 December, partnership agreement with Niépce in photographic experiments.

1830 Partnership with Bouton ends.

1833 On the death of Nicéphore Niépce on 5 July, his son Isidore succeeds as partner.

1834 20 March, first double-effect diorama, in collaboration with Hippolyte Sébron.

1835 Discovers development of the latent image with mercury vapour and revises contract with Isidore Niépce, 9 May.

1837 Discovers fixing the image with salt and again revises contract, 13 June.

1838 Daguerre and Isidore Niépce try to obtain subscriptions for the daguerreotype.

1839 7 January, Arago announces the invention of the daguerreotype to the Académie des Sciences.

8 March, Diorama destroyed by fire.

June or July, promoted Officer of the Legion of Honour.

30 July, daguerreotype process purchased by the French Government; law passed for pensioning Daguerre and Niépce.

14 August, daguerreotype patented in England, Wales and the British Colonies.

19 August, Arago publishes daguerreotype process at a joint meeting of the Académies des Sciences and des Beaux-Arts.

About 20 August, publication of Giroux edition of Daguerre's manual on the daguerreotype and the Diorama.

1840 Retires to Bry-sur-Marne.

1842 "Enlarges" Bry Church with a *trompe-l'œil* painting.

1844 Publishes "Nouveau moyen de préparer la couche sensible des plaques destinées à recevoir l'image photographique".

1851 Dies on 10 July.

L. J. M. DAGUERRE

INTRODUCTION

ONE day in 1827, after lecturing at the Sorbonne, the famous chemist Jean Baptiste André Dumas (1800–84) was approached by a lady who seemed to be in a very worried state of mind. "Monsieur Dumas," she said, "I have to ask you a question of vital importance to myself. I am the wife of Daguerre, the painter. He has for some time been possessed by the idea that he can fix the images of the camera. He is always at the thought, he cannot sleep at night for it. I am afraid he is out of his mind. Do you, as a man of science, think it can ever be done, or is he mad?"

"In the present state of our knowledge," replied Dumas, "it cannot be done; but I cannot say it will always remain impossible, nor set the man down as mad who seeks to do it." [1]

Mme Daguerre had to wait ten years before her husband's ceaseless pursuit of this apparent mirage was crowned with success. Dumas's opinion was justified, but it was only on 7 January 1839 that François Arago disclosed to the Académie des Sciences Daguerre's epoch-making discovery.

The ambition to fix the images of the camera obscura had occupied many artists and scientists ever since the publication in 1802 of Thomas Wedgwood's and (Sir) Humphry Davy's experiments had demonstrated the possibility of doing so. The startling news from Paris understandably spread like wildfire all over Europe. The smallest provincial papers copied every scrap of information they could glean from their larger contemporaries. The daguerreotype was the most talked-of topic in Europe, for such was the effect of the invention that the moment people heard about it they were consumed with curiosity as to how it was done. This curiosity was kept alive by rumours and counter-rumours regarding the nature of Daguerre's method (which remained a carefully guarded secret for another seven and a half months), diligently spread by Parisian journalists, probably with the connivance of that excellent publicity manager, the inventor himself, whose object was to gain time until Arago had secured for him a national recompense.

In view of the long delay, is it to be wondered at that some people began to doubt whether the invention were not a French swindle? Others, by nature opposed to everything novel, thundered indignantly against it on moral and religious grounds:

1

"The wish to capture evanescent reflections," wrote the *Leipziger Stadtan-zeiger*, "is not only impossible, as has been shown by thorough German investigation, but the mere desire alone, the will to do so, is blasphemy. God created man in His own image, and no man-made machine may fix the image of God. Is it possible that God should have abandoned His eternal principles, and allowed a Frenchman in Paris to give to the world an invention of the Devil? . . . The ideal of the Revolution—fraternity, and Napoleon's ambition to turn Europe into one realm—all these crazy ideas Monsieur Daguerre now claims to surpass because he wants to outdo the Creator of the world. If this thing were at all possible, then something similar would have been done a long time ago in antiquity by men like Archimedes or Moses. But if these wise men knew nothing of mirror pictures made permanent, then one can straightway call the Frenchman Daguerre, who boasts of such unheard of things, the fool of fools." [2]

In Paris and, to a lesser extent, in London, Daguerre had long been celebrated as the inventor and painter of dioramas, but the invention of the first practicable process of photography, which eventually proved to be "the greatest discovery since that of the printing press", [3] fired the imagination of the public everywhere. It was the culminating success in the career of a self-made man whose natural genius and energy had overcome the disadvantages of humble birth and lack of education.

Chapter I

DAGUERRE AS ARTIST

DAGUERRE'S EARLY LIFE

THE name Daguerre is of Basque origin in the form *d'Aguerre*. L. J. M. Daguerre's grandfather, Jean Jacques Daguerre, was a naval surgeon; his wife's maiden name was Marie d'Huillier. Their son Louis Jacques Daguerre was first crier at the bailiwick's (local magistrate's) court at Cormeilles-en-Parisis, a small town in the Department Seine-et-Oise, picturesquely situated about ten miles from Paris on the south-west slope of the Cormeilles hills. Here he married on 19 February 1787 a local girl, Anne Antoinette Hauterre, who was then twenty years old (born 7 July 1766). Exactly nine months later, on 18 November 1787, Anne Antoinette gave birth to a boy. To his father's Christian names was added a third, Mandé.

The best known of the Daguerre family at this period was Dominique, who may have been a brother or cousin of Louis Jacques. Dominique Daguerre was a dealer in fine furniture, porcelain, glass, jewellery, and novelties, at the Couronne d'Or in the rue St Honoré, and has been called "the most fashionable Parisian *marchand-mercier* of his day", patronized by the French Court, the Prince of Wales (later King George IV), and several Russian Grand Dukes. Dominique Daguerre was agent for Wedgwood ware in Paris from 1787 on, and supplied furniture and *objets d'art* to the Prince of Wales from about the same date, both for Carlton House and for the first Pavilion at Brighton. Soon after, he set up an establishment in Sloane Street, London, in partnership with another Frenchman, E. M. Lignereux. Perhaps the Prince of Wales's lavish patronage prompted this step. At any rate, by 1795 the Prince owed Daguerre over £15,000.*

Dominique Daguerre would hardly be of interest in this biography of L. J. M. Daguerre were it not for the fact that Eliza Meteyard in her book *A Group of Englishmen* (1871) tried to establish a connection between Tom Wedgwood's photo-

* F. J. B. Watson, "George IV as an Art Collector", *Apollo*, London, June and December 1966.

graphic experiments (which took place in the *late* 1790s) and the invention of the daguerreotype. Her theory was that Dominique's son, on visits to the Wedgwood pottery works in 1791 and 1793, saw some of Tom Wedgwood's attempts. Miss Meteyard was wrong on three points: at the time of these visits Tom Wedgwood had not yet started his photographic experiments; Dominique's son was not L. J. M. Daguerre; and even if he had been, he was only six years old at the time of the second visit.

Only the first few years of Louis Jacques Mandé Daguerre's life were spent in Cormeilles, for a year or two after the suppression of the bailiwicks in 1790 Daguerre *père* found employment as a minor clerk on the royal estates at Orléans. He was obviously a royalist, for his daughter, born in Cormeilles on 12 September 1791, was christened Marie-Antoinette.

Louis Jacques Mandé Daguerre was sent to the elementary school—the *école publique*—at Orléans, but owing to the Revolution and the extended period of wars there was a great shortage of teachers and instruction was very haphazard and scanty. The First Republic cared even less for public education than the monarchy had done, and as the schools were visibly deteriorating, parents neglected to send their children to school altogether. In 1798, for instance, only 1,200 children out of 20,000 who ought to have gone to school in the Department of the Seine in fact did so, and hardly one person in a hundred could read or write.[4] Louis' faulty education was, however, compensated for to some extent by his natural intelligence. He was quick in the up-take and displayed, in particular, a gift for drawing almost from the moment he could hold pencil or brush, his colourful landscape sketches surprising everyone who saw them. Portraits of his parents, made at the age of thirteen, convinced them of his talent, and he was apprenticed to a local architect in whose office he received three years' training as draughtsman. At the end of this period the sixteen-year-old lad remained, however, much more interested in sketching landscapes and por-traits than in architectural plans, though his knowledge of the rules of perspective and practice in accurate delineation of buildings and architectural details were to stand him in good stead in years to come.

Louis was now determined to go to Paris to study art, but his father remained steadfastly against the idea of exchanging a steady career for the instability of an artist's life. After weeks of argument he had to give way to his son's persistence, and so in 1804, the year Napoleon became Emperor, Louis was allowed to go to Paris. But to keep the youth under some control in the temptations of the capital, he was apprenticed to Ignace Eugène Marie Degotti (died December 1824), the celebrated stage designer, with whom he lodged.

Degotti had come to Paris from Naples about 1790 under the patronage of

Louis XVI's younger brother, the comte d'Artois (later Charles X), who, it is said, was in his dissipated youth much more frequently seen behind the scenes at the Opéra than in the royal box. In 1804 Degotti rose to the position of chief designer at the Opéra, where the charming art of the eighteenth century and the traditions of Boucher and Fragonard, who both had worked there, survived in spite of the powerful influence of David's severe classicism.

As Daguerre's name does not appear among the apprentices at the Académie impériale de Musique (the Opéra) he presumably worked at the private studio in the house of his master at the Five Mills, near the Barrière Poisonnière. The elder Daguerre's precaution in directing that his son should live with his master failed in the desired result, however, for Daguerre soon drifted into the bohemian habits of his artist friends.

Popular *rendezvous* were the large number of garden cafés where people could listen to music, sing, watch acrobats, and—above all—dance, for this was a dance-mad period like the 1920s. Daguerre was a good dancer, which made him much sought after, but it was not only in the ballroom that he shone: in his desire to be in the public eye he joined in choreographic groups in the fairy-scenes at the Opéra, enjoying the applause of the audience. At parties in artists' studios he found it fun to make his entry upside down, walking on his hands. At tight-rope acrobatics "he arrived at such a degree of agility and equilibrium that he could, without disadvantage, vie publicly with the incomparable Furioso". Daguerre's great urge to shine is a characteristic trait of people of humble birth who are gifted; they often have a craving for public acclamation (a psychological balance provided by nature for any inferiority complex arising out of low birth and lack of education). Daguerre was determined that these should not be stumbling blocks on the road to success, and he was driven by a burning desire to succeed. Fortunately his mental and physical powers allowed him to perform extraordinary feats of endurance, and his subsequent success and fame must be largely ascribed to unbounded energy and relentless perseverance in anything he wished to attain.

At Degotti's his unusual manual dexterity and intuitive understanding of decorative effects soon won the confidence of his master, who entrusted him with several important productions, with which, however, the pupil's name was not officially connected.

PANORAMAS

After three years' or so apprenticeship with Degotti, Daguerre became assistant to Pierre Prévost (1764–1823), whose fame as a painter of panoramas was so great that the invention of this popular form of exhibition is often mistakenly attributed to him. The panorama had, however, its origin with Robert Barker (1739–1806),

an Irishman who worked in Edinburgh as a portrait painter. In 1787 Barker took
out a patent for panoramic painting, and in the following year exhibited in Edin-
burgh a view of that city, the first picture of the kind. Barker then started similar
exhibitions in Glasgow and London, where his first completely circular panoramic
painting, "The English fleet anchored between Portsmouth and the Isle of Wight",
was shown at his premises in Leicester Square in 1792. Robert Fulton (1765–1815),
who studied art in London under Benjamin West, became for a time Barker's
associate; later he introduced the invention into France, where he took out a
patent of importation valid for ten years, on 26 April 1799. Soon afterwards he
ceded his rights to an American couple, Mr and Mrs James Thayer, and with the
proceeds of the sale was able to give up painting and devote himself to his steam-
boat invention. The new proprietor of the patent immediately erected two rotun-
das, each 17 metres in diameter, on the boulevard Montmartre (their site is still
indicated by the Passage des Panoramas) and there displayed in June 1800 the first
panoramas in Paris.* One was a "View of Paris" from the roof of the Tuileries,
painted by Denis Fontaine, Pierre Prévost, Constant Bourgeois, Jean Mouchet, and
Charles Marie Bouton; the other represented "The evacuation of Toulon by the
English in 1793" by Prévost, Bourgeois, and Bouton, and was regarded as the better
of the two.

The general enthusiasm for panoramas in England, France, and other countries
was caused by the astonishing illusion of reality of the depicted scene. Placed in
semi-darkness, and at the centre of a circular painting illuminated from above and
embracing a continuous view of an entire region, the spectator lost all judgment of
distance and space, for the different parts of the picture were painted so realistically
and in such perfect perspective and scale that, in the absence of any means of com-
parison with real objects, a perfect illusion was given.[5]

The early panoramas were by no means looked upon merely as excellent enter-
tainment. Just how seriously they were taken is proved by the fact that a com-
mittee of the Institut de France was set up, which in September 1800 reported
that the invention "merited the interest and approbation of the Institute, which
ought to testify its satisfaction to citizen James [Thayer] and to the artists, and
to urge them to redouble their efforts to achieve new successes which would earn
them more and more the approval of the educated public and the benevolence of
the Government."[6] No less a painter than David was overheard to remark, on

* The account of the first panoramas in Paris given by E. G. Robertson in his *Memoires Récréatifs Scientifiques
et Anecdotiques*, Paris, 1831, is completely incorrect.

taking his pupils to see one of Prévost's panoramas: "Really, one has to come here to study Nature!" [7]

Numerous towns all over Europe and North America soon had panorama buildings exhibiting enormous wall-paintings of scenery or battles. In 1807 James Thayer in collaboration with Prévost constructed on the boulevard des Capucines a panorama nearly twice as big as those on the boulevard Montmartre. It measured 32 metres in diameter, and the painting was 110 metres long by 16 metres high. The platform for the spectators held 150 people and was situated about 12 metres from the painting. In all three buildings Prévost exhibited panoramas glorifying the Emperor: the camp of Napoleon's invasion forces and fleet against England at Boulogne in 1804, the Battle of Wagram, and the interview of Napoleon with Alexander I at Tilsitt in 1807. Greatly flattered, the Emperor planned to have eight of his victorious battles immortalized by Prévost, but the failure of the Russian campaign in 1812 put an end to the project. The restoration of the Bourbons was celebrated by a panorama of the disembarkation of Louis XVIII at Calais. Very popular panoramas were views of Rome, Naples, London, Amsterdam, Antwerp, Jerusalem, Athens and Rio de Janeiro.

Daguerre worked for Prévost from about 1807 until early in 1816, but the only outstanding event in his life during this period was his marriage to Louise Georgina Smith (1790–24 March 1857) on 10 November 1810 at the Reformed Church of Paris. According to the marriage licence he lived at 25 rue du Faubourg Montmartre, while the address of the bride was stated to be 32 rue des Martyres.

Louise Smith was born in 1790 at Monceaux-sous-Paris (today the quartier Monceau) of English parents, William and Sara Smith (née Glaisher). A certain amount of confusion surrounds her surname, which appears as Smith on the marriage licence and as Arrowsmith on her tombstone. What caused her and her two brothers to change their name is not known, but the following may perhaps throw some light on this mystery. Mme Daguerre's brother John (1790–1873), who settled in London in 1810, is up to November 1823 [8] referred to as Mr Smith, but on 10 February 1824 a patent was granted to him in the name of John Arrowsmith.[9] By profession a map-maker, John Smith was a nephew of Aaron Arrowsmith, the well-known geographer and publisher of maps, whom he assisted from 1810 until his death in April 1823, after which he set up on his own account as cartographer, until eventually he inherited his uncle's business (from his cousins) in 1839. Is it not possible that this branch of the family, having simplified their name to Smith in order to make life easier in France (and the French are notoriously slap-dash at spelling names!), reverted to Arrowsmith as a condition of inheritance?

At any rate, John's younger brother Charles (born 1798), who lived in Paris and became Daguerre's assistant at the Diorama, appears in dictionaries of French artists as Charles Arrowsmith, though he is referred to as plain Mr Smith in 1822.[10]

Of the numerous artists who passed through Prévost's studio, the most talented, after Daguerre, was Charles Marie Bouton (1781–1853), a pupil of David. Bouton assisted Prévost in his first panorama, the view of Paris, in 1800, and remained his collaborator for more than twelve years.

DAGUERRE'S GRAPHIC ART

Like all the other assistants, Daguerre worked at Prévost's as one of a team: the first independent public manifestation of his talent appeared at the Salon of 1814—an oil painting depicting "Interior of a chapel of the Church of the Feuillants, Paris". It was soon clear, however, that Daguerre was not an outstanding artist, and receiving little encouragement from art critics his interest wandered into other fields. During a period of twenty-six years he exhibited only six paintings at the Salon (see appendix). Judging from the drawings and paintings which have survived, contemporary comparisons of Daguerre with Horace Vernet and even with Claude Lorraine can only be described as the uncritical flattery of friends. Even "Holyrood Chapel by moonlight" (Plate 12), undoubtedly Daguerre's best painting, which (ostensibly) gained him the Legion of Honour, is rather a skilful and realistic representation of the subject than a work of art.

Daguerre was one of hundreds of artists including Géricault, Ingres, Isabey, and Vernet, who made topographical drawings for the monumental *Voyages pittoresques et romantiques en l'ancienne France* which appeared in numerous parts with thousands of lithographs between 1820 and 1878. Sets of this twenty-volume work, edited by Baron J. Taylor, Charles Nodier, and Alphonse de Cailleux, are at the British Museum and the Victoria and Albert Museum. The fate of Daguerre's ten drawings for this work is not known, but allowing for the fact that the lithographs are only copies by other artists, they do give some idea of Daguerre's originals. The same applies to Lemaître's engraving (1827) (Plate 6) of Daguerre's painting "The Chapel of the Feuillants" (1814), which was then in the Luxembourg Gallery. The engraving was published by Liébert in *Galerie du Luxembourg, des Musées, Palais et Châteaux Royaux de France*. (For a complete list of these reproductions of Daguerre's graphic art see appendix.)

DAGUERRE'S STAGE DESIGNS

It was as a stage designer, or rather as creator of stage effects and clever illusions, that Daguerre's imaginative powers were to find their true outlet. His talent was at once apparent when early in 1816 he obtained a contract as stage designer at the Théâtre Ambigu-Comique, at a salary of 5,000 francs a year (then £200). Originally founded in 1769 as a puppet theatre, the Ambigu was the oldest and best-known of the six smaller Parisian theatres—the others being Franconi, Gâité, Porte Saint-Martin, Vaudeville, and Variétés. Apart from these there were only the five high-brow royal theatres: the Académie royale de Musique (the Opéra), the Théâtre-Français (Comédie-Française), Feydeau, Odéon, and Opéra-Buffe (Opéra-Comique). The Ambigu-Comique, Franconi, and Gâité were situated on the boulevard du Temple, popularly known as the "boulevard du crime" in allusion to the melo-dramatic nature of the plays performed there. The melodrama, in which crime was invariably punished and virtue rewarded in the last scene, was then a new *genre*, an entertainment for the lower classes and depending to a great extent on excitement and spectacle. And since the visual aspect of the entertainment was gradually assuming greater importance, talented artists found ready employment at these little theatres.

Daguerre's first task at the Ambigu was to redecorate the auditorium. His colour scheme was bold and considered somewhat overwhelming for the archi-tectural design. But the curtain was admired as a most skilful *trompe-l'œil*; it represented an immense blue drapery, partly drawn up by cords and gold tassels, revealing a Gothic gallery with an admirable effect of light. It was very similar to the curtain Daguerre had recently painted for the Opéra-Comique, except that in this case the perspective view represented a row of Roman monuments. Daguerre was fond of architectural perspectives: in 1820 he painted another one on the curtain of the new Odéon Theatre (rebuilt after a fire in 1818), for which he also carried out the ceiling decoration representing the signs of the Zodiac and the divinities presiding over the twelve months of the year.

During the period 1816–22, Daguerre designed the scenery for the following thirteen melodramas at the Ambigu[11]: "Les Captifs d'Alger" by Bernos, opening 9 April 1817; "Les Machabées" by Cuvelier and Léopold, 23 September 1817; "Le Songe ou la Chapelle de Glenthorn" by Mélesville, 22 July 1818 (some writers have made two plays out of this title); "La Forêt de Sénart" by Boirie, 14 October 1818; "Le Belvédère" by Guilbert de Pixérécourt, 10 December 1818; "Les Mexicains" by Mélesville, 18 May 1819; "Calas" by Victor Ducange, 20 Novem-

ber 1819; "Le Mineur d'Auberval" by Frédéric, 25 April 1820; "Le Colonel et le Soldat" by Victor Ducange, 11 July 1820; "Thérèse" by Victor Ducange, 23 November 1820; "Anne de Boulen" by Rougemont, 8 May 1821; "Le Vampire" by Charles Nodier, 1821; "Elodie" by Mélesville, 10 January 1822. (Plate 2.)

One of Daguerre's sets for "Les Captifs d'Alger", representing the bridge of a ship, brought him immediate renown. At least one critic asserted that: "All the merit of this work consists in the superb decoration of the third act." The ingenuity of his lighting effects impressed even more than the scenery. In this field Daguerre's ability proved incomparable, for he understood better than anyone else how to vary the play of light and shade on the *décor* in order to animate the scene—effects, it must not be forgotten, that had to be achieved with oil lamps. If the painter P. H. Valenciennes had cause to complain some years previously that when an actor says "Night is coming on" the stagehands invariably turn out all the lights at once, Daguerre taught them the art of producing subtle and gradually changing light effects. In the third act of "Le Songe" he introduced a moonlit scene which was by general consent considered "a masterpiece of this *genre*", and his extraordinary ability to seize upon a theatrical point and produce a spectacular effect firmly established Daguerre's reputation as an innovator. "One could not leave off applauding it. . . . The success obtained is due solely to M. Daguerre, the designer, and it is he alone who should have been named" (as the creator of "Le Songe"). The success of "Les Mexicains" was also in large measure attributed to Daguerre. "This young painter extends from day to day the limits of his art. His decoration of the second act representing the moonrise is the most astonishing thing that could be produced." "Le Belvédère" found the highest praise. "How can one find words to describe the magical effect of the last scene [an eruption of Etna]? It is wisest not to search for them at all, and to recommend it without eulogies to the admiration of all who are interested in the progress of the arts. I have only one word to say to justify this admiration—it is by M. Daguerre." The *Journal des Théâtres* wrote after the first-night of "Thérèse": "The names of MM. Victor Ducange the poet, Adrien the composer, and Daguerre the painter, were proclaimed in the midst of fanfares." "All Paris has seen M. Daguerre's *décor*" was the comment of another critic. As people demanded more and more moonlit effects, Daguerre introduced another in the cemetery scene of "Le Vampire", until eventually stage production became solely a matter of showy effects. "Le Mineur d'Auberval" was even specially written so that Daguerre could devise a fog to fill the stage and then gradually disperse at sunrise, but unfortunately the mechanism did not work properly and the effect was lost.

Desire for perfection was one of Daguerre's outstanding characteristics, but the success of his *décors* at the Ambigu turned him into a seeker after effects with which to win easy popular acclaim. His striving for extreme naturalism led him more and more beyond the bounds of art into the field of showmanship. Critics were so completely taken in by Daguerre's skill in *trompe-l'œil* that they solemnly declared he had in "La Forêt de Sénart" introduced a real stream on the stage, with real trees and grass.

Ten years earlier, no French dramatic critic would have dreamed of mentioning in his review the name of the stage designer. It was the poetry that counted in classical tragedy and the comedy of manners, and not visual effects. But now the new kind of theatre-going public—the *petite bourgeoisie*—had a new kind of play to suit their tastes—the melodrama—and together with the novel *décors* of Daguerre and his imitators, it revolutionized the theatre. Daguerre had a vivid sense of the taste of the middle and lower classes—the patrons of the little theatres on the "boulevard du crime"—for sumptuousness and spectacular effects. It was the beginning of a policy in the pursuit of which a hundred years later Hollywood turned the cinema into the biggest entertainment industry.

At the end of 1819 Daguerre, now a celebrity in the theatrical world, was invited to become one of the chief designers at the Académie royal de Musique, a position which he shared with his old master Degotti and with Pierre Luc Charles Cicéri (1782–1868). Degotti had for some years been replaced as *décorateur-en-chef* by Jean Baptiste Isabey (1767–1855), the most brilliant miniaturist of the period, who held the position for three years, until he offended Napoleon by excessive familiarity. (He is said to have leap-frogged over the Emperor's back to prove to some friends the degree of his intimacy, but this foolish act of bravado misfired.) Isabey's position was filled by his pupil and son-in-law Cicéri, designer at the theatre of the Imperial Court, and interior decorator of the Palais Royal under the Restoration. Cicéri made over three hundred stage designs for the Opéra, the Opéra-Comique, the Comédie-Française, and the Théâtre de la Porte Saint-Martin, where he competed with Daguerre's *décors* at the Ambigu. He was in the front rank of stage designers from the Restoration until near the end of the Second Empire.

Among other designers at the Opéra, each with his speciality, were de Gosse, Daguerre's assistant at the Ambigu, and Jean Pierre Alaux (1783–1858), a former panorama painter with whom Daguerre had worked in Prévost's studio.

Daguerre remained designer for the Ambigu during the two years in which he was active for the Opéra. In that short period only one production in which he had a hand is especially mentioned—"Aladin and His Wonderful Lamp", an opera in

five acts by Nicolo, with libretto by Etienne. Both Cicéri and Daguerre designed five scenes each, which the *Miroir des Spectacles* praised in the highest terms in their review in February 1822:

> "Never has the Opéra offered the public a more magnificent and elegant spectacle. The decorations and costumes cost 50,000 *écus*, but, to be just, there are ten new decorations which do honour to MM. Cicéri and Daguerre. Those which attracted most attention are the Palace of Aladin in the third act, the bronze hall of the Palace of Tamorkan in the fifth act, and finally the Palace of Light with a moving sun in the closing scene. . . . The brilliant reputations of the two painters of the Opéra have grown still greater. We are no longer dependent on Italy for our *décors*. Today we surpass our masters."

As so often before, it was neither the composer nor the librettist but the designer who was singled out for praise, for by general consent the highlight of the show was the moving sun in the Palace of Light, blazing on columns inlaid all over with spangles—the work of Daguerre, who was aided in his fairy-like arrangement by the novel gas-lighting, which was inaugurated with the first performance of "Aladin" on 22 February 1822 in the new opera house in the rue le Peletier. No wonder that for decades this scene was remembered as the acme of luxury and splendour.

The previous month the Ambigu had put on "Elodie", for which Daguerre, assisted by de Gosse, designed his last *décor*—the scenery for the second and third acts. "One seeks in vain for interest in 'Elodie'," ran one review, "but, as compensation, what pomp of spectacle, what decoration! M. Daguerre has surpassed himself, which seemed impossible."

These and similar accounts of Daguerre's achievements in the theatrical field have given rise to the quite unfounded but often-repeated claim that prior to Daguerre the art of stage design in France was in a state of infancy. This backward condition was undoubtedly true of the post-Revolutionary period. Napoleon was not interested in the theatre, and the theatre was not a fashionable form of entertainment during the Empire. Productions were consequently very simple during this period compared with the exquisite and elaborate court productions staged under Louis XIV, XV, and XVI. For example, during the twenty-eight years that Giovanni Girolamo Servandoni (1695–1766) was at the Académie royale de Musique, this creator of modern stage design in France carried out over sixty *décors* for the Opéra, in which one finds many of the effects (not even then new in France) with which Daguerre nearly three-quarters of a century later surprised the public afresh. Servandoni made full use of ingenious mechanical devices for *deus ex*

machina scenes, artificial fountains, pyrotechnique effects, and moveable coloured sources of light. In particular, the grand spectacles he organized in the *salle à machines* at the Tuileries during Lent, when speaking parts were forbidden, gave him unusual opportunities to display his imagination. In "The Enchanted Forest" (1754) the pale moon turned the colour of blood, a stream suddenly swelled into a torrent, trees opened to reveal dryades, and demons appeared out of walls of flame. The climax came when amidst peals of thunder the spellbound audience heard the frightful roaring of a gale which filled the theatre, and the trees crashed down, covering the stage with their debris.[12] This far from primitive production may be considered sufficient proof to refute the somewhat too sweeping claims made for Daguerre by people ignorant of the pre-Revolutionary theatre.

Caricature bust of Daguerre by
Jean-Pierre Dantan, 1838–39

Chapter II

THE DIORAMA

In addition to his commitments at the Ambigu and the Opéra, Daguerre was busy during 1821 and the first half of 1822 preparing a new kind of entertainment—the Diorama. This was an exhibition of enormous transparent paintings under changing lighting effects of the kind he had so successfully devised for the stage. It constituted, in the words of the English patent specification, "an improved Mode of publicly exhibiting Pictures or Painted Scenery of every Description and of distributing or directing the Day Light upon or through them, so as to produce many beautiful Effects of Light and Shade".

The idea of the Diorama very probably came to Daguerre on seeing the Diaphanorama of Franz Niklaus König (1765–1832). This successful landscape and *genre* artist from Berne had also been active as a theatrical scene-painter and was hence well acquainted with the technique of special lighting effects.

König's first transparent picture dates from 1811. Fours years later he arranged an "Exposition du Diaphanorama de la Suisse" in Berne, consisting of eight transparencies which included romantic views of the moonlit Lake of Brienz, sunset on the Jungfrau, and William Tell's Chapel by torchlight and moonlight. The pictures, painted in water-colour on paper, were shown in a darkened room by transmitted and reflected light, various degrees of transparency being achieved by oiling and partly scraping away the back of the paper. The exhibition was so popular that König painted more views and took his enlarged show to other Swiss towns. The following year he toured Germany with the Diaphanorama, and again in 1819–20 when he was received by Goethe at Weimar. From Dresden, König took his show to Paris, and after entertaining a select circle at the Tuileries—including the Duc d'Orléans and the celebrated painter Mme Vigée Lebrun—the Diaphanorama remained on public exhibition in Paris until the end of 1821.

Of the approximately one hundred Diaphanorama pictures which König is known to have executed, thirty-nine are preserved at the Art Museum in Berne.* The largest measures 85 cm. × 118 cm.

* Marcus Bourquin, *Franz Niklaus König, Leben und Werk*, Berne, 1964.

Despite Daguerre's claim to be the inventor of the Diorama, this form of entertainment can hardly be considered an independent invention: it is, as the patent states, "an improved mode", but still on the principle of the Diaphanorama, though much larger and more elaborate. Co-inventor * and partner in the new venture was Daguerre's former colleague at Prévost's, Charles Marie Bouton (16 May 1781–28 June 1853), now a celebrated architectural painter, considered by many of his contemporaries a rival to Horace Vernet.† Bouton, a frequent exhibitor at the Salon from 1810 until his death, was the more experienced and distinguished painter, Daguerre the greater expert in lighting and scenic effects. So the partnership was an ideal collaboration, each gaining much from the other's experience; but with one exception the partners never combined their efforts in one diorama, but usually exhibited one picture each.

A joint-stock company was formed and land acquired at No. 4 rue Sanson, in the heart of theatreland. The building was erected according to Daguerre's plans by the architect Châtelain at the corner of the Place du Château-d'Eau (now Place de la République) and the rue Sanson (renamed rue de la Douane in 1851).‡ It was in functional style—plain, with long windows to admit sufficient light for the paintings. (Plate 16.) The façade was 27 metres long (87 ft. 9 in.), the greatest depth of the building from the entrance to the windows at the back measured 52 metres (169 ft.), and the height 16 metres (52 ft.). At No. 5 rue des Marais, which then crossed the rue Sanson,** stood the Maison du Diorama (Plate 34), which housed the offices of the Diorama on the ground floor, while the upper storey with its large studio was inhabited by Bouton, until he moved to London in 1830. Then it became Daguerre's residence, who previously lived in the rue de Crussol.

All augured well for the success of the new enterprise, for Daguerre's décor for "Aladin ou la Lampe Merveilleuse" was still fresh in everyone's mind. On Thursday, 11 July 1822, the Diorama opened its doors to the public with a painting by Daguerre of "The Valley of Sarnen" in Canton Unterwalden, Switzerland, and one by Bouton of "The Interior of Trinity Chapel, Canterbury Cathedral".

"The visitors, after passing through a gloomy anteroom, were ushered into

* Bouton claimed in a broadsheet entitled "Nomenclature des Travaux Artistiques de M. Bouton" to be one of the inventors of the Diorama.

† At the seventh annual exhibition of the Académie des Beaux-Arts at the Louvre, Bouton's painting "St Louis at the Tomb of his Mother" received only one vote less than Horace Vernet's winning entry in the competition.

‡ The site is today occupied by the Caserne du Château-d'Eau and is quite unrecognizable. In 1925 the Municipality of Paris had a plaque fixed to the wall of the barracks inscribed: "Ici s'élevaient de 1822 à 1839 le Diorama de Daguerre et le laboratoire où celui-ci, perfectionnant l'invention de Joseph-Nicéphore Niépce, découvrit le Daguerréotype."

** This part of the rue des Marais is now built over by the barracks.

a circular chamber, apparently quite dark. One or two small shrouded lamps placed on the floor served dimly to light the way to a few descending steps, and the voice of an invisible guide gave directions to walk forward. The eye soon became sufficiently accustomed to the darkness to distinguish the objects around, and to perceive that there were several persons seated on benches opposite an open space, resembling a large window. Through the window was seen the interior of *Canterbury Cathedral*, undergoing partial repair, with the figures of two or three workmen resting from their labour. The pillars, the arches, the stone floor and steps, stained with damp, and the planks of wood strewn on the ground, all seemed to stand out in bold relief, so solidly as not to admit a doubt of their substantiality, whilst the floor extended to the distant pillars, temptingly inviting the tread of exploring footsteps. Few could be persuaded that what they saw was a mere painting on a flat surface. (A lady who accompanied the writer to the exhibition was so convinced that the church represented was real, that she asked to be conducted down the steps to walk in the building.) This impression was strengthened by perceiving the light and shadows change, as if clouds were passing over the sun, the rays of which occasionally shone through the painted windows, casting coloured shadows on the floor. Then shortly the brightness would disappear, and the former gloom again obscure the objects that had been momentarily illuminated. The illusion was rendered more perfect by the excellence of the painting, and by the sensitive condition of the eye in the darkness of the surrounding chamber.

While gazing in wrapt admiration at the architectural beauties of the cathedral, the spectator's attention was disturbed by sounds underground. He became conscious that the scene before him was slowly moving away, and he obtained a glimpse of another and very different prospect, which gradually advanced, until it was completely developed, and the cathedral had disappeared. What he now saw was a valley, surrounded by high mountains capped with snow." [13]

"*The Valley of Sarnen* is represented as being one of the most beautiful and romantic in Switzerland. It is surrounded by lofty mountains, whose outlines are for the most part gracefully varied; it is traversed by a river and intersected by numerous streams, which seem tributary to the beautiful lake in the bed of the valley. Some pleasing objects meet the eye in the mountainous scenery, and there are a few scattered hamlets and churches, which are agreeably situated. On the right foreground is a commodious *chalet*, where, it is said, travellers are hospitably entertained by the generous owner; near it is a fountain, from which a copious flow of water runs bubbling. The scenic view is well painted, and the diversified effect produced by the varying shadows, as they become transparent

or opaque, according to the approach of storm or the clearing up of the atmo-
sphere, cannot be surpassed. The stillness and clearness of the lake at one
moment, yielding at another, as the weather changes, to the successive copper
and leaden hues of the dense clouds 'prest by incumbent storms'—the distant
view of the snow-clad mountain, exhibiting in such a beautiful tone the varied
effects of light, shade, and colouring, according as the sun's rays and passing
clouds act upon its surface, cannot be too highly admired; the tints of nature
are in every part of the effect exquisitely pourtrayed [sic], and the charms of
the Swiss scenery displayed in the most extraordinary manner.''[14]

The Times reporter, after remarking that the reality of the scaffolding in ''Canterbury
Cathedral'' was so perplexing that even ''after a man has gazed to his heart's content,
his eyes still half refuse to believe but that the picture begins at the top of these
steps, and that the steps themselves, and the planks, and other debris of apparatus,
are part of the house in which he stands, and not of the show which he has paid to
see,'' gave his impression of ''The Valley of Sarnen'' in these words:

''The most striking effect is the change of light. From a calm, soft, delicious,
serene day in summer, the horizon gradually changes, becoming more and more
overcast, until a darkness, not the effect of night, but evidently of approaching
storm—a murky, tempestuous blackness—discolours every object, making us
listen almost for the thunder which is to growl in the distance, or fancy we feel
the large drops, the *avant-couriers* of the shower. This change of light upon the
lake (which occupies a considerable portion of the picture) is very beautifully
contrived. The warm reflection of the sunny sky recedes by degrees, and the
advancing dark shadow runs across the water—chasing, as it were, the former
bright effect before it. At the same time, the small rivulets show with a glassy
black effect among the underwood; new pools appear which, in the sunshine,
were not visible; and the snow mountains in the distance are seen more distinctly
in the gloom. The whole thing is nature itself—and there is another very curious
sensation which this landscape scene produces on the mind. The decided
effect of the thing is, that you look over an area of twenty miles: the distant
objects not included. The whole field is peopled: a house, at which you really
expect to see persons look out of the window every moment—a rill, actually
moving—trees that seem to wave. You have, as far as the senses can be acted
upon, all these things (realities) before you; and yet, in the midst of all this
crowd of animation, there is a stillness, which is the stillness of the grave. The
idea produced is that of a region—of a world—desolated; of living nature at
an end; of the last day past and over.'' [15].

Parisians found the Diorama infinitely more exciting than Prévost's panoramas, which, though representing nature with the greatest fidelity, were monotonous through being limited to one aspect of time. In the Diorama the spectator enjoyed, while looking at the view, the many momentary changes of mood which he knew so well from nature—from the hazy morning to the clear night, and from the calm beauty of a sunny day to the brooding and stormy sky. "The pleasing manner in which these almost imperceptible gradations pass over the surface of the picture can only be felt by the spectator; the mere description is inadequate to convey a just idea of the executive merits of the exhibition." [16] *The Times* considered panorama paintings "coarse sketches" in comparison with the Diorama, and "the Cosmorama surpassed fifty times over". Neither the Salon Cosmographique, the Galerie de Pompeii, the Panorama de l'Univers, the Diaphonorama transparent views of Switzerland, nor the "picturesque and mechanical theatre of Monsieur Pierre" and its imitator the Cosmosmecanicos showing mechanical animated views roused the spectator to a like degree of enthusiasm. There was even a "Diorama" by Auguste Hus in 1822, but it provided apparently so mediocre an entertainment that nothing is reported of its nature. In short, opinion was unanimous that Daguerre and Bouton had produced the *ne plus ultra* of pictorial illusion. Judging from newspaper accounts, the Diorama was a brilliant success, a sensation.

"MM. Daguerre and Bouton yesterday bore off a veritable triumph. Never has any representation of nature struck me so vividly." [17]

"Anyone who has not seen such marvels, does not know one of the greatest pleasures in store for him." [18]

"The Diorama, to which the public has been flocking in crowds since the opening day, is one of those inventions which constitute an epoch in the history of painting; it cannot fail to enlarge the boundaries of art by showing painters how to combine new effects. . . . We cannot sufficiently urge Parisians who like pleasure without fatigue to make the journey to Switzerland and to England without leaving the capital." [19]

"The Diorama is a new conquest, a happy application of the principles of optics and catoptrics to the effects of painting. The results are magic and justify the naïve expression of a child who exclaimed that 'it was more beautiful than nature'!" [20]

"The Diorama, a unique establishment in Europe, honours our epoch and our country. It has excited universal curiosity, and obtained the approval of all artists and people of taste." [21]

Each performance confounded the spectator afresh, so perfect was the per-

spective and subtle rendering of atmosphere in the pictures, and so natural and striking the constantly changing light effects. Few people could believe that they saw only a painting; the illusion of depth was so strong that they were convinced it was a large-scale model with real objects, and as a test they sometimes threw little balls of paper or coins at the picture. The imitation of water was so convincing that more than one reviewer believed Daguerre had heightened the effect by the introduction of real water. But this too was only an illusion, as can be seen from the account of another eye-witness.

"The representation of a stream of water flowing down a small and slight declivity is so perfectly natural as to impress every observer with the conviction that the artist has contrived, by some ingenious mechanism, to let real water issue from an aperture made in that part of the canvas." [22]

Up to 1831 there were usually two diorama pictures on view (after 1831 often three), generally one by Daguerre and one by Bouton. The exhibition of each picture required ten to fifteen minutes, so that the whole performance was over in half an hour at the most, but visitors could see the spectacle twice if they wished, as performances were continuous from 11 a.m. to 4 p.m. For an entertainment of such short duration the cost of admission—3 francs for the boxes and 2 francs for the amphitheatre*—was very high, rather underlining the fact that the Diorama was at first an upper-class entertainment.

One of the most interesting features of the Diorama was the system by which the audience was brought to the pictures, for on account of their enormous size— 22 metres wide by 14 metres high (71 ft. 6 in. × 45 ft. 6 in.)—and the complicated lighting arrangements, they remained stationary while the auditorium, a cylindrical room with a single opening in the wall like the proscenium of a stage, was slowly revolved from one picture to the other. Surrounding it was another rotunda with a similar opening through which the spectators beheld the picture. After ten to fifteen minutes the auditorium was rotated about 73°, until the proscenium was level with the second opening in the outer rotunda.

The auditorium—a light wooden construction 12 metres (39 ft.) in diameter and 7 metres 75 cm. (25 ft. 2½ in.) high—was supported by a strong wooden framework which turned round upon a pivot, its circumference resting on struts with rollers which revolved on a circular rail. The ingenious mechanism could be worked by one man, who at the sound of a bell turned a crank until the proscenium (7 metres

* 3 francs was then about 2s. 6d., equivalent to at least three times that sum in present-day value.

50 wide × 6 metres 50 high—24 ft. 4½ in. × 21 ft. 1½ in.) came to rest opposite
the second picture, which adjoined the first (see plan). At the back of the rotunda,
which was decorated with painted draperies and ornamental shields bearing the
names of famous artists, were nine boxes seating forty people, while the amphi-
theatre in front held 310 more, mostly standing, though a few benches were
provided.

Like stage scenery, the pictures were set back from the auditorium, 13 metres
(42 ft. 3 in.) from the front row, at the end of an enormous tunnel formed by
screens, which had the double function of giving depth to the painting, and con-
cealing its margins. The spectator was seated in a dim light until the curtain was
drawn up and the picture, lit up from the roof and from its rear, was revealed.
Being painted on fine transparent linen, the effect was one of extraordinary beauty
and reality of appearance. The great diversity of scenic effect was produced by a
combination of translucent and opaque painting, and of transmitted and reflected
light by contrivances such as screens and shutters. The front of the painting was
illuminated by daylight from a ground-glass skylight, into which a number of
coloured transparent screens could be interposed to vary the effect. Most of the
changing light effects were produced by modifying the daylight passing through
the back of the picture (hence diorama—Greek *dia* through, *horama* view) from the
long vertical ground-glass windows. This was achieved by interposing a large
number of similar coloured screens, which were worked by pulleys and counter-
weights. In this way the most varied effects from brilliant sunshine to thick fog
could be produced.

Whilst the ingenious construction and lighting arrangements of the Diorama
were protected by patent—at any rate in England—the most important part of the
invention—the method of painting the pictures—was not revealed for seventeen
years; in fact not until after the destruction of the Paris diorama by fire, and then
only in consideration of an extra amount in the French Government's pension for
the daguerreotype. A shrewd businessman, Daguerre knew how to drive a bargain.

The idea of painting transparent pictures was by no means new, though no one
had hitherto operated on such a gigantic scale; also novel was the modification of
the lighting by coloured screens. Yet reading John Imison's instructions for the
painting of transparencies, so fashionable in the late eighteenth and early nineteenth
centuries as window decoration, do they not sound like a description of one of
Daguerre's dioramas twenty years later—"The Ruins of Holyrood Chapel by
moonlight"? (See page 26.)

"No subject is so admirably adapted to this species of effect as the gloomy
Gothic ruin, whose antique towers and pointed turrets finely contrast their dark

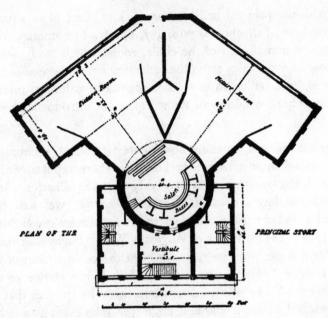

(a) Ground plan of the Diorama building, London, by
A. Pugin and J. Morgan, 1823

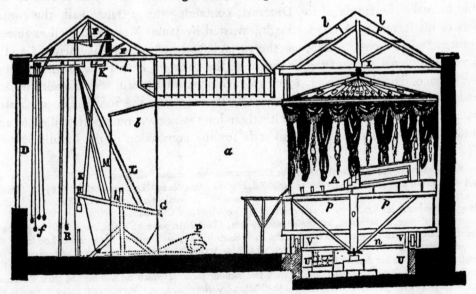

THE DIORAMA.

(b) Cross-section of the auditorium and picture emplacement of the Diorama, London

battlements with the pale yet brilliant moon. The effect of rays passing through the ruined windows, half choked with ivy, or of a fire amongst the clustering pillars and broken monuments of the choir, round which are figures of banditti; or others whose haggard faces catch the reflecting light: these afford a peculiarity of effect not to be equalled in any other species of painting. Internal views of cathedrals also, where windows of stained glass are introduced, have a beautiful effect.'' [23]

The phenomenal success of their novel entertainment* encouraged Daguerre and Bouton to extend their activities to London, where reports of the Paris Diorama had aroused the greatest interest. Early in 1823 Charles (Arrow)smith,† Daguerre's brother-in-law and assistant at the Diorama, was sent to London to prospect the scene, and entrusted the work to the French émigré architect Augustus Charles Pugin (1762–1832), father of Augustus Welby Pugin, the revivalist of the Gothic style. Pugin went over to Paris to inspect the construction of the Diorama, on which the London Diorama was to be modelled. His choice of a site in Park Square East, Regent's Park, was no doubt influenced by the fact that this area was then being developed by his friend and employer John Nash as a fashionable residential district. Nash was the designer of the Park and architect of most of the elegant Regency terraces encircling it. In 1823 he was building Park Square, and so was able to make the façade of the Diorama, containing the entrance hall, the centre part of his terrace. (Plate 17.) Pugin, assisted by James Morgan, a civil engineer, constructed at a cost of £10,000 the rotunda and picture emplacements, i.e. the purely functional parts of the Diorama, at the back (in Peto Place) invisible from the terrace. The façade (Nos. 17 to 19 Park Square East) still stands unaltered and undamaged by the war; only the word "Diorama" on the roof has been painted out. The picture emplacements with their long windows, now partly filled in and suitably buttressed in ecclesiastical style for the conversion of the building into a

* One of the signs of the popularity of the Diorama was the "orama" slang which was invented by artists and soon spread to middle-class circles in Paris. Balzac gives examples in "Le Père Goriot" (1835). "How's your healthorama?" "Here comes a famous souporama." "A bottleorama of claret." The same kind of slang is now being used in America as a result of the popularity of Cinerama.

† By profession an architect, art dealer, and painter, Charles Arrowsmith's pictures, chiefly English and French church interiors, were exhibited at the Paris Salon in 1827, at Douai in 1829, and in London at the Royal Academy, British Institution and Society of British Artists in 1830–33. More important were Arrowsmith's activities as art dealer, for it was he who introduced the work of Constable—among other English landscape painters—to the French public with two famous pictures which he had bought from Constable for £250 in 1824: "The Haywain" (now at the National Gallery) and the "View on the Stour" (now in the Huntingdon Library, California), as well as a small picture of Yarmouth. The success which these three paintings had the same year at the Paris Salon encouraged Arrowsmith to place commissions with Constable, whose work was to have a great influence on Courbet and the 1830 School.

Baptist Chapel in 1855, can still be seen from Peto Place. At present the premises are occupied by the Arthur Stanley Institute (Middlesex Hospital) for Rheumatic Diseases.

There was little difference between the Paris and London buildings, except that the latter had only two picture emplacements instead of three as in Paris,* because it was originally intended to show at Regent's Park only pictures already exhibited in Paris, so a studio for painting a new one while the others were on view was superfluous. Some English journalists claimed that the London Diorama was larger than the Paris one, but the dimensions were actually the same; in fact the auditorium held only 200, though presumably in greater comfort. The rotating machinery was constructed by an engineer named Topham on the same principle as that in Paris.

As already mentioned, the Diorama had been protected in England by a patent taken out by John Arrowsmith on 10 February 1824—four months *after* its opening on Monday, 29 September 1823. Except for the Nash façade, which was not quite finished, the building had been completed in four months. In London, the same two pictures with which the Paris Diorama had opened—"Canterbury Cathedral" and "The Valley of Sarnen"—were at first shown, and the English were no less enthusiastic in their appreciation than the French.

"Among the many exhibitions in the metropolis, there is not one which has excited more surprise, or has been more attractive, than the Diorama. The novelty of the plan, and the singular illusion of the views, took the town by surprise, and to one portion of the public at least, it became a matter of dispute whether they really were actually nothing more than paintings." [24]

The Times devoted a 1,200-word review to these two pictures, but since we have already quoted from the descriptions which appeared in this and other English papers, at the time of the opening of the Paris Diorama, on account of their greater clarity and fulness compared with those in French papers, the above extract from one notice may suffice.

"Canterbury Cathedral" and "The Valley of Sarnen" continued to draw crowds in 1824. On Easter Monday receipts exceeded £200, which means that 2,000 people visited the Diorama on that day at 2s. a time. In London the opening hours were slightly different from those in Paris; from ten until four, five, or six, according to season, and, unlike the Paris establishment, the London Diorama

* In Paris, visitors could sometimes see old dioramas in a fourth gallery, which was not connected with the rotunda, and had less good lighting arrangements.

usually closed for the winter; not that the weather was so much worse in London than in Paris, but Regent's Park was rather far from museums and theatreland, and people did not feel inclined to drive out there except in fine weather. In the 1840s, though, the Diorama remained open every winter until 31 December or even 31 January, in order not to miss the profitable Christmas season.

Up to 1830 all pictures shown here had already been exhibited in Paris for long periods—sometimes for over a year. After being shown in Regent's Park for a season they were sent on to the Diorama at Bold Street, Liverpool,* to Dublin, and a few even to America,† where they were shown for short periods in New York at the Lyceum (1841), Philadelphia at the Masonic Hall (1841), Boston, Baltimore, Charleston, and Washington, D.C., at Carusi's Assembly Room (April 1842).

Interest continued unabated throughout the first decade. Each new set of diorama paintings (for a complete list of dioramas and their dates of exhibition see appendix) was acclaimed a new triumph by *The Mirror of Literature, Amusement and Instruction*—one of the two or three general-interest magazines that existed prior to the foundation of *The Athenaeum* and *The Spectator* in 1828. (*The Art Journal* was founded in 1839 and *The Illustrated London News* not until 1842.) *The Mirror* gave regular reviews of the Diorama, and according to this source Daguerre's view of Holyrood Chapel was "the greatest triumph ever achieved in pictorial art" [25]; his "Roslyn Chapel" "surpasses every representation of architectural structure we ever saw" [26]; and "Ruins in a Fog" "entitles Mr Daguerre to be ranked as one of the most distinguished painters that ever lived." [27] The fog rose slowly to reveal through a ruined Gothic colonnade a forest of larches in a snow-covered valley—a similar effect to that which Daguerre had unsuccessfully attempted by different means on the stage nine years earlier.

The brilliantly successful *trompe-l'œil* created some confusion in the minds of critics who seemed to think that the nearer art came to the reproduction of nature, the closer it approached perfection. "The 'View of Brest Harbour' [by Daguerre] is not a vain representation—it is reality itself," wrote *The Mirror of Literature* on

* Nothing is known about the Liverpool Diorama. The only proofs of its existence are programmes of "Canterbury Cathedral", "Holyrood Chapel", and "The Valley of Sarnen" which are indexed at the British Museum but have been destroyed by enemy action, and a programme of "Canterbury Cathedral" at Liverpool Public Library.

† We are indebted to Beaumont Newhall for information concerning a broadsheet published in Philadelphia in 1841, which proves that Daguerre's dioramas were shown in America. It reads: "Daguerre's Diorama (from Paris). Brought to the U.S. by MM. Maffey & Lonati, and just arrived from New York. At the Masonic Hall." It is impossible that any dioramas came *direct* from Paris in 1841 because the Diorama there had been destroyed by fire on 8 March 1839. These must have been shipped from England. A further reference is contained in the *Daily National Intelligence*, Washington, D.C., 13 April 1842.

2 October 1824; and returning to the same subject the following year remarked:

"It was believed by thousands that the little boy in the foreground, with his shoes down-at-heel, was either a very quiet charity boy, or at least a suit of clothes stuffed, instead of the mere effect of the pencil; and in the view of the 'Cathedral of Chartres' [by Bouton] everybody saw, or at least fancied they saw, a real cobweb on the corner of the picture in the front. Such is the effect of pictorial illusion produced in the Diorama." [28]

Every new set of pictures was received with fresh eulogies:

"We have always considered the Diorama one of the most extraordinary and ingenious exhibitions ever presented to the public, and the most strikingly correct representation of the beauties of nature and the wonders of art. . . . Surprising as the former exhibitions in the Diorama were—and they appeared to have attained perfection—yet we hesitate not to say that they are surpassed by the views now open ['Roslyn Chapel' by Daguerre and 'Rouen' by Bouton] which cannot fail of rendering the Diorama more popular and attractive than ever. . . . We can scarcely expect our readers to believe that persons who have seen this chapel and observed it well, on viewing the Diorama might think themselves transported by some magic spell to the scene itself—so perfect is the illusion. Indeed, we know an artist, eminent not in one branch but in a general knowledge of the arts, who declared that had he not clearly ascertained that the view of Roslyn Chapel was a painting on a flat surface, he would have believed that the effect was produced by more than one position of the scenery, or rather by many scenes placed in different positions, yet such is not the case; the illusion, however, is so extraordinary that connoisseurs and even artists may be excused for scepticism on the subject." [29]

"The view of 'Mount St. Gotthard' [by Daguerre] taken from the town of Faido . . . is one of the most striking points in the romantic scenery which characterizes this pass of the Alps. On either side stupendous cliffs rise precipitously to a tremendous height, forming a chasm of unfathomable depth into which the Tessin falls in picturesque cascades; the principal one under the bridge being shown in motion, while the murmuring sound of the distant dashing of the water heightens the effect and *vraisemblance*. This beautiful representation of one of the grandest scenes in nature has the effect of bringing the reality before the eye so vividly as to excite those emotions and raise up those associations which a contemplation of the actual scene would produce in the mind; such truth, force and feeling is there in the picture."[30]

Another thing which strikes one in reading reviews of the Diorama is that critics were always inclined to praise the *latest* pictures as the best, viz.: "The most successful productions of this splendid exhibition,[31] "the best landscape that has ever been exhibited at the Diorama",[32] "more remarkable than any of its predecessors",[33] "the best of its series",[34] etc., etc.

Those who held the illusion of reality in the Diorama in such high esteem sometimes suspected they were deceived by mechanical devices which were (apparently) introduced to heighten certain effects. "The motion of the water, and the rising of the smoke from the cottage, and other tricks by which it is sought, but in vain, to add to the effect of the drawing, present to the wonder-loving wherewithal to exclaim about."[35]

When Bouton claimed in the programme of "Cloister of St Wandrille" that "the clouds move, the leaves of the shrubs which overgrow some of the ruins are agitated by the wind, and display their shadows on the adjoining columns; the sun appears and disappears, a door opens and closes in the picture", *The Mechanic's Magazine* objected (29 March 1828):

"The leaves are *not* agitated, though they may seem to be so—it is an optical deception accomplished by very simple and obvious means, and though a door does open and close in view of the spectator, it reveals nothing to his sight. The less the proprietors of the Diorama say about such mechanical devices as the shaking leaves and opening door, the better. Either the brush and canvas should have been left to produce their own impression (with the help always of the coloured screens, which are very allowable auxiliaries), or mechanical motion, if called in at all, should have been employed to far more purpose that it has ever yet been at these exhibitions."

The most popular subject during the first decade of the Diorama's existence was Daguerre's "Holyrood Chapel", exhibited in Paris in 1823 and in London in 1825.

The ruined Gothic chapel was depicted by moonlight (Plate 13); the figure of a woman in white was seen praying in front of a monument, while an old Scottish air was played on the flute. It was a picture that reflected admirably the mood of the romantic period.

"The stars actually scintillate in their spheres, occasionally obscured and occasionally emerging from the misty clouds, while the moon gently glides with scarcely perceptible motion, now through the hazy, now through the clearer air, and the light reflected upon the walls and shafts and shattered architrave becomes

dim or brilliant in proportion to the clearness or the obscurity of her course, so that, if this be painting, however exquisite, it still is something more; for the elements have their motions, though the objects they illuminate are fixed.''[36]

"Non contents d'avoir fait éclore
Vingt prodiges nouveaux, sous leur pinceau hardi,
Ces messieurs nous font voir encore
Des étoiles en plein midi,''

penned M. de Villiers, a salon wit, while "The Valley of Sarnen" inspired Jenny Dufourquet to a novel.

Apart from his dioramas, Daguerre painted a small number of easel pictures, four of which depict diorama subjects, a fact which has given rise to the assumption that they were studies for these dioramas, but this was not so. In each case the diorama was exhibited *before* the painting was shown at the Salon, and it is therefore far more probable that Daguerre expected to find a purchaser for the painting on account of the popularity of the diorama. Besides, it would surely have been senseless to make a finished oil painting as a *study* for the diorama, when the latter had to be painted totally differently for its special effects. Lacking these effects, the purely artistic merit of Daguerre's easel paintings was not rated very highly. A. Jal, for instance, reviewing the Salon of 1824 praises the diorama of Holyrood Chapel by moonlight, but ignores the oil painting of the same subject in the exhibition.

This picture (Plate 12), which was presented to the Walker Art Gallery, Liverpool, in 1864, remained unknown to historians until Helmut Gernsheim drew attention to it.[37] It is the largest of Daguerre's oil paintings, measuring 82 in. × 100 in., and so remarkably realistic that in a reproduction it may at first sight be taken for an actual photograph.

Jal did not refer either to Daguerre's other painting, of Roslyn Chapel, which was hung at the same Salon. Bouton was represented by three paintings, and both artists received the Cross of the Legion of Honour at the investiture which Charles X (who succeeded his brother Louis XVIII in September 1824) held on the occasion of this Salon, in January 1825, and can be seen in the painting of the ceremony by Heim, at the Louvre. The new king, who had lived as an émigré at Holyrood House in 1795–96, took a special interest in Daguerre's painting; but though the honour was officially bestowed on him and Bouton for their paintings at the Salon, it was rumoured that the actual reason for the decoration was their (one and only) joint diorama, a "View of the port and town of Sta. Maria (near Cadiz) in Spain" (1824). It represented the meeting of the duc d'Angoulême with Ferdinand VII of

Spain, and was painted at the request of the French royal family.*

This "political" subject was understandably not considered suitable for exhibition in England; neither did Daguerre's diorama "The 31 July 1830 at the Hôtel de Ville"—the scene of the "proclamation" of the duc d'Orléans as Citizen King Louis-Philippe—nor his "Tomb of Napoleon at St Helena" (1831) ever cross the Channel. Of this last-named picture Peron, president of the Société libre des Beaux-Arts, related that when an art student asked Daguerre for permission to copy it, he advised him: "Young man, come and see me whenever you like, but don't study here, for you would only be making the copy of a copy. If you want to study seriously, go out into the open air."[38] More surprising is the fact that Daguerre's famous moonlit view of Edinburgh during the fire of 15 November 1824, which was so successful in Paris that its exhibition had to be extended for two seasons, was not sent to London, and that his fantastic composition "The Beginning of the Deluge" (1829), which had all the imaginative power of John Martin's painting, but was still more romantic and awe-inspiring, due to the changing light effects, was withheld from the English public.

Contrary to expectation, Bouton does not appear to have been so successful at dioramic painting as Daguerre, with whose pictures his own were sometimes unfavourably compared. After an eulogy on Daguerre's "Village of Thiers", *The Athenaeum* made some rather caustic comments on Bouton's "Interior of St Peter's, Rome", exhibited at the same time.

"M. Bouton has been much less successful in his attempt to represent the interior of St. Peter's: the impression made on the mind by that glorious nave and dome in their reality has nothing in common with the idea which this picture would convey of the proportion and magnificence of the Vatican Temple. We had promised ourselves far better things from the Diorama."[39]

Other critics occasionally wrote in the same vein.

Soon after the closing of his last Paris diorama picture, the "Campo Santo at Pisa", on 14 May 1830, Bouton made London his home for the next ten years, taking over the management of the Regent's Park Diorama. There is no proof that his move was in any way connected with the July Revolution, as has been suggested.

* In 1823 the duc d'Angoulême, son of the comte d'Artois (later Charles X), entered Spain at the head of a French army to deliver the despotic Spanish king, who had been imprisoned by the Cortes at Cadiz, and restored him to the throne as absolute monarch. This military adventure was viewed with mixed feelings both in Spain and France, but on his return to Paris the duke passed with great pomp through the Arc de Triomphe on 2 December 1823. Both he, his wife, and his sister-in-law the duchesse de Berri had been among the early visitors to the Diorama in 1822, when Daguerre and Bouton and their families were presented to them.

On the contrary, the fact that on 16 May Daguerre put up a second picture of his own, instead of one by his partner as usual, points to an arrangement planned long beforehand. From two pressing notes which Daguerre sent in 1829–30 to Monsieur Dauptain, who we assume had invested money in the Diorama and did not want to see it getting into difficulties, it is apparent that the income of the Paris Diorama was insufficient to support both artists. (Later on it transpired that it was not even enough for one.)

(Letter No. 1)[40]

[1829 or 1830.]

MONSIEUR DAUPTAIN.

I am exceedingly sorry to have to trouble you; I can assure you that it is not my fault, but the small income which the last picture of M. Bouton brought in prevented our cashier, M. Martin, from giving me cash for this cheque. I certainly hope this will be the last time that I have to trouble you. It is really very embarrassing for me.

Please accept my best thanks.

DAGUERRE.

Kind regards to the ladies.

(Letter No. 2)[41]

Direction,
rue des Marais,
Maison du Diorama.
Paris, 1 July 1830.

My dear M. Dauptain,

As I was unable yesterday to pay the last instalment of 548 francs on my promissory note, I called on MM. Camus and Cotu and requested them to give me until tomorrow, Friday, which they will gladly do at a word from you. You would greatly oblige me by reassuring the bearer.

Yours very sincerely,

DAGUERRE.

Messrs Camus and Cotu,
rue des Arcis, No. 17.

As the financial position of the Diorama made it necessary for the partners to split up, Bouton took over full responsibility for the London Diorama, while Daguerre remained in sole charge of the Paris one. In this division lies the reason

why, with one exception, no more dioramas by Daguerre were sent to London.

We have been unable to find any references to new dioramas at Regent's Park during 1831; possibly Bouton lacked the time to paint two new pictures and left the previous pair on view for two seasons. From July of the following year Daguerre's "View of Paris from Montmartre" and Bouton's "Campo Santo, Pisa" were exhibited for a season. Thereafter Bouton showed exclusively his own pictures, with the exception of an old one of Daguerre's, "Brest Harbour", which was to be seen for a second season in 1837. A few of Bouton's dioramas were also reshown after an interval of several years; whilst in Paris Daguerre kept several of his dioramas up for two or even three years at a stretch. In fact, Daguerre and Bouton neglected the Dioramas somewhat after 1830, for both were much occupied with other interests: Daguerre with photographic experiments; Bouton with his series of London views (Plate 15), for which there was apparently a good market in Paris as well as in London.

The July Revolution led to a crisis in the Parisian theatre world, from which the Diorama also suffered. Things were going from bad to worse; and seeking to revive his show by novelty of effects, the ingenious producer somewhat exceeded the bounds of dioramic painting, as he had the limits of stage design in "La Forêt de Sénart" thirteen years before. For his "View of Mont Blanc taken from the Valley of Chamonix" he imported a complete chalet with barn and outhouses and put on the stage a live goat eating hay in a shed, and in an attempt to counter the frequently made criticism of the unnatural quietness of the scene* the performance was accompanied by the sound of an Alp-horn and songs, as will be seen from the interesting account of the German author and actor August Lewald, who was invited to breakfast at Daguerre's "Sal de miracle" in 1832.

We found ourselves under the eaves of a Swiss chalet. Farm tools lay scattered about; it seemed as if our unannounced arrival had driven away the shy owners. Below us we saw a small courtyard surrounded with buildings. On our right was an open window with some cloths hung out to dry; there was a rake, an axe, and some chopped wood lay under the stable door. On our left a goat bleated in its pen, and in the distance we heard the little bells of the herd ringing melodiously.

But further away, what a view! The valley covered with snow, surrounded by gigantic mountains! There was no longer any doubt of the scene before us; I

* See *The Times* review of 4 October 1823 on p. 17. *The Athenaeum* wrote on 25 March 1828: "If there is any fault to find [in Daguerre's view of Unterseen] it is perhaps its perfect quietude. The absence of everything like animal life (except the figure of one old woman at the extremity of the village, and of another seen at work through a window) gives a stillness to the scene that would almost make one suppose it a deserted village."

pointed out that before us lay Chamonix, 3,174 feet above sea-level; on the left the Montenvers, lifting its white head above the dark fir woods; in the middle of the valley the majestic hump of Mont Blanc, 14,700 ft. high; to its right, still shrouded in clouds, the Dôme du Goûter; below Mont Blanc the splendid Bossons glacier reaching right into the valley, and not far away, the Brévent. On the left, giant granite needles reached up towards the dark sky, and the Arveyron trickled over ice and snow through the valley. There were some paths in the snow, a few houses lay peacefully surrounded by dark snow-covered fir trees. . . . Everyone was still standing filled with astonishment when another surprise succeeded the first. Behind us there was a clattering of wooden plates, spoons and glasses. We looked round and saw girls in peasant costume serving a country breakfast consisting of milk, cheese, black bread and sausage, while a man-servant poured out Madeira, port and champagne into crystal glasses.

While at breakfast, we heard Alp-horns blowing a short solemn tune, after which a strong male voice down in the "valley" sang a national song, "The Chamois Hunter", in the dialect of the Chamonix valley. We were all greatly moved.

"That is not painting—its magic does not go as far as that!" exclaimed an English girl in the party. "Here is an extraordinary mixture of art and nature, producing the most astonishing effect, so that one cannot decide where nature ceases and art begins. That house is real, those trees are natural. . . . Who is the artist who created all this?"

"My friend Daguerre," I exclaimed enthusiastically. "His health!" We all clinked glasses. Daguerre approached and thanked us, obviously delighted at having been able to provide us with such a pleasant surprise in his Diorama.

"It is just for this mixture of nature and art that many art critics blame me; they say that my live goat, my chalet and my real fir trees are illegitimate aids for the painter. That may well be so! My only aim was to produce the most com-plete illusion; I wanted to rob nature, and therefore had to become a thief. If you visit the valley of Chamonix you will find everything as it is here: this chalet with projecting eaves, and the tools you see here, even the goat down there, I brought back from Chamonix."

"But the singers, the breakfast——?"

"We are in Paris, Mademoiselle. Dancers, singers, costumes, breakfasts of all nations and countries are supplied on our boulevards."

"Incomparable! Yes, only Paris can offer such surprises."

"And a breakfast like this, only Daguerre, the leading artist in his field. Come, let's go up those stairs and admire the smaller diorama pictures."[42]

"We stood beneath a fine cupola and were rotated; beautiful Edinburgh lit up by a conflagration, and Napoleon's tomb at sunset, passed before our enchanted eyes."[43]

Daguerre certainly knew how to turn the wheels of the publicity machine. The occasional entertainment of guests (including the press) at the Diorama paid handsome dividends, and critics who were slow to respond received a reminder. "I should be much obliged if you would publish your opinion of the picture and enlarge upon the general effect and the execution."[44]

The chalet having been erected inside the "tunnel" naturally greatly added to the spectators' illusion. It was quite impossible to distinguish between the true reality of the objects and the imitated reality of the view, even from the front row and using the best opera-glasses. People used to say facetiously that only the front half of the goat was real and that the rest formed part of the back-cloth! When Louis-Philippe took his family to the Diorama one of the young princes asked, "Papa, is the goat real?" to which the puzzled king replied, "I don't know, my boy, you must ask Monsieur Daguerre." Critics cast doubt upon the propriety of Daguerre's latest method. "Should one blame or should one praise M. Daguerre," wrote L'Artiste, "for following the example of M. Langlois* by adding to the means which painting gave him, artificial and mechanical means, strangers to art, properly speaking?"[45] Was it not a greater achievement to produce all the effects purely by painting, and much more gratifying to succeed in persuading the audience that the objects they saw were real although they were only painted? (As, for example, the scaffolding in "Canterbury Cathedral", the boy in "Brest Harbour", the cobweb in "Chartres Cathedral".)

Daguerre's next diorama subject was a romantic murder story. The curtain opened on a moonlit view of the Black Forest, showing the bodies of the Countess of Hartzfeld and her servant, who had just been murdered. The bandits had apparently left hastily, their fire was still burning. "The audience was seized with terror; everyone felt in danger, for one feared to see the assassins spring up on all sides." How easily was the sublime sensation of "delightful horror" aroused in the Romantic period! The critic of L'Artiste was so impressed that he went to the per-

* The innovation of forming the spectators' platform out of real objects is due to Colonel Jean-Charles Langlois (1789–1870), a Waterloo veteran, who in 1829 had a panorama built in the rue des Marais (quite near the Diorama) which was the largest so far constructed, measuring 35 metres in diameter. For his first panorama, "The Battle of Navarino", shown in 1830, Langlois bought the poop of an old battleship, from which the spectators surveyed the scene after having passed through part of the ship's interior, and this approach made the illusion of reality so strong that even reliable critics claimed one could not distinguish where the real ship ended and the painting began.

formance three times in one week, yet in the end he feared that his prose was inadequate to express the intensity of his emotion, for this diorama called for the great poetry of Byron; "M. Daguerre is not only a painter, he is a poet; he understands nature at its most picturesque and most frightening; he is initiated into all the secrets of art, and possesses inspiration."[46]

Realizing that he had departed too far from art in his Chamonix picture, Daguerre never made another aberration of this sort. He developed, instead, an improved kind of dioramic painting—the double-effect diorama in which, purely by means of painting and lighting, a complete transformation took place from day to night or *vice versa*. "The Central Basin of Commerce at Ghent", opening on 20 March 1834, was the first of these double-effect pictures. It showed a canal lined with picturesque medieval houses, and crowded with merchant shipping. As darkness fell, the houses and ships were lit up, and the gables and masts were silhouetted against the starry sky. Painted in collaboration with his pupil Hippolyte Victor Valentin Sébron (1801–79), this diorama proved a welcome change from the old stock subjects of mountain villages and ecclesiastical interiors. Sébron, a one-armed painter of architecture, landscapes, and portraits, whose work was frequently hung at the Salon between 1831 and 1878, has the distinction of being the only one of Daguerre's assistants whose name appears in association with his.* This distinction, and the fact that all the following dioramas were double-effect pictures produced in collaboration with Sébron, makes one wonder whether Sébron merely played a particularly important part in painting the pictures (Daguerre being at that time more than ever engrossed in photographic experiments) or whether the novel method of painting itself were due to him. If so, Sébron certainly showed unusual restraint in remaining silent when Daguerre published it in 1839 as his own, and in so doing cashed an extra pension from the Government.

Briefly, the method was as follows. The first effect was painted on the *front* side of transparent white calico, which had to be as free from joins as possible, and which was prepared on both sides with two coats of parchment size. The colours were ground in oil but applied to the calico with turpentine, and in single strokes, to avoid causing opacity. The second effect was painted on the *verso* of the calico by transmitted light, so that the artist could judge where to preserve and where to paint over the transparent parts of the first effect; this was done with opaque grey paint, the gradation of tones being produced by variation in the opacity of the paint. When this general effect of light and shade was obtained, the picture was

* In 1835 Daguerre sent Sébron on a trip to Flanders, but surprisingly these sketches were not used for dioramas.

coloured in transparent tints. In conjunction with coloured screens, Daguerre then achieved what he termed "the decomposition of form", on the principle that if a green and a red part of the painting are illuminated by red light, the red object will vanish while the green one will appear black, and *vice versa*. In this way astonishing changes could be brought about in the picture, and figures which had not been visible in the first effect appeared one by one in the second effect.

The most renowned of Daguerre's and Sébron's double-effect dioramas was "A Midnight Mass at Saint-Etienne-du-Mont", which was shown continuously for three years. Shortly before its opening on 11 October 1834, Daguerre wrote to the critic Charles Maurice Descombes:

"If only you knew how I have been working these last three months on my diorama picture, and what difficulties I had to conquer! Imagine the interior of a church seen by day and deserted. Then night comes on; the church is lit up and allows one to see a great number of figures. Finally, a midnight mass. And all this painted on the same canvas! I hope that this picture will please. In a few days, I shall ask you to be a judge of it."[47]

Unable to trace Descombes' impressions, we substitute those of a journalist named Gustave Deville, published in *Biographies des Hommes du Jour*, 1841.

"At first it was daylight, the nave full of [empty] chairs; little by little the light waned; at the same time, candles were lit at the back of the choir; then the entire church was illuminated, and the chairs were occupied by the congregation who had arrived, not suddenly as if by scene-shifting, but gradually—quickly enough to surprise one, yet slowly enough for one not to be too astonished. The midnight mass started, and in the midst of a devotion impossible to describe, organ music was heard echoing from the vaulted roof. Slowly dawn broke, the congregation dispersed, the candles were extinguished, the church and the empty chairs appeared as at the beginning. This was magic."

To celebrate the outstanding success of the "Midnight Mass" a banquet was held in honour of Daguerre on 30 November, at which a review of his previous achievements was recited in verse form.

À Daguerre

Si Corneille a créé notre scène tragique,
Si l'on doit à Talma le costume historique,
L'art du décorateur à Daguerre, aujourd'hui,
Doit une illusion inconnue avant lui.

Avant lui les décors, impuissante routine,
N'offrait à nos regards que coulisse et machine.
Mais par lui décoré théâtre reprit
Cet aspect qui sait plaire aux yeux comme à l'esprit.
Le *Songe* nous offrit un site d'Angleterre,
Qu'avait seul pu tracer le pinceau de Daguerre ;
La nébuleuse Écosse, à la lueur des feux,
Fit voir dans *Edimbourg* un tableau merveilleux.
Plus tard, il employa cette touche sévère
Qu'applaudit le public devant son *Belvédère*,
Et son art créateur, avide de succès,
Marcha dans une voie à d'autres sans accès ;
Il avança guidé par sa seule lumière,
Et bientôt en vainqueur parcourut la carrière.

Provot [Prévost] fut sans rivaux dans son Panorama,
Daguerre est sans égal dans son Diorama.
Il dispose à son choix de chaque effet solaire
Et, toujours, ce qu'il veut il est sûr de le faire ;
Son génie inventif n'est jamais arrêté,
Ce qu'il a résolu se voit exécuté.
Des rayons lumineux connaissant l'influence,
Il en sait calculer à son gré l'apparence ;
Soit en les composant ou les décomposant,
Il se montre non moins artiste que savant.
Par la chimie enfin, seul Daguerre a su rendre
Ce que jusques à lui nul n'avait pu comprendre.
Soumis à son génie, et par lui seul guidé,
Le même tableau plaît, cent fois redemandé.
Son obscure *Forêt*, chef-d'œuvre de peinture,
Trompe les yeux du peintre, égale la nature,
Et ce savant tableau, si plein de vérité,
Par son aspect fait croire à la réalité.

Saint-Etienne-du-Mont, sa noble architecture
Que relève si bien une riche sculpture,

Méritaient d'exercer son habile pinceau
Sûr de créer encore un effet tout nouveau.
Mais—sur l'éclat du jour s'étend un voile sombre,
Ses effets gradués sont remplacés par l'ombre;
En cette solitude, un doux saisissement
Plonge le spectateur dans le recueillement.
Un pieux sentiment dont son âme est pressée
Lui rappelle de Dieu, l'image et la pensée.
Une faible clarté perce au sein de la nuit;
Bientôt va commencer la *Messe de minuit*.
De son effet croissant, l'éclatante lumière,
Par cent lustres produite, éclaire la prière
Des fidèles nombreux, qui par enchantement
Viennent peupler la nef de moment en moment.
De ce tableau vivant l'illusion parfaite
Retrient l'œil et l'esprit dans une erreur complète
Mais l'aurore paraît—et tout s'évanouit.
Le jour a remplacé le messe de minuit.[48] G.

"The Midnight Mass" was followed by a spectacular open-air transformation scene in which the terrible catastrophe of the landslide at Goldau, Switzerland, on 2 September 1806, was re-enacted. When the curtain rose, the spectator saw one of the most beautiful and fertile valleys in Switzerland. Towards the centre of the view lay the village of Goldau surrounded by green meadows. In the distance, on the lake of Zug, one got a glimpse of the village of Arth. On the right rose the Rossberg (part of which later formed the landslide) and on the left the Rigi. Gradually a storm rose, rain fell, flashes of lightning illuminated the scene and thunder rolled. As night approached, the inhabitants came out of their houses, falling on their knees at the signs of the impending catastrophe, and imploring heaven for protection. Great rumblings indicated that their fears had been well founded but their prayers in vain. The valley was next seen by moonlight strewn with enormous rocks which had crushed 449 people beneath the ruins of their houses. According to *L'Artiste* the painting of the diorama had now arrived at "the highest possible degree of illusion, thanks to the day and night effects produced on the same canvas by the aid of M. Daguerre's new process. . . . This discovery is all the more valuable because what the diorama paintings still lacked was life, movement and human figures which animate and complete the landscapes and monuments. . . . When one considers that such a complete transformation is pro-

duced without any scene-shifting and by the sole modification of light, one cannot but admire the simplicity of the process and the author's great knowledge in optics and mechanics."[49]

"The Inauguration of the Temple of Solomon" brought forth fresh eulogies, and as if aware that constant praise must sound as monotonous as any other repetition, the critic of the *Journal des Artistes* introduced his review with this apology:

"Here is a new marvel of M. Daguerre. This is now almost the sole praise that one can give to the pictures of the Diorama, in order not to say the same thing every time; still, the word 'marvel' is in itself a repetition, for it was necessary to employ it for the *Valley of Goldau*, for the *Midnight Mass*, for the *Town of Ghent*, and for a good many other magnificent pictures, where the artist shows himself admirable to almost the same degree. . . . One really doesn't know any more how to express one's surprise in the presence of such astonishing results. Perhaps it is better to limit oneself to describing the scene as best one can:

It is night. By the faint light of the moon, veiled with clouds, one distinguishes in the darkness vast edifices adjacent to the precincts of the Temple. Porticoes, flights of stairs, courtyards, indicate a sumptuous building. In the background, facing the spectator, darkness slowly gives way to the illumination which is being prepared. Soon there appear other lights; magnificent candelabras illuminate an immense peristyle. A hundred thousand Jews gather in the courtyards of the Temple, which only a moment before had been empty. The priests and the Levites take their places in the procession leading to the entrance; sacred music is heard, incense is burnt in honour of Jehovah, and from the midst of the clouds a miraculous light illuminates the Temple with its brilliance, dazzling the eyes of the people gathered in religious silence.

All this happens in the same room, on the same canvas, with a use of colours and of light of which neither you nor I comprehend anything; for it is true to say that M. Daguerre is the only person who possesses the key to these magic operations."[50].

Daguerre had imagined an immense and magnificent edifice in a combination of Egyptian and Greek style, differing widely from the descriptions of the Temple in the Book of Kings. Indeed, he may well have drawn his inspiration from the fantastic Biblical illustrations of his English contemporary John Martin, to which his sketch for this diorama (Plate 10) bears a striking resemblance.

Notwithstanding the excellent reviews accorded to each new diorama, it was an open secret during the 1830s that the Diorama was running at a loss, one paper stating an amount of 20,000 francs a year (then £800),[51] though this figure was

presumably greatly exaggerated in an attempt to secure Government support, for no shareholder would put up with such a loss for several years running and Daguerre had not a sou to spare. From time to time he threw out hints that he might have to close the Diorama and go to England, "more generous than we are towards great talent". Being on the best of terms with the administrator, journalists did what they could to rouse the conscience of the public and of the Government.

"Is it true that the Diorama, that establishment without rival, is close to escaping us?" asked *L'Artiste* in 1833. "Is it true that M. Daguerre is forced to carry his talent to a more generous country? At present, he offers us at the same time the Black Forest, the Tomb of Napoleon, the Valley of Chamonix, and Venice,* all taken on the spot, and true with an unbelievable truthfulness. Alas, M. Daguerre receives as the fruit of his work 20,000 francs per year loss! This is suicide. How is it that our Government, which tries with so much care to revive the ideas of Napoleon [as a patron of art], does not think of supporting this beautiful establishment? The Diorama attracts visitors to Paris, yet the Government does not come to its aid. In fact, the Government does nothing for M. Daguerre. The public is certainly partly to blame too, but preoccupied with the grave questions of social conditions,† has the public the leisure to think of the Diorama? Besides, the public does not hear it spoken of, and so ignores it. This is a great calamity. . . . If we lose the Diorama, it is a misfortune for art, and a veritable shame for the capital."[52]

This evidence completely refutes Mentienne's tale of the great prosperity of the Diorama, supposedly bringing Daguerre a profit of up to 200,000 francs in some years, and enabling him to buy back the shares of the Diorama Company in order to be sole proprietor! Daguerre's letter to M. Degascq (page 94), is in itself proof of the continued participation of shareholders until 1839.

Similar pleas for a subsidy appeared in the press not infrequently, but they are usually coupled with the writer's advice to the "painter-director" to popularize the exhibition by lowering the price of admission to 1 franc or even to 50 centimes on some days of the week, and to raise the entrance fee to 3 or even 5 francs on others. Daguerre had already reduced the price to 2 francs 50 in 1831 and to 2 francs in 1832, but remained adamant against any lowering of the tone of his establishment which he feared would result from further reductions. Artists and their families were generously presented with free tickets or half-price coupons, valid

* This fourth diorama, the Grand Canal, Venice, had already been shown in 1828–29 and was now presumably reshown in the small gallery.

† Following the cholera epidemic of 1832.

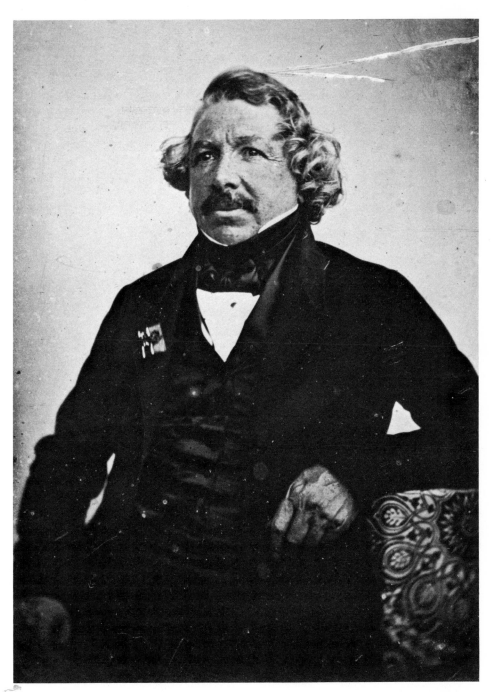

1. L. J. M. Daguerre. Daguerreotype by J. B. Sabatier-Blot, 1844

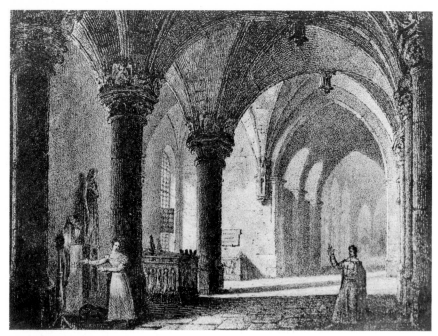

2. Lithograph of Daguerre's *décor* for ''Elodie'', Act III, Scene 1, at the Ambigu-Comique, 1822

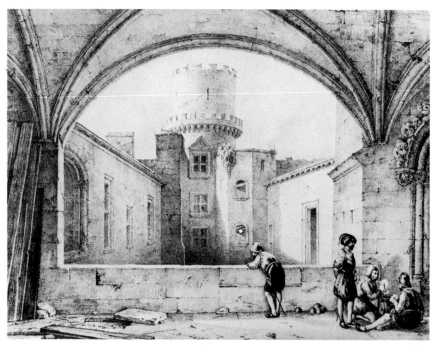

3. Château de Tournoël, gallery leading to the chapel. Lithograph from a drawing by Daguerre, 1829

4. The Bridge of Thiers. Lithograph from a drawing by Daguerre, 1833

5. The church of Brou. Lithograph from a drawing by Daguerre, 1825

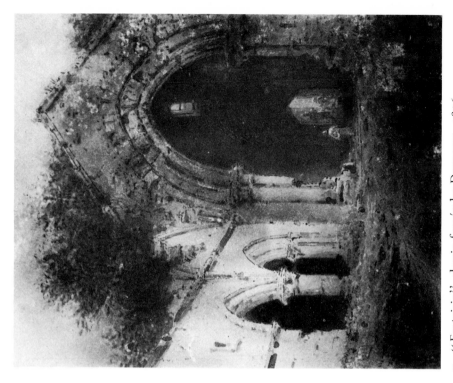

7. "Fantaisie", dessin-fumée by Daguerre, 1826

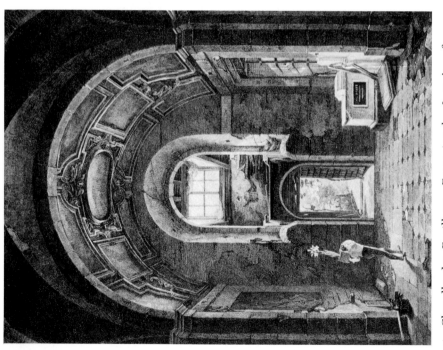

6. Chapelle des Feuillants. Engraving by Lemaître from a painting by Daguerre, 1814

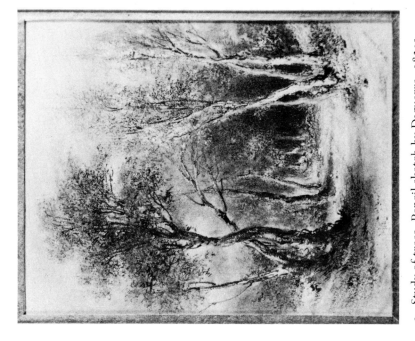

9. Study of trees. Pencil sketch by Daguerre, 1820s

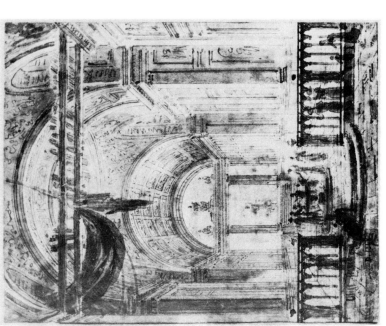

8. Pen-and-wash drawing of a church interior by
Daguerre, 1820s

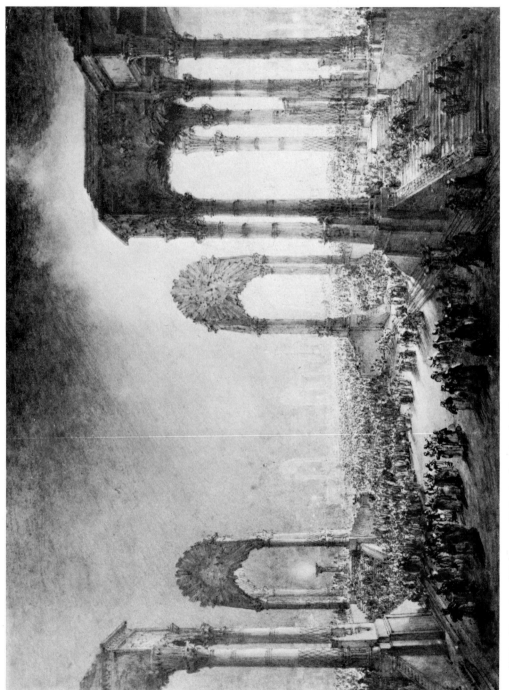

10. "The Temple of Solomon." Sepia drawing by Daguerre, 1836

11. Landscape with ruin. Oil painting by Daguerre, 1834

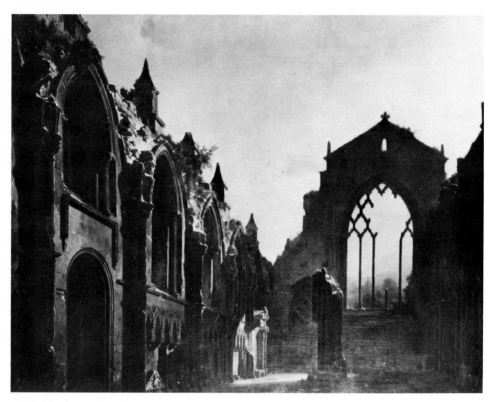

12. Holyrood Chapel, Edinburgh. Oil painting by Daguerre, 1824

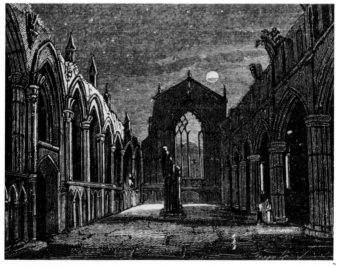

13. Woodcut of Daguerre's diorama of Holyrood Chapel,
1823

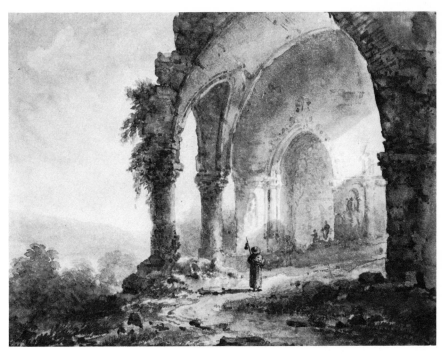

14. Ruined Gothic church with figures. Water-colour by Daguerre, 1821

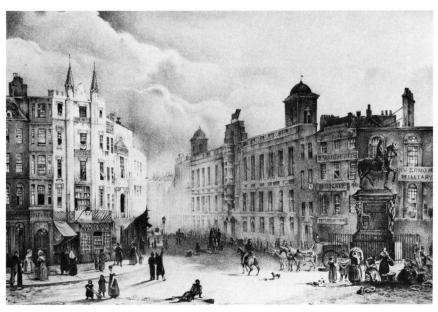

15. The Strand and Northumberland House, London. Hand-coloured lithograph by C. M. Bouton, c. 1832

16. The Diorama in Paris. Woodcut, *c.* 1830, showing in the background the cupola of Colonel Langlois' panorama

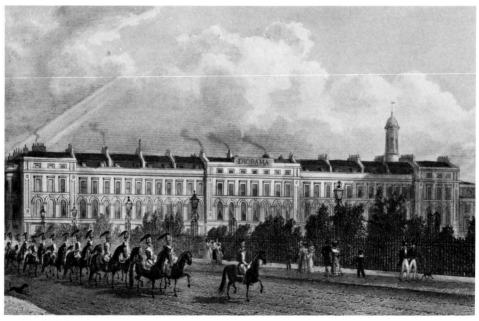

17. The Diorama in Regent's Park, London. Coloured engraving dated 1829, from a drawing by H. Shepherd

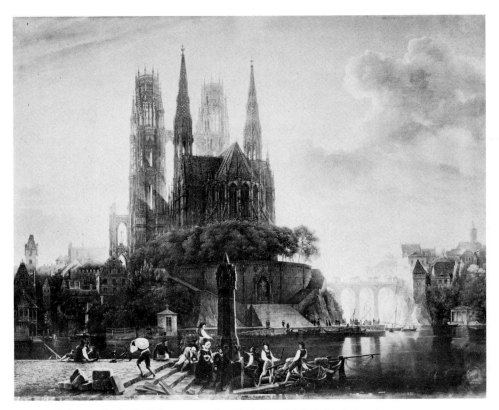

18. A Gothic cathedral. Oil painting by Karl Friedrich Schinkel, 1815

19. Carl Gropius's Diorama, Berlin, 1827. Reproduction

20. Dioramic coloured lithograph of an alpine village, c. 1836. Daylight scene by reflected light

21. The same picture. Night scene by transmitted light

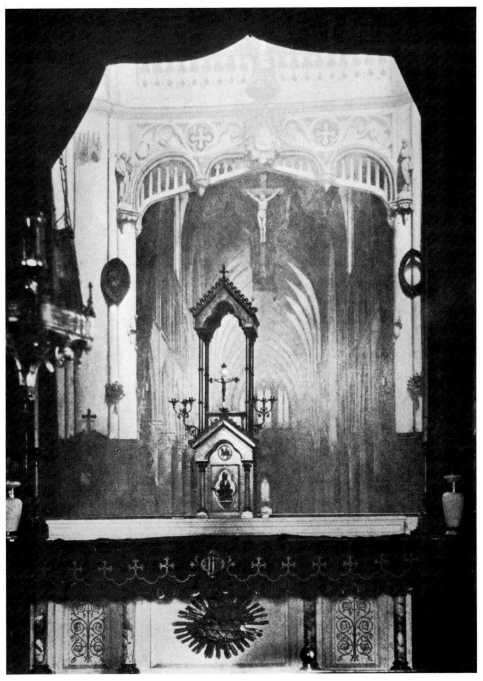

22. *Trompe-l'œil* painting by Daguerre behind the altar "extending" the church of Bry-sur-Marne, 1842

23. Physionotrace of a lady, 1793. Drawn by Fouquet, engraved by Chrétien. Physionotrace of I. B. De Pille, 1790. Drawn by Fouquet, engraved by Chrétien

24a. Silhouette of a lady, c. 1792

24. Silhouette machine, c. 1780. From Lavater's "Essays on Physiognomy"

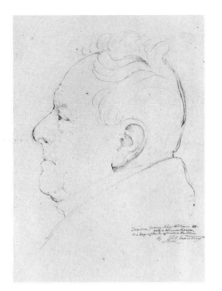

26. Diorama ticket, 1830, with Daguerre's autograph

25. King William IV. Sketch made by Sir Francis Chantrey with the camera lucida, 1830

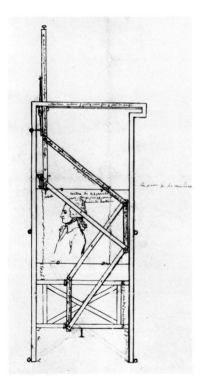

27. Drawing of the physionotrace machine invented by Chrétien, 1786

28. Lithograph of a gentleman drawing with Wollaston's camera lucida, invented 1807

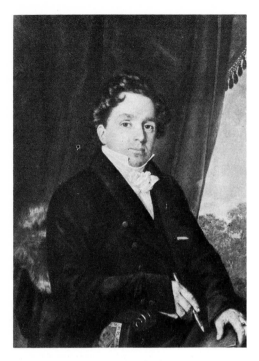

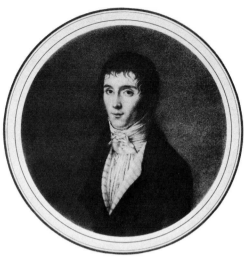

29. (*left*) Photogravure of a miniature of Daguerre by Millet de Charlieu, 1827

30. (*above*) Gouache portrait of Nicéphore Niépce by C. Laguiche, *c.* 1800

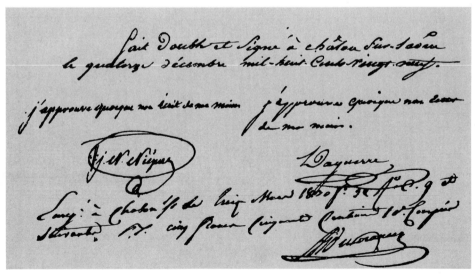

31. Signatures of Nicéphore Niépce and Daguerre on their contract of 14 December 1829

for a limited period, which are especially interesting for a personal touch—they bear Daguerre's handwritten signature (Plate 26) and, up to 1830, Bouton's as well.

Spurred on by Daguerre's fresh successes in dioramic painting, Bouton made similar double-effect pictures for the London Diorama. In June 1835 was shown "The Interior of the Church of Santa Croce, Florence"—a close imitation of Daguerre's "Midnight Mass", even to the "Grand Machine Organ" which played the Kyrie from Haydn's Mass No. 1 during the midnight service.

The other view shown with it—"the Campo Vaccino at Rome" (Forum Romanum)—was Bouton's first attempt at a landscape apart from town views. It did not strike the public as particularly interesting, and the following Easter was replaced by a transformation scene obviously modelled on Daguerre's "Valley of Goldau" which had opened in Paris six months earlier. A full moon revealed the "Village of Alagna in Piedmont" situated under the shadow of Monte Rosa and other snowclad peaks. The twinkling lights of the distant village are reflected in the lake, and smoke rises from the chimney of a chalet in the foreground. As night comes on the lights are extinguished. The inhabitants, accustomed to the thunder of avalanches, have gone to bed. At the approach of a violent storm, a few lamps are lighted in the village; the church bell sounds the alarm, but this is soon drowned in the terrific crash of an avalanche. Morning dawns, bringing to view the destruction of the village; only the church spire rises out of the masses of snow. "It is a work of witchcraft, if it be a picture . . . so admirably managed as to be almost awful",[53] and so popular was this diorama that the London printseller W. Spooner in the Strand published a small imitation diorama of it. (Plates 20 and 21.) The change of programme at the Diorama was, however, too slow for the popular demand, and so before long Spooner and another printseller, Reeves & Sons, Cheapside, added new subjects not in the repertory. These published "diorama" pictures usually measure 6 in. × $7\frac{1}{2}$ in. not counting the surrounding cardboard frame, and the paper transparencies are first viewed by reflected and then by transmitted light.

Bouton's "Basilica of St Paul's-without-the-walls, Rome" (1837), representing the interior before and after its destruction by fire on 16 July 1823, also drew forth all the superlatives The Athenaeum had at its command: "admirable work of art", "quite magical", "recalls to mind the wonders of the old magicians". The following year this journal referred to Bouton's latest picture, "The Cascades of Tivoli", as "a new marvel", adding "it is no exaggeration to give the pictures there exhibited that appellation".

Early in 1840 Bouton returned to Paris, prospecting the scene for a new Diorama to replace Daguerre's establishment which had been destroyed by fire in March of the previous year. He eventually opened one on the boulevard Bonne-

Nouvelle in 1842, with a view of Freiburg. This Diorama, too, was burnt down seven years later. Undaunted, Bouton immediately had a new building erected on the Champs-Elysées where, among other pictures, he showed the funeral of the Archbishop of Paris.[54]

After Bouton's departure the London establishment exhibited dioramas by Charles Caius Rénoux (1795–1846), a painter of landscapes, historical subjects, architecture and interiors, and exhibitor at the Salon from 1822 until 1843. Like Daguerre and Bouton, he was a Chevalier of the Legion of Honour (June 1838). Nothing is known about his business arrangements with Bouton, nor can it be ascertained whether he actually came to London to run the establishment, or merely sent over his pictures. According to *The Mirror of Literature*, these fully sustained the pre-eminent reputation of the Diorama, while *The Athenaeum* felt that they were "only one degree less excellent than the pictures of MM. Bouton and Daguerre". Rénoux's dioramas were all double-effect pictures. His first subject, "The Shrine of the Nativity at Bethlehem", was after a sketch by David Roberts, R.A. "No description can give a just idea of the splendour of the magic transitions of light as displayed in the bursting forth of the noonday's sun, to the softening 'religious light' emitted from the candles in the various niches."[55] Though Bouton had already familiarized the English public with midnight masses in Catholic churches, this was apparently a spectacle that lost none of its appeal even though the subject was by now only a variation on an old theme. Each picture moved critics and public alike to fresh outbursts of enthusiasm. Rénoux's "Exterior view of Notre-Dame, Paris, in evening light" was shown in 1843.

> "The bell rings, a curtain rises, and we are looking on the time-worn towers, transepts, and buttresses of Notre-Dame, its rose window on the left, and the water around its base reflecting back the last beams of the setting sun. Gradually these reflections disappear, the warm tints fade from the sky, and are succeeded by the cool grey hue of twilight, and that again by night—deepening by insensible degrees till the quay and the surrounding buildings and the water are no longer distinguishable, and Notre-Dame itself scarcely reveals to us its outlines against the sky. Before we have long gazed on this scene the moon begins to emerge slowly—very slowly, from the opposite quarter of the heavens, its first faint rays tempering apparently rather than dispersing the gloom; presently a slight radiance touches the top of one of the pinnacles of the cathedral—and glances as it were athwart the dark breast of the stream; now growing more powerful, the projections of Notre-Dame throw their light and fantastic shadows over the left side of the building, until at last, bursting forth in serene and unclouded majesty, the

whole scene is lit up, except where the vast Cathedral interrupts its beams, on the quay here to the left, and where through the darkness the street lamps are now seen, each illumining its allotted space. Hark! the clock of Notre-Dame strikes! and low and musical come the sounds—it is midnight—scarcely has the vibration of the last note ceased before the organ is heard* and the solemn service of the Catholic Church begins—beautiful, inexpressibly beautiful—one forgets creeds at such a time, and thinks only of prayer: we long to join them."[56]

Repetition is, however, an acid test, for it invites comparison. Rénoux was soon to experience this when he failed to live up to his last success with his "Interior of St Ouen's Church, Rouen", which was described as "the most ambitious Gothic interior which the French magicians have hitherto transferred to Regent's Park". "The coming on of night, the illumination of the church—partly by taper, partly by moonlight—are less real than former essays of like quality" complained *The Athenaeum*. "The natural course of those who repeat any favourite effect tends to exaggeration at the expense of Nature, and M. Rénoux would not do ill to take this hackneyed truth by way of text for his next year's sorcery."[57]

Not only day and night, storm and calm, sunshine and showers, but even winter and summer were magically changed at the Diorama.

Rénoux died in Paris on 15 March 1846, and his view of "Heidelberg in winter and summer", and "Notre-Dame", which had been on view since Easter 1845, continued to be shown during 1846. When the Diorama reopened on 31 March for the 1847 season, it was with the work of a new artist, Diosse, a pupil of Daguerre. Since all Daguerre's diorama pictures are supposed to have perished in the fire which destroyed the Paris Diorama in March 1839, only Diosse's own and some old ones of Bouton and Rénoux were exhibited during the next few years.

Diosse's "Interior of St Mark's, Venice" followed the established tradition of a daylight effect changing to a midnight service with figures, accompanied by a Kyrie which for a change was taken from Mozart's Mass No. 12 instead of Haydn's No. 1.

For the next season Diosse had a real surprise in store—a view of "Mount Etna" under *three* different aspects: first in the calmness of night, with the ruins of the theatre of Taormina, lit up by moonlight, dimly visible in the foreground. As day breaks, the sun reveals the entire landscape, with Etna's broad white summit standing out in sharp relief against the intensely blue sky (second aspect). The landscape is then seen under the full blaze of the mid-day sun; slowly the day declines, the shadows lengthen, and night descends, but this time it is not a calm night. Fitful

* Playing the Gloria from Haydn's Mass No. 1.

bursts of light and distant rumbling from the mountain indicate the coming of another of those eruptions which have desolated the country around Catania (third aspect). Now volumes of smoke and flame issue from the crater, the red-hot lava as it is thrown up momentarily lights up the dense clouds of smoke and steam, while streams of liquid fire rush down the mountainside, revealing by their own light the extent of the desolation, engulfing even the beautiful bay which forms the middle distance of the picture. "The artist has been immensely successful," wrote the *Art Journal*; and this verdict was shared by every other paper. This was indeed the *ne plus ultra* of the pre-cinema show, an impression which the woodcut appearing twenty years later in F. Marion's *Optical Wonders* (1868) completely fails to convey (apart from being wrong in several constructional details of the Diorama).

In October 1848, while crowds made their way to Regent's Park to witness the sensational volcanic eruption, the Diorama building, with the machinery and pictures, was sold by auction for the remaining 74 of the 99 years' lease and acquired by Sir Samuel Morton Peto, a railway contractor and Member of Parliament for Norwich, for £6,750. The change of ownership does not appear to have affected Diosse's management of the establishment. His next picture, "The Valley of Rosenlaui", with effects of lightning, thunder, storm, rain, and sunshine, provided almost as good an entertainment as "Mount Etna". Diosse was also responsible for importing in 1850 the first diorama by a non-French artist, "The Castle of Stolzenfels" by Nicholas Meister of Cologne. The famous fortress on the Rhine was represented at sunset and in a thunderstorm. The pattering of raindrops is said to have been so realistic that a lady hastily put up her umbrella.

"Stolzenfels" together with "Mount Etna" were the last dioramas shown at Regent's Park, up to April 1851. After that advertisements and reviews cease, a sign that the exhibition of dioramas had come to an end.* For the next four years the building seems to have stood empty. Then rumours of its conversion into a Baptist chapel were confirmed when the picture emplacements were externally buttressed in ecclesiastical style. Eventually, on 2 May 1855, the building re-opened as a Baptist chapel, which it remained until 1922 when it was converted into a clinic for rheumatic diseases (see p. 23).

We regret our failure to trace a winding-up notice for a tidy ending, or even the clues to an untidy one—and what end could have been more appropriate for this palace of magic than a dramatic fire—a last super-diorama outshining the wonderful spectacle of "Mount Etna"? But no, nothing of that nature occurred, so there remains no other conclusion but that the Diorama, the first and most

* Diosse's "St Mark's, Venice" and "Friburg" (Switzerland) were, however, shown at the Hungerford Hall, Strand, later (n.d.) in 1851.

famous in Britain, was pushed out of business by the mass of inferior competitors, after sustaining public interest for nearly thirty years. During that period thirty-five dioramas were exhibited, several of them for more than one season. The range of subjects was perhaps rather limited—over half of the paintings represented interiors of churches or ruins, six showed Alpine villages, and the rest general town views or landscapes. For the sake of contrast, an architectural and a landscape picture were usually combined in the same programme.

To the present generation, used to the cinema, a diorama show would seem decidedly tame, yet culturally and socially it was a kind of forerunner of the cinema; and, as we have seen, contemporary reports invariably expressed the greatest astonishment and delight at the unbelievable illusion of reality that was created by the subtle changing effects no less than by the more spectacular transformation scenes. The many foreign views, too, no doubt had a special appeal to the general public who, before the days of Cook's Tours, had little chance of travelling abroad, and so the Diorama admirably fulfilled the nineteenth-century requirement of amusement and instruction.

At the time of its closing down no fewer than five rival dioramas were competing with each other in London, not to mention the panoramas and a host of other "oramas" which had sprung up during the 1820s, '30s, and '40s under grandiose titles leaving one guessing about the form of entertainment, ranging from peepshows of prints to geological models: Betaniorama, Cosmorama, Cyclorama, Europorama, Georama, Hydrorama, Kalorama, Kineorama, Myriorama, Nausorama, Neorama, Octorama, Physiorama, Pleorama, Poecilorama, Typorama, Udorama, Uranorama.

In a way, all these shows were descendants of the Eidophysikon of Philip de Loutherbourgh, R.A. (1740–1812), which enjoyed immense popularity in London in the 1780s. On a small stage 6 ft. wide by 8 ft. deep were shown model scenes with ingenious lighting and sound effects. In "A Storm at Sea":

"the clouds positively floated upon the atmosphere, and moved faster or slower, ascended or descended. Waves carved in soft wood and highly varnished undulated and threw up their foam, but as the storm began to rage, grew more and more violent, till at last their commotion appeared truly awful. The vessels, exquisite little models, rose and sank and appeared to move fast or slow according to their bulk and distance from the eye. Rain, hail, thunder and lightning descended in all their varying degrees of intensity and grandeur. Natural-looking light from the sun, the moon, or from artificial sources, was reflected naturally back wherever it fell on a proper surface. Now the moonlight appeared sleeping on the wave, now a lurid flash lit up the tumultuous sea. Old mariners could

hardly persuade themselves they were not once more surrounded by the most imminent danger, and that they ought not themselves to reply to the signal guns of distress, which in the pauses of the terrific gale were heard faintly asking for assistance. . . ."

The public had been quite captivated by the Eidophysikon. Sir Joshua Reynolds, a frequent visitor, recommended his pupils to see it "as the best artificial school in which to study the beauties and sublimities of nature". Gainsborough too was often seen there and relates how he once enjoyed the opportunity of comparing a real thunderstorm with the imitated thunder of de Loutherbourgh. The discovery that an actual thunderstorm was going on at the time had caused consternation among the audience, some of whom considered that it was a warning sent by God against presumption. The creator of the Eidophysikon, on the other hand, beamed with delight. Clutching Gainsborough by the arm he exclaimed: "By God, Gainsborough, our thunder's best!"[58]

Soon after this event Robert Barker had patented his system of panoramic painting (see p. 6). When the Regent's Park Diorama opened, panoramas were still being shown by Robert Burford in Barker's original Panorama building in Leicester Square, and panoramas of London, Paris, and Lisbon also enjoyed a great vogue at the Colosseum, a building erected from the designs of Decimus Burton the year after the Diorama was opened, and only about a couple of hundred yards farther north. At the Theatres Royal, Covent Garden, and Drury Lane, "Moving Panoramick Views" were sandwiched between a tragedy and a pantomime. In 1824 Charles Marshall's "Peristrophic Panorama" of the Battles of Ligny, les Quatres-bras, and Waterloo, painted on 10,000 sq. ft. of canvas, was shown at Spring Gardens, Trafalgar Square, accompanied by a military band.

Following the popularity of the Regent's Park Diorama, the Covent Garden and Drury Lane theatres added to their repertoire dioramas painted by a number of artists, including Clarkson Stanfield, R.A., the marine painter, and David Roberts, R.A., famous for Eastern subjects. These effect pictures regularly appeared in the programme to fill up the evening, just as the early "flickers" helped to fill variety theatres in the 1890s. Indeed, the titles of these "Grand Moving Pictures" foreshadow the desire for news-reels and travel films: "Moving Diorama of the Polar Expedition, being a series of views representing the progress of His Majesty's ships the *Hecla* and *Fury* in their endeavours to discover a North-West Passage from the Atlantic to the Pacific Ocean" (shown by David Roberts at Covent Garden in 1830); and Stanfield's "Grand Moving Picture of a voyage to the Isle of Wight including a visit to Cowes Regatta" at Drury Lane, 1828. These moving

panoramas and dioramas were presumably painted on a continuous roll of material, which was unwound from one giant spool on to another.

Competing with the Regent's Park establishment, in which only dioramas by foreign artists were shown, was the British Diorama at the Royal (later Queen's) Bazaar, Oxford Street, which exhibited in 1828–29 Stanfield's "The City of York" and "Entrance to the Village of Verex near Aosta"; and Roberts' "The Temple of Apollinopolis in Egypt" and "The Church of St Sauveur, Caen". Burnt down on 27 May 1829, the Royal Bazaar was reconstructed the following year, but most of the pictures shown here were considered inferior to "the real Diorama". Charles Arrowsmith's "View of the Coronation [of William IV] in Westminster Abbey" was said to be "merely a large and indifferently painted picture" (i.e. not a picture with dioramic effect.)[59]

In June 1833 Hippolyte Sébron, Daguerre's pupil, exhibited here "an inimitable copy" of John Martin's famous "Belshazzar's Feast", but painted with dioramic effect. "In grandeur of design, and execution, it surpasses any picture ever before exhibited, and being painted on near *two thousand* [square] *feet* of canvas, occupies in magnitude the space of four dioramic views."* John Martin, indignant at Sébron's infringement of his copyright, tried to have the exhibition stopped, but the Vice-Chancellor refused his application for an injunction.

It is obviously impossible to mention more than a few titles out of the hundreds of diorama paintings shown at rival establishments to the original one, but it may be of interest to list the large number of galleries in London where dioramas were shown. In addition to the two Theatres Royal and the Queen's Bazaar, dioramas were exhibited at the Bazaar, St James's Street; the Chinese Gallery, Hyde Park Corner; the Egyptian Hall, Piccadilly; the Gallery of Illustration, 14 Regent Street, Waterloo Place; the National Gallery of Practical Science and Works of Art, Adelaide Street (later called the Adelaide Gallery); the New Society of Painters in Water Colours, 53 Pall Mall; the Portland Gallery, 316 Regent Street, Langham Place; the St George's Gallery, Hyde Park Corner; the Tourists' Gallery, Her Majesty's Concert Room, Haymarket; the Walhalla, Leicester Square; the Western Institution, Leicester Square; Willis's Rooms, King Street, St James's; 60 The Quadrant, Regent Street; the Linewood Gallery, Leicester Square; the Hungerford Hall, Strand; and the Gallery of the National Institution for the Exhibition of Modern Art. Few of these were, however, true dioramas, and the modern use of the term "diorama" to denote models with painted backgrounds and sometimes

* Quoted from a broadsheet in the Gernsheim Collection. This was an absurd claim, for "Belshazzar's Feast" was not even equal in area to one of Daguerre's or Bouton's paintings, which covered 3,253 sq. ft. of canvas (71½ ft. × 45½ ft.).

mechanically changing light effects, for advertising displays and in museums, is, of course, quite incorrect. A fashionable word at the time, the Diorama also served as the title of a curious miscellany published in London in 1837, whose only connection with the Regent's Park Diorama was its publication of reviews of ''Brest Harbour'' and ''Chartres Cathedral''. ''The Diorama, or, amusing sketches of life and manners. This volume comprises among its original and diversi-fied selections, humorous incidents, pleasing anecdotes, amusing dissertations, historical incidents, delineations of character, biographical sketches, affecting narratives, singular customs, curious contrivances, interesting facts, romantic stories, natural curiosities, productions of art, poetical effusions.''

The Diorama in other Countries

Considering the enormous success of the Paris and Regent's Park Dioramas in the 1820s, it is not surprising that a few enterprising spirits in other countries should have tried their luck with similar establishments, but neither Daguerre nor any of his collaborators were in any way connected with the Dioramas in Breslau, Berlin, Cologne, and Stockholm, nor were any of their pictures shown in these cities.

The Breslau Diorama, the first in Germany, was opened by August Siegert about November 1826 with a diorama of Naples and Vesuvius, but nothing further is known about it. A year later Carl Wilhelm Gropius (1793–1870) opened a Diorama in Berlin. (Plate 19.) Gropius, a theatrical painter, had formed the ambition to start a similar show after visiting Daguerre's Diorama, but his plans failed to find support until his friend Carl Friedrich Schinkel, the celebrated Berlin painter and architect, had been to Paris in May 1826. Schinkel had already introduced in his panoramic paintings in Berlin astonishing illusionist effects twenty years earlier, by incorporating in the scenery moveable cut-out figures, and changing light effects. He was immediately infected with enthusiasm for the Diorama and promptly drew up a plan for the building, which was erected soon afterwards at the corner of Georgen- and Universitätsstrasse, on a site made available by King Friedrich Wilhelm III. The interior arrangement was similar to that in Paris and London, though Gropius's dioramas were slightly smaller—20 metres by 13 metres (65 ft. × 42 ft. 3 in.). Schinkel's system of lighting the paintings by fitting long mirrors outside the windows probably constituted an improvement upon Daguerre's.

Gropius's Diorama opened on 29 October 1827 with two paintings: a view of a rocky gorge near Sorrento, and ''Interior of the Church of Brou'', which had been copied from Daguerre's illustration in ''Voyages pittoresques''. (Plate 5.) He is also stated by Max von Boehm to have painted for Gropius's Diorama views of Vesuvius, Mont Blanc, Milan Cathedral, St Peter's, and the Capitol, Rome—

all favourite subjects at that period. Subsequent subjects included the Grindelwald glacier, Genoa harbour seen from the Palazzo Doria, the Scaliger tombs in Verona, and an imaginary Gothic cathedral at sunrise. The latter, copied from a painting by Schinkel (1815) (Plate 18), was shown for sixteen months, starting in June 1830. In the foreground one saw a canal with boats, and sleeping people. Dawn heralded a beautiful summer day. Slowly the sun rose, and after the last stroke of six on the cathedral clock, a hymn was played on the organ; the people knelt before the statue of the Madonna in prayer. The view of Grindelwald glacier was accompanied by the sound of cracking ice, splashing water, and the rumbling of distant avalanches. Gropius's dioramas (and those in Breslau and Cologne) had changing light effects and were in every way similar to Daguerre's.

In August 1832 Gropius introduced the Pleorama—a kind of moving panorama with changing light effects, invented by the architect Langhans of Breslau. The auditorium, which during diorama exhibitions held about 200, was now got up in the form of a small ship holding 30 people, who were taken on an hour's "voyage" in the Gulf of Naples, or down the Rhine from Mainz to St Goar. The illusion of movement was achieved by the back-cloth slowly traversing the stage, giving the impression of a moving viewpoint on the part of the spectator.* By October 1833 the novelty had worn off (or perhaps the reduced seating capacity made the Pleorama unremunerative), for dioramas were resumed and continued until 31 May 1850. In the twenty-three years of its existence, twenty-eight dioramas had been shown, of which a high proportion were interiors and exteriors of churches, and Italian views. Gropius's dioramas unfortunately shared the fate of Daguerre's and Bouton's. They were destroyed by fire in their place of storage on 7 August 1881.

Nothing is known about the Cologne Diorama except that one of its pictures, "The Castle of Stolzenfels" by Nicholas Meistèr, was exhibited at Regent's Park in 1850.

Two rival shows in Stockholm in 1843 were called "Diorama", but the first *real* Diorama was erected in 1846 by G. A. Müller, scene-painter at the Royal Theatre and an early daguerreotypist. This Diorama, which was just outside Skansen, was taken over by Christoffer F. Möller six years later, but it could not be ascertained for how many years the exhibitions continued. The building stands to this day.

* A similar idea was introduced in 1903 by a cinema proprietor, George C. Hale of Kansas City. "Hale's Tours", shown in every big town in America, and in London, took the visitor on a short train journey through the Rocky Mountains, Bonnie Scotland, or Wild Wales. The auditorium was in the form of a railway carriage, beneath which floor-shaking machinery and a compressed-air cylinder emitting the sound of a steam engine had been installed to make the trip more convincing. The films, taken from the front of a railway engine, and showing the railway lines rushing towards the onlooker and telegraph poles flashing past, made him jump nervously in his seat.

Chapter III

THE INVENTION OF PHOTOGRAPHY

"Light is that silent artist
Which without the aid of man
Designs on silver bright
Daguerre's immortal plan."[60]

STRANGE as it may seem—and in contrast to the other pioneers of photography: Wedgwood, Niépce, Talbot—there is no reliable information on the motives which led Daguerre to the idea of photography. He himself remained silent on this point, but after his death a few vague guesses on the part of friends gained currency and were soon repeated as fact. Peron, President of the Société libre des Beaux-Arts, of which Daguerre had been a member, saw Daguerre's approach from the psychological angle: "My great works, my dioramas, are perishable. To win immortality I need a second, more permanent, renown." Knowing him as a boastful yet determined man, Figuier makes Daguerre exclaim after attending one of the lectures of Professor Charles,* "I shall go further. I shall fix permanently these fugitive images!" Both these remarks ring true and sound a convincing expression of Daguerre's character. Mentienne junior, writing down the traditional stories heard from his father, Daguerre's old friend the Mayor of Bry, circumstantially relates how, one summer afternoon in 1823, Daguerre, resting in a darkened room, observed a ray of sunlight coming through a chink in the shutters and projecting the image of a tree on to a painting he was working on. The following morning, astonished to find faint traces of the image still on the painting, Daguerre tried to repeat the phenomenon, but in vain. He then attempted it in the camera obscura, and remembering at last that he had mixed iodine in his colours, undertook a long series of experiments on the light-sensitivity of iodine, which led him to photography. This picturesque myth, related for the first time forty years after Daguerre's death,[61] is too fantastic to merit a detailed confutation: as will be seen later, all the facts are against it.

* Prof. Jacques Charles (1746–1823) in his public lectures at the Louvre and the Conservatoire des Arts et Métiers is said to have demonstrated making profile portraits on silver chloride paper, which were, however, unfixed.

Daguerre most probably first learned to appreciate the camera's valuable aid for perspective drawing during his employment at Prévost's Panoramas (1807–16). It is not known to what extent he made the original camera sketches or whether his task was limited to copying on a greatly enlarged scale those of Prévost. There is little reason to doubt that Daguerre—like most artists of the period—used the camera* for the topographical views he made for *Voyages pittoresques*, as well as for the preparatory sketches necessary for each diorama. It would indeed be curious if at one time or another the idea had not occurred to him, as it was to occur to Fox Talbot in 1833: "How charming it would be if it were possible to cause these natural images to imprint themselves durably and remain fixed upon the paper!"[62] As a matter of fact, Daguerre was haunted by similar visions. One day in 1824 he entered the shop of Vincent and Charles Chevalier, famous for their optical instruments not only in Paris but throughout Europe, to choose some lenses. Thereafter Charles Chevalier (1804–59) (Plate 55), son of Vincent, frequently called at Daguerre's home in the rue de Crussol to try out new lenses, and admiring the pictures on the ground-glass of the camera Daguerre would each time ply him with the same question: "Won't one ever succeed in fixing these perfect images?" The desire to improve the camera obscura soon formed a bond between them, and scarcely a week went by without Daguerre calling at the Chevalier's shop on the Quai de l'Horloge, Île de la Cité, for a chat about cameras and lenses. One day he arrived in a state of great excitement. "I have found a way of fixing the images of the camera!" he exclaimed. "I have seized the fleeting light and imprisoned it! I have forced the sun to paint pictures for me!" "Anyone who did not know the man as well as we did," commented Charles Chevalier,[63] "would certainly have believed him to be seized with a fit of madness." Daguerre was in an irresponsible mood and declared he would not go to the Diorama that day. "So much the worse for the Parisians; they will have to do without the moon this afternoon, for I shan't go!"† and off he dashed to tell the good news to his friends Paul Carpentier, Peron, and others. However, nothing more was heard of the wonderful camera picture. "Admitting that Daguerre had really found what he announced—and for myself I have no reason to doubt it," wrote Charles Chevalier, "it is certain that he had cried victory prematurely, or rather, that after having obtained the image he had not been able to fix it."

Like Wedgwood and Davy, Niépce, Talbot, and numerous other experimenters in photography, Daguerre attempted to record the camera image on paper coated

* Daguerre's camera obscura for drawing is preserved at the Conservatoire National des Arts et Métiers.
† The reference to the moon would date this incident 1824 when "Holyrood Chapel by moonlight" was enchanting Parisians.

with silver chloride*—a silver salt well known to darken in light. At first he thought mere washing in water would suffice to make these images permanent, and his disappointment must have been great when on returning home he saw that the image had blackened all over!

On 12 January 1826 a certain Colonel Laurent Niépce de Sennecey-le-Grand came to Chevalier's to order for his cousin, who lived in the country, a camera with meniscus prism. He impressed on the opticians the need for a good lens giving very clear definition, for, he explained, his relative was engaged in experiments on fixing the images. The Chevaliers could not hide their surprise at this news, so the colonel produced from his pocket a metal plate depicting "A young girl winding flax on her distaff" to show what progress his cousin had made in sun-drawing.†
Several people in the shop, among them the comte de Mandelot, insisted that the plate was only an ordinary engraved plate, and a lively discussion ensued as to the possibility of making pictures by light.

Some days afterwards a young man came to Chevalier's and bought a cheap camera obscura. "I am sorry," he said, "that I cannot afford your apparatus with a [meniscus] prism, for with this instrument I should no doubt succeed better in fixing the fleeting images which trace themselves on the ground-glass." "For the third time, this fantastic idea!" thought Chevalier. "Either this *is* possible, or there must be an epidemic of madness!" But his doubts were swept away by the sight of some positive pictures on paper, which, though imperfect, seemed to him most remarkable.‡ "Well," said the inventor, "since I cannot myself experiment with the prism camera, I will give you some of the substance I use and you can test it for yourself." It was a brown liquid like thick tincture of iodine, in a small bottle. Chevalier followed his informant's verbal instructions, but forgot the most vital point—he carried out all his preparations in broad daylight! He waited in vain for another call from the inventor, who was never heard of again. The modesty of this mysterious inventor of photography in refraining from making his rightful claims public in 1839 is hard to believe in. Later writers, feeling as we do that the story is most unconvincing as it stands, embroidered the tale and composed a suitable ending—the destitute experimentor starved to death or threw himself into the Seine!

* After the announcement of Fox Talbot's photogenic drawing in 1839, J. B. Biot stated that Daguerre had made similar experiments in 1826 and gave the preparation of the silver chloride paper used. *Comptes rendus de l'Académie des Sciences*, 18 February 1839, p. 246.

† This picture was not reproduced in the camera but made by laying the engraving on a sensitive plate.

‡ Baron Ernouf, writing fifty-one years after the event, states that the picture was a view from a mansard window showing roofs, chimneys, and the dome of the Pantheon. However, Chevalier does not mention the subject of this picture, and we assume that Ernouf was using his imagination in this, as in other details.

If any value is to be attached to Chevalier's reminiscences, published many years later, we would suggest that he had compressed the three occurrences—Daguerre's premature claim, Colonel Niépce's visit, and that of the unknown inventor—for the sake of dramatic effect, into a fortnight: a most improbable coincidence. If we assume that no reliance can be placed on the date January 1826, and if we further assume that the imperfect paper pictures Chevalier saw were negatives (unfixed, but which could have been safely examined in the dim light of the shop), the unknown experimenter might have been Hubert, who wrote in September 1836 that he had experimented with chloride of silver on paper "seven or eight years ago" (see p. 73). Hippolyte Bayard (see p. 88) did not start his experiments on paper photographs until 1837, but he is not ruled out, once we doubt the accuracy of Chevalier's date.

Charles Chevalier's incredulity was shaken by this singular coincidence of events succeeding one another so rapidly. When Daguerre called at the shop a day or two later he greeted him full of excitement: "Upon my word, you have come just in time! Somebody is trying to forestall you. Here is the philosopher's stone"; adding as he handed him the little phial, "Test it for yourself." But Daguerre, too, obtained no results. Chevalier then decided to tell him about the work of Niépce. "Perhaps you are following the same path, so why don't you get in touch with M. Niépce? Here is his address."

Like all men sure of their superiority and accustomed to success, Daguerre did not like to be given advice, but curiosity left him no peace of mind, and as soon as he got home he wrote to Nicéphore Niépce.

Thus Chevalier's mediation established the link between Niépce and Daguerre —a partnership to which not only France but the whole world owes one of the most brilliant scientific inventions. The importance of Chevalier's introduction— referred to rather offensively later on by Arago as "the indiscreet revelations of an optician"—cannot be overrated, for without the knowledge of Niépce's process to build upon, it is reasonably certain that Daguerre would never have succeeded in inventing the daguerreotype.

Joseph-Nicéphore Niépce (1765–1833) (Plate 30), the son of a King's Coun-sellor, was living quietly on his country estate Gras, at St Loup-de-Varennes, 6 kilometres from Châlon-sur-Saône, where he also had a town house. The family fortune, though diminished by the Revolution, was still adequate to allow him and his brother Claude to devote much of their time to scientific pursuits when, as young men, they retired from the army and navy respectively. In 1807 the Niépce brothers patented the "Pyréolophore", an ingenious and surprisingly early com-bustion engine which actually propelled a boat on the rivers Saône and Seine. During

the next twenty years they expended most of their efforts, genius, and their entire fortune, on this engine, which accounts for the slowness of Nicéphore Niépce's progress in photography.

When the craze for the newly invented art of lithography swept France it naturally attracted the attention of Nicéphore Niépce. Unable to draw well, he placed engravings, made transparent with wax, on stones coated with light-sensitive varnish of his own composition and exposed them to sunlight. Thus lithography led to what Niépce later termed "Heliography"—sun-drawing.

Attempts at true photography using a camera started in April 1816, and were carried out by Nicéphore Niépce alone, though with constant advice from his brother, who moved to Paris (and later to London), believing that a great metropolis offered better chances for the exploitation of the pyréolophore. Using locally made camera obscuras (a common aid to drawing in those days), Niépce tried to take the view from his attic workroom at Gras, and throughout the correspondence of the brothers no other subject for camera-pictures is ever mentioned. Not only was this procedure convenient, but it enabled him to judge progress by comparison of results.

Niépce soon succeeded in obtaining the view in the camera obscura on paper sensitized with chloride of silver, though the lights and shades were reversed, as had been foreseen by Claude. By the end of May he was able to send his brother some better impressions, having discovered how to sharpen the image by using a simple cardboard diaphragm. The pictures were partially fixed with nitric acid and could be viewed in daylight for a short while. This was a notable advance on the experiments of Thomas Wedgwood* (1771–1805), who had failed to obtain pictures in the camera obscura, and those he obtained by simply laying objects on the sensitive paper could only be looked at by candlelight. Niépce tried to print through one of his negatives, and though he did not succeed in obtaining a positive impression, in his knowledge of this possibility he forestalled Fox Talbot.

During the next few years Niépce tried many different light-sensitive substances, but though he was undoubtedly acquainted with Gay-Lussac and Thénard's *Recherches Physico-Chimiques* (Paris, 1811), which contains much information concerning the chemical action of light, and was in touch with the famous Parisian chemist Vauquelin, who in 1798 had discovered the light-sensitivity of chromium, asking him for certain chemicals which were unobtainable in the provinces,[64] he did not progress beyond the stage reached within the first two months. His researches took no remarkable turn until July 1822, when he made his first successful and permanent heliographic copy of an engraving (of Pope Pius VII) by means of bitumen of Judea on glass—a totally different principle from photography with silver salts. Niépce had

* Wedgwood's experiments were published by Sir Humphry Davy in the *Journal of the Royal Institution*, Vol. 1, 1802, p. 160.

experimented with this asphalt, which is used in engraving and lithography on account of its resistance to etching fluids, for the last two years. He spread on a glass plate a thin layer of bitumen dissolved in oil of lavender, and laid on it an engraving made transparent by oiling it. When exposed to light for two or three hours the bitumen under the white parts of the engraving hardened, whilst that under the dark lines remained soluble and could be washed away with a solvent consisting of oil of lavender and white petroleum. The resulting picture was unalterable by light, but was unfortunately dropped and broken by a clumsy admirer.

In the following years Niépce copied by this method several engravings on metal (usually zinc or pewter) instead of glass, for they were intended to be etched and printed from. The most successful heliograph is a copy of an engraving of Cardinal d'Amboise, Minister of Louis XII, which Niépce made in 1826 and had printed by the Parisian engraver Augustin François Lemaître (1797–1870) in February 1827. (Plate 35.)

In the same year in which he produced this photo-engraving, Niépce succeeded for the first time in fixing permanently the image from nature. The world's first photograph (Plate 32) is also on a pewter plate, size 16·5 cm. × 20·5 cm. The subject fits the description of the view from his window which Nicéphore gave in a letter to Claude on 28 May 1816, when he was experimenting with photography on paper. On the left is the pigeon-house (an upper loft in the Niépce family house), to the right of it is a pear-tree with a patch of sky showing through an opening in the branches, in the centre, the slanting roof of the barn. The long building behind it is the bakehouse, with chimney, and on the right is another wing of the house (as it was at the time). Owing to the small light-sensitivity of bitumen of Judea, the exposure in the camera lasted about 8 hours on a summer's day. This length is not only confirmed by Niépce's son, but is evident in the picture itself, in which the sun seems to be shining on both sides of the courtyard!

As in the photo-engravings, the latent image was rendered visible by dissolving away the parts of the bitumen which had not been hardened by light. The result was a permanent direct positive picture in which the lights were represented by bitumen and the shades by bare metal.

Daguerre's motive in approaching Niépce was no doubt the desire to find out how far his rival had progressed, and to ascertain the nature of his process. Receiving only a very guarded reply, he was seized with anxiety.

"Suddenly, Daguerre became invisible! Shut up in a laboratory which he had arranged in the building of the Diorama where he lived, he set to work with renewed ardour, studying chemistry, and for about two years lived almost continually in the midst of books, retorts and crucibles. I have caught a glimpse of

this mysterious laboratory, but neither I nor anyone else was ever allowed to enter it. Mme Daguerre, MM. Bouton, Sibon [Sébron], Carpentier, etc., can bear witness to the accuracy of these memories."[65]

Carpentier confirmed:

"How many times have I seen him, shut up in his studio for two or three days without leaving it, eating without taking any notice of the food which Madame Daguerre, alarmed, had brought him, not sleeping, obsessed with his idea."[66]

Daguerre must have regretted his inadequate education now as never before. Lacking all knowledge of physics and chemistry, his experiments were rather a hit-or-miss affair. His researches led him to neglect the business of the Diorama and all the ordinary affairs of everyday life to such an extent that his wife seriously began to fear for his sanity (see p. 1).

The first letter which Daguerre addressed to Niépce was unfortunately lost with several others during the latter's stay in Paris in 1827, when his pocket-book slipped down the lavatory at his hotel. Isidore Niépce, his son, relates that his father was somewhat taken aback at Daguerre's direct approach without an introduction or even disclosing the name of his informant. Niépce was suspicious that Daguerre only wanted to pump him, and the phrase, "For a long time I, too, have been seeking the impossible", contradicted the claims put forward in other parts of Daguerre's letter. Niépce's first reaction was to ignore the letter, but on 25 January he wrote a polite reply, giving no indication of the nature of his work or his progress. There the matter would have rested had not Daguerre addressed a second more pressing letter to Niépce a year later, which prompted the latter to enquire of Lemaître, his engraver, on 2 February 1827:

"Do you know M. Daguerre, one of the inventors of the Diorama? . . . This gentleman having been informed, I know not how, of the object of my researches, wrote to me last year during January, to inform me that for a very long time he had been occupied with the same object, and to ask me if I had been luckier than he in my results. Nevertheless, if one is to believe him, he had already obtained some very astonishing results; yet in spite of that, he asked me to tell him first of all, whether I believed the thing possible. I will not hide from you that such incoherence of thought surprised me, to say the least. I was all the more discreet and reserved in my expressions, but nevertheless I wrote to him in a manner civil and obliging enough to elicit a reply on his part. This I have received only today, that is to say after an interval of more than a year; and he addresses me solely to know how far I have progressed, and asks me to send him a picture,

although he doubts that it may be possible to obtain sufficiently strong shades by this process of engraving; and this made him attempt researches in another application, connected more with perfection than with multiplying prints. I am going to leave him in the path of *perfection*, and by a laconic reply, cut short accounts of which the *multiplicity*, as you may well understand, could be for me equally disagreeable and fatiguing. Please let me know if you know M. Daguerre personally, and what opinion you have of him." [67]

To this Lemaître replied five days later:

"You ask if I know M. Daguerre? For several years, without knowing him intimately, I have met him at evening parties. Last spring, having been commissioned by a publisher to engrave one of his pictures which is in the Luxembourg Gallery [68] I went to show him the drawing which I had made after it; that is how I made his acquaintance. I have only met him since when I went to see one of his pictures at the Diorama. At the end of the month I have to submit to him a proof of my engraving, which is nearly ready.

As to the opinion which I have of him, as a painter M. Daguerre has great talent for imitation and exquisite taste in the composition of his pictures. I believe him to have an unusual gift for everything concerning mechanics and effects of light; this is evident to anybody visiting his establishment. I know that for a long time he has been working on improving the camera obscura, without, however, being acquainted with the aim of his work except what you tell me, and the comte de Mandelot to whom you have spoken of it." [69]

Meanwhile Niépce gave Daguerre a strong hint that there was no point in continuing their correspondence.

Châlon-sur-Sâone,
[3] February 1827.
"Sir,
Yesterday I received your reply to my letter of 25 January 1826. For the last four months I have not been working any more; the winter months are too unfavourable. I have considerably improved my process of engraving on metal, but the results I have obtained are not yet good enough, and so I cannot satisfy the desire which you express. I ought doubtless to regret this more for my sake than for yours, sir, since your mode of application is quite different and promises you a degree of superiority over my engraving method. This does not prevent me from wishing you all the success which you could hope for.
I have the honour, etc." [70]

It soon became evident that Daguerre's boastful claims could not be substantiated by results. Despite Niépce's sarcastic tone, he sent him in March an example of his *graphic* art, hoping Niépce would assume it to be the result of his photographic process. It was a bait in exchange for which Daguerre hoped to obtain a specimen of heliography, from which to deduce Niépce's process. Niépce was impressed by the picture but not entirely hoodwinked by this manœuvre. On 3 April he wrote to Lemaître:

"M. Daguerre has sent me a little drawing, very elegantly framed, made in sepia and finished by his process. This drawing, representing an interior, produces a good effect, but it is difficult to decide to what extent the result was achieved by his process, since the brush has intervened. Perhaps, sir, you already know this kind of drawing which the author calls *dessin-fumée*,* and which is on sale at Alphonse Giroux's?

Whatever M. Daguerre's intention may have been, as one kindness deserves another, I shall send him a pewter plate lightly etched according to my process, choosing as subject one of the engravings you sent me. This can in no way compromise the secret of my discovery."[71]

Niépce's gift was of no more use to Daguerre than the *dessin-fumée* had been to him, for the cautious inventor carefully removed from it the bitumen coating, leaving only the lines etched by acid in the metal, so that his rival would not be able to ascertain what substances had been used. The heliograph, representing an engraving of the Holy Family, had been obtained by superposition in spring 1826. Niépce also sent a print pulled from it by Lemaître in February 1827, "very defective and much too weak".

"You will judge from this," Niépce wrote on 4 June 1827, "that I need all your indulgence, and if I have at last decided to send you this package, it is only to respond to the desire which you have been good enough to express. I believe, in spite of its failings, that this method of application is not at all to be despised, since I, unacquainted with the arts of drawing and of engraving, have been able to obtain such a result. I beg you, sir, to tell me what you think of it. This is not one of my recent results but dates from last spring; since then I have been diverted from my researches by other matters. I shall resume them today, now that the country is in its full splendour, and shall devote myself exclusively to

* A description of *dessin-fumée* is given by J. M. H. Hamman in *Des Arts graphiques*, Geneva, 1857. He writes: "The Abbé Soulacrois in 1839 also used this solution (10 gr. of white gum lac in 100 gr. of alcohol) for making drawings produced with the carbon of a candle to which he added a few touches of sepia, emphasizing the highlights with twisted pieces of paper in order to give them all the verve of a wash drawing. The real inventor of the *dessin-fumée* seems to be Mandé Daguerre."

copying views from nature. There is no doubt that this offers the more interesting results, but I am fully aware of the difficulties which it will present in engraving. The enterprise [i.e. engraving] is beyond my powers, and my ambition is limited to being able to show by more or less satisfactory results the possibility of complete success if a skilful and practised hand in the process of aquatinta would subsequently co-operate in this work.

You will probably ask me, sir, why I engrave on pewter instead of on copper. I have naturally used the latter as well, but for my first attempts I had to give preference to pewter, since some of the plates are intended for my experiments in the camera obscura, and the brilliant whiteness of this metal renders it much more suitable to reflect the image of the objects represented.

I think, sir, that you have probably followed up your first attempts; you are on too beautiful a path to remain there! Occupying ourselves with the same object, it should be of mutual interest to reciprocate our efforts to attain the goal. I shall therefore learn with much satisfaction that the new experiments you have made with your improved camera obscura have come up to your expectations. In this case, sir, if there is no indiscretion on my part, I would be as desirous of knowing your results as I would be delighted to be able to offer you those of my own researches on the same lines." [72]

Daguerre made an impartial but severe criticism of ''The Holy Family'' which damped Niépce's spirits, but he did not respond to Niépce's request, for the simple reason that he had no photographic results to show nor any worth-while experiments to report.

About the middle of August 1827 Nicéphore Niépce received the disturbing news that Claude was dangerously ill. He immediately set out with his wife (Marie-Agnès Mignon, née Roméro (1760–1855)) for London, and being obliged to spend some days in Paris waiting for passports, took the opportunity of making Daguerre's acquaintance.

''He came to see us yesterday,'' he wrote to his son on 2–4 September. ''The meeting lasted three hours; we are to visit him again before our departure, and I do not know how long we shall stay there, for it will be the last time, and the conversation, on the subject which interests us, is truly inexhaustible.

I can only repeat to you, my dear Isidore, what I have already told M. de Champmartin [Isidore's father-in-law]. I have seen nothing here that has struck me more or given me more pleasure than the Diorama. We were taken round by M. Daguerre, and could study quite at our ease the magnificent pictures exhibited there. The interior view of St Peter's, Rome, by M. Bouton, is certainly an

admirable work and produces the most complete illusion. But nothing could be better than the two views painted by M. Daguerre: one of Edinburgh taken by moonlight during a fire, the other of a Swiss village [Unterseen] showing a wide road, facing a prodigiously high mountain covered with eternal snow. These representations are so true, down to the smallest details, that one really believes one sees rural and wild nature, with all the fascination that the charm of colour and the magic of chiaroscuro can produce. The illusion is so great, even, that one is tempted to leave one's box to go over the plain and climb to the top of the mountain. There is not, I assure you, the least exaggeration on my part, the objects being, or at least appearing, the natural size. They are painted on canvas or taffeta coated with a varnish which has the inconvenience of being sticky, which necessitates precautions when this kind of decoration has to be rolled up for transport, for it is difficult not to tear it in unrolling it.

But let us return to M. Daguerre. I must tell you, my dear Isidore, that he persists in believing that I am further advanced than he is in the researches which we are both pursuing. What is certainly proved now is that his process and mine are quite different. His process has something marvellous about it, and the results are obtained with a speed comparable to that of the electric current. M. Daguerre has succeeded in fixing on his chemical substance some of the prismatic colours; he has already fixed four and is working to fix the three others, in order to have the seven colours of the spectrum. But the difficulties which he encounters constantly grow in proportion to the modifications which this same substance has to undergo in order to retain several colours at the same time; what frustrates and completely baffles him is the fact that from these various combinations entirely opposite effects result. For instance, a blue glass which throws on the said substance a darker tone, produces a tint lighter than that on the part submitted to direct (sun)light.* On the other hand, this retention of the elementary [spectrum] colours is limited to fugitive tints so feeble that one cannot perceive them at all in full daylight: they are only visible in the dark, and for this reason: the substance in question is of the nature of Bologna stone and Pyrophore.† It absorbs light but cannot retain it for any length of time, for if the action of this fluid [i.e. light] is prolonged, it eventually decomposes it. M. Daguerre does not claim to fix by this process the coloured images of objects, and even if he should succeed in surmounting all the obstacles, he could only use this method as an

* Although the light passing through the blue glass looked dark in colour, it had a stronger effect on the phosphorescent powder, because the blue and violet end of the spectrum is the most active chemically.

† Niépce refers to barium sulphide, first found near Bologna, 1602–04. Pyrophore (potassium sulphide), which ignites in air, was discovered in 1711 by Wilhelm Homberg.

intermediate step. According to what he has told me, he has little hope of suc-
ceeding, and his researches can hardly have any other object than pure curiosity.

My process appears to him preferable, therefore, and much more satisfactory
considering the results I have obtained. He feels how interesting it would be for
him to procure some views from nature with the aid of a process equally simple,
easy and quick. He requested me to make some experiments with coloured
glasses in order to ascertain whether the impression produced on my substance
would be the same as on his. I have just ordered five of them from Vincent
Chevalier, such as he has already made for M. Daguerre. The latter attaches the
greatest importance to the rapidity with which the images are fixed—a very
essential condition, in fact, which ought to be the prime object of my researches.
As to the mode of application to engraving on metal, he is far from depreciating
it, but as retouching the image with the burin would be indispensable, he believes
that this application would give only very imperfect results for views [from
nature]. Glass etched with fluoric acid seems to him preferable for this kind of
picture. He is sure that printing ink, applied with care to the surface etched by
acid, would produce, when mounted over white paper, the effect of a good print,
with more of the effect of the original [because untouched by an engraving tool],
which would be more pleasing.

The chemical composition M. Daguerre uses is a very fine powder which
does not adhere to the material on which it is put, and which therefore has to
lie horizontally. This powder on the slightest exposure to light becomes so
luminous that the dark room is entirely illuminated by it. The process has the
greatest analogy, as far as I can remember, to sulphate of Baryte or Bologna
stone, which also has the property of retaining certain rays of the prism.'' [73]

It is evident that all Daguerre had to show Niépce was some abortive photo-
chemical experiments with phosphorescent substances which he had been testing
for the last three years,[74] though obviously fully aware now that they would not lead
him nearer his goal of fixing camera images, if he had ever seriously entertained
that idea at all. For when his original intention of using these substances for special
diorama effects failed—on account of their short period of luminosity (up to
48 hours) after exposure to light—he hoped it might be possible to produce
luminous paint and claimed that ''as soon as he was able to obtain all the primary
colours he would paint a picture which would be visible by its own light in the
middle of the night.'' [75]

Niépce was clearly impressed by the Diorama and Daguerre's experiments with
luminous substances: his refraining from any derogatory remarks about these latter

futile attempts and his delight that Daguerre believed him further advanced are typical examples of his extreme modesty and credulity.

Paul Carpentier recalled [76] that Daguerre had demonstrated to the members of the Société libre des Beaux-Arts (some time after its foundation in 1830) his experiments of spreading on pieces of cardboard substances which had the property of absorbing separately the three primary colours red, yellow, and blue. When carried into a dark room, after having been exposed to sunlight, the substances were seen to be luminous in their respective colours. However, when Daguerre performed these experiments for Niépce, he interposed various coloured glasses, to compare the effect on these substances, though it is doubtful that he found any change except in brightness, for whatever the colour of the light to which these phosphorescent powders are exposed, they always glow with the colour particular to them.*

Niépce had correctly guessed that one of the powders used was "Bologna stone", a phosphorescent mineral discovered near Bologna in 1602–04. This find led scientists to search for, and to produce synthetically, a variety of other substances which had the property of being luminous in the dark†; it even led to the ingenious speculation that the moon might be composed of a mass of phosphorescent minerals, absorbing the rays of the sun by day and emitting them again during the night!

Niépce took with him to London several specimens of heliography, looking forward to showing them to Claude, who so far only knew about them from his brother's letters. Arriving at Kew in September, Nicéphore was shocked to find Claude mentally as well as physically afflicted by dropsy. The latter's belief that he had invented a perpetual motion machine, with which the brothers had hoped to recoup part of the family fortune which had been lavished on the pyréolophore and on heliography, proved nothing but a delusion.

The proprietor of the Coach and Horses Inn, where the Niépces lodged during their stay at Kew, seems to have been a typical landlord, for Nicéphore complained to Isidore on 5 November 1827: "Our hosts are very nice people, but the meals are bad, the beds worse, and it is terribly expensive. It costs us, for your mama and me, *over a hundred francs* [£4] a week for board and lodging."

Seeing the prospects of the perpetual motion machine shattered, Niépce immediately set to work to find a Maecenas for his invention of heliography—or at least to obtain official recognition for it. His first approach was to King George IV,

* These experiments were by no means novel, and are to be found, even including the interposition of coloured glasses, in many books of chemical experiments, such as Frederick Accum's *Chemical Amusements*, London, 1817, pp. 174–182.

† Powdered calcinated barium sulphide emits in the dark an orange light, sometimes blended with yellow and blue; some layers of pulverized oyster shells mixed with sulphur and calcinated emit yellow or green light; other layers give off red, yellow, or bluish-green light.

through the good offices of William Townsend Aiton, Director of the Royal Botanical Gardens, Kew, and the Marquess of Conyngham, Lord Steward of the Royal Household. Their efforts were of no avail, however, because the invention had not been examined by an official body such as the Royal Academy or the Royal Society; Niépce's specimens were returned, together with his memoir on the process. The invention being considered of greater scientific interest than artistic merit, Niépce's next step was to obtain the necessary attestation from the Royal Society. Francis Bauer, F.R.S. (1758–1840), a well-known botanist living at Kew Green, undertook to submit to the Royal Society Niépce's communication and specimens, which were all reproductions of engravings with the exception of one picture representing the view of the courtyard from an upper window at Gras (Plate 32). In his four-page "Notice sur l'héliographie", dated "Kew, le 8 décembre 1827" (page 67), Niépce refers to these pictures as: "The first results of my long researches on the manner of fixing the image of objects by the action of light", and asks indulgence for their defects, for "they are only the first steps in an entirely new field". He mentioned that his process could be applied to pewter, copper, stone, and glass: the latter, if blackened lightly (with printing ink) in the engraved parts, would give a vigorous picture when placed over white paper. Although no copies could be printed from it, "M. Daguerre regards it as eminently suitable for rendering all the delicate tones of Nature." "I have set myself a problem important for the arts of drawing and engraving. If I have not yet been able to collect together all the facts necessary for its complete solution, I have at least indicated those which could contribute to it effectively. It will be admitted that the difficulty lay essentially in the demonstration of the principal fact [of fixing images by light], and this difficulty having been overcome, seems to me a happy augury for the subsequent results which I have grounds to hope for." Niépce concluded his communication with the formal declaration: "I am the inventor of this discovery, I have not confided the secret of it to anyone, and this is the first time that I have given it publicity. I congratulate myself on making it known in a country as justly renowned for the cultivation of the arts, as for the welcome and protection which talent receives there." Notwithstanding these flattering remarks, and Niépce's introduction to two of the Vice-Presidents of the Royal Society, Dr W. H. Wollaston and Sir Everard Home, the memoir and specimens were never formally submitted to the Society, because the cautious Niépce had only alluded in general terms to his invention. Considering that all but one of Niépce's pictures were copies of engravings, the novelty and ingenuity of heliography was by no means obvious to outsiders unacquainted with the method of production. Niépce's reluctance to disclose the manipulation can, however, also be understood, for he feared this might be harmful to the commercial exploitation of

the invention, for which he still hoped to find a patron through the Society of Arts, and lacking both time and money he could not safeguard his interests by patent prior to meeting the Royal Society's stipulation. There is no record at the Society of Arts of any correspondence with Niépce. It is certain that all his plans fell to the ground, and disappointed at this lack of interest in the very country which he had thought would welcome and protect new talent, Niépce returned to France about the beginning of February 1828. Before finally turning his back on England he presented to Francis Bauer the manuscript of his communication to the Royal Society, the photograph from nature (Plate 32), three heliographs of engravings, two prints of Cardinal d'Amboise (Plate 35), and one of a landscape after Claude Lorraine. He also gave a heliograph to his landlord, B. Cussell. All these specimens are inscribed "Les premiers résultats obtenus spontanément par l'action de la lumière" and dated 1827, the date of their attempted presentation to the Royal Society. The view from nature bears Bauer's additional remark: "Monsieur Niépce's first successful experiment of fixing permanently the image of nature."*

On their way home the Niépces stayed a fortnight in Paris. The failure to find support for heliography in England and the disappointment about the perpetual motion machine had changed Niépce's attitude towards Daguerre's overtures. He was all the more ready to come to an understanding after receiving from him a sympathetic note (3 February 1828):

"Since your departure [last September] I have made two pictures, one for the Diorama and the other for the exhibition at the Museum [the Salon at the Louvre, but it was not hung], which have occupied me all the time so that I could not continue my researches.

As for you, sir, I am sorry to see that other occupations have diverted you from your interesting discovery, and that you found only discouragement in England. But console yourself: the same could not happen here; particularly if you arrive at the result which you have the right to hope for, I can assure you that it will not be regarded with the same indifference. It would be a real pleasure to me, if agreeable to you, to indicate to you how to derive profit from it. I cannot hide from you that I have a burning desire to see your attempts from nature,† for while my own discovery has as basis a more incomprehensible

* The subsequent history of these photographic incunabula, their rediscovery by the authors in 1952, and the full French text of Niépce's memoir will be found in the authors' detailed accounts in The Photographic Journal, Section A, January 1951 and May 1952.

† This indicates that Niépce had not shown Daguerre the view from nature—the least perfect but most important part of his invention—wishing to see first what progress his plans would make in England.

principle, it is certain that you are much more advanced in results, which must surely encourage you." [77]

Niépce had several meetings with Daguerre, but having given Bauer his only view from nature he could not satisfy Daguerre's curiosity. Daguerre was somewhat taken aback at this news—possibly even suspicious. Niépce spoke of a partnership " to join me in mutual work on the improvement of my heliographic processes and the various ways of applying them, taking a share in the profits which its improvement will permit us to hope for." [78] Daguerre wanted to see a camera picture first, he was not interested in copying engravings by superposition. He and Lemaître urged Niépce to concentrate on views from nature, and the latter offered to carry out the engraving process if Niépce would send him some views on copper.

Ascribing the shortcomings of his view from nature, and in particular the very long exposure, to the ordinary non-achromatic bi-convex lens he had been using so far, Niépce ordered from Chevalier an achromatic lens and one of Wollaston's periscopic lenses,* both of which gave greater all-round sharpness than the usual bi-convex lenses fitted in camera obscuras, which rendered the centre of the image sharp but the edges diffused. Moreover, these new lenses were also faster, for on account of their superior design they could be worked at a larger aperture.

The Niépces did not arrive home until 26 February, and for the next few months Nicéphore was much occupied in putting his brother's affairs in order, for Claude had died on 10 February, only a few days after Nicéphore's departure. At last in May he was able to resume photographic experiments. On 20 August he wrote to Lemaître:

"I have now entirely given up copying engravings, and restrict myself to views taken with the perfected camera obscura of Wollaston. The periscopic lenses have given results much superior to those which I obtained up to the present with ordinary lenses, and even with the meniscus prism of V. Chevalier. My sole object is now to copy nature with the greatest fidelity; I devote my time exclusively to that purpose, for only when I have succeeded in this can I seriously begin to tackle the various fields of application of which my discovery is capable." [79]

Niépce still hoped that he might eventually be able to transform his camera views into printing-plates, and following Lemaître's advice, abandoned pewter,

* In his paper "On a periscopic camera obscura and microscope", Phil. Trans. Roy. Soc., July 1812, Wollaston stated, "The lens is a meniscus . . . so placed that its concavity is presented to the objects, and its convexity towards the plane on which the images are formed. The aperture of the lens is 4 in., its focus about 22 in." The lens had a fixed diaphragm of 2 in. and included a field of view of 60°.

which was too soft a metal for engraving. From now on he made heliographs on silver-plated sheets of metal (doublé d'argent) and silvered copper plates (argent plaqué), thus combining brightness of surface—which he needed for views from nature to be pictures in themselves—with hardness of metal, just in case any of them should turn out well enough to be engraved by Lemaître.

In 1829 Niépce discovered that the contrast of the picture could be increased by blackening the bare parts of the silvered plate with vapour of iodine in an iodizing-box. The bitumen forming the light parts of the image remaining unaffected by the iodine vapour was then removed with alcohol, and the resulting photograph consisted of shiny metallic silver and dark silver iodide; there was no bitumen at all. The contrast between shadows and highlights was much greater and the details of the picture so much improved that Niépce considered this modified process (though no quicker) good enough to describe to Daguerre, who replied on 18 September 1829:

"It is impossible to be more excited than I was when I heard that you have continued your experiments, and especially at the thought that you have obtained new results; I will receive with great pleasure examples of your successes."[80]

In sending Daguerre a heliograph at the beginning of October Niépce mentioned his intention to publish the results of his labours. He had in fact made several drafts of a synopsis and written an introduction to a booklet to be entitled "On Heliography, or a method of automatically fixing by the action of light the image formed in the camera obscura. A work in which the researches and the methods which have led to this new invention are fully and conscientiously explained, together with results, more or less satisfactory, that prove its existence." [81] It is significant that Niépce makes no reference to copying engravings by superposition but concentrates on camera images, "not with the splendour and variety of their colours, but with all the gradations of tone from black to white."

Daguerre and Lemaître praised the fine detail in the view from Niépce's window* but criticized the tone values, above all objecting to the effect of sunlight on parallel opposite sides of the building, resulting from the long exposure. Nevertheless Daguerre was impressed, advised Niépce to postpone publication, and offered his collaboration in exploiting the process:

"As regards your intention of publishing your method, there should be found some way of getting a large profit out of it before publication, apart from the honour this invention will do you." [82]

* This picture no longer exists; it was most probably destroyed in the fire at the Diorama.

Impoverished as he was, Niépce thought this a sensible suggestion.

"It is impossible, my dear sir," he replied on 23 October, "to be more delighted than I am with the extremely obliging offer you have been good enough to make me. I am infinitely grateful to you for it and accept it with great pleasure. Perhaps you have forgotten the verbal communication that you received from me about this subject during my stay in Paris. In this case it is extremely pleasing to me to remind you of it. I offered you, my dear sir, to join me in mutual work on the improvement of my heliographic process, and the various ways of applying it, taking a share in the profits which its improvement will permit us to hope for. I can only rejoice at your decision, which with the help of your knowledge would guarantee my success, and knowing the loyalty of your sentiments, everything inspires me with justifiable confidence. As the matter has not yet reached the stage of exploitation, my offer at the present moment could not relate to any other object beyond research and experiments mutually carried out with the common aim—attainment of complete success; I flatter myself with the assurance that you, my dear sir, would be willing to devote a few months to work of this nature." [83]

Though Wollaston's meniscus lens had failed to bring about a sufficient shortening of the exposure, Niépce still clung to the idea that it could only be reduced by optical means, instead of searching for a more light-sensitive substance.* He was undoubtedly influenced in his prompt acceptance of Daguerre's offer by the news from Lemaître that Daguerre had a greatly improved camera,† for he wrote to his engraver on 25 October:

"In order to achieve success the exposure must be short, i.e. the image must be sharp and brilliant. For this, a camera as perfect as M. Daguerre's is necessary, and without it I fear I shall be condemned to approach my goal more or less, without ever reaching it. I have therefore hastened to reply to his obliging offers of service." [84]

Niépce made a similar offer of partnership to his trusted friend Lemaître, still hoping that eventually camera pictures could be engraved. Daguerre did not approve

* In 1853 Niépce's cousin Abel Niépce de Saint-Victor (1805–70) in collaboration with Lemaître took up this process again, and by various modifications speeded up the exposure to a few minutes for laid-on copies, and 10–15 minutes for views in the camera. Two years later he fulfilled Nicéphore's ambition to take a photograph in the camera, etch it, and pull paper prints from it. This proves that heliography *was* capable of perfection and practical application, though Daguerre's improvements took a different direction.

† In a letter to Niépce on 15 November 1829 Daguerre claimed that his camera was three times as fast as any other. (Isidore Niépce, *Historique de la Découverte improprement nommée Daguerréotype*, Paris, 1841, p. 28.)

of the idea of converting the novel and unique camera pictures, towards which they were striving, into the older art of engraved plates, and for this reason Lemaître did not become a full partner, though he is included in the contract (in clause 8) which was signed by Daguerre and Niépce at Châlon on 14 December 1829 (see appendix) (Plate 31), with the object of perfecting and exploiting heliography. In this ten years' partnership agreement Niépce is clearly stated to be the *inventor* of the process, which Daguerre promised to improve. Hence the order of their names in the firm's title—Niépce-Daguerre. The profits were to be shared equally, despite the somewhat unequal contributions of the two partners: Niépce had to supply Daguerre with complete details of his process, whilst Daguerre had merely to provide "a new design of camera obscura", his talents, and his energy. The reason for this must be sought in the fact that after thirteen years of research on heliography Niépce found himself in a *cul-de-sac*. Moreover he was getting on in years—he was now sixty-four—and was in debt. Daguerre, on the other hand, was in the prime of life, energetic, and full of confidence that he would turn heliography into as successful an invention as the Diorama then was, even though he had not as yet any photographic results to contribute.

In character and appearance the partners form a most striking contrast. Niépce, twenty-two years Daguerre's senior, the descendant of an old aristocratic family, had received a good classical education, and also possessed an extensive knowledge of chemistry, physics, and mechanics. Had he chosen to live in Paris instead of being content to remain the local squire in the isolation of the provinces, he would probably have played a rôle in the intellectual life of the capital. But this cultured and refined man preferred his quiet study at Gras to the brilliant salons of Paris, in order to devote all his time to experiments. Always extremely polite, modest, and inclined to understate his attainments, Niépce's tight-lipped and sad expression tells of his long and constant struggle against disappointment. (Plate 30.)

Everything in the happy, animated features of Daguerre expresses the confidence of a quick-witted and impulsive showman. Though he had no family tree or education to speak of, he could point with pride to his self-made success which had earned him a considerable reputation in artistic circles. Always bursting with self-confidence, his inclination to boastfulness made him perhaps a trifle common, but this failing was compensated for by his *joie-de-vivre* and winning personality, which made him a good mixer. Bright eyes, full smiling lips and curly hair gave him an attractive appearance, marred only by very pronounced freckles. (Page 13.)

During Daguerre's stay at Gras Niépce initiated him into the mysteries of heliography and handed him a detailed description of the manipulation, as stipulated in the agreement. This document, entitled "Notice sur l'héliographie" and dated

Translation of Nicéphore Niépce's "Notice sur l'héliographie" submitted to the Royal Society, London, December 1827

MEMOIR ON HELIOGRAPHY *

* I think I may give this name to the object of my investigations, until a more exact nomenclature has been found.

Heliography: [Sun] Drawings & Etched Plates.
An account of some results obtained
spontaneously by the action of Light.

The experiments which I have the honour to put forward are the first results of my long researches *on the method of fixing the image of objects by the action of light, and of reproducing it by the known processes of etching.*

I was occupied with these researches, when a recent circumstance hastened my departure for England; this prevented me from continuing them and arriving at more satisfactory results. I would request, therefore, that these first attempts be judged less from the artistic point of view but rather according to the methods by which the results were obtained; for complete success depends on the efficacy of these methods. I would at the same time crave for my work the indulgence which one will perhaps be more disposed to accord to it, if one considers it only as the first steps which I ventured to make in an entirely new field.

My framed pictures, made on pewter, will doubtless be found too weak in tone. This defect springs principally from the fact that the light parts do not contrast sufficiently with the shades which result from the metallic reflection. It should be easy to remedy this by giving more whiteness and brilliancy to those parts which represent the effects of light, and by receiving the impressions of this fluid [e.g. light] on plated silver well polished and burnished; for then the contrast between white and black would be all the more marked, and this latter colour, intensified by means of some chemical agent, would lose its glare, which is unpleasant to the eye, and even sometimes produces an incongruous [negative] effect.

My attempts at etching leave still more to be desired as to clarity of line and depth of etching; I have decided to bring them forward only in order to prove this important application of my processes, and the possibility of improving it. The obstacles which I have had to surmount proceeded less from the nature of these processes than from the insufficiency of my skill in an art [etching] the practice of which is unfamiliar to me. I should state that my process can be applied to copper as well as to pewter. I have tried it several times on stone, with success, but I believe that glass would perhaps be preferable. It would suffice, after having obtained the image, lightly to blacken the etched part, and to place it over white paper, in order to obtain a vigorous picture. M. Daguerre, painter of the Diorama in Paris, has advised me not to neglect this mode of application, which would not have, it is true, the advantage of multiplying the pictures, *but which he regards as eminently suitable for rendering all the delicate tones of Nature.*

Among the principal means of improving my results, optics takes first place. I was still lacking in this resource [i.e. a good lens] in one or two attempts at views by the aid of the camera obscura, whatever effort I made to improve it by special [lens] combinations. However, it is only by perfecting this kind of apparatus as much as possible that a faithful image of Nature could be obtained and properly fixed. I regret being unable to explain other improvements more closely connected with the principle of my discovery, and therefore more worthy of interest; I shall abstain, therefore, from speaking of them, being convinced, besides, that such an explanation is not strictly speaking necessary in order to give an opinion of some kind on the invention.

I have set myself a problem important for the arts of drawing and etching. If I have not yet been able to gather together all the facts necessary for its complete solution, I have at least indicated those which, in the present state of my researches, could contribute to it more effectively, even if they are only secondary; it will be admitted that the difficulty lay essentially in the demonstration of the principal fact [of fixing images by light], and this difficulty having been overcome, seems to me a happy augury for the subsequent results which I have grounds to hope for as soon as I can arrange for superior means of execution which I have so far lacked.

I will say nothing about the advantages which my discovery promises in its various applications. It may perhaps suffice to point out its striking novelty, which may recommend it to the attention of the curious. I should declare formally that I am the inventor of this discovery, I have not confided the secret of it to any-one, and this is the first time I have given it publicity. I congratulate myself on making it known in a country as justly renowned for the cultivation of the arts, as for the welcome and protection which talent receives there.

Kew, *8 December 1827.*

N. NIÉPCE
of Châlon-sur-Saône, rue de l'Oratoire.
Département de Saône-et-Loire.

The original MS was rediscovered by the authors in 1952 and is now in the Gernsheim Collection, University of Texas.

24 November 1829, with some additions of 5 December, was published in 1839 by Daguerre together with his own process of daguerreotype.

Though Daguerre's much-vaunted camera turned out to be nothing fundamentally new (except that it was the first to be made of metal), the Wollaston type periscopic meniscus lens had been improved by Chevalier, on Daguerre's instruction, by being made achromatic. It was the best and most expensive lens that could be supplied at the time. Nevertheless, experience proved that Niépce's high hopes remained unfulfilled, and this was later admitted by Daguerre.* The camera, bearing a label "Pièce envoyé à Mr· Nicéphore Niépce par Daguerre", is preserved at the Musée Denon at Châlon. It is a box made of zinc, 65 cm. long × 36 cm. high × 36 cm. wide, with fixed back containing the plate-holder; the focal length was varied by moving the wooden lens panel backward or forward by means of a handle on the outside of the camera. Niépce improved the instrument by fixing in front of the lens (now missing) a zinc iris diaphragm—the first of its kind †—the opening of which could be varied by an external lever.

In the *exposé* of his process which Niépce had prepared for Daguerre he refers to two camera views on glass, giving "results which, though very imperfect, appear deserving of notice here, because this mode of application may be brought more easily to perfection and become later on a most valuable method of heliography".

Only one of these glass photographs is known. It represents a table laid for a meal, often mistakenly described as Niépce's first photograph from nature, with such wrong date attributions as 1822 or 1823. It is true that Niépce had already used glass for his first successful engraving, of Pope Pius VII in 1822, but the correspondence with his brother contains no reference to a *camera* picture on glass nor to a still-life subject: the only camera photographs mentioned are of the view from his window. From two factors it may be deduced that this picture was made after January 1829: (*a*) In that month Niépce ordered a supply of glass plates; (*b*) Daguerre took a great many still-lifes, Niépce never, so this one was probably made under Daguerre's influence some time after the signing of the partnership agreement. Indeed, the possibility that this still-life is by Daguerre cannot be excluded (see p. 70) even though two glass pictures are mentioned by Niépce in November 1829.

Nothing remains of this still-life but a rather poor half-tone reproduction made

* In a footnote to the "Notice sur l'Héliographie" in his Manual Daguerre states: "Experience proved that the achromatic camera, though resulting in clearer images, did not impart that extreme sharpness which was anticipated from its use." He omitted to mention that his other claim, that the camera was three times faster than any other, was hypothetical.

† Charles Chevalier stated at the Societé Française de Photographie on 28 May 1858 that he first made an iris diaphragm in 1840, which proves that Niépce received the camera from Daguerre without it.

in 1891 (Plate 36). The original glass picture, like that of Pius VII, was unfortunately broken—and in the most extraordinary circumstances. In 1909 it was lent by the Société Française de Photographie to Peignot, a professor at the Conservatoire des Arts et Métiers, for scientific tests. The purpose of these is rather mysterious, since Niépce had fully described his process; nor will Professor Peignot's findings ever be known, for seized one day with a fit of madness he smashed everything in his laboratory, including this photographic *incunabulum*.[85] Thus, all but one of Niépce's few photographs from nature have been lost, the only exception being his first success—the view from his window at Gras.

After Daguerre's return to Paris the partners never met again. They continued their researches separately, exchanging results and advice. Their attention was chiefly directed to iodine, which Niépce had been using both as an after-treatment to darken parts of his picture and as a light-sensitive substance (no doubt in conjunction with silver).* Niépce had tried to obtain images on it prior to his association with Daguerre, and had only been turned from these experiments "from the impossibility, or nearly so, of fixing permanently the images received on iodine, and of obtaining the lights and shades in their natural order" (i.e. a direct positive and not a negative).[86] It is necessary to stress this fact because historians have so far accepted Daguerre's claim that it was he who "first pointed out iodine not merely as a means of darkening certain portions of a picture already made, but as the sensitive coating upon which the image was to be made photographically".[87] This claim was "substantiated" a few years later by Gaudin, who related[88] the circumstances of the discovery: one day a spoon was accidentally put on a heliographic plate which had been exposed to iodine. From the fact that the parts of the plate protected from light by the spoon did not blacken, Daguerre rightly assumed that it was not simply the addition of iodine to the silver-coated plate which darkened it—it needed the action of light as well. Daguerre when he heard of this story dismissed it as fiction,[89] but nevertheless it has remained among the anecdotes surrounding the invention of photography.

Niépce failed to obtain any satisfactory results with iodine on silver-coated plates. On the other hand he informed Daguerre on 8 November 1831 that he had succeeded once by an inexplicable fluke in obtaining a positive camera picture on iodized pewter: "The light acted strongly on the iodine and in such a way that the lights and shadows were produced in their natural order. I don't know how or why this effect took place, for I have never been able to produce it again, though

* Iodine was discovered by Courtois in 1811 and named by Sir Humphry Davy, who reported on its light sensitivity when mixed with nitrate of silver in the *Philosophical Transactions of the Royal Society*, 13 February 1814.

operating in exactly the same manner." Unable to fix the image, Niépce naturally felt that his old process with bitumen had brought him nearer the goal, but out of loyalty to his partner he continued the experiments, "only because you appear to attach a certain importance to them". By 1832, however, he bitterly regretted having wasted so much time on these apparently fruitless attempts with iodine.

On 5 July of the following year Niépce died suddenly of a stroke, disappointed not to have lived to see his invention brought to perfection. He was in his sixty-ninth year. Daguerre was very shocked at this news. "I loved him as a father!" he wrote to Isidore. "This is a terrible blow for me too; indeed, I am writing this with tears in my eyes, and cannot describe to you the sorrow I feel. . . . This loss deprives me of all courage at this moment. We must, however, redouble our efforts in the thought that we shall make his name immortal by the publication of his invention. How happy he would have been to see that day. . . . It is a comfort to me, to find again in the son, the friend whom I have lost."

Impoverished, Niépce's widow and son were obliged to sell the estate and all their remaining property. (The house in Châlon had already been sold in 1830.) Isidore, now thirty-eight years old, automatically succeeded his father in the partnership, but did little or nothing to further the invention. He lived quietly in the village of Lux, which lies half-way between Châlon and St Loup-de-Varennes.

Meanwhile Daguerre continued experimenting with iodine on silvered plates. He also devised a modification of Niépce's original heliography, using as sensitive coating the residuum of oil of lavender dissolved in alcohol or ether and spread on polished metal or on glass. After exposure in the camera the latent picture was brought out by holding the plate over a dish of petroleum, which in evaporating penetrated the coating and acted as a solvent, destroying it in proportion to the extent to which it had been hardened by light.[90] Though a finer gradation of tones was achieved by this procedure than by immersing the plate in a solvent, as Niépce had done, the exposure remained just as long as before, i.e. 7 or 8 hours for a camera view. As already indicated, we cannot dismiss the possibility that the photograph illustrated in Plate 36 was made by this process and sent by Daguerre to Nicéphore Niépce in the early 1830s. Seen in this light several otherwise inexplicable factors concerning this photograph would be accounted for, in particular the desire of the Société Française de Photographie to have the sensitive coating (which did not look like bitumen) analysed by Professor Peignot.

Satisfied with the greatly superior light-sensitivity of iodine, as compared with bitumen or lavender oil residue, Daguerre pertinaciously continued testing it, although the reversal of the tone values, and the impossibility of fixing the image, drove him nearly to despair. He tried all manner of substances as an after-treatment

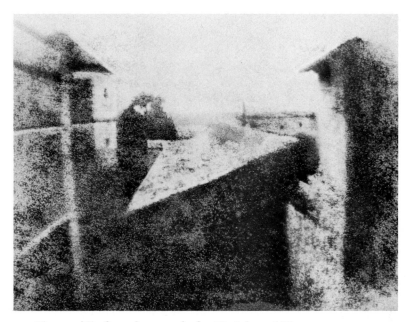

32. The world's first photograph, by Nicéphore Niépce, 1826

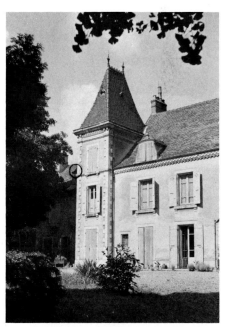

33. Nicéphore Niépce's house Gras, showing dormer window (ringed) from which the first photograph was taken

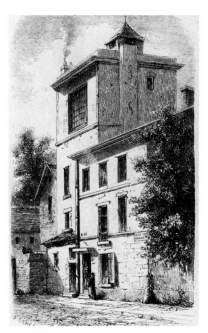

34. "Maison du Diorama" — Daguerre's house in rue des Marais, Paris

35. Cardinal d'Amboise. Niépce's most successful photo-engraving. Print pulled in February 1827 from an etched heliograph made in 1826

36. Table laid for a meal. Heliograph on glass by Nicéphore Niépce, c. 1829

37. Still-life of casts. The earliest surviving daguerreotype by Daguerre, 1837

38. The Tuileries and the Seine from the Quai d'Orsay. Daguerreotype by Daguerre, 1839

39. Notre-Dame from the Pont des Tournelles. Daguerreotype by Daguerre, 1838–39

40. The Boulevard du Temple. Daguerreotype by Daguerre, 1838–39

41. Arrangement of fossil shells. Daguerreotype by Daguerre, 1837–39

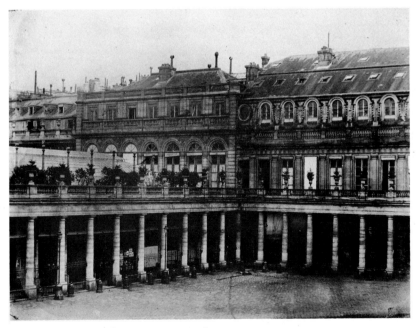

42. The Palais Royal. Daguerreotype by Daguerre, 1839

43. Mosque of Kalaun, Cairo. Daguerreo-
type by Girault de Prangey, 1842

44. S. Luigi de' Francesi, Rome. Daguerreo-
type by Girault de Prangey, 1842

45. View of Rome from the Palatine Hill. Daguerreotype by Girault de Prangey, 1842

46. Gate of the old market, Athens. Daguerreotype by Girault de Prangey, 1842

47. Church of St Theodore, Athens. Daguerreotype by Girault de Prangey, 1842

to make the dark parts of the picture light, and the light parts dark. It would be strange if Daguerre did not consult Berzelius' Treatise on Chemistry, which contributed in an exceptional degree to the dissemination of chemical knowledge, particularly after it had been translated from the Swedish into English, German, and French, in which latter language it appeared during the very period into which Daguerre's photographic researches fall. Not having any chemical knowledge, Daguerre may have combed systematically through the eight volumes of this famous chemical treatise (which, incidentally, lists over a hundred light-sensitive substances) to see which chemicals might serve his purpose. One day, between 1831–35,

> "An experiment made on a plate taken out of the camera obscura, and on which the image had become apparent by the coloration of the iodine [iodide] by light, had demonstrated to me that carbonic acid gas,* in contact with the slightly moistened plate, had produced, by its combination with the parts of the iodine [iodide] affected by the light, a very white composition, and had thus put the lights and shades in their natural state again; but the gradation of tone was imperfect . . . I had also noticed that by putting chlorate of potassium in a capsule and heating it with a lamp in a box very similar to that used nowadays for the mercury, the image produced by the coloration of the iodine [iodide] by light, appeared light-coloured, absolutely as brought about today by mercury vapour."[91]

But though these methods resulted in positive pictures, their tone-gradation was unsatisfactory.

Daguerre in his long series of experiments approached the goal step by step. He knew from Niépce that it was not necessary to continue the exposure in the camera until a strong image appeared on the plate, but that a very faint, almost invisible image could be brought out by an after-treatment. In improving heliography, he had the ingenious idea of bringing out the picture by the *vapour* of petroleum, and this led him to try all kinds of volatile chemicals, some of which, as we have just seen, put him on the track of another important principle—the conversion of a negative into a positive.

The circumstances surrounding Daguerre's discovery of the development of the latent image with mercury vapour cannot, therefore, have been quite so accidental as related in one of the classic legends of photography. One spring day in 1835, so the story goes, Daguerre put away in his chemical cupboard an under-exposed plate, intending to repolish and use it again. On opening the cupboard next morning he saw to his amazement that the plate bore a distinct picture! Not knowing which chemical had wrought the miracle, Daguerre repeated the conditions of the previous

* Carbonic acid gas, which is produced when making phosphorus from phosphoric acid, is mentioned in Berzelius' *Traité de Chémie*, Paris, Vol. I, 1829.

day and deliberately made an under-exposed plate, putting it in the cupboard and leaving it overnight. The next day, it also bore an image. For days on end Daguerre repeated this procedure, each day taking another chemical out of the cupboard. By a lengthy process of elimination of all the chemicals the cupboard contained, he eventually found that the vapour from a few drops of spilt mercury* had made the positive images appear. Having gained this knowledge, a satisfactory method of making pictures by light had been found; it was evident now that the plate required only a short exposure and that a completely invisible or latent image could be developed and converted into a positive picture by the condensation of mercury vapour. This has some analogy to a curious experiment described in Volume II of Berzelius' *Traité de Chémie*, to which we believe Daguerre may have referred. If a glass plate is written on with agalmatolith (soapstone) and the letters rubbed off again, they can be made to reappear by breathing on the plate; the condensation settling only on those parts not touched by the soapstone.

The principle of developing a latent image has remained the same in every process of photography up to the present day, though the chemical substances employed have changed.

Shortly after the publication of the daguerreotype in 1839, at a soirée to which distinguished scientists, artists, and other notabilities had been invited to meet Daguerre, one of the guests said to him, "You must have felt immense satisfaction when you first saw the marvellous effect of the mercury vapour." "Alas!" replied Daguerre, with a sadness which struck all his hearers, "the many preceding disappointments had depressed me so much that I was no longer capable of feeling excited about it. You must not forget that this discovery only happened after eleven years of discouraging experiments which had damped my spirits," and he went on to explain by what processes he had eventually achieved success step by step. "I first tried corrosive sublimate [bichloride of mercury]; it marked the images a little, but coarsely. I then tried sweet mercury or calomel [subchloride of mercury]; this was already better.† That day, hope returned to me more than ever, and brought back my old zeal. From this, it was only a short step to the vapours of metallic mercury, and good fortune led me to take it."[92]

Daguerre spoke to Mentienne about his discovery in similar terms: "When I was certain of success, I could not believe in this miraculous result."

But to return to 1835, the pictures were not permanent yet; nevertheless

* According to Berzelius, Vol. III, 1831, mercury begins to evaporate slowly at ordinary room temperatures from 68° F. on. When heated to 140° F. or more, it volatilizes rapidly.

† These allied substances are mentioned in Berzelius, Vol. IV, 1831. He says of calomel that "solar light blackens it".

Daguerre felt that his discovery was such an immense improvement on Niépce's that the firm should from now on be called "Daguerre and Isidore Niépce" instead of "Niépce-Daguerre". Isidore was summoned to Paris, briefly informed of the improvement, but not shown any results (because the images were not fixed). He was asked to give his consent to the proposed change in the contract, and when persuasion failed Daguerre used pressure to get his signature to the additional agreement which he had already drawn up. Isidore rightly argued that his partner had only fulfilled his promise to improve his father's process, as contracted under their partnership agreement of December 1829, but his pleading was in vain. Impoverished as he was, and with a wife (née de Champmartin) and four children to support, he had no choice but to sign. A translation of the terms of this additional agreement of 9 May 1835 will be found in the appendix.

A few months later, with his usual self-assurance Daguerre triumphantly but prematurely announced his discovery in the *Journal des Artistes*—"prematurely" because his claim to have found a method of fixing the images permanently was not borne out by the facts.

"It is said that M. Daguerre has discovered a means of receiving on a plate of his own preparation the images produced by the camera obscura, so that a portrait, a landscape, a view of any kind, projected on this plate in the ordinary camera obscura, *leaves its imprint* there in light and shade, and thus presents the most perfect of all drawings. . . . A preparation put on top of the image preserves it during an indefinite time. . . . Physical science has probably never presented a marvel comparable to this."[93]

A year later an architect named Hubert, himself engaged in photographic experiments, had his attention drawn to the notice, and doubting Daguerre's boastful claims, sent to the same paper this sarcastic reply under the heading "M. Daguerre, the camera obscura, and the drawings which make themselves".

"I doubt whether M. Daguerre has really accomplished all that has been attributed to him by officious friends; if he had, as is claimed, obtained *the most perfect of all drawings*, he would no doubt have shown it publicly even without the second condition—that is to say, the *preparation to preserve it for an indefinite time*; he would have to make a night-album, enclosing his results between black paper and only showing them by moonlight . . ."

Hubert went on to explain that chloride of silver, the most light-sensitive substance then known, produces faint and indistinct images, with the lights and shades reversed:

"The researches which I have made on this subject seven or eight years ago,

and of which I have spoken to several chemists and artists, make me think that even if we assume that a substance more sensitive than chloride of silver has been discovered, one would still have great difficulty in obtaining *the most perfect of all drawings*: for if we assume taking in the camera obscura the image of a plaster cast lit up in bright sunshine and set against a dark background, and even if we assume placing the camera obscura and the object to be copied on the same turntable and rotate it according to the sun's movement in order that the shadows should remain unchanged, and even if we assume that an almost instantaneous discolouration [of the sensitive material] would not be necessary, this would still be a far cry from copying portraits and landscapes, which have by no means the brightness of plaster exposed to full sunlight.

"I repeat, I so much doubt M. Daguerre's anticipated results that I find myself almost tempted to announce that I, too, have discovered a process, the possibility of which has recently been questioned in the *Journal des Artistes*—a process, namely, for obtaining the most perfect of portraits, by means of a chemical composition which fixes them in the mirror at the moment one looks at oneself!"[94]

Hubert's remarks disclosed so much knowledge of the subject that Daguerre did not try to put up any defence. Fearing that the writer was a potential rival in the invention of photography, he made contact with him and—*mirabile dictu*—talked him into becoming his assistant! What stronger proof could there be of Daguerre's winning personality and persuasive powers, so often spoken of by his friends? Hubert remained Daguerre's loyal assistant throughout the most critical years of the invention. Judging from the above letter, it was probably at his suggestion that Daguerre concentrated for a long time on the photography of plaster casts. Hubert (*d.* 1839) himself took several excellent daguerreotypes of groups of casts, and wrote an interesting practical handbook of the process, published in June 1840.[95]

It was not until May 1837 that Daguerre found a way of fixing the pictures permanently, using a solution of common salt in hot water to dissolve the part of the silver iodide not affected by light. Again he asked Isidore Niépce to come to Paris. Excitedly he told him that he had at last succeeded in solving the problem completely. Unlike the last occasion of their meeting, he proudly showed him some pictures. Isidore was amazed and delighted, but his joy was soon damped by new conditions which Daguerre tried to impose upon him. They had already been embodied in a document which Daguerre now put in front of him for signature. Isidore was startled to read:

Final Agreement

I, the undersigned, hereby declare that M. Louis-Jacques-Mandé Daguerre, painter, member of the Legion of Honour, has informed me of a process of which

he is the inventor. This process has for its object the fixing of the images produced in the camera obscura, not with their colours, but with perfect gradation of tones from white to black.

This new method has the advantage of reproducing objects sixty or eighty times* more quickly than that invented by M. Joseph-Nicéphore Niépce, my father, and improved by M. Daguerre. For the exploitation of that invention a provisional partnership agreement was signed on 14 December 1829, by which it was stipulated that the process mentioned above is to be made known under the following title:

Process invented by M. Joseph-Nicéphore Niépce and improved by M. Louis-Jacques-Mandé Daguerre.

After the communication which he has made me, M. Daguerre consented to transfer the new process of which he is the inventor and which he has perfected, to the partnership founded according to the above-mentioned provisional agreement, on *condition* that this new process shall bear the *name of Daguerre* alone; it may, however, only be published simultaneously with the first process, in order that the name of M. Joseph-Nicéphore Niépce may always figure, as it should, in this invention.

By the present agreement, it is and remains understood that all the articles and underlying principles of the provisional agreement of 14 December 1829 remain in force.

According to these new arrangements between MM. Daguerre and Isidore Niépce, which form the final contract referred to in article 9 of the provisional agreement, the said partners having decided to publish their different processes, have chosen to do so by subscription.

This subscription shall be advertised in the press. The list shall be opened on fifteenth March one thousand eight hundred and thirty-eight and closed on fifteenth August following.† The price of the subscription shall be 1,000 francs. The subscription list shall be deposited at a notary's, and he shall take charge of the money subscribed. The number of subscribers shall be limited to 400. The terms of subscription shall be as favourable as possible. The processes cannot be made public unless at least one hundred subscribers are found. Failing this the partners will consider another method of publication. If before the opening of the subscription a purchaser for the processes is found, the price accepted must not be less than 200,000 francs.

* This proved later to be a grossly exaggerated claim, but of course I. Niépce had no means of checking it, and trusted his partner's statement.

† Presumably owing to a misreading of handwriting "Aout" was taken to be "Avril" and the subscription date has sometimes been wrongly given as April.

Executed in duplicate and agreed in Paris, this thirteenth day of June one thousand eight hundred and thirty-seven, at the residence of M. Daguerre at the Diorama, and signed in approval of the above.

Isidore Niépce. Daguerre.

Niépce indignantly refused to put his signature to this document which seemed to him an odious usurpation of his father's rightful claim to the invention. He declared that he would not put up with Daguerre's ridiculous pretensions any longer; in the face of this flagrant violation of all feelings of honour there was only one course left to him—to take legal steps to render him justice. Seeing how upset his partner was, Daguerre tried to calm him by simulating agreement with his feelings. As demands had failed to subdue him, he tried persuasion. "You are right," he said in a changed tone, "I should have a bad opinion of you if you acted differently towards a man whose memory is as dear to me as to yourself." Yet without Isidore's agreement to the alteration of the terms, he was afraid, he said, that he would have to keep his own process—which he insisted had nothing in common with Niépce's —to himself. He suggested, therefore, that they should now try to find subscribers for heliography, and that his own invention should not be offered until later on. Isidore at once saw through Daguerre's cunning manœuvre. He realized that no one would pay a penny for his father's slow process, particularly if it became known that another much quicker method existed—and Daguerre was sure to publicize the fact. If his partner's process should really prove to be an entirely new method, as he claimed—and Isidore had no means of checking this statement, as Daguerre did not reveal any chemicals—his refusal to sign now might perhaps absolve Daguerre legally from any obligation to share the profits with him. These thoughts rushed through his head as he faced Daguerre, not knowing what to decide. In despair he signed in the end, for his financial position did not allow him any other course but to accept Daguerre's terms.

"All his conduct has been nothing but a heap of shameful and despicable char-latanism," raged Isidore afterwards,[96] for he was of the opinion that Daguerre had merely improved his father's process. "Would M. Daguerre have thought of using iodine if it had not been revealed to him by my father? I know that he might reply to this that nothing is impossible to him, and that he knew the properties of iodine perhaps even before M. Courtois had thought of extracting this seaweed substance." Daguerre, on the other hand, was equally convinced that he had devised a totally different method, and that in offering to share the profits half-and-half he was doing more than his duty to his dead partner's son.

The facts are, heliography was not a practicable process, although by it the world's

first photograph was taken. Admittedly Daguerre did build up his process upon Niépce's knowledge, but mercury development was an entirely new principle, and it is futile to argue, as did Isidore and Fouque in uncritical partisanship, that Daguerre had not changed anything in the principles of Nicéphore Niépce's invention, that the mode of operation was the same, and that he had "only" changed some of the substances.* Of course, the basic principle—of fixing permanently the images of the camera—remained the same, but the means employed were not. The real case against Daguerre is surely that he had contracted to apply his talents and energy to perfect heliography, by whatever means he could. Even if the final process were in fact a new one, Isidore could still have held it to be only a perfection of the original process within the legal and moral meaning of the 1829 agreement.

Great as was Isidore's indignation, he kept it in check for the time being, for the success of Daguerre's invention seemed assured, and a turn of fortune in sight. Quite apart from the commercial aspect of the matter, his gentle and shy nature made him averse from quarrelling; he would rather give way meekly than start legal quibbling. As the months passed by, Isidore became more reconciled to the situation, persuading himself that he had perhaps done Daguerre injustice in ascribing to him unworthy motives. By November the old friendly relations were re-established.

"MY DEAR DAGUERRE, Lux, 1 November 1837

You will doubtless, my dear friend, have been more fortunate than I, and very probably your portfolio is by now enriched with the most beautiful pictures! What a difference between the method which you employ and the one by which I toil on! While I require *almost a whole day* to make one picture, you need only *four minutes*!† What an enormous advantage! It is so great, indeed, that no person, knowing both methods, would employ the old one.

This reflection makes me feel less painfully my own want of success. For, though the old system might be described as the result of my father's labours, to the perfection of which you equally contributed, it is certain that it could not become the exclusive object of a subscription. Therefore, I think we should content ourselves with simply mentioning it, in order to make both methods known, for of the two, yours alone will obtain the preference!"97

In the nine months which elapsed between the signing of the final contract and

* Fox Talbot used the same line of argument in his claim that the collodion process was covered by his Calotype patent.

† Four minutes was an exaggerated claim which Isidore trustingly believed. The exposure was 20 minutes to half an hour. Also, it is impossible to compare the exposure required for a landscape, which Niépce took, with a plaster bust which Daguerre was probably practising on.

the opening of the subscription, Daguerre tried hard to interest various governments in the purchase of the invention. No reliable evidence has been found about this attempted exploitation, and Daguerre's claims—at the time when the French Government were considering its purchase in 1839—that he had refused offers from (unspecified) foreign countries must be regarded with suspicion. Had he received any offers from "England, Russia, Prussia, and the United States"[98] within the purchase price asked, his acceptance would have been a foregone conclusion, since according to the final agreement with Isidore Niépce the outright sale of the invention was his first object. The Paris correspondent of the *Morning Post* reported early in March 1839 that Daguerre had refused 500,000 francs offered by the Emperor of Russia, but this can certainly be discounted as a rumour emanating from the inventor himself in the hope of influencing the French Government's offer. The claim that "England had offered the inventor a sum of 200,000 francs for his discovery, but the artist preferred to give it to his country"[99] made in a biographical article published by the Institut des Archives Historiques must also be regarded as glorification at the expense of truth. In reality, it was only in February 1840, *after* the purchase of the invention by the French Government, that Daguerre and I. Niépce sent a special agent to England, who *failed* in his mission to find a purchaser (see page 150). In any case, the notion that an invention of such far-reaching consequences could be used by one country to the exclusion of all others strikes us as fantastic today as America's attempt to keep the secret of the atom and hydrogen bombs will seem to posterity.

Having failed to sell the invention outright, Daguerre tried the subscription scheme. He attracted all the publicity he could by driving round Paris with the bulky apparatus weighing 50 kg. on a cart, photographing public buildings and monuments. But Parisians were suspicious of the mumbo jumbo that went on under the black cloth. Daguerre was known as a skilful painter of illusions. As a scientist he had no status at all, and his idea of holding up a mirror (a polished silver plate) to Nature and retaining the images automatically on it seemed like a fairy-tale. Few people were willing to risk a thousand francs on something they could not test for themselves until some future date, when the method would be revealed to them and other shareholders. Indeed, Daguerre himself no longer had much faith in the subscription scheme. "I am convinced", he wrote to Isidore, "that we shall find very few subscribers, because a secret known to so many is no longer a secret; hardly a year would go by before it would be generally known. The people who have promised you to subscribe have doubtless come to the same conclusion. . . . Finally, people find the price too high, the more so as one has to add at least another 250 francs for the apparatus. As to portraits, of which I told you that according to

my experiments I am certain to be able to take them, this was solely to ascertain the possibility, for one must not assume that people who would make quite nice pictures [of other subjects] would also have luck with portraits. . . . I am solely concerned to prove that it is possible." This was rather a climb-down, considering that he had written to Isidore on 17 January 1838, "I have made some experiments with portraiture, which succeeded well enough, so that I have the desire to show one or two of them in our exhibition. For complete success, however, a special apparatus is necessary."

Undaunted by failure to find a sufficient number of subscribers by 15 August, Daguerre planned another subscription to start on 15 January 1839, and this time he prepared the way with greater care and circumspection. Knowing from experience that it was not enough simply to advertise a subscription in the newspapers, he now had a press hand-out printed, and planned an exhibition of forty to fifty daguerreo-types to coincide with the opening of the new subscription scheme. Through the courtesy of Beaumont Newhall we are enabled to publish for the first time the complete text of Daguerre's broadsheet, of which apparently only the copy now at George Eastman House has survived.

DAGUERREOTYPE

The discovery which I announce to the public is one of the small number which, by their principles, their results, and the beneficial influence which they exert on the arts, are counted among the most useful and extraordinary inventions.

It consists in the spontaneous reproduction of the images of nature received in the camera obscura, not with their colours, but with very fine gradation of tones.

M. Nicéphore NIÉPCE, of Châlon(s)-sur-Saône, already known for his love of the arts and his numerous useful inventions, whom sudden death unexpectedly tore from his family and from science on 5 July 1833, had found after many years of research and persistent labour one principle of this important discovery; by numerous and infinitely varied experiments he had succeeded in obtaining the image of nature with the aid of an ordinary camera obscura; but his apparatus did not give the necessary sharpness, and the substances on which he operated were not sufficiently sensitive to light, so his work, however surprising in its results, was nevertheless very incomplete.

For my part, I was already occupied with similar researches. It was in these circumstances that relations were established between M. NIÉPCE and me in 1828 [sic], as a result of which we formed a partnership with the object of per-fecting this discovery.

I brought to the partnership a camera obscura modified by me for this application which rendered a larger field of the image sharp and greatly influenced our later success.* Some important modifications which I made to the process, combined with the continual researches of M. NIÉPCE, augured well, when death came to separate me from a man who besides vast and profound knowledge had all the qualities of the heart; may I be permitted here to pay a just tribute of esteem and regret to his memory, which will always be dear to me.

Upset by this loss, I abandoned my work for a while; but soon, pursuing it with renewed eagerness, I attained the goal which we had set ourselves.

This apparently happy result did not, however, render the effects of nature sufficiently correctly, because the operation lasted several hours.

In this state the discovery was extraordinary, but it would not have been of any utility.

I realized that the only way to succeed completely was to arrive at such rapidity that the impression could be produced in a few minutes, so that the shadows in nature should not have time to alter their position; and also that the manipulation should be simpler.

It is the solution of this principle that I announce today; this new process to which I have given my name, calling it DAGUERREOTYPE, and which differs entirely as regards rapidity, sharpness of the image, delicate gradation of the tones, and above all, the perfection of the details, is very superior to that invented by M. NIÉPCE, in spite of all the improvements which I made to it. The difference in its sensitivity to light as compared with M. Niépce's process is as 1 to 70, and compared with chloride of silver, it is as 1 to 120. In order to obtain a perfect image of nature only *three to thirty minutes at the most* are necessary, according to the season in which one operates and the degree of intensity of the light.

The imprint of nature would reproduce itself still more rapidly in countries where the light is more intense than in Paris, such as Spain, Italy, Africa, etc., etc.

By this process, without any idea of drawing, without any knowledge of chemistry and physics, it will be possible to take in a few minutes the most detailed views, the most picturesque scenery, for the manipulation is simple and does not demand any special knowledge, only care and a little practice is necessary in order to succeed perfectly.

Everyone, with the aid of the DAGUERREOTYPE, will make a view of his castle or country-house†: people will form collections of all kinds, which will

* This contradicts Daguerre's statement quoted on p. 68, footnote.

† This is obviously addressed to a class of people who could easily afford 1,000 francs for the subscription.

be the more precious because art cannot imitate their accuracy and perfection of detail; besides, they are unalterable by light. Even portraits will be made, though the unsteadiness of the model* presents, it is true, some difficulties [which need to be overcome] in order to succeed completely.

This important discovery, capable of innumerable applications, will not only be of great interest to science, but it will also give a new impulse to the arts, and far from damaging those who practise them, it will prove a great boon to them. The leisured class will find it a most attractive occupation, and although the result is obtained by chemical means, the little work it entails will greatly please ladies.

In conclusion, the DAGUERREOTYPE is not merely an instrument which serves to draw Nature; on the contrary it is a chemical and physical process which gives her the power to reproduce herself.

<div align="center">

DAGUERRE,

Painter, inventor and director of the Diorama.

</div>

Note. On 15 January 1839 an Exhibition comprising 40–50 pictures proving the results of the DAGUERREOTYPE will be opened at the same time as a subscription, the conditions of which will then be announced.

(Printed by Pollet, Soupe and Guillois, rue St-Denis, 380.)

To give the invention status, Daguerre approached, towards the end of 1838, a number of distinguished scientists, including François Arago, J. B. Biot, J. B. Dumas, Alexander von Humboldt, and the artists Paul Delaroche, Henri Grevedon, and Alphonse de Cailleux, Curator at the Louvre, in the hope that their good opinion would overcome the scepticism of the public. Quite unexpectedly the matter took a different turn, for Arago immediately recognizing the importance of the invention used all his influence both as politician and as scientist to raise it from the sphere of commerical speculation to its proper place in science and art.

François Jean Dominique Arago (1786–1853), Director of the Paris Observatory, a member and permanent secretary of the Académie des Sciences, was also leader of the left wing of the republican opposition in the Chamber of Deputies—a party whose members came from the *élite* of the intellectual middle class. Humanitarian, liberal, and progressive, they pushed through reforms and supported scientific research. Foreseeing the immense benefits photography could bring to science, art, and industry, Arago knew that the invention could not remain the property of a

* It seems rather unfair to blame it on the model when the difficulty lies in the excessive length of the exposure.

few private individuals but was destined to serve all mankind. A great plan took shape
in his mind: France should buy the invention and liberally present it to the whole
world. Promising to use all his influence with the Government, he dissuaded
Daguerre from the contemplated subscription scheme and intended exhibition.

Arago's patronage proved the turning point in the fortunes of the invention and
inventor alike. To give the discovery official status and explain its principles, Arago
decided first of all to make a statement at the meeting of the Académie des Sciences
at their next session, on Monday, 7 January 1839, in which he elaborated on the
various points in Daguerre's broadsheet.

"Everybody knows the optical apparatus called the camera obscura invented
by J. B. Porta*; everyone has noticed with what clarity, truthfulness of form,
colour, and tone, external objects are reproduced on the screen placed at the
focus of a large lens which constitutes an essential part of this instrument; and
everyone who has admired these images will have felt regret that they could not
be rendered permanent.

From now on there will be no need for this regret, for M. Daguerre has
devised special plates on which the optical image leaves a perfect imprint—
plates on which the image is reproduced down to the most minute details with
unbelievable exactitude and *finesse*. In fact, it would be no exaggeration to say that
the inventor has discovered the means of *fixing the images*, if only his method
preserved the colours; but I must hasten to explain, in order to undeceive the
public, that in M. Daguerre's copies—as in a pencil drawing, an engraving, or, to
make a more correct comparison, in an aquatint-engraving—there are only white,
black and grey tones representing light, shade, and half-tones. In other words, in
M. Daguerre's camera obscura light itself reproduces the forms and proportions
of external objects with almost mathematical precision; but while the photo-
metric proportions of the various white, black and grey tones are exactly pre-
served: red, yellow, green, etc., are represented by half-tones, for the method
produces drawings and not pictures in colour.

M. Daguerre has shown three members of the Academy, MM. de Humboldt,
Biot, and myself, some results achieved by his process; principally a view of the
long gallery connecting the Louvre with the Tuileries; a view of the Île de la
Cité with the towers of Notre-Dame; several views of the Seine with some of its
bridges; also views of some of the [Customs] barriers of the capital. All these

* In his *Magiae Naturalis*, 1558, Porta disseminated knowledge of the original form of the camera obscura,
then literally a darkened room, but he did not invent it. Nor did the portable camera originate with him.
(See the authors' *History of Photography* for the evolution of the camera obscura.)

pictures bear examination under a magnifying-glass without losing any of their sharpness, at least as regards objects which remained stationary while their picture was taken.

The time necessary for taking a view, when one wants to achieve great vigour of tone, varies with the intensity of the light, the hour of the day, and with the season. In summer at mid-day, eight to ten minutes suffice. In other climates, Egypt for example, one could probably limit oneself to two or three minutes.

M. Daguerre not only had to discover a substance more sensitive to light than any hitherto known to physicists and chemists; he had also to find a way of stopping its sensitivity at will, and this is precisely what he has achieved: when he has fixed his picture it can be exposed to full sunshine without undergoing any further alteration.

The extreme sensitivity of M. Daguerre's preparation does not constitute the only characteristic by which his discovery differs from *the imperfect attempts* formerly made to draw *silhouettes* on a layer of *chloride of silver*.* This white salt turns dark under the influence of light and what is white in the original is represented dark, while dark tones are rendered white. On M. Daguerre's plate, however, the picture has the same tone values as the external object, i.e. white corresponds to white, half-tones to half-tones, and black to black.

I have tried to set out all the advantages of M. Daguerre's invention for travellers, and all that it offers today to learned societies and to private gentlemen who spend so much energy in delineating famous buildings in various parts of the country.† The ease and accuracy of the new process, far from damaging the interests of the draughtsman, will procure for him an increase in work. He will certainly work less in the open air, and more in his studio [i.e. copying daguerreotypes].

The new substance will also provide physicists and astronomers with very valuable methods of investigation. At the request of the Academicians already mentioned, M. Daguerre has projected the image of the moon, formed at the focus of a lens of medium quality, on to one of his plates, where it left a visible white imprint. When a committee of the Academy, composed of MM. Laplace, Malus and myself, had previously made a similar experiment with chloride of silver, they failed to obtain any appreciable effect: perhaps the exposure was not long enough. In any case, M. Daguerre was the first to produce a noticeable chemical modification by the moon's light.

* Arago refers to Prof. Charles (see p. 48, footnote).

† He refers to *Voyages pittoresques*.

M. Daguerre's invention is the fruit of several years' assiduous work, during which he had as collaborator his friend the late M. Niépce of Châlon-sur-Saône. Wondering how he could best be compensated for his trouble and expense, the distinguished painter did not fail to realize that a patent would not help him: once revealed, anyone could use his process. It seems, therefore, indispensible that the Government should compensate M. Daguerre direct, and that France should then nobly give to the whole world this discovery which could contribute so much to the progress of art and science. To further this project I intend to address a request to the Ministry or to the Chambers as soon as M. Daguerre has initiated me into all the details of his method, and has given proof that in addition to giving the brilliant results shown, the method is also economical, easy, and capable of being used by travellers anywhere.''

As Arago sat down, the physicist Biot rose and declared that he completely supported Arago's opinion. Having seen Daguerre's astonishing pictures on several occasions, and heard him relate some of the numerous experiments on the sensitivity of his preparation, Biot was of the same opinion as Arago, that the invention would provide the physicist with a new and valuable method of studying the properties of light. Up to now, physicists had to make these studies with the aid of their eyes only. Now Daguerre put at their disposal an independent means of testing it—an artificial retina.[100]

Before the contents of Arago's speech became known, Paris was already teeming with rumours, for his eagerly awaited announcement of Daguerre's epoch-making invention had been forestalled the previous day by the *Gazette de France*—a scoop due to H. Gaucheraud, a journalist.

''We have much pleasure in announcing an important discovery made by M. Daguerre, the celebrated painter of the Diorama. This discovery seems like a prodigy. It confounds all the theories of science in light and optics, and, if borne out, promises to revolutionize the art of drawing. . . .

Let our readers fancy the fidelity of the image of nature represented by the camera obscura, and add to it an action of the solar rays which fixes this image with all its gradations of lights, shadows, and middle tints, and they will have an idea of the beautiful pictures which M. Daguerre has shown us to gratify our curiosity. M. Daguerre cannot work on paper, he requires a plate of polished metal. We saw several views of the Boulevards, Pont Marie, and the environs, and many other spots, reproduced on copper with a truth which Nature alone can render to her works. M. Daguerre shows you the plain plate of copper: in

your presence he places it in his apparatus, and in three minutes if there is a bright summer sun, and a few more if autumn or winter weaken the power of its beams, he takes out the metal and shows it to you, covered with a charming drawing representing the object towards which the apparatus was turned. Nothing remains but a short mechanical operation—of washing, I believe—and the picture which has been obtained in so few minutes, remains unalterably fixed, so that the hottest sun cannot destroy it.

Messrs Arago, Biot, and von Humboldt have ascertained the reality of this discovery, which excited their admiration, and M. Arago will in a few days make it known to the Academy of Sciences.

Nature in motion cannot be represented. . . . In one of the views of the boulevards of which I have spoken, all that was walking or moving does not appear in the picture; of two horses of a hackney coach on the stand, one unfortunately moved its head during the exposure and so the animal appears without a head in the picture. Trees are very well represented, but their colour, apparently hinders the solar rays from producing their image as quickly as that of houses. This causes a difficulty in landscape work, because there is a certain point of perfection for trees, and another for all objects the colours of which are not green. The consequence is that when the houses are finished, the trees are not, and when the trees are finished, the houses are overdone.

Inanimate nature, and architecture, are the triumph of the apparatus which M. Daguerre means to call after his own name—Daguerotype [sic]. . . . For a few hundred francs travellers may perhaps soon be able to procure M. Daguerre's apparatus, and bring back views of the finest monuments and of the most delightful scenery of the whole world. They will see how far their pencils and brushes are from the truth of the Daguerotype. Let not the draughtsman and the painter, however, despair—the results obtained by M. Daguerre are very different from their works, and in many cases cannot be a substitute for them. The effects of this new process have some resemblance to line engraving and mezzotinto, but are much nearer the latter: as for truth, they surpass everything.''

Nowadays photography is so completely taken for granted that it is difficult for us to realize how startling the idea seemed to Daguerre's contemporaries that Nature could be made to produce a spontaneous picture unaided by an artist. ''The Photogenic discoveries have unfolded a new order of possibilities, and will aid in leading to one mighty cause, ruling the universe of matter in a dominion second only to the spontaneity of the Creator.''[101] Even the usually restrained and objective *Literary Gazette* wrote of ''the great sensation caused by the dagueroscope'' [sic], and trying hard to reveal the mysteries which they didn't understand themselves,

naïvely explained that "by exposing the copper to these reflections and immediately rubbing it over with a certain material, the likeness of whatever is so impressed is retained with perfect accuracy".[102] Another paper supplied the useful information that "a plate of some kind is coated with black varnish", while a fleck on a picture led Jules Janin to believe that "by taking a magnifying glass you can see a bird which passed in the sky"[103] (in an exposure of 20 minutes!)

The profound astonishment and admiration for the daguerreotype was brought out daily in new reports, though a certain disappointment that the pictures were not in colour and that movement could not be represented is sometimes discernible.

"The discovery of M. Daguerre has been for some time past the subject of marvellous statements. . . . Yet the accounts, fabulous as they appear, are conformable to the truth, except that M. Daguerre's pictures do not give the colour but only the outlines—the lights and shades of the model. It is not painting, it is drawing, but drawing carried to a degree of perfection which art can never attain. The facsimile is faultless.

Every picture that was shown us produced an exclamation of admiration. What fineness in the strokes! What knowledge of chiaroscuro! What delicacy! What exquisite finish! . . . How admirably are the foreshortenings given: this is Nature itself. All this is wonderful. But who will say that it is not the work of some able draughtsman? Who will assure us that they are not drawings in bistre or sepia? M. Daguerre answers by putting a magnifying-glass into our hand, whereupon we perceive the smallest folds of a piece of drapery and the lines of a landscape invisible to the naked eye. With the aid of a spy-glass we bring the distance near. In the mass of buildings, of accessories, of imperceptible lines which compose a view of Paris taken from the Pont des Arts, we distinguish the smallest details; we count the paving-stones; we see the dampness caused by the rain; we read the inscription on a shop sign. . . .

M. Daguerre has hitherto made his experiments in Paris only, and even under the most favourable circumstances they have always proceeded with a slowness which has not allowed him to obtain complete success except with inanimate nature, or nature in repose. Motion escapes him, or leaves only indefinite and vague traces. It may be presumed that the sun of Africa would give him instantaneous autographs [sic]—images of nature, in motion and life."[104]

Among the most admired subjects were three views of the Boulevard du Temple taken from the Diorama by morning (Plate 40), noon, and evening light; and another of the same street in which one pedestrian was visible—a man having

his boots cleaned, which caused him to stand still during the relatively long exposure.

As soon as reports of Daguerre's invention reached other countries a host of experimenters came forward with claims of priority. Though most of these claims do not bear investigation (several "inventors" very generously said they would not reveal their process until Daguerre had received his just reward!), some people had succeeded in obtaining impermanent images on paper sensitized with silver salts (a method quite well known and generally used by scientists for measuring the relative intensity of light sources), and a few deserve to rank as independent inventors.* The most formidable rival to Daguerre was William Henry Fox Talbot, F.R.S. (1800–77), who, directly he heard the news, hastily prepared a communication on his process of "Photogenic Drawing" on which he had been working since 1834, and showed his prints to the Royal Institution on 25 January and to the Royal Society five days later. This roused Francis Bauer, F.R.S., to champion the cause of his old friend as the true inventor of photography by exhibiting the heliographs Niépce had brought to England in 1827. As is often the case with champions, Bauer claimed too much when he stated that they were "quite as perfect as those productions of M. Daguerre described in the French newspapers"[105]—productions he was not in a position to judge, as none had been shown outside Paris.

Charles Chevalier and Lemaître also expressed regret at not seeing Niépce's name incorporated in the title of the invention of photography on silvered plates, which was henceforth to be known as the daguerreotype. Arago's zeal to assist his protégé led him to make a number of inaccurate statements concerning Nicéphore Niépce's pioneer work and Daguerre's researches, no doubt based on information received from Daguerre. He asserted, for example, before the Académie des Sciences, that "M. Daguerre had already, in the lifetime of his friend, invented the entirely new process he now uses, and several of the pictures so much admired by the public existed at that period [i.e. before July 1833]. In the last five or six years M. Daguerre's method has only undergone the slightest improvements, and only an eminent artist could have felt the necessity for making them." Biot was equally uncritical in his acceptance of Daguerre's claims, for in support of Arago's statement he cited the article in the *Journal des Artistes* of 27 September 1835 (see p. 73) as "undeniable proof that the discovery then announced was precisely the same as the process Daguerre showed all Paris at the end of 1838".[106]

Arago must have been greatly impressed by Daguerre's personality, for he did everything possible to further his invention. His attitude was markedly different

* These claims are discussed in the authors' *History of Photography*.

towards Hippolyte Bayard (1801–87), who deserves a more prominent position as
an independent inventor of photography than is usually accorded to him. A minor
civil servant, Bayard had been making photographic experiments in his spare time
since 1837. Redoubling his efforts after the announcement of the daguerreotype, he
was sufficiently successful by early May to show direct positive photographs on paper
to Biot and Arago. To his surprise, he was requested to defer publication of the
method, which, though entirely different from Daguerre's, might have prejudiced
the outcome of the negotiations with the Government concerning the daguerreotype.
It would have been a most inopportune moment for the announcement of a second
similar invention in France, and would have greatly dimmed the blaze of glory with
which Daguerre's name had been surrounded by Arago. He arranged, therefore,
with Duchâtel, the Minister of the Interior, to give Bayard 600 francs (then worth
about £25) to enable him to buy a better camera and lens, and to subsidize further
experiments, and this seems to have persuaded the timid inventor to fall in with
Arago's wishes. He did not publish his manipulation until February 1840, though
thirty of his photographs were publicly exhibited in June 1839—before any of
Daguerre's. For the time being, Daguerre only showed his pictures personally to
journalists and distinguished artists and scientists, such as the British party visiting
Paris in May 1839: the astronomers Sir John Herschel and General Sir Thomas
MacDougall-Brisbane; the physicists James Forbes and Sir John Robison; James
Watt, jnr., engineer; (Sir) Robert Impey Murchison, geologist, and Joseph Barclay
Pentland, explorer. What they saw surpassed all their expectations. Herschel in
particular was so impressed that he said, "This is a miracle! Attempts so far made
in England [by Fox Talbot, the Rev. J. B. Reade, and himself] are childish
amusements in comparison!"[107] On his return to Edinburgh Sir John Robison
reported to the Society of Arts:

"The perfection and fidelity of the pictures are such that on examining them
by microscopic power, details are discovered which are not perceivable to the
naked eye in the original objects: a crack in plaster, a withered leaf lying on a
projecting cornice, or an accumulation of dust in a hollow moulding of a distant
building, are faithfully copied in these wonderful pictures. . . .

There can be no doubt that, when M. Daguerre's process is known to the
public, it will be immediately applied to numberless useful purposes, as, by
means of it, accurate views of architecture, machinery, &c., may be taken, which,
being transferred to copper or to stone, may be disseminated at a cheap rate; and
useful books on many subjects may be got up with copious illustrations, which are
now too costly to be attainable: even the fine arts will gain, for the eyes accus-

tomed to the accuracy of Daguerrotype pictures, will no longer be satisfied with bad drawing, however splendidly it may be coloured."[108]

Samuel F. B. Morse (1791–1872) (Plate 62), a leading American portrait painter, was in Paris at the time of the great excitement about Daguerre's invention, in order to patent his electro-magnetic telegraph. Having himself been engaged in photographic experiments in his student days, he too was eager to meet Daguerre.

"You have perhaps heard of the Daguerrotipe [sic]", he wrote to his brothers* on 9 March, "so called from the discoverer, M. Daguerre. It is one of the most beautiful discoveries of the age. I don't know if you recollect some experiments of mine in New Haven, many years ago, when I had my painting room next to Professor Silliman's—experiments to ascertain if it were possible to fix the image of the Camera Obscura. I was able to produce different degrees of shade on paper, dipped into a solution of nitrate of silver, by means of different degrees of light; but finding that light produced dark, and dark light, I presumed the production of a true image to be impracticable, and gave up the attempt. M. Daguerre has realized in the most exquisite manner this idea.

A few days ago I addressed a note to Mr D. requesting, as a stranger, the favor to see his results, inviting him in turn to see my Telegraph. I was politely invited to see them under these circumstances, for he had determined not to show them again, until the Chambers had passed definitively on a proposition for the Government to purchase the secret of the discovery, and make it public. The day before yesterday, the 7th, I called on M. Daguerre, at his rooms in the Diorama, to see these admirable results.

They are produced on a metallic surface, the principal pieces about 7 inches by 5, and they resemble aquatint engravings, for they are in simple chiaro oscuro, and not in colors. But the exquisite minuteness of the delineation cannot be conceived. No painting or engraving ever approached it. For example: In a view up the street, a distant sign would be perceived, and the eye could just discern that there were lines of letters upon it, but so minute as not to be read with the naked eye. By the assistance of a powerful lens, which magnified fifty times, applied to the delineation, every letter was clearly and distinctly legible, and so also were the minutest breaks and lines in the walls of the buildings, and the pavements of the streets. The effect of the lens upon the picture was in a great degree like that of the telescope in nature.

Objects moving are not impressed. The Boulevard, so constantly filled with a

* The editors of the New York *Observer*, who published his letter on 20 April. This was, Morse says, the first thing the Americans learned about the daguerreotype.

moving throng of pedestrians and carriages, was perfectly solitary, except an individual who was having his boots brushed. His feet were compelled, of course, to be stationary for some time, one being on the box of the boot black, and the other on the ground. Consequently his boots and legs were well defined, but he is without body or head, because these were in motion.

The impressions of interior views are Rembrandt perfected. One of Mr D.'s plates is an impression of a spider. The spider was not bigger than the head of a large pin, but the image, magnified by the solar microscope to the size of the palm of the hand, having been impressed on the plate, and examined through a lens, was further magnified, and showed a minuteness of organization hitherto not seen to exist. You perceive how this discovery is, therefore, about to open a new field of research in the depth of microscopic nature. We are soon to see if the minute has discoverable limits. The naturalist is to have a new kingdom to explore, as much beyond the microscope as the microscope is beyond the naked eye.

But I am near the end of my paper, and I have unhappily to give a melancholy close to my account of this ingenious discovery. M. Daguerre appointed yesterday at noon [Friday 8 March] to see my Telegraph. He came, and passed more than an hour with me, expressing himself highly gratified at its operation. But while he was thus employed, the great building of the Diorama, with his own house, all his beautiful works, his valuable notes and papers, the labor of years of experiment, were, unknown to him, at the moment becoming the prey of the flames. His secret indeed is still safe with him, but the steps of his progress in the discovery and his valuable researches in science are lost to the scientific world. I learn that the Diorama was insured, but to what extent I know not. I am sure all friends of science and improvement will unite in expressing the deepest sympathy in M. Daguerre's loss, and the sincere hope that such a liberal sum will be awarded him by the Government as shall enable him, in some degree at least, to recover from his loss.''[109]

The fire, which broke out at one o'clock in the afternoon, was believed to have started through the carelessness of a workman in the picture emplacements. Being mainly constructed of wood, and containing ten highly inflammable diorama paintings, the entire building was ablaze in a few minutes, and the audience had a narrow escape. Daguerre's house was not burnt down as Morse assumed, but lying only next door and being threatened by flying sparks, he begged the firemen to let the Diorama burn, and to save the contents of his laboratory. They were able to carry the daguerreotype apparatus and pictures, documents, and household linen to safety. Daguerre's notebook containing his experiments, at first believed lost, was reported by Arago ten days later to have been found.

The Diorama was under-insured; only three of the ten paintings were covered, two of which were said to have been sold to Russia for 30,000 francs (£600 each).[110]

After an existence of seventeen years the Diorama which had first brought Daguerre international fame lay in ruins. It was a calamity bringing one chapter in Daguerre's life to a sudden end, but it was far from a tragedy, for—whether due to neglect or to other causes—the Paris Diorama was already on its last legs, and the destruction occurred at a time when he was carried on a wave of enthusiasm into a new and altogether more propitious period of his life.

Did not the "Immortals" honour him with an allegorical poem of several hundred lines, "Lampétie et Daguerre"?[111] Lampétie, a goddess of light and daughter of Helios, married Daguerre and together they created many wonderful pictures (for the Diorama). Enraged, her sister Pyrophyse, goddess of fire, reproaches Lampétie for allowing herself to be enslaved by a mere mortal, and burns down the Diorama. But Lampétie comforts Daguerre, and out of their intimacy is born a still greater miracle, photography.

> Favori au soleil, époux de la lumière,
> Le miracle accompli par notre intimité
> Est le titre immortel de ta sublimité.

The burning down of the Diorama made it all the more imperative for Daguerre to obtain some return for his new invention. Two months had elapsed since Arago had first raised the issue, yet the Government had not given any indication that a national reward was under consideration. Obliged to urge Tannegui Duchâtel, the Minister of the Interior, to solicit the Chambers without further delay, Arago informed him:

"MONSIEUR LE MINISTRE,

After fifteen years of assiduous, delicate, and expensive researches, MM. Niépce and Daguerre have at last been able to fix the images produced in the camera obscura—to employ the solar rays themselves for drawing—to give birth in four or five minutes to pictures, in which objects preserve mathematically their forms, even to the minutest details; in which linear perspective and variety of tones are produced with a degree of fineness hitherto unknown.

I do not exaggerate when I affirm that the method which M. Daguerre has finally hit upon gives most admirable results. Unhappily for the fortune of this talented artist, the method cannot become the object of a patent. As soon as it is known, everyone will be able to apply it; the most clumsy operator will be able to take views as perfect as those of an experienced artist.

The author of so fine, so unexpected, and so useful a discovery, has certainly done honour to his country, and his country alone can recompense him.

I know personally that M. Daguerre has refused certain tempting offers made to him in the name of several powerful sovereigns. This circumstance cannot fail to augment the interest which everyone takes in him. It will increase, in the Chambers, the already very large number of people only awaiting an opportunity to show the sympathy they feel for the unhappy inventor of the photogenic process and of the Diorama. I take the liberty, therefore, M. le Ministre, of asking you if the report be true that you intend to solicit the Chambers for a national reward in favour of M. Daguerre.

I most ardently desire to receive an affirmative answer, in which case I put myself entirely at your disposal, both for the preliminary stipulations and for the discussions that such a proposition might give rise to. If, however, contrary to my expectations and my wishes, you should not think it proper that the Government take the initiative, you will not consider it wrong, I hope, if, acting according to a desire which has arisen from every seat in the Chamber of Deputies, I should endeavour myself, by a formal proposition, to interest that Chamber in the discovery of our ingenious fellow-countryman.''[112]

What strength of character is revealed in this letter! Daguerre could not have hoped for a more energetic sponsor. Impressed by the force of Arago's arguments, the Minister acted with astonishing promptness. On 5 June he formed a committee consisting of Arago, Vitet (a Deputy), and Paul Delaroche, member of the Académie des Beaux-Arts, requesting them to report to him as quickly as possible "whether there are grounds for recommending to the Chambers a national recompense for the authors of this important discovery." Immediately on receipt of this report, a provisional agreement was drawn up between him, Daguerre, and I. Niépce, which specified:

Article 1. MM. Daguerre and Niépce junior undertake to make over to the Minister of the Interior acting for the State, the process of M. Niépce senior, with its improvements by M. Daguerre, and also the last process of M. Daguerre for fixing the images of the camera obscura. They will place in the hands of the Minister of the Interior a sealed packet containing the history and an exact and complete description of the said processes.

Article 2. M. Arago, member of the Chamber of Deputies and of the Academy of Sciences, who is already acquainted with the said processes, will first of all examine the documents and certify their correctness.

Article 3. The packet is not to be opened and the description of the process is not

to be published until the draft of the Bill here discussed has been adopted. After the Act has been passed M. Daguerre must demonstrate the process if so required, in the presence of a Commission appointed by the Minister of the Interior.

Article 4. M. Daguerre, in addition, undertakes to reveal in the same manner the details of his process of painting the Diorama and the mechanical arrangements which characterize it.

Article 5. He is obliged to publish any improvements which he may make from time to time in each and all of these inventions.

Article 6. As remuneration for surrendering these rights, the Minister of the Interior pledges himself to request from the Chambers for M. Daguerre, who hereby signifies his acceptance, an annual pension for life of 6,000 francs [£250]. For M. Niépce, who also joins in the acceptance, an annual pension for life of 4,000 francs [£166.13.4.]. These pensions will be recorded in the register of Civil Pensions of the Treasury. They shall not be subject to any deductions.* Half of these pensions will revert to the widows of MM. Daguerre and Niépce.

Article 7. In the event that the Chambers should not pass the proposed Bill for these pensions, this present agreement shall be regarded as null and void and the sealed packet will be returned to MM. Daguerre and Niépce.

Article 8. This present agreement is to be registered with the stipulated fee of one franc.

Executed in triplicate, Paris, 14 June 1839.

 Approved (*signed*) T. DUCHÂTEL.
 (*signed*) DAGUERRE.
 (*signed*) I. NIÉPCE.

Attested that the copy corresponds with the original attached to the draft of the Bill

(*signed*) The Minister Secretary of State to the Department of the Interior

 DUCHÂTEL

Daguerre's original aim had been an outright payment of 200,000 francs—the minimum sum the partners were willing to accept according to their final contract

* "Elles ne seront pas sujettes aux lois prohibitives du cumul." Eder-Epstean, apparently not sure of the meaning of this point, found it simpler to omit it altogether.

of 13 June 1837. Arago considered that this "might give to the transaction the base character of a sale" and suggested instead, pensions representing 5% interest p.a. on this capital sum, to be divided equally between Daguerre and I. Niépce, according to the contract. Feeling, however, that Daguerre deserved a higher proportion as the inventor of the only *practicable* process, a tactful way out of the difficulty was found by asking Daguerre to disclose his method of dioramic painting (article 4) and to promise to make known any future improvements in photography which he might devise (article 5). This Daguerre was more than willing to do, since for many years the Diorama had only been a liability, and he had no intention of starting another one.

A few days later he wound up the affairs of the Diorama by calling a shareholders' meeting at his new flat in the Boulevard St Martin, where he had been living since the fire.

Monsieur Degascq,
Rue St Honoré
No. 348.
SIR,

You are invited on Friday 5 July at seven o'clock in the evening to M. Daguerre, Boulevart [sic] St Martin No. 17, in order to deliberate on the situation of the Société du Diorama, its dissolution, and the various measures connected with it.

It is indispensable that you attend this meeting, or send a representative.

Any delay could seriously compromise the interests of the firm.

Yours truly,

1 *July* 1839. DAGUERRE.

(*For facsimile see page 96*)

Meanwhile, on 15 June Duchâtel had submitted the Bill incorporating the terms of the provisional agreement concluded the previous day to King Louis-Philippe for signature, and the same afternoon he laid it before the Chamber of Deputies for their sanction. In his exposition the Minister emphasized the novelty of the invention, its incalculable services to science and art, the simplicity of the manipulation and hence the impossibility of patenting the invention and the need for Government action. After setting forth the reasons for granting I. Niépce a pension even though "the method belongs exclusively to M. Daguerre", Duchâtel exhorted the Deputies to support the Bill, by making the invention a matter of national pride. "Gentlemen, we hope that you will concur in a sentiment which has already awakened universal

sympathy, and that you will never suffer us to leave to foreign nations the glory of endowing the world of science and of art with one of the most wonderful discoveries that honour our native land."[113]

Two committees were now charged with examining the scope of the invention and reporting on it to the Lower and Upper Chambers.* In presenting his 5,000-word report to the Chamber of Deputies on 3 July, Arago explained that he had examined Daguerre's invention closely on the four grounds of novelty, artistic value, rapidity of execution, and usefulness in scientific research. After briefly mentioning some previous experiments in the field of photography, Arago gave a resumé of the work of Nicéphore Niépce and his association with Daguerre. His regret that the daguerreotype had not been invented in time to record the monuments of Egypt during Napoleon's campaign of 1798 formed the prelude to a remarkable forecast of the important part that photography was destined to play.

For an opinion on its utility to artists he had turned to the historical painter Paul Delaroche, who on first seeing a daguerreotype in 1838 had exclaimed in bewilderment, "From today, painting is dead!"† On second thoughts Delaroche saw the invention in a different light, for he now realized "the immense service it would render to art. . . . The painter will obtain by this process a quick method of making collections of studies which he could not otherwise procure without much time and labour, and in a style very far inferior, whatever might be his talents in other respects."

As to the simplicity of the process, Arago claimed: "The daguerreotype does not demand a single manipulation that is not perfectly easy to everyone. It requires no knowledge of drawing, and is not dependent upon any manual dexterity. By observing a few very simple directions, anyone may succeed with the same certainty and perform as well as the author of the invention."

So far, of course, only inanimate objects could be taken. The most important application of the daguerreotype—portraiture—Arago admitted was not yet possible, but he believed that "a very slight advance beyond his present progress" would enable Daguerre to use his process for taking portraits from life, and there was no fear that he would leave such improvements to other experimenters. The Committee therefore recommended unanimously that the Chamber should adopt without alteration the Bill proposed by the Government. The Bill was passed.

The following Sunday, 7 July, Daguerre exhibited a number of wholeplate

* The Committee of the Chamber of Deputies consisted of MM. Arago, Étienne, Carl, Vatout, de Beaumont, Tournouër, François Delessert, Combarel de Leyval and Vitet—all names distinguished in science.

† Gaston Tissandier in *Les Merveilles de la Photographie*, Paris, 1874, p. 64, implies incorrectly that this was said in August 1839. Tissandier is, incidentally, the earliest source of this classic anecdote that we have been able to trace.

(16 cm. × 21 cm.) daguerreotypes of street views and casts from the Musée des Antiques in one of the rooms of the Chamber of Deputies, to give deputies and peers alike an opportunity to convince themselves that the statements made in their respective Chambers were not exaggerated. Ten days later (17 July) the Bill had its first reading (with the same exposition of the Minister of the Interior) at the Chamber of Peers, which at that period sat at the Palais du Luxembourg. The peers did not vote on the Bill, however, until 30 July, when the celebrated chemist Louis Joseph Gay-Lussac (1778–1850) as spokesman of the special committee presented his report.* Referring to Arago's report to the Chamber of Deputies and to the daguerreotypes submitted to their inspection, Gay-Lussac stated a problem which must have been uppermost in the minds of many Frenchmen. "Why, considering our wise laws which look after the interests of inventors and public alike, does the Government propose to purchase the invention in order to make it generally available?", and he immediately answered his rhetorical question:

"Given to the public, the process will receive innumerable applications useful to mankind, but if it remains the secret of an individual, the invention will long remain stationary. As public property it will be developed and improved by general emulation. Seen in this light, it is desirable that the process should become public property; but there is still another reason why it is the duty of the Government to show its interest in M. Daguerre's process and to provide adequate compensation for its author. . . . M. Daguerre's process is a great discovery. It is the beginning of a new art in an old civilization; it will constitute a new era and secure for us a title to glory. Do not let it be handed down to posterity accompanied by ingratitude! Let it stand forth as splendid evidence of the protection which the Chambers—the July Government—and the whole country, afford to great inventions. . . . The committee is unanimously in favour of adopting the Bill without alteration."

When the vote was taken, 237 peers were in favour and only three against. After submitting the "Bill for the Acquisition of the Process of M. Daguerre to fix the Images of the Camera Obscura" to the King once more for signature, it became law on or about 1 August.

The secret of the method was not revealed, however, until 19 August. No doubt this was in order to allow time for the publication of a manual on the history and practice of the daguerreotype, the manufacture of apparatus by Giroux, and above

* This committee consisted of barons Athalin, Besson, Gay-Lussac, Thénard, the marquis de Laplace, vicomte Siméon and the comte de Noë.

Facsimile of Daguerre's autograph letter to M. Degascq, 1 July 1839

PRIX . 2 FR.

HISTORIQUE ET DESCRIPTION

DES PROCÉDÉS DU

DAGUERRÉOTYPE

et du Diorama,

PAR DAGUERRE,

Peintre, inventeur du Diorama, officier de la Légion-d'Honneur, membre de plusieurs Académies, etc., etc.

PARIS.

ALPHONSE GIROUX ET Cie,
RUE DU COQ-SAINT-HONORÉ, 7, *où se fabriquent les Appareils;*

DELLOYE, LIBRAIRE,
PLACE DE LA BOURSE, 13.

1839.

NOUVEAU MOYEN

DE

PRÉPARER LA COUCHE SENSIBLE DES PLAQUES

DESTINÉES A RECEVOIR LES

IMAGES PHOTOGRAPHIQUES,

PAR M. DAGUERRE.

LÉTTRE A M. ARAGO.

PARIS,
BACHELIER, IMPRIMEUR-LIBRAIRE
DU BUREAU DES LONGITUDES, DE L'ÉCOLE POLYTECHNIQUE, ETC.,
QUAI DES AUGUSTINS, 55.

1844

(*a*) Cover of first edition of Daguerre's Manual, about 20 August 1839 (*George Eastman House*)

(*b*) Title-page of Daguerre's brochure, 1844

all for completing the patent for the process in England. Daguerre's business acumen did not, perhaps, bring in such handsome dividends as he had anticipated, but at least he did his best to prepare all these matters well in advance. He engaged a patent agent in England on 1 June (a fortnight before the provisional agreement with Duchâtel), and on the 22nd of the same month assigned the monopoly of the manufacture and sale of his apparatus in France and elsewhere, with the exception of England, to Alphonse Giroux, a relative of Mme Daguerre. Chevalier was understandably offended when he heard this, for not only had he made all the apparatus for Daguerre for the last fifteen years, but Giroux was not even an instrument maker, but a fancy-stationer, with a shop at No. 7 rue du Coq Saint-Honoré. "An optician was needed, a stationer was chosen", was his caustic comment; but things were smoothed out again when he was asked to supply the lenses—"the soul of the apparatus". The whole outfit was called "Le Daguerréotype", and was to be considered the only authentic apparatus, as proof of which each camera bore the following guarantee: "Aucun Appareil n'est garanti s'il ne porte la signature de Mr· Daguerre et le cachet de Mr· Giroux. LE DAGUERRÉOTYPE exécuté sous la Direction de son Auteur à Paris chez Alph. Giroux et Cie, Rue du Coq St Honoré No. 7." (Plate 111.) Each camera was stamped with a serial number.

According to the contract (see appendix) Giroux was to keep half the profits from the sale of apparatus, the other half to be divided equally between Daguerre and Niépce. Carefully preserving secrecy regarding the invention to which he was pledged under article 3 of his agreement with the Minister of the Interior, Daguerre was unable to divulge to Giroux the construction of the apparatus until the Bill had been passed by the Chamber of Deputies (3 July); while details of the manipulation of the process (which Giroux was to publish as an instruction booklet) could not be revealed to him until the Upper Chamber had passed the Bill (30 July). Giroux pledged himself not to sell any apparatus or daguerreotype pictures he might have taken (after 30 July) until the process was made public by the Government (19 August). In these circumstances he had barely six weeks in which to manufacture the apparatus and only eighteen days to publish the 79-page manual. Time was, in fact, extremely short and all apparatus available on 19 August was sold within a few hours.

Chapter IV

THE DAGUERREOTYPE IN FRANCE

AFTER seven and a half months of intense publicity, rumours and counter-rumours, meetings of deputies and meetings of peers, speeches by men famous in science, and a special law the like of which not only France but no other country had ever passed before, the day had at last come to make known to the whole world the daguerreotype process, details of which had been so eagerly awaited for so long. The eyes of the whole world were focused on Paris, and, in order to give the publication the distinguished setting that national pride demanded, the Minister of the Interior suggested to the Secretary of the Académie des Sciences (Arago) that the communication be made *urbi et orbi* at a public joint meeting of the Académies des Sciences and des Beaux-Arts at the Institut de France on Monday, 19 August. It was a beautiful summer's day, and a day of solemnity at the Institute. Artists, scientists, and amateurs crowded round the doors of the Collège Mazarin from mid-day on, though the meeting was not due to start until three o'clock—an eagerness to which the Académie was not at all accustomed. The benches reserved for the public had long been filled by every notability in science, literature, and the arts. Uncomfortably pressed together, they kept mopping their brows, while still more people demanded admission, until at last all available standing room was occupied and the crowd overflowed into the corridors and into the courtyard. Others walked up and down the Quai de Conti waiting for news of the meeting.

A murmur of curiosity greeted Daguerre and Niépce when punctually at three o'clock they took their places next to Arago on the platform. (Plate 109.) In front of them were placed the apparatus and three daguerreotypes. Arago began his address with an apology for taking the place of the inventor.

"I have to express my regret that the inventor of this ingenious apparatus is not himself able to explain all its properties to this meeting. This morning, even, I begged—I entreated the able artist to yield to a wish which I well know is universal; but a bad sore throat, fear of not being able to make himself understood without the aid of illustrations—in short, a little nervousness—proved obstacles

which I have not been fortunate enough to overcome. I hope that the meeting will kindly make allowances for my giving a simple verbal communication on such a complicated subject, and without being sufficiently prepared."[114]

Daguerre's obstinate refusal at the last moment to address such a distinguished gathering himself can only be ascribed to stage-fright—a trait not at all in keeping with his character. We can only assume that he was suddenly overcome by an acute awareness of the inadequacy of his scientific education, and that he feared to give away, through answers to questions perhaps, that his invention was not so much the crowning effort of a great scientific mind, as the result of endless practical experiments by an amateur pursuing an *idée fixe*.

In the circumstances, Arago fell back on his communication of 3 July to the Chamber of Deputies, interpolating now and then lengthy explanations of the process, and though his account was delivered with little preparation, the eloquence and enthusiasm with which he praised the discovery was received with the deepest attention by probably the largest gathering that had ever assembled at the Institute. Everyone was hanging on his words, anxious not to miss the promised disclosure of the secret chemicals, each one of which was greeted with a murmur of astonishment, for no one had the slightest idea what substances were used. That two of them were *vapours* surpassed everything that had been imagined.

Unfortunately no verbatim report exists of Arago's address marking the official birthday of photography, though Dr Alfred Donné's and Jules Janin's detailed accounts of the meeting in the *Journal des Débats* and *L'Artiste* respectively give some indication of his actual words. Arago himself admitted in the separately published *Rapport*, and in the *Comptes Rendus* of the Academy, "In the absence of any guide, not only to the expressions used by the Secretary of the Academy but even to the order of his arguments, we have after some hesitation decided that we should reprint the written report which M. Arago presented to the Chamber of Deputies, adding some notes concerning the method, which had to remain secret before the Chamber."

The fact that he had only some hastily prepared notes to refer to may account for a few incorrect statements which tended to exalt Daguerre's achievements at Niépce's expense; Isidore was annoyed to hear it said that his father required an exposure of *three days*, and that he made only photo-copies of engravings. Daguerre was dismayed at the highly scientific exposition, which, though very impressive, made his process sound so much more complicated than it really was. He now wished he had made the explanations himself, for instead of giving practical manipulatory details, Arago informed the assembly that J. B. Dumas had calculated the thickness of the layer of iodide of silver to be not more than one-millionth of a

millimetre, and that this eminent chemist on examining a daguerreotype under the microscope had found that the light parts were composed of tiny globules of mercury each measuring about $\frac{1}{800}$th of a millimetre in diameter! He also caused confusion by his frequent juxtaposition of theory and practice, such as that the plate should be inclined at an angle of 45° in the mercury box if the picture were to be viewed vertically (practice), but if anyone wanted to look at it at an angle of 45°, it would be necessary to place the plate horizontally in the mercury box (theory). On the question of portraiture—the most important application of the daguerreotype—Arago was less hopeful than he had been in his report to the deputies.

"In general", he stated, "there is little ground for believing that the same instrument will ever serve for portraiture, for the problem consists of two apparently irreconcilable conditions. In order to arrive at a short exposure, that is to say, the four or five minutes of immobility that one can expect of a living person, it is necessary to expose the face to full sunshine, but the dazzling light would force even the most insensitive person to blink continually; he would grimace, and his usual expression would be gone. Fortunately, M. Daguerre has recognized that the rays which pass through certain blue glasses produce almost all the photogenic effects. By placing one of these glasses between the sitter and the sun, one will have a photogenic image almost as quickly as if the glass were not there, and as the light will be softened by the blue glass, there would be no need to make grimaces or blink continually."[115]

"Enthusiastic cheers resounded from the grave benches even of the Academy" as Arago ended his dissertation, and the President, Michel Eugène Chevreul, complimented Daguerre in the warmest terms.

"There was as much excitement as after a victorious battle", wrote one eye-witness in a lively account of the nervous tension of the dense crowd.

"Truly a victory—greater than any bloody one—had been won, a victory of science. The crowd was like an electric battery sending out a stream of sparks. Everyone was happy to see others in a happy mood. In the kingdom of unending progress another frontier had fallen. Often it seems to me as if posterity could never be capable of such enthusiasm.

Gradually I managed to push through the crowd and attached myself to a group near the meeting-place, who seemed to be scientists. Here I felt myself at last closer to events, both spiritually and physically. After a long wait, a door opens in the background and the first of the audience to come out rush into the vestibule. 'Silver iodide,' cries one. 'Quicksilver!' shouts another, while a third

48. The Cathedral, Athens (detail). Daguerreotype by Girault de Prangey, 1842

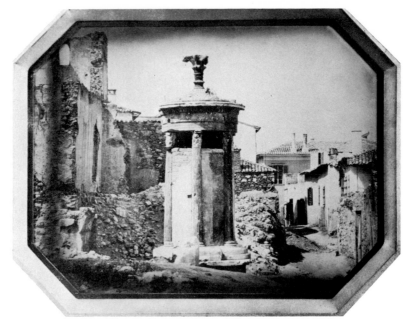

49. Monument of Lysicrates, Athens. Daguerreotype by Baron Gros, 1850

50. The Propylaea, Athens. Engraving copied from a daguerreotype by Joly de Lotbinière, autumn 1839

51. Small temple at Baalbek. Daguerreotype
by Girault de Prangey, 1843

52. Sculpture on Genoa Cathedral. Daguerreo-
type by Girault de Prangey, 1842

53. Panoramic view of Paris, 1846. Daguerreotype by Friedrich von Martens, taken with a panoramic camera of his own invention from the Louvre. Like most daguerreotypes the picture is reversed

54. Daguerreotype group, 1844. On the right, the optician N. M. P. Lerebours (1801–73), on the left, Friedrich von Martens (1809–75). Standing, the scientist Marc-Antoine Gaudin (1804–80)

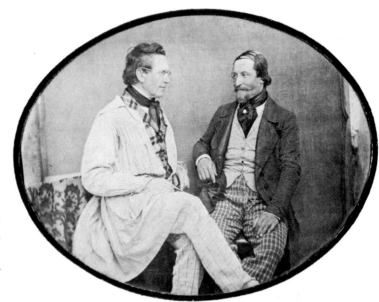

55. The optician Charles
Chevalier (1804–59)
(on left) and a friend.
Daguerreotype, 1843–
1844

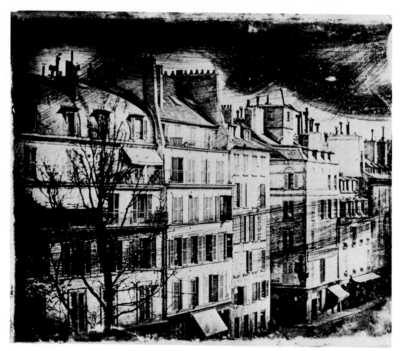

56. View taken by Daguerre from his third-floor flat at 17 Boulevard Saint-Martin. Early 1839

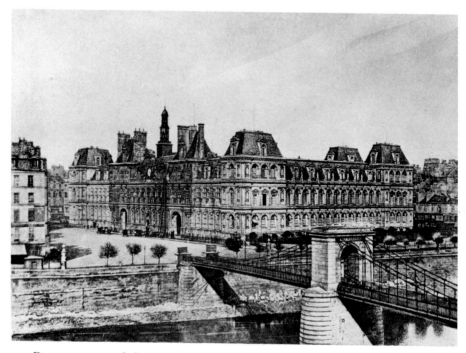

57. Daguerreotype of the Hôtel de Ville, Paris, by N. M. P. Lerebours, etched by H. Fizeau, 1842

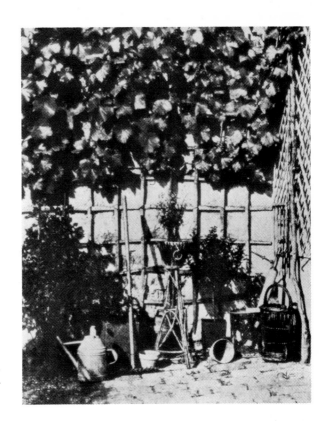

58. Garden courtyard.
Daguerreotype by Hip-
polyte Bayard, 1847

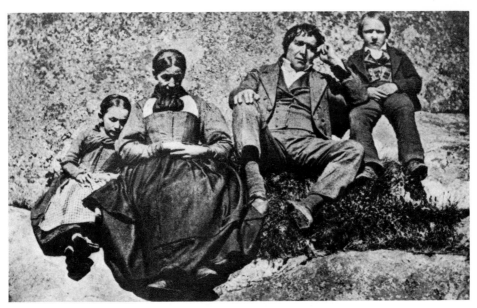

59. Open-air group. Daguerreotype by Adolphe Braun, *c.* 1843

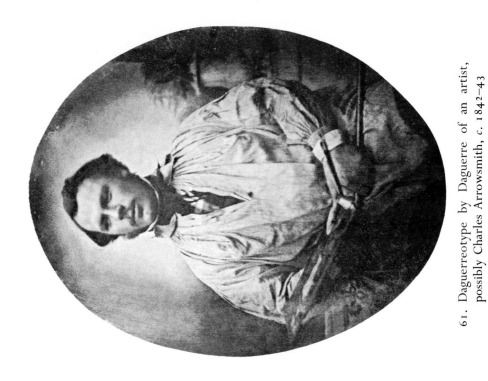

61. Daguerreotype by Daguerre of an artist, possibly Charles Arrowsmith, c. 1842–43

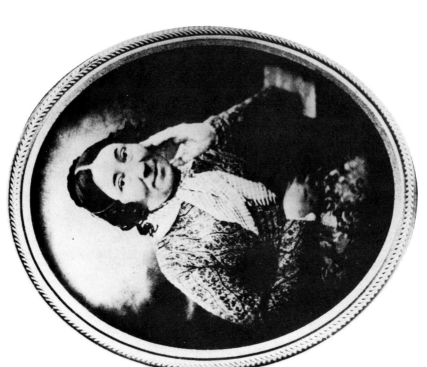

60. Louise Georgina Daguerre. Daguerreotype portrait by her husband taken at Bry, c. 1845

maintains that hyposulphite of soda is the name of the secret substance. Everyone pricks his ears, but nobody understands anything. Dense circles form round single speakers, and the crowd surges forward in order to snatch bits of news here and there. At length our group too manages to catch hold of the coat-tails of one of the lucky audience and make him speak out. Thus the secret gradually unfolds itself, but for a long time still, the excited crowd mills to and fro under the arcades of the Institute, and on the Pont des Arts, before it can make up its mind to return to everyday things.

An hour later, all the opticians' shops were besieged, but could not rake together enough instruments to satisfy the onrushing army of would-be daguerreo-typists; a few days later you could see in all the squares of Paris three-legged dark-boxes planted in front of churches and palaces. All the physicists, chemists, and learned men of the capital were polishing silvered plates, and even the better-class grocers found it impossible to deny themselves the pleasure of sacrificing some of their means on the altar of progress, evaporating it in iodine and con-suming it in mercury vapour.

Soon there appeared a pamphlet in which Daguerre fully described his process, and as, alas, my money was not sufficient to buy the apparatus, I bought the brochure in order to be able at least to daguerreotype in imagination. I still see it before me, its violet-grey covers decorated with a vignette of the Pantheon with the inscription 'Aux grands hommes la patrie reconnaissant'. The publisher could not help rubbing in the immortality of the inventor in this rather obvious way."[116]

Another of the two hundred or so people who failed to gain admission and had to wait in the courtyard was Marc-Antoine Gaudin (1804–80) (Plate 54), at that time partner of the optical instrument maker N. M. P. Lerebours (1807–73) (Plate 54). Gaudin speaks of the festive occasion in very similar terms. Directly the meeting was over he hurried to the nearest chemist's to buy iodine and mercury. By the next morning everything was in working order, and as soon as it was light he iodized a plate and pointed his apparatus—a cardboard box fitted with a spectacle lens—towards the window, and waited patiently for a quarter of an hour. The mercury was vaporized by a candle flame and—as Arago had said—the picture appeared like magic. Though his first success was only an ink-black silhouette of houses, with the balustrade of the window prominently in the foreground, the proud creator of the photograph hastened to show it to Lerebours, whose proper camera he borrowed to try his luck with a view of the Louvre.

"We all felt an extraordinary emotion and unknown sensations which made us madly gay. . . . Everyone wanted to copy the view offered by his window, and

very happy was he who at the first attempt obtained a silhouette of roofs against the sky: he was in ecstasies over the stove-pipes; he did not cease to count the tiles on the roofs and the bricks of the chimneys; he was astonished to see the cement between each brick; in a word, the poorest picture caused him unutterable joy, inasmuch as the process was then new and appeared deservedly marvellous.''[117]

How often did not the photographer say to himself almost in desperation: ''Ah! if only I had left it longer in the camera! Ah! if only I hadn't left it in so long! Without that damned spot, how pretty it would be!'' If it were rare to achieve perfect pictures at first, the difficulty only contributed to the charm and mystery.

Charles Chevalier states that he too hastily constructed iodizing and mercury boxes according to notes he had made at the Institute. His first experiments made jointly with Captain Richoux and Dr Fau were unsuccessful, but on the 21st they obtained a satisfactory result, believed to be the first following publication of the process. Up to that time only Daguerre, Hubert, Arago, and perhaps Isidore Niépce had practised the daguerreotype, but within a few days all the physicists, chemists, and savants of the capital were pointing their cameras at the principal monuments. In most cases their apparatus was home-made, and looked an odd assortment of boxes, for Giroux had not been able to produce in the time available a sufficient quantity to meet the demand—and this despite the fact that his daguerreotype outfits were priced at 400 francs (£16), while each plate cost 3.50 francs (about 2s. 6d.). So great, indeed, was the shortage of cameras that a second-hand camera obscura (for drawing) fetched 575 francs (£23) at an auction!

In his report of the meeting at the Institute, which appeared in L'Artiste on 25 August, Jules Janin (1794–1874) laid great stress on the difficulties accompanying the pleasures of daguerreotyping, stating that either it was an art for the few, or Arago's report was incorrect. Worried by this, Daguerre immediately called on the critic and novelist, whom he found discussing the invention with some friends. ''You are wrong to call it impossible!'' Daguerre reproached him. ''My process certainly needs some care, but I should have thought it well within the comprehension of everyone. You journalists, writers, dreamers—and I like you because you are able writers and have specially helped to popularize my invention—well, you are all naturally clumsy, you have never worked with your hands! Come with me to my flat, and I will show you how to make a good picture, exact, true, and clear, and I swear Raphael himself never made one so beautiful.''

The party thereupon marched off to Daguerre's modest third-floor flat at 17 Boulevard Saint-Martin, opposite the Ambigu-Comique. They were shown into a

simple room decorated with fine engravings and plaster casts, full of bottles, retorts, and other mysterious apparatus.

Daguerre took a silvered copper plate, cleaned it with nitric acid and polished it well with pumice powder and a buffer. He then placed it in a box containing a little dish of iodine, which vaporizes at normal temperature. The room was darkened but not completely blacked out, so that it was possible to check the progress of the iodizing. After about a quarter of an hour the plate had attained the correct golden colour, being covered with a microscopically thin layer of light-sensitive iodide of silver. It was put into a dark-slide and inserted into the camera, which had already been focused on a view out of the window. The "doors" of the dark-slide were opened and an exposure of 6 minutes given. The plate bearing the latent image was then placed in the mercury box at an angle of 45° and the mercury in the container at the bottom heated by a spirit-lamp underneath. When the thermometer on the box showed 60° C. (140° F.) the lamp was withdrawn but the exposure to mercury vapour continued until the temperature had fallen to 45° C. Through a window in the box the spectators were able occasionally, by the light of a taper, to get a glimpse of the formation of the image caused by fine mercury globules settling on the plate. After about 20 minutes the development was complete: Daguerre took the plate out and held it up for all to admire. "The view looks as if it had been drawn by the brush of the fairy queen Mab", commented Janin. The mercury had settled on all the parts which had been affected by light, forming the lights of the picture. The unchanged iodide was now dissolved by washing the plate with a solution of hyposulphite of soda to make the image permanent,* leaving the bare silver forming the dark parts of the picture. After a final rinse in hot distilled water the plate was carefully dried over a flame. Immediately afterwards it was framed under glass, for the mercury adhered only lightly to the plate and could easily be rubbed off or scratched through carelessness.

The experiment having been completed to the satisfaction of all present, Janin expressed regret that Daguerre had not demonstrated the manipulation on 19 August, for it was evident now that a demonstration of this kind would have convinced the public that daguerreotyping was not such a complicated procedure as Arago's learned theorizing about too much or too little iodine, or mercury, hypo, shade, or sunshine, had made it appear.[118] Realizing the need for practical instruction, Daguerre arranged with Duchâtel to give for a few weeks free public demonstrations at the Ministry of the Interior every Wednesday and Saturday, while on Tuesdays he gave free advice from eleven to three at the Conservatoire des Arts et

* Up to 14 March 1839, when Sir John Herschel communicated this fixing salt to the Royal Society, Daguerre had used common salt, which is less effective.

Métiers "to all willing to bring their attempts. I hope that by this means one will before long see no more bad pictures giving a poor idea of my process."[119]

The first of this series of public demonstrations took place on 7 September in a room at the Ministry of the Interior on the Quai d'Orsay before an audience of about 120, including several distinguished writers, artists, and scientists. After explaining the purpose of the different parts of the apparatus, Daguerre placed the camera on the balcony of the room, and looking at the sky, explained that an exposure of twenty minutes was necessary. The audience watched every step of the demonstration eagerly, and expressed their great admiration when after an hour and a half the picture was handed round to enable everyone to compare it with the actual view. Daguerre assured them that on a country outing it would only be necessary to take the camera for the plates could be sensitized up to four hours beforehand and the mercury development could be postponed until after the excursion.[120]

One of the greatest difficulties was to judge the exposure, which varied enormously, as can be seen from Daguerre's two demonstrations just described. Even the following table by Hubert published posthumously in June 1840—the first exposure table in Europe—is only a rough guide.[121]

Full sunshine	in summer	in winter
White objects	$4\frac{1}{2}$, 5, 6 mins.	8, 9, 10 mins.
Coloured objects	8, 9, 10, 11 mins.	12, 15, and 17 mins.
Diffuse light		
White objects	12, 15, 18 mins.	25, 30, 40 mins.
Coloured objects	20, 25, 30 mins.	40, 50, 60 mins., and this last is often not sufficient.

Despite all his efforts to prove the contrary, rumours of difficulty persisted for a while. Opening his *Charivari* three days after his first public demonstration Daguerre was hurt to see an unkind journalist was poking fun at the amount of paraphernalia necessary to take a picture, and claiming that it required the assistance of two mechanics, three chemists, and four assorted scientists, as well as the presence of the inventor, to get a result.[122] Several early caricatures made fun of the long exposures. One was rudely captioned "Patience is the virtue of asses" (Plate 86). Another showed a "Daguerréopipeur" having a nap during the exposure, for, as the title explained, "Le talent vient en dormant" (Plate 87). Photography proved a happy hunting-ground for Daumier and other caricaturists until they and the public got used to the novelty, for perhaps no other invention ever captured the imagination of the public to such a degree and conquered the world with such lightning rapidity

as the daguerreotype. In Vienna a "Daguerre-Waltzer" became the rage for a time. In Barcelona a large crowd gathered on 10 November 1839 in the Plaza de la Constitucion, where bands played and flags were flying, to witness the taking of the first daguerreotype, under the auspices of the Academy of Sciences. The picture taken by Don Ramon Alabern was then disposed of by lottery.

A leading German cultural magazine *Europa: Chronik der Gebildeten Welt* (Stuttgart, 1839) published a poem entitled

Daguerre's Lichtbilder	*Daguerre's Light-Pictures*
Alles dient des Geistes Stärke,	Everything serves the power of the mind,
Sage, was verborgen bleibt	Tell me what remains hidden from him
Ihm, der diese Wunderwerke	Who writes these marvellous works
Mit dem Strahl der Sonne schreibt?	With the sun's rays?

In London a comic song by "Phaeton" dedicated to "L. J. M. Daguerre Esquire of Photogenic Celebrity" became a hit.

O Mister Daguerre! Sure you're not aware
Of half the impressions you're making,
By the sun's potent rays you'll set Thames in a blaze,
While the National Gallery's breaking.

O Mister Daguerre (&c.)

The unmarried now who dwell in "the Row"
Their suspicions and fears will be hinting,
That the *type* will be done by themselves and a *sun*
Who will claim half the profits of printing.

O Mister Daguerre (&c.)

The new Police Act will *take down* each fact
That occurs in its wide jurisdiction
And each beggar and thief in the boldest relief
Will be *giving a color* to fiction.

O Mister Daguerre (&c.)

Men's heads will be *done* by a "stroke of the sun"
And I fear by these facts you'll be stagger'd,

But it's truth on my word, that without *steel* or *sword*
By *copper* and *silver* you're *Dagger'd*.

O Mister Daguerre (&c.)

All Paris was seized with "daguerreotypomania", so amusingly derided by Théodore Maurisset (Plate 110) in December 1839. The caricature shows a crowd of people pushing into the enterprising establishment of Susse Frères, attracted by an enormous advertisement to buy daguerreotypes for New Year's gifts. Over the entrance large notices proclaim that "Non-inverted pictures can be taken in 13 minutes without sunshine."* While one photographer is just aiming his camera up the skirts of a tight-rope dancer on the left, another tries to take the portrait of a child whose mother and nannie do their best to keep his struggles in check. Baron Séguier, inventor of the portable apparatus for travellers (see page 113), passes by, his boxes tucked under his arm. Their contents are displayed in the right foreground, where Dr Donné (who attempted the first portrait) holds a sitter imprisoned in a posing-chair as if he were in the stocks, calmly counting the minutes while his victim endures the torture. Above this pleasant open-air studio, daguerreotypes are etched according to Donné's system (see page 110). A procession of daguerreotypomaniacs, carrying a banner with the inscription "Down with the aquatint" passes the gallows, where a few engravers deprived of their livelihood have already hanged themselves, while other gallows are still to be let. Nearby, a group of revellers drunk with enjoyment dance to music round a mercury-box as if it were the Golden Calf. Train- and ship-loads of cameras are being exported, and daguerreotypomaniacs have good reason for holding a public meeting to worship the invention: has not competition by rival firms (to Giroux's) already reduced the price of apparatus to 300, 250 and even 200 francs? The sun smiles benignly down on his creation. Surveying the things that had come to pass during the last few months, Maurisset adds a touch of prophecy: a photographer recording the scene from a balloon with a basket in the form of a camera—as are the railway carriages and the clock-tower surmounting the Maison Susse Frères.

The first edition of Daguerre's Manual published by Giroux and entitled *Historique et Description des Procédés du Daguerréotype et du Diorama* (facing p. 97) appearing on or about 20 August was quickly sold out. Published by order of the Government, it contained a reprint of the various parliamentary speeches by Duchâtel, Arago, and

* On 11 November 1839 Cauche exhibited to the Académie des Sciences a prism lens by means of which the image was not laterally transposed, thus overcoming one of the initial drawbacks of the daguerreotype.

Gay-Lussac; a history of the invention; Nicéphore Niépce's description of helio-graphy and Daguerre's improvements on it; manipulatory details of the daguerreo-type process; and an account of the method of dioramic painting completely ignoring Bouton's claim as co-inventor and Sébron's part in double-effect painting. Editions by other publishers followed in quick succession, some identical in content, others restricted to the practical instructions in the manipulation. Simultaneously a large number of foreign editions made their appearance, three of them printed in Paris for sale abroad. Altogether no fewer than thirty-two editions were published during 1839 and 1840 in eight languages: French, English, German, Spanish, Swedish, Italian, Hungarian, and Polish (see appendix). A more convincing proof of the rapid spread of the daguerreotype in Europe and America could not be imagined. Indeed, we know of no discovery or invention that created so much sensation.

Daguerre had added some critical footnotes in the manual to Niépce's descrip-tion of heliography, depreciating his dead partner's invention; this enraged Isidore, who wrote to his mother on 8 September:

"Daguerre has just published a brochure containing (1) father's process, (2) the modifications made to it, (3) his process, and finally that of the Diorama. Some days ago we had a lively quarrel in this respect; I completely floored him! And like all men lacking integrity, he changed suddenly, and from being arrogant and furious, as he had been while he saw me calm, he became supple and insinua-ting when he saw the indignation into which his past and present conduct had thrown me. But I admit that I did not know how to profit by my victory; we parted on apparently friendly terms. And now the brochure, to which he has made notes and, unknown to me, reprinted some of father's letters and mine, has just appeared! It gives me a proof of his knavery, his ingratitude, and his desire to disparage father's fame. I shall have to publish an article to make his conduct known and to remove the unfavourable impression which his critical notes on father's invention have produced."[123]

"Post tenebras lux" was the motto on the title-page of Isidore's brochure *Historique de la Découverte improprement nommée Daguerréotype, précédée d'une notice sur son véritable inventeur feu M. Joseph-Nicéphore Niépce*, but the light came slowly, for it was not until August 1841 that the booklet appeared.

"The admiration aroused by M. Daguerre's first results, the halo of glory with which he was benevolently crowned, the premature homage rendered to a man whose pride and vanity was thus exalted, infuriated many honorable people who, for many years acquainted with the researches of M. J.-N. Niépce, wanted to unmask the machiavellism which took away from a co-citizen, a friend, a

parent, the honour which he had acquired during twenty years of laborious and assiduous research. . . .

The footnotes on heliography were inspired by M. Daguerre's excessive conceit and dictated by the bitterness of jealousy! By this criticism he intended to disparage the achievement of the first inventor, and to add, by this iniquitous method, to the glory which he claimed for himself. Shame to the man who, trampling on all feelings of honour and delicacy, has used such hideous methods to enhance his merit! Shame to Daguerre, who without respect for the ashes of a man 'whose memory is so dear to him', dares to place a sacrilegious hand on the works by whose aid he has acquired so much celebrity.''

It had taken a long time to rouse the meek Isidore to such an outburst of indignation, though the immediate effect was nil (Daguerre disdained to reply), because this polemical brochure seemed to the prejudiced public to be inspired by the very same defects of character which Niépce ascribed to Daguerre. Later generations have taken a different view, for from the moment of the publication of Nicéphore Niépce's correspondence in 1867 [124] Daguerre could no longer stand alone as the inventor of photography. Indeed, in the authors' opinion Nicéphore Niépce is the discoverer of photography (1826) and Daguerre the inventor of the first practicable process (1837).

Directly after the publication of the daguerreotype, Daguerre sent specimen pictures to King Ludwig I of Bavaria, the Emperor Ferdinand I of Austria, the Emperor Nicholas I of Russia, and King Frederick William III of Prussia. King Louis-Philippe, who promoted Daguerre from Chevalier to Officer of the Legion of Honour in June or July, was no doubt recipient of a specimen at an earlier date. Prince Metternich, Arago, and Alphonse de Cailleux were also presented with specimen pictures. All these were inscribed by the inventor on the verso "Épreuve ayant servi à constater la découverte du Daguerréotype, offerte à . . .". Those to royalties were signed "par son très humble et très obéissant serviteur Daguerre"; those to Arago and de Cailleux "par son très devoué serviteur Daguerre". In return Daguerre received various princely gifts such as diamond-encrusted snuff-boxes and gold medals, but some of the honours conferred on him showed obviously a deeper appreciation: the Prussian "Pour le Mérite" (1843), the honorary membership of the Society of Arts, Edinburgh (July 1839) and of the Academies of Munich (November 1839) and Vienna (1843). Contrary to expectation, neither the Académie des Sciences nor des Beaux-Arts conferred any honours on their fellow-countryman. Nor was Daguerre ever elected an honorary Fellow of the Royal Society of London as was falsely reported by some French and German newspapers in August 1839—possibly as a hint to other academies to follow suit.

Wishing to profit from the obvious advantages of the daguerreotype for book illustration, and for views to be sold separately, several publishers immediately set to work. The only means of publication was, of course, to copy daguerreotypes as lithographs or engravings, but at least the public could be promised truthful representations of architecture, sculpture, and landscapes—three branches in which the daguerreotype was perfect as it came from the inventor. Daguerreotypes were a great contrast to the romantic views published during the previous decades, when there was a craze for embellishing, exaggerating heights, and extending spaces, so that it would have been difficult for a visitor to recognize the view drawn, which sometimes the artist had not even seen himself, but copied, with "improvements", from an earlier source.

The most enterprising of the early publishers of photographic views was N.P. Lerebours, the optical instrument maker, who equipped a number of artists and writers with daguerreotype outfits of his own manufacture (similar to Giroux's) and commissioned them to take views in France, Italy, Spain, Greece, Corsica, Egypt, Nubia, Palestine, and Syria. Lerebours also received for his publication views from individual daguerreotypists in London, Bremen, Stockholm, Moscow, Geneva, Algeria, and of the Niagara Falls. The historical painter Horace Vernet (1789–1863) left Paris for Egypt on 19 October 1839 in order to daguerreotype scenes for his planned painting of the Battle of Nezib, and at the same time to take views for Lerebours, who supplied him with the apparatus and a darkroom tent. Vernet, who was accompanied by Frédéric Goupil Fesquet, wrote from Alexandria on 6 November: "We keep daguerreotyping away like lions, and from Cairo hope to send home an interesting batch—for here there is little to sketch. Tomorrow we are to make experiments with the instrument before the Pasha, who earnestly desires to appreciate for himself the results of a discovery known to him as yet only by description."[125] Goupil Fesquet reported an exposure of two minutes in Alexandria on 7 November, whereas the Pyramids required fifteen to twenty minutes on the 20th. By 15 December Lerebours had for sale at his establishment in the Place du Pont-Neuf the first daguerreotypes taken to his order in Italy and Corsica.

The first series, of sixty views, contained only eight French subjects because—explained Lerebours chauvinistically—"we wished to try our art on the master-pieces possessed by foreign nations, and were desirous of reserving the greater degree of perfection for those of our country." The second series, of fifty-one views, completed in October 1843, consisted chiefly of French landscapes and architecture. Altogether 110 out of a total of 1,200 daguerreotypes taken were published as copperplate engravings under the title Excursions Daguerriennes (1841–43) (Plate 50) (see appendix). There was also one picture not from a daguerreotype—Longwood,

Napoleon's house at St Helena, where the weather was too bad for photographing, and the artist had recourse to the pencil.*

Among the authors contributing to the text were Charles Nodier and Baron Taylor, two of the editors of *Voyages pittoresques*, who, in spite of the many advantages photography offered, continued to commission artists to make drawings for their publication, which was carried on until 1877 without ever having used a photograph—and this in the country where photography was invented!

Two of the plates in the second series of *Excursions Daguerriennes* were printed direct from actual etched daguerreotypes by Fizeau's process. (Plate 57.)

Daguerre did not approve of converting his novel pictures into the older art of engraving. Moreover, he did not believe that they could be etched satisfactorily, and was quite annoyed when Dr Alfred Donné (1801–78) on 23 September 1839 laid before the Académie des Sciences an etched daguerreotype plate and paper prints from it. "Scarcely a month has passed since my process was made known, and already, on all sides, people claim to have extended its boundaries by finding the means of multiplying its results by engraving and other means not yet determined. I feel, therefore, obliged to address myself to you [Arago] today, in order to protest against these supposed innovations, the object and means of which have been strangely exaggerated."[126] It seems that Daguerre resented the idea that anyone but himself should improve the daguerreotype, but in spite of this protest experiments with etching continued.

A similar process to Donné's was devised by Dr Joseph Berres (1796–1844) of Vienna in 1840, but both techniques had the fault that the engraved plate was weak, yielding only a few impressions. Donné could pull forty prints. Berres achieved 200, and his brochure *Phototyp nach der Erfindung des Prof. Berres in Wien* (1840), illustrated with five plates, in an edition of 200, was the first publication with photomechanically produced illustrations. By the autumn of 1841 Berres was able to print 500 copies from an etched daguerreotype, which, however, had to be of solid silver: silver-plated copper would not yield so many impressions. In 1842 the French physicist Hippolyte Fizeau (1819–96) perfected his method of etching daguerreotypes by depositing chloride of gold on the highlights, which enabled the plate to bear repeated etching in the dark parts (the bare silver). Strengthening the printing plate with a deposit of copper enabled him to pull at least ten times as many impressions as Berres, for when the copper deposit had worn off, the plate could be electrotyped again. Fizeau's prints show excellent half-tone, which was supplemented by aquatint grain when necessary. From the fact, however, that only two of his etched

* This fact is explained in a loosely inserted publisher's notice, missing in most copies, to which our attention was drawn by Beaumont Newhall.

daguerreotypes were used in *Excursions Daguerriennes* it seems probable that the constant renewal of the plate was troublesome and expensive. Nevertheless Fizeau's results were the most successful of the early photo-etching methods, and the process in its final form was patented in England by A. Claudet in November 1843.

Some of the finest architectural and landscape views of the early period were taken by a French amateur, Joseph-Philibert Girault de Prangey (1804–92), whose work remained entirely unknown until recently. De Prangey was an expert on Arabian architecture. Engravings of his sketches made in 1832–33 of the Alhambra in Granada, in Dibujo and other places in Southern Spain are exhibited in the Casa de los Tiros, Granada. In 1842 de Prangey undertook a long and arduous journey through Italy, Egypt, Syria, Palestine, and Greece, arriving home two years later with about a thousand fine daguerreotypes. Some of the close-ups—as far as we know the first ever taken—formed the basis of the illustrations in his book *Monuments arabes d'Égypte, de Syrie et d'Asie Mineure*, Paris, 1846. By the courtesy of the late comte de Simony the authors were afforded an opportunity to see the entire *opus*, which strangely enough has survived although the daguerreotypes were not glazed but still standing in their original plate boxes into which Girault de Prangey had placed them over 100 years ago. Those illustrated here for the first time (Plates 43–48, 51, 52) are among the best which the authors were enabled to acquire for their collection.

Théophile Gautier (1811–72) took a daguerreotype outfit on a trip to sunny Spain in 1840. But judging from his book *Voyage en Espagne*, frequent rain made it impossible to take many pictures, though a good view of Burgos Cathedral is mentioned.

The free publication of the daguerreotype—as Gay-Lussac forecast—brought about rapid improvements. As it came from the inventor, the daguerreotype had certain disadvantages, most of which were overcome by French, American, Austrian, and English experimenters in the course of the next twenty-two months.

(1) The daguerreotype was too slow for portraiture. This important application was achieved by (i) reduction in the size of the picture, and hence shortening the focal length of the lens; (ii) improving the optical side by (a) constructing double achromats of greater aperture—an improvement which was undertaken almost simultaneously by Chevalier and Petzval, (b) by the use of a concave mirror to reflect the object, instead of passing the light through a lens (Wolcott's mirror camera); (iii) by chemical acceleration with bromine or chlorine vapours, an advance due to John Goddard, Natterer, Kratochwila, and Claudet.

(2) Being a direct positive, the image was laterally reversed—a fault which could

be remedied, at the expense of increased exposure, by using a reversing prism in front of the lens—a device recommended by both Cauche and Chevalier.

(3) The equipment was too bulky and expensive. This state of affairs was soon changed by a number of scientific instrument makers in Paris, who constructed smaller apparatus. Competition naturally resulted in considerable price reductions: by November 1839 Lerebours was able to advertise Daguerre's apparatus (an imitation) for 260 francs.

(4) The mercury adhering only lightly to the plate, the picture was easily damaged —a difficulty which was overcome by toning the image, after fixing, with chloride of gold. This improvement, due to Hippolyte Fizeau, protected the plate from abrasion, and also helped to prevent oxidation of the silver.

(5) Each daguerreotype was a unique picture. Successful etching processes were devised to convert daguerreotypes into printing plates, but proved too complicated for widespread use.

(6) One final drawback which remained inherent in the process was the difficulty of seeing the image, on account of the glare from the polished silver, unless held at a certain angle.

Disadvantages of the Daguerre-Giroux outfit were its bulk, high price, and the slowness of the lens. The wooden camera consisted of two boxes, the rear one with the ground-glass sliding within the front box containing the lens. Made for taking wholeplate-size pictures—16·4 cm. × 21·6 cm. (6½ in. × 8½ in.)—its external dimensions were 31 cm. × 37 cm. × 26·5 cm. (12¼ in. × 14½ in. × 10½ in.), increasing to 51 cm. (20 in.) when fully extended. By means of a mirror fixed at 45° behind the ground-glass the operator could conveniently see the image right way up. The complete equipment included a plate box, an iodizing box, a mercury box and spirit lamp, various bottles of chemicals, buffers and powders for polishing the plates, plate-racks, etc. The whole paraphernalia weighed 50 kg. (110 lb.)— "a frightening apparatus for the amateur, a veritable storehouse" was Chevalier's opinion. "What artist would ever decide to burden himself with such complicated and heavy equipment?"

The early Giroux cameras were fitted with the old achromatic meniscus lens* (Wollaston type) which constituted the "great improvement" to the camera which Daguerre had given Niépce under their partnership agreement of December 1829. The lens, which had a focal length of 38 cm. (15 in.) was contained in a brass

* As Chevalier could not produce a sufficient number of lenses in the short time available, some of the Giroux cameras were fitted with lenses by Lerebours and others. These lenses are of the plano-convex type, with a focal length of 16 in. and a diameter of about 3¼ in., the effective aperture being reduced to F. 17 by a fixed $\frac{15}{16}$ in. stop.

mount, with a simple brass disk acting as shutter. Though its diameter was 8·1 cm. (3¼ in.), its effective aperture was reduced to F.14 by a 2·7 cm. (1⅛ in.) stop fixed inside the lens tube to give increased sharpness to the image. The focal length was longer than necessary for the plate size, and this factor, combined with the small lens opening, was the cause of the very long exposures. Chevalier was fully aware of these defects, but considered himself only the manufacturer and not the designer of the lens, which he had constructed according to Daguerre's requirements. He couldn't see the sense of having a big and expensive lens and then reducing its effectiveness by such a small aperture. After the publication of the daguerreotype Chevalier immediately started to design a more suitable lens—a double achromat, the prototype of which he showed to the Société d'Encouragement pour l'Industrie nationale in 1840. The double achromat could be used with slight modifications for both landscapes and portraiture, was more rapid, and covered a wider field than the old meniscus lens. The rear component, consisting of a double-convex and a double-concave lens cemented together, had a diameter of 8 cm. The front component, having a diameter of 6·5 cm., consisted of a convex-concave lens cemented to a double-convex lens. For portraiture, the front lens was inserted in a longer lens-tube without a diaphragm, the slight softness ensuing from this arrangement being outweighed by the greater rapidity. Having improved the objective, Chevalier set to work to lessen the burden of the photographer. He constructed a wooden folding camera called "Le Photographe", in which the long sides were made collapsible (after the lens-board and ground-glass had been removed) by being divided horizontally along the middle, and hinged. The entire equipment was packed into a wooden travelling box measuring 50 cm. × 28 cm. × 21 cm. (19¾ in. × 11 in. × 8¼ in.). The original 1840 "Photographe" was wholeplate size, but during 1841 Chevalier introduced halfplate and quarterplate models of the ordinary rigid-box form, but of much finer craftsmanship than Giroux's. When a mirror prism was fixed in front of the lens, the image was received the right way round—a further improvement which Chevalier introduced in July 1841. With the quarterplate "Photographe" (for 8·2 cm. × 10·8 cm. plates) portraits could be taken in two minutes—and this was before the introduction of chemical acceleration.

In the construction of a convenient travelling outfit Chevalier had been anticipated by an amateur, Baron Pierre-Armand Séguier (1803–76), who showed his equipment to the Academy in November 1839. Contained in a wooden box, the whole outfit weighed 35 continental pounds and occupied only one-third of the volume of Daguerre's apparatus, though taking pictures the same size. The following month Séguier suggested a bellows camera for increased portability, unaware—like everyone else—that this type had been invented by Nicéphore Niépce. Séguier was

the first, however, to introduce the photographic tripod,* the ball-and-socket head, and the darkroom tent.[127] Séguier's apparatus was manufactured and sold by Lerebours and cost between 290 and 380 francs, according to the quality of the lens supplied.

The universal wish to have daguerreotype portraits can be well understood. Long before the invention of photography there was a great desire among the middle class for cheap portraiture. For centuries good portraits were the privilege of the aristocracy and the more prosperous upper bourgeoisie who could afford the fees of a good miniature painter or even a portrait in oils by an established artist.

The pioneer of cheap portraiture was the silhouette; and since it could be semi-mechanically produced, demanded a sitting of only a few minutes, and could be easily copied, the silhouette may be regarded as an ancestor of the photographic portrait by which it was superseded.

Black profile portraits were well established by the time they were nicknamed "silhouette" after Etienne de Silhouette (1709–67), whose drastic economies when Controller-General of the public finance department of Louis XV caused wits to call "silhouette" anything which was cheap and skimpy. Silhouette himself made these pictures as a pastime in retirement at Bry-sur-Marne, where incidentally he is buried in the village cemetery not far from Daguerre.

The first silhouette portraits or "shades" of which there is a definite record were made of William and Mary, by a Mrs Pyburg in 1699, but they became fashionable only in the second half of the eighteenth century.

Silhouettes were painted on card, glass, ivory, plaster, etc., in which case they were in the nature of a profile miniature portrait filled in with black (Plate 24a); or they were cut out of black paper freehand, and pasted on a white, or occasionally coloured, background, or the whole head could be cut out of white paper and mounted on black. As time went on they were elaborated by touching up with gold or even with colours. There is no chronological order of the various processes, and sometimes the same artist worked in several media.

For people who could not draw, a simple method was devised. The sitter was posed in a special chair to support the head and whole body. The shadow of the head, cast by the light of a wax candle, was received on an oiled-paper screen behind clear glass, fixed on one side of the posing-chair (Plate 24). The artist sat behind the screen, the frame of which had a moveable arm-rest to steady his hand. The life-size outline of the shadow which he traced was then usually reduced to a small size by using a pantograph or "parallelogrammum delineatorum" invented early in the seventeenth century by Christopher Scheiner.

* The Giroux camera was placed on some kind of solid stand, not supplied with the outfit.

Mrs Edward Beetham, a professional silhouettist (or "profilist" as they were called) active in 1785 in Fleet Street, avoided the necessity for pantographic reduction by using a camera obscura with which she could draw the sitter's profile in a small size and then fill it in with black.

Additional copies could easily be made from the original "shade" either by the pantograph or the printing method described in 1780 by Philip Heinrich Perrenon. The silhouette was laid on a piece of tin which was cut out, coated with a black mixture of linseed oil and pine-soot, and printed with a simple press like a rolling-pin. The "Limomachia", a patent machine "for taking likenesses by which the usual objections to the art, viz. time, trouble, and expense, are entirely removed", was used by Raphael Pinion, "portrait grinder", at his "manufactury" in Leicester Square, London. C. Schmalcalder also patented a profile machine in London, in 1806. It was "for cutting out profiles on copper, brass, hardwood, card, paper, ivory, and glass".

Johann Kaspar Lavater (1741–1801), the famous physiognomist, believed that the silhouette, although the least finished form of portraiture, was the most truthful and revealing of character, and consequently he used about 150 silhouettes among the illustrations in his monumental work *Physiognomische Fragmente* (Zürich, 1775–76). Lavater recommended the shadow-tracing method described above, but mentioned that a more powerful light source than a candle—a solar microscope or a megascope—would be preferable. It is the megascope which Prof. Charles of Paris is supposed to have employed in his demonstrations (see page 48, footnote).

Lavater's work created an enormous interest in both physiognomy and the silhouette, and for a time there was an absolute craze for these portraits which required no knowledge of drawing. Anyone could make silhouettes by the shadow-tracing method, and people collected and exchanged them with friends as they did carte-de-visite photographs eighty years later. They fancied themselves students of physiognomy, and used to send Lavater their own and their friends' silhouettes for a character-study, just as some people nowadays send specimens of handwriting to a graphologist.

While the silhouette was at its zenith, a still better process for executing mechanically and rapidly small and cheap portraits was introduced in France—the physionotrace (Plate 27). The instrument was a wooden framework about 1 m. 75 cm. high, containing a vertical pantograph and a reticulated "sight" to keep the operator's eye always in the same position relative to the sitter, who was posed in profile behind the apparatus. When the artist moved the pointer over the outlines of the face, the pencil at the other end of the pantograph drew these outlines on paper in nearly natural size. By a second pantograph operation the portrait was reduced to 5–7 cm. in diameter, and was then engraved in the usual way. (Plate

23.) Gilles-Louis Chrétien (1754–1811), a violoncellist in the royal orchestra at Versailles, exhibited his physionotrace machine to the Académie des Sciences in 1786. The novelty lay in its application to small portraits, and their multiplication by subsequent engraving, rather than in the instrument itself, which appears to have been adapted from Benjamin Martin's "Perspective Table" published in London in 1770. This apparatus, however, Martin himself attributed to Sir Christopher Wren.

Chrétien's partner Edme Quenedey (1756–1830), a professional artist, opened a physionotrace studio at the Palais Royal in June or July 1788. He made the original drawings and the reductions, which were engraved by Chrétien at Versailles. The original sketch, costing 6 livres (= francs) could be made in four minutes, and for another 15 livres a dozen prints were supplied within four days. The sitter could for a further 24 livres buy the plate, from which 2000 prints could be pulled.

By August 1789 Quenedey had learned enough about engraving to make himself independent. Chrétien took a new artist partner, Fouquet, and later Fournier, and worked near the Louvre until his death. One hundred physionotraces by Fouquet and Chrétien were shown at the Salon of 1793, and 600 two years later. Mme de Staël, Thomas Jefferson, Kosciusko, Louis XVIII, and many other celebrities sat to Quenedey, who sold their portraits at his shop. Though the fashion for the physiono-trace lasted longest in Paris, it was not confined to that city; Quenedey also intro-duced it into Brussels and Hamburg, and it was practised by a French émigré, Charles Balthazar Julien Fevet de Saint-Mémin (1770–1852), during his exile in the United States from 1793–1844, working in New York, Philadelphia, Washington and Baltimore.

The third and last invention preceding photographic portraiture was neither exclusively employed for portraits nor was its use as widespread. But since the camera lucida invented by W. H. Wollaston in 1807 was an optical instru-ment aiding the portrait-artist—and no less a man than Sir Francis Chantrey, R.A., the sculptor, made extensive use of it (Plate 25)—it may well have a place in this discussion of the forerunners of photographic portraiture. Unlike the camera obscura, with which this instrument is often confused by the layman because of its name (a complete misnomer), the camera lucida was not a camera at all. It was a small prism through which the artist saw a virtual image on his paper (Plate 28), which facilitated the delineation of the portrait, or view. It demanded a certain amount of skill in drawing. The use of the camera lucida was chiefly propagated through Capt. Basil Hall's book *Travels in North America* (1829), illustrated with sketches made with the camera lucida. The leading maker of the instrument was Chevalier of Paris.

Attempts at photographic portraiture had been going on since September 1839. The earliest portrait in Europe which can be documented was shown by Dr Alfred Donné on 14 October 1839 to the Académie des Sciences when presenting his

etching process.[128] According to a German newspaper[129] this portrait of a lady left much to be desired, for she had to keep her eyes shut on account of the bright sun-shine, which made her look asleep or blind. Her face was powdered white, this colour acting more quickly on the plate than flesh tones. François Gouraud states in his instruction manual published in Boston, April 1840, that shortly before he left Paris (that is, about the end of October 1839) for the United States, Abel Rendu, an employee at the Ministry of Public Instruction, succeeded in taking portraits in which the sitter's eyes appeared open, in 1 min. to 2 mins. 27 secs., by means of the old Wollaston meniscus lens, which greatly shortened the exposure—no doubt because it was used without a stop—compared with Chevalier's and Lerebours' lenses, but was only sharp in the centre of the picture. "As M. Rendu did not attach any great importance to a discovery which did not offer the positively mathematical perfection which M. Daguerre required, he did not wish to make the thing an affair of reputation." Gouraud does not state the size of the portraits, but presumably they were small.

"The first portrait that I have seen was exhibited at M. Susse's, Passage des Panoramas", wrote Gaudin. "The human image was very dark compared with that of a plaster cast which figured on the same plate; the sitter had contracted features and a grimace expressing suffering. Nevertheless, the patient's eyes were half open, and he had at least kept still."[130] Lerebours and Susse's edition of Daguerre's Manual published in November 1839 contains probably the earliest instructions on portraiture to be published:

"To make a portrait, it is necessary to have recourse to a bright light; and this precaution is all the more necessary when the subject's complexion is high-coloured, for red is, so to speak, the equivalent of black.* One can only succeed well by exposing the person to the sun in the open air, with reflections from white draperies.

If, as indicated by M. Arago [actually Daguerre], one places a large square of blue glass in front of the sitter, this will avoid fatigue which would inevitably cause blinking, and as the blue rays act in the most energetic manner, the opera-tion will not be any slower."

During 1840 it was still necessary to pose for several minutes in sunshine —a very long time to keep motionless—and the ferocious expression of the few intrepid people who submitted themselves to such experiments bore witness to their resolution and ordeal. Little wonder that sitters should strongly resent these ghastly daguerreotype productions, but photographers thought the sitters unreasonable. Often they are, yet in this case one must feel sympathy for them.

* The sensitive coating of the daguerreotype was colour-blind.

"The most terrible enemy which the daguerreotype has to combat is, without contradiction, human vanity. When a portrait is painted, the flattering hand of the artist knows how to soften the irregular features of the face, to make graceful a stiff pose, and to give an effect of grace and dignity to the whole. Therein lies the talent of the portrait painter; one expects a likeness, but above all one wants to look beautiful—two demands which are often incompatible.

It is not thus with the photographic artist: unable to correct the imperfections of nature, his portraits unfortunately often have the fault of portraying the sitter too truthfully; they are in a way *permanent mirrors* where vanity does not always find what it wants."[131]

> Peu flatteur par principe,
> Aimant la vérité,
> Le daguerréotype
> Enlaidit la beauté.

In the early days of daguerreotype portraiture Queen Victoria asked Alfred Chalon, the fashionable miniature painter, whether he were not afraid that photography would ruin his profession. "Ah, non, Madame," he replied in a mixture of French and English, "photographie can't flattère."[132]

Since it proved impossible to take portraits with wholeplate apparatus, Lerebours and Buron introduced quarterplate cameras designed specially for portraiture and fitted with single or double achromatic plano-convex lenses of very short focus. With Lerebours' apparatus introduced in May 1840 at a price of only 75 francs, portraits could be taken in two minutes. Early in July 1841 Buron had a quarterplate camera on sale measuring only 15 cm. × 17 cm. × 30 cm. (6 in. × $6\frac{3}{4}$ in. × $11\frac{3}{4}$ in.), and so designed that all the equipment fitted into the camera box, the total weight being only 3·8 kg. (about 8 lb. 6 oz.). Two lenses could be used with this camera: one of 20 cm. focal length for landscapes, and one of 8 cm. focal length for portraits on one-eighth plates.* The sitter was posed quite close to the camera (about 20 in. to 2 yards), his head fixed in a head-rest (which by the way was not a photographic device but was used by Sir Thomas Lawrence and other portrait painters). Owing to the short focal length of the lens, the parts nearest the camera—nose and hands—were often distorted. The exposure was 1 minute in full sunshine, or 2 to 3 minutes if the sky was covered with white clouds.

In January 1841 the world again heard some astonishing news from Paris:

* A half-length portrait of a man, measuring $\frac{1}{2}$ × 1 in., is exhibited at the Conservatoire des Arts et Métiers, Paris. It must be one of the earliest daguerreotype portraits, though the museum authorities are unaware of this fact.

Daguerre had made photography instantaneous, he had conquered movement. Arago himself had announced it to the Academy on 4 January, so it must be true. Daguerre had devised a new method which would enable one to photograph in one or two seconds moving objects such as trees agitated by the wind, running water, a tempest at sea, sailing ships, the movements of crowds, etc. Duchâtel, hoping to hear more about it, invited Daguerre to come and see him.

"An indisposition which obliges me to keep to my room prevents my accepting your kind invitation", was Daguerre's reply.

"I shall soon have the honour of seeing you and informing you of the improvement which I have just made to my process. I asked M. Arago to communicate it to the Academy only in order to establish the date; for although the principle of this new discovery is certain, the details of it have not yet been sufficiently worked out for me to be able to make it public.

You have given such powerful support to the publication of my process that I should be very ungrateful if I did not put you first *au courant* with all the improvements which I might make to it.

Please give my respects to Madame la Comtesse Duchâtel, and accept the expression of my most sincere gratitude.

Your very humble and obedient servant,

DAGUERRE."133

Bry sur Marne
8 *January* 1841.

Robert Hunt, F.R.S., one of the fathers of photography in England, received a no less evasive reply to his enquiry.

"SIR,

I have received your very amiable letter & I wish I could give you an answer more suitable to your wishes & to my desire of being either agreeable or useful to you. But though the principle of my new discovery is certain, I am determined not to publish it before I have succeeded in making the execution of it as easy to every body as it is to myself. I have announced it immediately at the Royal Academy of Paris merely to take date & to ascertain my rights to the priority of the invention. By means of that new process it shall be possible to fix the image of objects in motion such as public ceremonies, market places covered with people, battles, &c. The effect being instantaneous.

I sincerely regreet [sic] to be unable for the present to give you any more

precise information & I hope for another opportunity of being of some service to you.

I am, Sir, very respectfully your obedient S^t.,

<div align="right">DAGUERRE."*</div>

Paris the 19th of February,
 1841.

King Louis-Philippe, hoping that Daguerre would at long last be able to take his portrait by the marvellous new process, appointed 6 March at eleven o'clock for a sitting. It was a fine day and Louis-Philippe was posed in the garden of the Tuileries. "His Majesty sat with his face turned towards the sun, wearing black with a white cravat, and no hat. The operation lasted five minutes."[134] "The result was disastrous."[135] As the portrait turned out a failure, Daguerre never referred to the episode. The new process was obviously not so successful as the public had been led to believe from Daguerre's original claim.

At last in June Arago was able to satisfy popular demand and to reveal the mysterious means that made the plate so sensitive.[136] The prepared plate was submitted to the influence of electricity. A single electric spark, he stated, sufficed to make it so hypersensitive that one could not uncover and re-cover the lens quickly enough; the image was therefore always "veiled" through over-exposure. Not satisfied with the results he had so far obtained, Daguerre declined to confirm the process by showing a specimen until he had succeeded perfectly, but yielding to the demand for the secret he had decided to make it public so that the method might be improved at the hands of other experimenters. Arago's communication was greeted with acclamation everywhere.

"Let us consider but a moment the new world which is thus opened up to us, which but a few days since would have appeared a dream of fancy. The vast horizon, heaven, earth, and all around us can be represented in an instant. . . . The passing vapour, the dazzling meteor, the oscillations of lofty buildings, the most delicate and rapid changes in outward objects, the physiognomy of living beings, the movements of crowds—there is no end to all that may be saved to futurity from oblivion. . . .

At present we may notice, that on the morning of the 15th (August), at 8 o'clock, an artillery officer in the king's service daguerreotyped all the guards then at the castle of the Tuileries; he had ranked them in small detachments in

* Daguerre's letter, written in English, is in the John Pierpont Morgan Library, New York. In publishing it in *A Popular Treatise on the Art of Photography*, Glasgow, 1841, p. 70, Robert Hunt altered "battles" to "cattle", believing these more likely to be found in market-places.

order of battle here and there in the Court(yard), their muskets resting. A great crowd had stopped on the Place du Carrousel, all along the rails to observe the curious experiment.''[137]

It was all a deceptive triumph; unfortunately Daguerre had again cried victory too soon. ''Some great obstacle appears to have interfered with the successful practical use of this new and important discovery'', was Robert Hunt's sarcastic comment.[138] The truth was simply that the thing could not be done. On 5 July Arago apologized to the Academy for an error that had slipped into his report, but this correction made no difference. No one obtained any results, but soon the matter was forgotten, for on 7 June the Academy had learned from Arago that a Frenchman living in London, Antoine Claudet, F.R.S. (1797–1867), had discovered a means of greatly increasing the sensitivity of the plate by treating it with vapours of chlorine, as well as iodine, and this time the claim was borne out in practice. As neither Goddard's nor Kratochwila's acceleration methods seem to have been known in Paris, Claudet's chemical acceleration was considered the most important improvement in the daguerreotype since Hippolyte Fizeau's communication to the Academy on 10 August 1840 of his method of toning the image, after fixing, with chloride of gold, which increased the contrast of the image, protected it from abrasion, and tended to preserve the silver from oxidation.

Claudet's method speeded up the daguerreotype to such an extent that exposures which had formerly been counted in minutes were now reduced to seconds. With quarterplate cameras open-air portraits could be taken in the shade in 5 to 12 seconds and in full sunshine in 1 to 4 seconds. At last public portrait studios could be opened. Lerebours was probably the first in this field in France, taking about 1,500 portraits in 1841[139]; he was also one of the first to take ''Académies''— nude studies for artists, and others. Prominent among the daguerreotype portraitists in Paris were the brothers Louis and Auguste Bisson, who opened a studio some time in 1841. In March 1842 they were awarded a medal by the Société d'Encouragement pour l'Industrie Nationale for a daguerreotype said to measure ''nearly one metre''—which could only have been of an architectural subject. About 1848 the Bissons were established by a financial backer in an elegant studio in the fashionable district of the Madeleine. This became a meeting place for well-known writers and artists such as Gautier, Baudelaire, Balzac, Delacroix, Cormenin, and the art critic Janin. About this time the Bisson brothers daguerreotyped all the members of the Chamber of Deputies and the Senate. These portraits were published as lithographs.

Working with smaller and therefore faster cameras ($\frac{1}{6}$ or $\frac{1}{8}$ plate) than Lerebours,

and accelerating with bromine vapour, Gaudin was able to take some instantaneous street views in $\frac{1}{10}$ second showing people and traffic, provided they were not moving too rapidly. He showed a distant view of Pont-Neuf with traffic to the Académie des Sciences in October 1841. A black velvet flap thrown over the lens acted as shutter.[140] Gaudin seems to have been the earliest to attempt portraits of little children (in 1843), and realizing that this demanded a psychological approach as well as an instantaneous process, he invented the stock phrase used by photographers of children all over the world to this day: "Now look in the box and watch the dickeybird!"[141]

To what extent exposures varied with the focal length of the lens and the size of camera used is clearly indicated in the following exposure table.[142]

	$\frac{1}{6}$ plate (sec.)	$\frac{1}{4}$ plate (sec.)	$\frac{1}{2}$ plate (sec.)	whole- plate (sec.)
Sky veiled by slight white clouds.				
Apparatus turned to north	2–4	10–15	15–20	20–50
Apparatus turned to south	1–2	5–10	10–15	15–30
On an open terrace	1–2	5–12	10–20	20–40
With the object illuminated by the sun	A fraction of a sec.	1–4	3–6	6–10

The first important display of daguerreotypes anywhere formed part of the Exposition des Produits de l'Industrie Française held at the Palais de l'Industrie in 1844. Nearly 1,000 daguerreotypes by the Bissons, Claudet, Derussy, Plumier, Sabatier-Blot, and others were shown.

By 1847 photography had become such a widespread hobby and profession that 2,000 cameras and over half a million plates were sold in Paris alone.[143] This year constituted the zenith of the popularity of the daguerreotype in France. Leading professionals such as Richebourg, Derussy, and Victor Plumier in Paris and I. Thierry and Vaillat in Lyons took up to 3,000 portraits a year at a price varying from 10 to 20 francs according to size and quality of frame. From 1847 on, Talbot's paper process, improved by Blanquart-Evrard, won increasing favour with artists for landscape and architectural subjects, and three years later Baron Gros, diplomat and keen amateur photographer, forecast: "Is it not easy to foresee that the daguerreotype has almost run its course, and that its rival on paper is destined by its indisputable advantages to carry the day against it?"[144] Eventually it was, however, not the paper process that was destined to introduce a new era in photography, but Frederick Scott Archer's wet collodion process. Published shortly before Daguerre's

death, it superseded both the daguerreotype and the paper process within a few years.

At the Great Exhibition in 1851 it was, strange to say, not the French but the Americans who won the highest praise for daguerreotypes. The French were at that time regarded as leading in photography on paper.

Daguerre did not occupy himself very much with his invention after its publication, and all the important improvements made to the process were devised by others. Somewhat conscious of the fact, perhaps, that under the conditions of his pension he was supposed to reveal any future progress he might make, he did from time to time communicate to the Academy via Arago some imaginary improvements like his lightning process of 1841, and minor ones like the suggestion he put forward in March 1843: "much struck with the unequal results which pictures generally present, even those by people who are constantly taking them, I determined to seek some way of remedying this serious inconvenience"—which Daguerre correctly attributed to the general lack of care in the preliminary cleaning and polishing of the plates. A regular and highly polished surface undoubtedly gave better results (and in this technical perfection the Americans excelled), but whether the polishing and the subsequent removal of dust particles from the plate and from the lens by boiling water, as Daguerre recommended, really increased the speed of the operation is more than questionable.

Exactly three years after his first premature announcement of instantaneous photography, Daguerre claimed to have found new and more sensitive substances which would enable him to photograph a galloping horse and birds in flight. The announcement, which he made this time personally at a meeting of the Société libre des Beaux-Arts, on 30 January 1844, again caused much speculation as to the substances involved, but with his usual delaying tactics Daguerre kept the world in suspense until 22 April, when Arago read his communication to the Academy. It was a complicated method entailing the use of solutions of bichloride of mercury, cyanide of mercury, white oil of petroleum acidulated with nitric acid, chloride of gold, and of platinum (probably the first use of platinum in photography).[145] These substances formed a thicker sensitive coating and were claimed to give better gradation of tone, and an appearance of depth. However, once more the wish proved to have been father to the thought, for there was no question of making exposures in $\frac{1}{1000}$th of a second, as stated in *The Art Union*, June 1844, and photographs of galloping horses and birds in flight were not achieved until nearly forty years later. As a matter of fact, Gaudin found that with the new process two seconds were necessary for portraits on quarterplates which he would have taken in one second by the old one, and he did not consider them any better either. Daguerre regarded

his new process as sufficiently important to justify its publication as a brochure (facing p. 97), but despite his efforts to give it greater publicity it entirely failed to find practical application.

DAGUERRE'S LATER YEARS

Since 1840 Daguerre had been living at Bry-sur-Marne, about six miles east of Paris, where he had bought a small property. It is perhaps strange that a man who had always enjoyed the hustle and bustle of Parisian life should at the early age of fifty-two decide to retire to a little village of 400 inhabitants. Had he wished, he could certainly have increased his modest pension many times over by opening (after 1841) a photographic studio in the capital, for the attraction of having one's portrait taken by the inventor himself would have been irresistible. People would have come to Paris from all over the world for that reason alone. Perhaps Daguerre regarded this idea as too commercial and beneath his dignity. He was now an Officer of the Legion of Honour, and wanted to live the life of a gentleman. Perhaps, too, after fifteen years of worry and struggle with his invention he wanted a peaceful life at last.

He added to the seventeenth-century house a square tower 65 ft. high and decorated externally with paintings in Moorish style. Here he fitted up a studio, laboratory, and darkroom, and from this retreat used to enjoy watching thunderstorms—and occasionally taking a portrait of friends and relations with Chevalier's "Photographe", which he admitted was better than Giroux's instrument. He also carried out extensive alterations to the large garden, remodelling it into a miniature imitation of Swiss scenery, and, as far as his resources permitted, always had some workmen busy improving the property.

The Daguerres had no children, but about ten years after their marriage they had taken into their home an illegitimate infant daughter of one of Mme Daguerre's brothers, so it is said, whom they brought up as their own. This girl, Marguerite-Félicité Arrowsmith, later became Mme de Sainville.

At Bry Daguerre was on intimate terms with the Mayor, Mentienne senior. Living close to one another, they used to meet every day for a chat, walking up and down in the main square under the big, old poplar trees. The evenings, too, Daguerre frequently spent at Mentienne's home, recalling his past achievements and disappointments. At the municipal election following his arrival Daguerre was elected Councillor, and many a time his influence smoothed over the difficulties which tend to arise in such assemblies.

Another of his friends was a remarkable elderly lady, Mlle de Rigny, the lady of

the manor, who was very learned, especially in science and astronomy, and noted for her brilliant conversation.

Wishing to create at Bry a permanent reminder of his residence there, Daguerre conceived the idea of decorating the church with a perspective painting behind the High Altar. When he told Mlle de Rigny of his plan she offered to pay all the expenses of the necessary structural alterations, and the matter was put in hand. For six months he worked with unabated energy on this last work, which was to be less ephemeral than his dioramas. Representing the interior of a fine Gothic cathedral with stained-glass windows, tombs of knights, and their banners hanging above, the painting included all the favourite effects which had delighted Parisian audiences. Light entering the nave from the right strikes the pillars, on some of which hang paintings of Biblical subjects so perfectly represented that it seems one could unhook them. A beam of light strikes some cobwebs apparently spun only that morning. One of the candles has just gone out and the still glowing wick sends smoke into the air. Bouquets of flowers are painted so realistically that you want to touch them. But the most important *trompe-l'œil* effect only became apparent when the 13 ft. × 19 ft. 6 in. painting was unveiled on 19 June 1842. On entering the little church the community of Bry was transfixed with astonishment: Daguerre's magic art had transformed the simple little church into a grand cathedral twice its real length. Up to World War I the painting was classified as a national monument, but shortage of money and lack of interest have allowed it to deteriorate since. (Plate 22.)

Daguerre did not live idly at Bry. Another example of his improvement of the local amenities occurred in the revolutionary year of 1848, when Mlle de Rigny feared a repetition of the frightening experiences of 1793. Advised by the mayor to keep the local working-class people contented by giving employment to as many as possible, she asked Daguerre to organize some national workshops in her park, and an elaborate landscape garden was laid out according to his design, with ruined castle and chapel, a grotto and a miniature lake with rocks and rustic bridges.

Daguerre also devoted much time to graphic art. He sought in vain a means to fix pastel drawings so as to render them non-smearing and made a number of monochrome paintings on glass, employing lamp-black mixed with gluten. The technique was rather similar to his *dessins-fumées* of 1826 but gave broader effects, for these drawings were made with the finger, the degree of transparency depending on the pressure used. The picture was backed with white paper to show up the highlights, and framed.

Daguerre regularly attended the monthly meetings of the Société libre des Beaux-Arts at the Hôtel de Ville, Paris, and he would frequently take the opportunity to visit one or other of the leading daguerreotype portrait studios. There he

listened with much interest to the latest improvements, and expressed astonishment at the sight of new marvels. "But it is impossible! How did you obtain such a perfect result?" he would ask naïvely, as though a complete stranger to the process.

At Bry Daguerre was always delighted to receive visitors from all countries who wanted to lionize the famous inventor. Several well-known photographers were granted a sitting, though the majority of such requests met with a polite refusal. The well-known portraits by A. Claudet, William England, J. E. Mayall, and Charles R. Meade show him sitting in a chair, his head supported by his left hand,* a pose which he obviously regarded as the most attractive, for he photographed his wife in a similar position. (Plate 60.) Resting the head on the hand, of course, avoided the necessity for a headrest.

So the years went by pleasantly, Daguerre enjoying full health and strength, when quite suddenly during lunch on Thursday, 10 July 1851, he collapsed. His wife and niece sent for their neighbour and old friend Mentienne, who supported Daguerre in his arms. Mme Daguerre, seeing perspiration break out on his face, said with relief: "Oh, it is nothing serious, my dear husband is going to recover"; but Mentienne, feeling his spasms growing weaker, realized that his life was ending, and in less than an hour Daguerre was dead. A heart attack was the cause.

The funeral took place two days later. A deputation from the Société libre des Beaux-Arts, all the inhabitants of Bry and the neighbouring villages came to pay their last respects. Everyone loved Daguerre and many sobbed during the funeral orations of Mentienne and Peron, who ended, "Farewell, then, dear Daguerre, farewell for ever to your mortal remains: we salute your immortality which is beginning now, and which your noble works have so worthily merited!" Chevalier came forward and in a tearful voice paid his tribute in these few words: "Honour to Daguerre, the inventor of photography! He deserves a national monument; he must have a national monument." Soon afterwards, the Société libre des Beaux-Arts opened a subscription for a monument on Daguerre's tomb, for which the municipal council of Bry gave the ground.

The monument was inaugurated on 4 November 1852. The Mayor and Corporation, the President and many members of the Société libre des Beaux-Arts, and many other painters, photographers, architects, and Parisian notabilities, the Daguerre family and friends, and the entire neighbourhood, had assembled. After a requiem in the church, the long procession passed between a guard of honour formed by the National Guard on its way to the churchyard. Peron, too upset to read his long and carefully composed discourse, handed it over to the Secretary-General of the Society to read. Mentienne thanked the Society for the tombstone, designed by Rohault de

* The photographs were evidently not taken with a reversing prism judging from the buttoning of his waistcoat and the position of his order.

Fleury with a portrait medallion by Husson. The four sides of the pedestal bore this inscription: "To Daguerre, the Société libre des Beaux-Arts, MDCCCLII / Sciences, Fine Arts / Diorama, Daguerreotype / The Municipal Council of Bry, to Louis-Jacques-Mandé Daguerre, born at Cormeille-en-Parisis on 18 November 1787, died at Bry on 10 July 1851. Gratuitous and perpetual grant of ground, by resolution of 10 August 1851."

Mme Daguerre, left with only half the pension, had difficulty in supporting herself and her niece, and in 1853 was obliged to sell the property to a religious order, the Ladies of St Clothilde, retaining a residence in the studio. She presented to the Minister of Fine Arts Daguerre's apparatus, graphic and photographic pictures, notebooks, and anything else in his studio and laboratory she thought worth preserving for posterity. All this material is stated to have been deposited at the Conservatoire des Arts et Métiers, yet there remains only a complete Giroux outfit of 1839, Daguerre's camera obscura for sketching, three daguerreotypes, and a box of pastel colours.

Mme Daguerre survived her husband by nearly six years. She died at Bry on 24 March 1857 and was buried beside him. The Ladies of St Clothilde did not make any structural alterations to the house or garden, but during the Siege of Paris a fierce battle between the French and German armies raged round Bry for three days, from 30 November to 2 December 1870, during which the house and tower—which had served as a look-out post—were totally destroyed. Mme de Sainville's house at Noisy-le-Grand near Bry was occupied by the Germans and pillaged: Mentienne suffered in the same way, so nothing remains of the Daguerre relics possessed by either.

Over thirty years elapsed before a public monument was erected to commemorate the inventor of the daguerreotype. Through the efforts of the Société Française des Archives photographiques, historiques, et monumentales, an international subscription was opened for the erection of a monument at his birthplace, Cormeilles. The inauguration of the monument, surmounted by a bust by Capellaro, took place on 26 August 1883 in the presence of a large crowd. M. Hement, Inspector-General of Public Instruction, gave a long and flowery address, which was punctuated by bravos after nearly every sentence. After further speeches by Mentienne, junr., representing Bry as its mayor, and others, congratulatory telegrams were read, and Étienne Carjat, caricaturist, portrait photographer, and one-time editor of Le Boulevard, recited a poem, "L'Art du Pauvre", in which this ardent republican praised Daguerre's art above that of Pheidias, Apelles, Raphael, da Vinci, Rubens, and Rembrandt, because for the first time in history it permitted the poor to have family portraits too.

Avant toi, sublime inventeur,
L'art, dédaigneux du prolétaire,
Accaparant peintre et sculpteur,
Appartient aux grands de la terre.

Tous : ducs, papes, rois, empereurs,
Mangeurs d'argent, foudres de guerre,
Se disputent marbre et couleurs :
Aujourd'hui le pauvre a Daguerre !

Carjat's fourteen-verse poem was followed by a "Daguerre" cantata specially composed for the occasion by M. Lebey and sung by the local choral society. A sonnet to Daguerre by M. Joiselle was also much applauded. A banquet at the Town Hall followed by a firework display and torchlight procession concluded the festivities and so ended the most memorable day in the history of Cormeilles.

Fourteen years later the community of Bry on 27 July 1897 unveiled a monument with bronze bust by Élise Bloch in the Place Carnot. This monument was erected from international subscriptions collected by the Société Française de Photographie, following the example of the Photographer's Association of America, who had honoured Daguerre with a monument in Washington in August 1890.

Daguerre and his former partner Niépce are both commemorated by streets named after them, in the fourteenth district of Paris just south of Montparnasse Cemetery.

Chapter V

THE INTRODUCTION OF THE DAGUERREOTYPE IN AMERICA

THE earliest detailed information about the daguerreotype to be published in America was contained in Samuel Morse's letter in the New York *Observer* of 20 April 1839, quoted on pp. 86/87.

Soon after his return home Morse (Plate 62), who was President of the National Academy of Design, New York, wrote to Daguerre:

New York, May 20, 1839.

To M. Daguerre.

DEAR SIR,

I have the honour to enclose you the note of the Secretary of our Academy, informing you of your election, at our last Annual Meeting, into the Board of Honourary [sic] Members of our National Academy of Design. When I proposed your name, it was received with enthusiasm and the vote was unanimous. I hope, my dear sir, that you will receive this as a testimonial, not merely of my personal esteem, and deep sympathy in your late losses,* but also as a proof that your genius is, in some degree, estimated on this side of the water.

Notwithstanding the efforts made in England† to give to another the credit which is your due, I think I may with confidence assure you that throughout the United States your name alone will be associated with the brilliant discovery which justly bears your name. The letter I wrote from Paris the day after your sad loss* has been published throughout this whole country in hundreds of journals, and has excited great interest. Should any attempt be made here to give to any other than yourself the honour of this discovery, my pen is ever at your service.

I hope before this reaches you that the French Government, long and deservedly celebrated for its generosity to men of genius, will have amply supplied all your losses by a liberal sum. If, when the proper remuneration shall be secured to you in France, you should think it may be to your advantage to make an arrangement with the Government to hold back the secret for six months or a year, and

* Morse refers to the destruction of the Diorama by fire.
† Morse refers to Fox Talbot's invention of photography on paper.

would consent to an exhibition of your *results* in this country for a short time, the exhibition might be managed, I think, to your pecuniary advantage. If you think favorably of the plan, I offer you my services gratuitously.

<div align="center">

SAML F. B. MORSE,

President N. A. D.[146]

</div>

This was the first honour Daguerre received from abroad on account of his invention.

An English resident in New York, D. W. Seager, on 16 September took the first successful daguerreotype in the New World. The date is vouched for by his letter of 7 November 1839 to the American Institute[147] and confirmed (approximately) by a note of Morse in the New York *Journal of Commerce* on 28 September 1839. It is remarkable that Seager was able to obtain the information necessary for the construction of the apparatus and to take a good picture by 16 September, considering that the process was only made public in Paris on the afternoon of 19 August. Fast steamships of the period took fifteen to seventeen days to cross the Atlantic. It must therefore be assumed that Seager received Daguerre's manual, published on or about 20 August, or at least the *Journal des Débats* of 20 August containing Donné's full report of the meeting, by a fast French steamer leaving not later than about 26 August. On the other hand, according to a picturesque story related in 1882 by the brother of George W. Prosch, a scientific instrument maker and photographic pioneer in America, Seager was in England at the time of publication of the daguerreotype, and just as the ship in which he was sailing from London was leaving the dock, a friend threw him a copy of Daguerre's manual.* But whether it was a farewell gift which brought knowledge of photography to America, or the good services of a friend in Paris, the fact remains that Seager had contrived to master the manipulation by 16 September. His view, showing St Paul's Church, New York, and the surrounding houses, taken with an exposure of 8 to 10 minutes, aroused much interest when exhibited at Dr James Chilton's drug-store, 263 Broadway.

"The specimen at Chilton's is a most remarkable gem in its way. It looks like fairy work, and changes its color like a camelion [sic] according to the hue of the approximating objects. Ladies, if they are pretty, with small feet and delicate hands, fond of science, ought to call and see it. It is the first time that the rays of the sun were ever caught on this continent, and imprisoned, in all their glory and beauty, in a morocco case, with golden clasps."[148]

On 5 October Seager gave the first of a series of public evening lectures on the

* This could only have been the French manual, for Memes' English translation was not published until *after* Seager had taken his first photograph.

daguerreotype at the Stuyvesant Institute on Broadway, demonstrating the process in every respect except that of actually taking a picture, which could not be done by candle or lamp-light. Seager not only introduced the daguerreotype into the United States but he must also be credited with the compilation of the earliest exposure-table in the world (see page 133), which is contained in the first American brochure on photography published by Dr Chilton in March 1840. This 16-page booklet consisted of a reprint of Daguerre's practical instructions from J. S. Memes' translation[149] of Giroux's first edition, various French improvements abstracted from the *Athenaeum*, London, 30 November 1839, together with Chilton's observations. As some of Seager's exposures seem rather long, it should be pointed out that they refer to the autumn and winter only, and to wholeplate pictures.

Besides Seager, several other scientifically minded men experimented with the daguerreotype, foremost among them Samuel Morse, at that period professor of the literature of the arts of design at the University of the City of New York. With an outfit made by George W. Prosch, constructor of his telegraph instruments, Morse towards the end of September took a view of the Unitarian church from his room on the third floor of the University, the apparatus and chemicals being strictly in accordance with the directions in Daguerre's manual which Morse had bought as soon as it was on sale in New York. The exposure required was about 15 minutes. Apparently Morse did not make such good progress as Seager, for he wrote to Daguerre on 19 November that he had been experimenting "with indifferent success, mostly, I believe, for want of a proper lens. I hoped to be able to send you by this opportunity a result, but I have not one which I dare send you". As a portrait painter Morse was naturally most interested in this aspect. His earliest models were his daughter and a friend whom he posed in October on the roof of the University in full sunshine with their eyes closed, for the exposure lasted from 10 to 20 minutes. The result can hardly have been more successful than those attempted in Paris at the same period. The woodcut published by Root[150] is not trustworthy, for contrary to Morse's own statement, the girls are shown with open eyes.

Another photographic pioneer was Dr John William Draper (1811–82), an Englishman by birth and professor of chemistry at New York University. His source of knowledge of the daguerreotype was the *Literary Gazette*, London, which on 24 August printed a full report of Arago's speech. This paper, together with other English newspapers giving extracts or translations of Donné's report, arrived in New York on the *British Queen* on 20 September, having left Portsmouth on the 3rd. Constructing a camera from a cigar-box and fitting it with an ordinary double-convex spectacle lens of 14 in. focus and 4 in. diameter, Draper, like Morse, took a

picture of the Unitarian church from the University building. The exact date of this photograph is not known, but it was presumably taken about the end of September, for Draper claimed "within a day or two after the daguerreotype was made known here by the above Gazette [*Literary Gazette*] I had accomplished the object".

Realizing that the exposure must be drastically reduced before satisfactory portraits could be taken, Draper fitted his camera with a spectacle lens of shorter focal length (7 in.) and larger diameter (5 in.).[151] Having experimented for several years on the chemical effects of light on sensitive paper (photometry), Draper was aware of the difference between the visual and the chemical focus of non-achromatic lenses. In order to obtain a sharp image he therefore "pushed the back of the camera to the violet focus",* after having focused visually on the ground-glass in the usual way. Draper made these early attempts at portraiture indoors. At first he powdered the sitter's face with flour, but soon abandoned this procedure, for it unnecessarily increased the contrast between face and dress. At length in December he succeeded in taking what may be considered his first successful portrait: in a letter addressed on 31 March 1840 to the *London & Edinburgh Philosophical Magazine* Draper stated that he had "succeeded during the winter in producing portraits by the daguerreotype".

Soon after this, Draper and Morse opened a portrait studio together, but before continuing their story, the work of other early experimenters must be mentioned.

Following a detailed description of the process published by Professor J. F. Frazer in the *Journal of the Franklin Institute,* Philadelphia, for October 1839, or possibly one that had already appeared in the *United States Gazette* published in Philadelphia on 25 September, Joseph Saxton, an employee of the United States Mint, took the first daguerreotype in Philadelphia on 16 October. The picture, measuring $1\frac{1}{8}$ in. \times $1\frac{1}{2}$ in. and showing the old arsenal and the cupola of the Philadelphia Central High School, was taken from a window of the Mint. It is the earliest surviving American daguerreotype and is preserved at the Historical Society of Pennsylvania. Though by no means perfect, even allowing for blemishes and dust which may have accumulated on it later, this first attempt was nevertheless "sufficiently successful to demonstrate the beauty of the art when perfected; and we add that the success also shows the art to be quite susceptible of great and important improvement".[152]

Meanwhile early in October Alexander S. Wolcott (1804–44), a New York manufacturer of dental supplies, jointly with his partner John Johnson, started

* The chemically most active rays are the blue and violet which are shorter and meet in front of the visually most effective rays (red and yellow) when passed through a lens. The difference between the visual and chemical focus is about 2 per cent. of the focal length of the lens used.

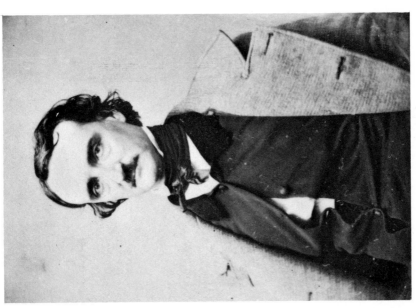

63. Edgar Allan Poe (1809–49). Daguerreotype by S. W. Hartshorn, 1848

62. Samuel F. B. Morse (1791–1872). Daguerreotype attributed to Daguerre, 1845

65. A little girl. Daguerreotype by Rufus Anson, New York, c. 1848

64. Dorothy Catherine Draper, taken by her brother Prof. John William Draper, summer 1840. One of the earliest successful daguerreotype portraits

67. Chief Justice Lemuel Shaw. Daguerreotype by South-worth & Hawes, c. 1850

66. John Quincy Adams (1767–1848), 6th President of the United States. Daguerreotype by Southworth & Hawes, Boston, 1844

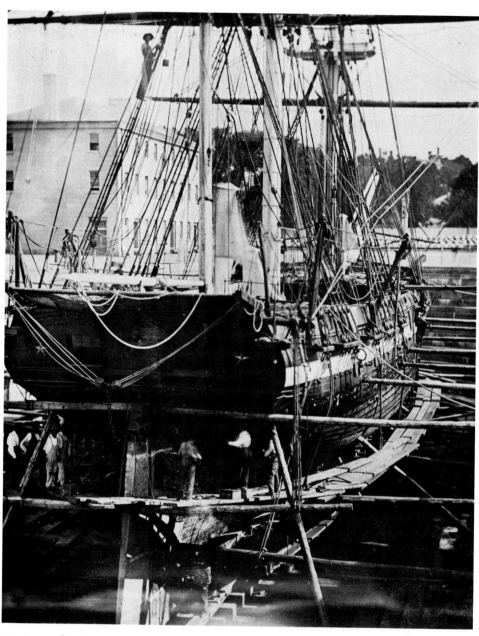

68. A vessel in Boston dry dock. Daguerreotype by Southworth & Hawes, *c.* 1850

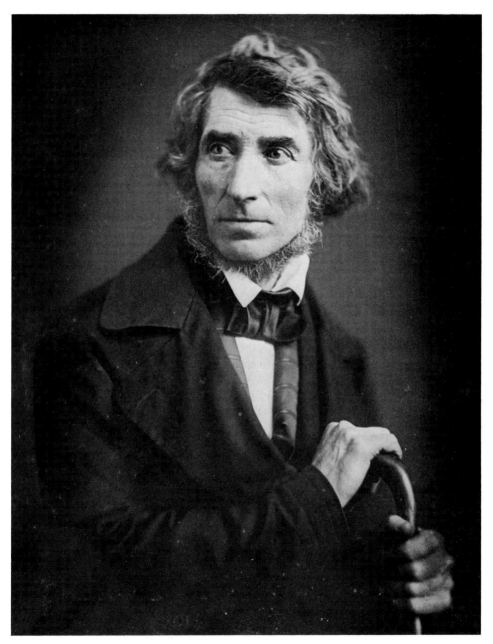

69. The painter Asher B. Durand, by an unknown American daguerreotypist, *c.* 1854

70. Cincinnati waterfront. One of eight daguerreotypes by Fontayne & Porter, forming a panorama, September 1848

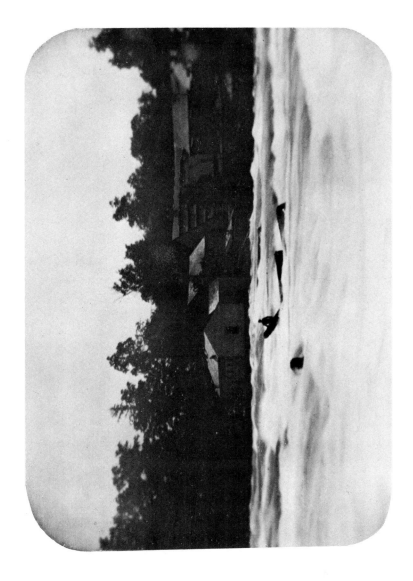

71. A man stranded on the rocks in the Niagara River. Daguerreotype by Babbitt, 1853

72. A lady with reading-glass. Daguerreotype by A. Claudet, *c.* 1845

73. A gentleman holding "Bell's Life & Sport". Daguerreotype, c. 1845

74. A lady. Daguerreotype by Richard
Beard, 1842. One of the earliest
surviving daguerreotype portraits in
Britain

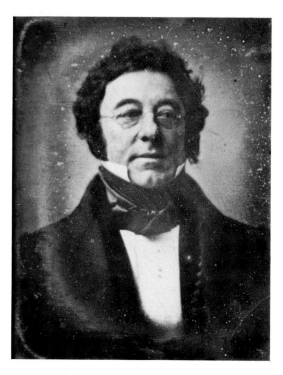

75. A gentleman. Daguerreotype by
Richard Beard, c. 1842

76. A youth. Daguerreotype by Richard Beard, c. 1842

77. Fox Talbot (1800–77). Daguerreotype by A. Claudet, 1844 (detail)

78. A lady in bonnet. Daguerreotype by William Telfer, c. 1848

79. A lady. Daguerreotype by A. Claudet, c. 1850

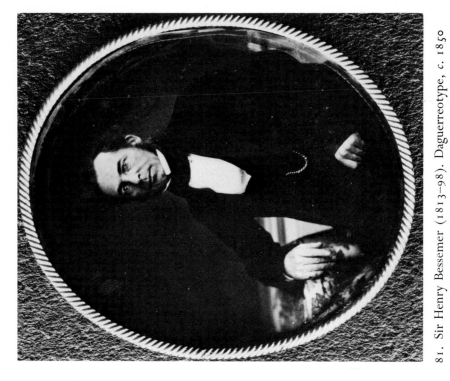

81. Sir Henry Bessemer (1813–98). Daguerreotype, c. 1850

80. Gioachino Rossini (1792–1868). Daguerreotype, c. 1850

83. The Duke of Wellington. Daguerreotype by A. Claudet, 1844

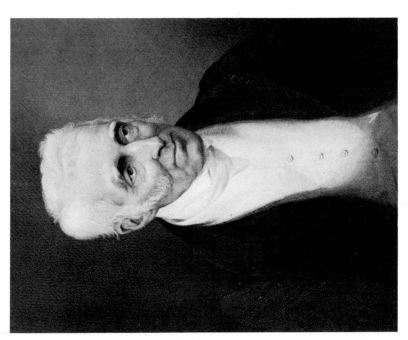

82. The Duke of Wellington (1769–1852). Engraving by H. P. Ryall, 1845, copied from Claudet's daguerreotype

85. Still-life. Stereoscopic daguerreotype, c. 1852

84. The geography lesson. Stereoscopic daguerreotype by A. Claudet, 1851

TABLE OF GENERAL RULES

FOR EXPOSURE OF THE PLATE IN THE CAMERA IN TAKING EXTERIOR VIEWS

The following Table is compiled partly from observation, and partly from analogy, and applies only to the period from the month of October to February. The observations were made upon ordinary views.

State of the weather	Hours of the day						
	8	9	10	11 to 1	1 to 2	2 to 3	3 and after
	(min.)	(min.)	(min.)	(min.)	(min.)	(min.)	(min.)
Very brilliant and clear, wind steady from W. or N.W., very deep blue sky, and absence of red rays at sunrise or sunset. Time employed	15	8	6	5	6	7	12 to 30
Clear, wind from S.W., moderately cold, but a slight perceptible vapor in comparison with above. Time employed	16	12	7	6	7	8	15 to 40
Sunshine, but rather hazy, shadows not hard, nor clearly defined. Time employed	25	18	14	12	14	16	25 to 40
Sun always obscured by light clouds, but lower atmosphere clear from haze and vapor. Time employed	30	20	18	16	15	20	35 to 50
Quite cloudy, but lower atmosphere free from vapors. Time employed	50	30	25	20	20	30	50 to 70

It is impossible at present to state precisely the time required to expose the plate in the camera at all seasons of the year: but the above table, drawn up by Mr D. W. SEAGER, of this city, and which coincides in general with the observations of others, may prove useful as a guide to experimenters. The time will necessarily decrease as the summer months approach. Much, however, depends upon the selection of the view; a white marble edifice, for instance, requires less time than darker buildings.—Ed.

experimenting in the hope of taking portraits. Finding it impossible to arrive at reasonably short exposures with an ordinary camera, Wolcott had a novel type of apparatus designed for him by Henry Fitz (1808–63), a maker of telescopes and lenses. In this a concave mirror was used to reflect the rays onto the sensitive plate, instead of passing them through a lens. The suggestion to substitute a mirror for the lens had already been made by Dr Andrew Fyfe (1792–1861), President of the College of Surgeons, Edinburgh. In his communication "On Photography" to the Society of Arts, Edinburgh, in April 1839, Dr Fyfe had said, "The concentration of the rays by a metallic mirror so as to get quit of the interference of the lens would no doubt be a great improvement in the camera obscura, provided it could be accomplished."[153] It is, of course, possible that Fitz took the idea from the well-known Gregorian telescope* in which the objects are reflected from a concave mirror onto another small concave mirror, which in Wolcott's camera was replaced by the daguerreotype plate. The apparatus was patented by Wolcott on 8 May 1840, and this is the first U.S. patent relating to photography.

On 7 October 1839 Alexander Wolcott took a tiny profile portrait of John Johnson, possibly with the mirror camera, though considering the date of the patent, more likely with a small ordinary camera. This portrait is claimed to be the first successful one not only in the United States but in the world—but can one call a profile on a $\frac{3}{8}$-in. plate—smaller than most signet-rings—a good portrait?

Wolcott's camera (page 170) was constructed so that the light-rays passing through the open front of the wooden box 15 in. long × 8$\frac{1}{2}$ in. high × 8 in. wide were reflected by a concave metal mirror at the back of the camera on to the sensitized plate, which was held in a small frame somewhat behind and in the centre of the open front, facing the mirror. The brass pedestal carrying the frame and plate could be moved backwards and forwards, the base of the pillar sliding in a slot in the bottom of the box. When the operator had obtained the exact focus on an unsensitized plate by looking through an opening in the top of the camera, the plate was removed and a sensitized one put in its place. On account of the open front of the camera, a certain amount of stray light was unavoidable. The concave mirror, of 7 in. diameter and 12 in. focal length, had the great advantage of reflecting several times more light on to the plate than if the light had passed through a lens. Another advantage was that the image was not reversed; but, on the other hand, the mirror limited the size of the portrait to 2 sq. in., and the image was slightly soft.

* Invented by James Gregory, F.R.S. (1638–75).

During the winter experiments continued, and by the beginning of March 1840 Wolcott was able to open the world's first portrait studio at 52 First Street. The New York *Sun* on 4 March contained the following account:

"Sun Drawn Miniatures. Mr A. S. Wolcott, No. 52 First Street, has introduced an improvement on the daguerreotype, by which he is enabled to execute miniatures, with an accuracy as perfect as nature itself, in the short space of from three to five minutes. We have seen one, taken on Monday, when the state of the atmosphere was far from favorable, the fidelity of which is truly astonishing. The miniatures are taken on silver plate, and enclosed in bronze in cases, for the low price of three dollars for single ones. They really deserve the attention of the scientific, and are a valuable acquisition to art, and to society in every respect."

Nine days later the same paper reported that Wolcott had moved to rooms in the new granite building at the corner of Broadway and Chambers Street. Here Wolcott and Johnson installed an ingenious lighting system. Two adjustable mirrors fixed outside the window reflected the sunlight on to the sitter, after passing through a trough of plateglass filled with a solution of sulphate of copper, the blue colour of which had the same function as Daguerre's suggested blue glass. Behind the sitter, who was supported by a headrest, a plain screen served as background. It was Wolcott's mirror camera and lighting arrangements that made possible the first portrait studio in Europe, which was opened in March 1841 in London (see page 152).

Morse, seeing that the portrait business at last showed prospects of success, "proposed to Wolcott to join him in the working of the invention".[154] Receiving a negative reply, he suggested to Prof. Draper a joint venture, and this seemed an ideal partnership of artist and scientist. A shed with a glass roof was hastily constructed on the roof of the University, where from about April 1840 on they took portraits at a charge of $4 (£1) per picture.[155] Morse being a well-known portrait painter, the partners had during the summer vacation all the business they could possibly attend to. Many leading people of the city sat for their portraits. Among others, a good picture was taken of Mr Frelinghuysen, the candidate for the vice-presidency. The main drawback to the business lay in the fact that they could only operate on sunny days. In dull weather they used to teach the manipulation to would-be photographers. Indeed, there were more people wishing to be trained, than wanting their portraits taken.

Adopting the same lighting arrangements as Wolcott, Morse and Draper found that they could take portraits in 40 seconds to 2 minutes, according to the intensity of the light. If posed in direct sunshine in the open air, the time was reduced to 20–90 seconds, but they preferred indoor portraits, which gave a better likeness. Instead of the patented mirror camera, Morse and Draper used an ordinary locally constructed camera with a combination lens consisting of two non-achromatic bi-convex lenses of 4 in. diameter and a combined focal length of 8 in., mounted in a conical tube, reducing the effective lens opening to $3\frac{1}{2}$ in.

"The chair in which the sitter is placed has a staff at its back, terminating in an iron ring, that supports the head, so arranged as to have motion in directions to suit any stature and any attitude. By simply resting the back or side of the head against this ring, it may be kept sufficiently still to allow the minutest marks on the face to be copied. The hands should never rest upon the chest, for the motion of respiration disturbs them so much, as to bring them out of a thick and clumsy appearance, destroying also the representation of the veins on the back, which, if they are held motionless, are copied with surprising beauty. . . .

Those who undertake daguerreotype portraitures will of course arrange the backgrounds of their pictures according to their own tastes. When one that is quite uniform is desired, a blanket, or a cloth of drab colour, properly suspended, will be found to answer very well. . . . It will be readily understood, that if it be desired to introduce a vase, an urn, or other ornament, it must not be arranged against the background, but brought forward until it appears perfectly distinct on the obscure glass of the camera. . . .

Different parts of the dress require intervals differing considerably, to be fairly copied; the white parts of a costume passing on to solarization before the yellow or black parts have made any decisive representation. We have, therefore, to make use of temporary expedients. A person dressed in a black coat, and open waistcoat of the same colour, must put on a temporary front of a drab or flesh colour, or by the time that his face and the fine shadows of his woollen clothing are evolved, his shirt will be solarized and be blue or even black, with a white halo around it. Where, however, the white parts of the dress do not expose much surface, or expose it obliquely, these precautions are not essential; the white shirt collar will scarcely solarize until the face is passing into the same condition. Precautions of the same kind are necessary in ladies' dresses, which should not be selected of tints contrasting strongly. . . .

Miniatures procured in the manner here laid down are in most cases striking likenesses, though not in all. They give, of course, all the individual peculiarities, a mole, a freckle, a wart. Owing to the circumstance that yellow and yellowish

browns are long before they impress the substance of the Daguerreotype, persons whose faces are freckled all over give rise to the most ludicrous results. . . . The eye appears beautifully; the iris with sharpness, and the white dot of light upon it, with such strength and so much of reality and life, as to surprise those who have never before seen it. Many are persuaded, that the pencil of the painter has been secretly employed to give this finishing touch.''[156]

This communication which Draper had sent in April or May to the *London & Edinburgh Philosophical Magazine* was the first detailed description on this subject to appear in Europe, where at the time of its publication it was not yet possible to take good portraits. Many writers have ascribed the success of early portraiture in America to the peculiar clarity of the atmosphere and to the mirror camera, but it must be assumed that it was chiefly due to the ingenious lighting system, since it was possible to take portraits with the ordinary camera as well as with the mirror camera.

None of Wolcott's portraits seem to have survived so it is impossible to draw any comparison between them and the portrait of Miss Dorothy Catherine Draper (Plate 64), sister of Dr Draper, whom he photographed in June 1840. It is the earliest good photographic portrait in the world which survived until modern times.* It was taken in 65 seconds when the sky was covered with thin white clouds, and measured $3\frac{1}{2}$ in. \times $2\frac{3}{4}$ in. On 28 July Draper sent it to the astronomer Sir John Herschel—one of the English fathers of photography. In thanking Draper for it, Herschel declared it to be ''by far the most satisfactory *portrait* I have yet seen'', † and it seems rather hypercritical that he should have remarked that the bright spot in each eye *ought*, under the microscope, to exhibit a picture of the external landscape seen through the window of the apartment!

After five or six months Draper withdrew from photographic portraiture and devoted his time to scientific pursuits. On 27 July 1842 he took the first solar spectrum photograph, in Virginia. This daguerreotype, which he also sent to Sir John Herschel, formed the basis of the latter's memoir ''On the action of the rays of the solar spectrum on the daguerreotype plate'', published in the *Philosophical Magazine*, February 1843.‡ Draper also took the earliest diffraction spectrum photographs.[157]

Left on his own, Morse moved to the new premises of the *Observer*, where his brothers erected for him another room with a glass roof. Here he was ''tied hand

* Fortunately the daguerreotype had been photographed in 1933 before the image disappeared, no doubt through a misguided attempt to clean it.

† The only other portraits Herschel could have seen were the bad ones taken in Paris.

‡ This rare historical item, which measures about $3\frac{1}{2}$ in. by 3 in. and is in perfect condition, is preserved at the Science Museum, London.

and foot during the day endeavouring to realize something from daguerreotype portraits" for over a year. "My ultimate aim is the application of the daguerreotype to accumulate for my studio models for my canvas", he wrote to a cousin in February 1841. He continued to augment his income by giving instruction at 25 to 50 dollars a course. Among his pupils were men who afterwards became leading daguerreotypists in the States—Edward Anthony, Mathew B. Brady, and Albert S. Southworth.

Though Daguerre did not himself follow up Morse's suggestion to introduce his process into the States personally and to have an exhibition of his pictures (see p. 130), the idea certainly struck him and Giroux as offering enough prospects to make it worth while to establish an overseas agency for the sale of apparatus. François Gouraud, a friend and pupil of Daguerre, arrived in New York on 23 November 1839, supplied, no doubt, with an introduction to Samuel Morse, and through him met the editors of the New York *Observer*, who on 30 November wrote: "We can find no language to express the charm of these pictures, painted by no mortal hand."

"Having the good fortune to possess a collection of the finest proofs which have yet been made, either by the most talented pupils of Mr Daguerre, or by that great artist himself," wrote Gouraud on 29 November in his invitation to a private view, "I have thought it my duty, before showing them to the public, to give the most prominent men and distinguished artists of this city the satisfaction of having the first view of perhaps the most interesting object which has ever been exposed to the curiosity of the man of taste; and therefore, if agreeable to you, I shall have the honour of receiving you on Wednesday next the 4th of December from the hour of eleven o'clock to one o'clock inclusive, at the Hotel François, No. 57 Broadway, where this invitation will admit you."*

The thirty daguerreotypes which these prominent New Yorkers admired were of similar subjects to those shown in Paris, and aroused equal interest and enthusiasm. The four-page leaflet listing the pictures constitutes the first photographic exhibition catalogue.

"We have seen the views taken in Paris by the 'Daguerreotype' and have no hesitation in avowing that they are the most remarkable objects of curiosity and admiration, in the arts, that we ever beheld. Their exquisite perfection almost transcends the bounds of sober belief. Let us endeavor to convey to the reader an impression of their character. Let him suppose himself standing in the middle of Broadway, with a looking glass held perpendicularly in his hand, in which is

* The circular is quoted in full in Robert Taft, *Photography and the American Scene*, New York, 1938 (Dover Publications, 1964), p. 41.

reflected the street, with all that therein is, for two or three miles, taking in the haziest distance. Then let him take the glass into the house, and find the impression of the entire view, in the softest light and shade, vividly retained upon its surface. This is the Daguerreotype! . . . There is not an object even the most minute, embraced in that wide scope, which was not in the original; and it is impossible that one should have been omitted. Think of that!"[158]

It is clear from this eulogistic review that the French daguerreotypes were infinitely superior to anything that had so far been seen in the States.

During the next fortnight the exhibition was open to the public at a charge of one dollar, and two demonstrations were given daily. On 20 December Gouraud moved his collection to the "new granite building"—where Wolcott and Johnson opened their Daguerrian Parlor three months later—reduced the price of admission by half, and took a number of pupils, among whom was Morse. This proves that Morse had not obtained very satisfactory results so far, but by February 1840 his pictures were so much improved technically that one of them was praised in the *Evening Post* as being equal to the best of those taken by Daguerre himself. When Gouraud tried to take the credit for Morse's success[159] the latter replied: "All the instruction professed to be imparted by M. Gouraud, I have felt it necessary to forget."[160] Moreover, Morse publicly accused Gouraud of degrading the name of Daguerre by selling toilet articles and patent medicines at his exhibition. In the midst of this quarrel carried on in the press Gouraud moved to Boston, where he opened his exhibition on 6 March. Here, too, he took pupils, among them Edward Everett Hale, Albert Sands Southworth, and Josiah Johnson Hawes: the latter two the following year together opened a portrait studio in Boston, and produced what many people consider the finest daguerreotypes in America (Plates 66–68). It was in Boston, at the end of March or beginning of April 1840, that Gouraud published *A Description of the Daguerreotype Process; or a Summary of M. Gouraud's Public Lectures according to the principle of M. Daguerre*. This sixteen-page brochure (reprinted by Beaumont Newhall in *Image*, 1960, No. 1) gives in the authors' opinion—and contrary to what Morse said—the clearest and most practical instructions on daguerreotype manipulation. It ends with a very lucid description of "the manner of taking portraits" in which Gouraud gives full credit to Abel Rendu, who had instructed him in this novel branch just before he left Paris. Gouraud's description precedes that of Draper (see p. 136) by several months.

In spite of the excellent recommendation with which Gouraud came to the States, he turned out to be a swindler. In April 1840 the law caught up with him, for he had left New York without paying his rent. Giroux too was restive at receiving no payment on the apparatus sold in the States, and sent another representative

to find out what was wrong. Quite possibly Gouraud was replaced as agent, but he continued his demonstrations in various American towns—Providence R.I., Buffalo, and New Orleans, where his daguerreotype collection was destroyed by fire in January 1843.[161]

Among the most successful daguerreotypists of the early period was John Plumbe (1811–57), a Welshman by birth, who opened the Plumbe National Daguerreian Gallery in Boston in 1840 and by September 1845 had a chain of fourteen studios "constituting the most extensive establishment of the kind in the world"[162] and stretching across the American continent from Boston to St Louis. This enterprising businessman, whom the New York *Herald* called "The American Daguerre", also employed lithographers to copy daguerreotype views and portraits, which he published as "Plumbeotypes" at his Philadelphia branch. However, he had undertaken more than he could manage and in 1847 became bankrupt.

By 1841 most of the principal towns in the States had a daguerreotype establishment, or at least a visiting daguerreotypist. Most of these were uneducated people who had been attracted to the business by the quick returns offered, and having but scanty knowledge of the manipulation, their results were usually poor. John Quincy Adams, 6th President of the United States, recorded in 1843: "Four daguerreotype likenesses of my head were taken, two of them jointly with the head of Mr Bacon—all hideous"; and "We stopped at a daguerreotype office, where three attempts were made to take my likeness. I believe that none of them succeeded."[163] Cyrus Macaire, a Frenchman seeking his fortune in Amerca in 1840–41, was one of the itinerant photographers in the Southern States. Owing to under-exposure his portraits often turned out black and were refused by the sitter. Undaunted, Macaire passed them off on the slaves, who recognized themselves without hesitation in the portraits of their masters. This business proved so good that in the end Macaire posed whites to furnish the portraits of negroes.[164]

Two Germans, William Langenheim (1807–74) and his brother Frederick (1809–79) opened a daguerreotype studio at the Exchange in Philadelphia in 1841 or 1842. Among the many prominent Americans who sat to them were President Tylor, Henry Clay, and General Lewis Cass. A daguerreotype they made of people sitting drinking at a table in the Exchange restaurant hung for a time in the corridor of the building as an advertisement, but according to L. W. Sipley (*The Pennsylvania Arts and Sciences*, 1937) its "demoralizing" effect raised a storm of protest. Unfortunately this first advertising photograph does not seem to have survived.

Today the Langenheims' reputation as daguerreotypists rests chiefly on their panorama of the Niagara Falls made up from five separate views taken in July 1845. Sets of these daguerreotypes, mounted in specially designed frames, were presented to Queen Victoria, the Kings of Prussia, Saxony, and Württemberg, the Duke of

Brunswick (the birthplace of the Langenheim brothers) and to Daguerre, who sent them letters of appreciation and gold medals. The Langenheims' own panorama was shown at the exhibition which Beaumont Newhall arranged at the Museum of Modern Art in 1937 to celebrate the centenary of Daguerre's first successful picture.

The most famous name in the history of American photography is that of Mathew B. Brady (1823–96), who has already been mentioned as a pupil of Morse in 1840–41. Before opening a Daguerrian Gallery in New York in 1844, Brady was in business as a manufacturer of daguerreotype cases. During the next forty-eight years he photographed every American of note. "The fact that Mathew Brady sought you out to take your picture meant that you were news. You could be notorious, or interesting, or famous. You need not necessarily be good and great." In this way Brady fulfilled his ambition to form a National Historical Portrait Gallery. Unfortunately the Government did not have the same vision as the photographer.

A novel business was established by a daguerreotypist named Platt D. Babbitt in 1853 at the Niagara Falls, where he was granted a monopoly by General Porter, the manager of the American side. Babbitt set up a pavilion under which his camera stood in position all day; when a party of visitors gathered on the edge of the cliff to admire the Falls, he would take them unawares, and of course they were always glad to buy the picture as a souvenir. Babbitt was probably the first to specialize in this kind of tourist photography. Soon after Babbitt had obtained his concession, two men boating on the upper Niagara river got caught in a fast current, were sucked into the rapids, and their boat smashed on the rocks. One of them was swept over the Falls at once, but the other, named Avery, clung for eighteen hours to a log which was jammed between two rocks. All attempts at rescue failed, for the water rushed past at eighteen to twenty miles an hour, and eventually the doomed man, exhausted, was swept away. Babbitt took several daguerreotypes, which are in the nature of early news photographs, and presented one of them (Plate 71) to John Werge, who wrote about the occurrence.[165]

In this year, 1853, the daguerreotype reached its most widespread popularity in the States. Shortly before, no fewer than 10,000 people were estimated to be earning their living as daguerreotypists, to which may be added at least another 5,000 in allied trades such as the manufacture of apparatus, chemicals, plates, and cases.[166] On the banks of the Hudson a town grew up round a large factory making daguerreotype supplies, and was appropriately named Daguerreville. Three million daguerreotypes were estimated to be produced annually, and there were about a hundred portrait studios in New York alone.[167] This fierce competition brought down the price of daguerreotypes to as little as eight shillings, complete in an ornamental leather case, and hand-coloured.[168] The daguerreotype remained popular in America until the mid-sixties, longer than anywhere else.

At the Great Exhibition in London, 1851, American daguerreotypes were particularly praised, the Jury stating:

"Every observer must be struck with their beauty of execution, the broad and well-toned masses of light and shade, and the total absence of all glare which render them so superior to many works of this class. Were we to particularize the individual excellences of the pictures exhibited, we should far exceed the limits of space to which we are necessarily confined. Where all is good, it follows that the remarks must be restricted to peculiar excellence alone. It is but fair to our own photographists to observe that, much as America has produced and excellent as are her works, every effort has been seconded by all that climate and the purest of atmospheres could effect; and when we consider how important an element of the process is a clear atmosphere, we must be careful not to overrate that superiority of execution which America certainly manifests."

The best pictures in the American section were those of M. M. Lawrence of New York, who received the highest award, a Council Medal. He showed a number of uncoloured portraits, two of them measuring $10\frac{1}{2}$ in. \times $12\frac{1}{2}$ in. Mathew Brady, exhibiting forty-eight portraits, received only a Prize Medal, the next highest award, for, it was remarked, "The artist having placed implicit reliance upon his knowledge of photographic science, has neglected to avail himself of the resources of art." The only other award to an American was a Prize Medal to John A. Whipple, a portrait photographer of Boston, for a daguerreotype of the moon taken that year —a photograph spoken of by the Jury as marking a new era in astronomical photography. Special mention should also be made of the huge panorama of Cincinnati taken in September 1848 by Charles Fontayne and his partner W. S. Porter. This 8-ft. long panorama is composed of eight 12 in. \times 10 in. daguerreotypes of the Cincinnati waterfront (Plate 70) taken from across the Ohio river in Newport and covering a stretch a little over two miles long.

The high praise accorded to American daguerreotypes at the Great Exhibition is partly due to their technical brilliance. They are particularly clear, owing to their highly polished surface, for the Americans used steam-machinery to drive circular cleaning and buffing wheels and their plates are therefore free from the buff-lines visible in most English and continental daguerreotypes. Another reason for the great prominence of the Americans at the Crystal Palace is the fact that none of the leading German daguerreotypists such as Stelzner and Biow were represented. To avoid any erroneous impression we would add that two of the highest awards went to British daguerreotypists, namely A. Claudet (Council Medal) and E. Kilburn (Prize Medal), while J. E. Mayall, an American by birth but an Englishman by adoption, had to content himself with an Honourable Mention.

Chapter VI

THE DAGUERREOTYPE IN BRITAIN

ON 7 January 1839, in recommending that the French Government should grant Daguerre and Isidore Niépce pensions and then nobly give the discovery to the whole world, Arago reasoned that the daguerreotype could not be protected by a patent, for as soon as disclosed, the manipulation could be carried out by everybody. This was ostensibly also the intention of the Government, for in laying the Bill relating to the discovery before the Chamber of Deputies on 15 June and before the Chamber of Peers on 17 July, the Minister of the Interior supported his request for the pensions with this statement:

"Unfortunately for the authors of this beautiful discovery, it is impossible for them to bring their labour into the market and thus indemnify themselves for the sacrifices incurred by so many attempts so long fruitless. Their invention does not admit of being secured by a patent. As soon as it becomes known, anyone can make use of it. . . . It thus follows that this process must belong to everybody, or remain unknown."

Nevertheless, Daguerre and Isidore Niépce on 1 June 1839[169] engaged an English patent agent, Miles Berry, to take out a patent "to make, use, exercise and vend, within England, Wales, and the town of Berwick-upon-Tweed, and in all Her Majesty's Colonies and Plantations abroad, an invention of A NEW OR IMPROVED METHOD* OF OBTAINING THE SPONTANEOUS REPRODUCTION OF ALL THE IMAGES RECEIVED IN THE FOCUS OF THE CAMERA OBSCURA."

On or about 15 July, Berry was instructed:

"immediately to petition Her Majesty to grant Her Royal Letters Patent for the exclusive use of the same within these kingdoms, and in consequence therefore I [Miles Berry] did apply for such Letters Patent and Her Majesty's Solicitor-General, after hearing all parties who opposed the same,† was pleased on or about the second day of August to issue his report to the Crown in favour of the Patent being granted, and it consequently passed the Great Seal in the normal

* The daguerreotype was a "new or improved method" compared with Talbot's Photogenic Drawing.
† Preamble to the patent. It is not known who were the persons who opposed it, but their patent agent was Delianson Clark (see p. 148).

course, being sealed on the day above named [14 August] which is some days
prior to the date of the exposition of the said invention or discovery to the French
Government at Paris by Messrs Daguerre and Niépce, according to the terms of
their agreement.''

Whereas Miles Berry stated in the preamble to the patent on 14 August that ''the
French Government have purchased the invention for the benefit of that country'',
five days later at the Institut de France Arago solemnly repeated the declaration he
had made before the Chamber of Deputies on 3 July: ''France has adopted this
discovery, and from the first moment she has cherished a pride in liberally presenting
it to the whole world.''

Why was England alone singled out for patenting the daguerreotype? The theory
has been advanced that Daguerre wanted to protect himself against the possible
rivalry of Fox Talbot; but this argument is only partly correct, for when Talbot
published his paper method in February it became evident that the two inventions
were quite different. We believe that an entirely different reasoning persuaded
Daguerre to make this move, and the French Government to turn a blind eye to it.
The discovery of photography was a matter of national pride. Talbot's claim to have
preceded Daguerre in fixing the images of the camera obscura annoyed the French,
for his results were extremely primitive in comparison with Daguerre's, and, so
far, his method seemed hardly applicable to camera pictures. If the English wanted
to photograph, therefore, they would have to make use of the superior French
process, thereby openly acknowledging that the invention of practical photography
belonged to France alone.

Even before Daguerre thought of patenting his process, he planned to sell his
apparatus in England—the leading country in commerce and industry, and a favourite
hunting-ground for commercial speculators. Barely three weeks after Arago's pre-
liminary announcement of the daguerreotype he had an agent in London (probably
Antoine Claudet) to receive subscriptions for the camera,[170] and in assigning to
Alphonse Giroux the monopoly of manufacturing and selling daguerreotype appara-
tus, England was the only country excepted (see Giroux contract in appendix).

Throughout the spring and summer of 1839 English people had eagerly gathered
what details they could about the wonderful ''sun pictures'' from the reports of
journalists and returning travellers who had actually seen them. At last, on 13
September, the first of a number of daily public lectures was given by M. de St Croix,
an enterprising Frenchman who had bought a Giroux outfit and some daguerreo-
types and, after attending the first of Daguerre's demonstrations at the Quai d'Orsay,
came to London with the intention of introducing the process. The demonstration

took place at 7 Piccadilly, and in the presence of a number of scientists and artists M. de St Croix produced in an exposure of 20 minutes "a beautiful miniature representation of the houses, pathway, sky, &c., resembling an exquisite mezzo-tint."[171] The novelty was so great that on another day, even a partial success after two hours of failure was praised: "Owing to the unfavourable weather, the image after all was imperfect, but the parts which *did* tell were wonderfully beautiful."[172]

At the same time, the first daguerreotypes were offered for sale by a chemist named Robinson in Store Street, Bedford Square, who was also the first person to advertise silvered copper plates for the daguerreotype process.[173]

From early October on, exhibitions of daguerreotypes and daily demonstrations of the manipulation took place at the Royal Adelaide Gallery of Practical Science, West Strand, by M. de St Croix, and at the Royal Polytechnic Institution, 309 Regent Street, by the resident chemist, J. T. Cooper. At these newly founded institutions lectures on applied science and exhibitions of curious natural phenomena afforded that peculiarly Victorian blend of instruction and recreation so eagerly sought by the new enlarged middle class. It is amusing that the earliest public exhibitions of daguerreotypes and regular demonstrations of the process were sandwiched between other novelties such as an electric eel, a diving bell in which the public could descend into a fourteen-foot reservoir, "the Invisible Girl", safety signal lamps, working models of steam engines and steam-guns which must have been rather disturbing during the performances on the new musical instruments, the Aeolophon and the Terpodion. It was a natural development that out of these demonstrations there later grew the first photographic studios in England, for these institutions drew large crowds whose curiosity, aroused by the lecture, led them to try the novel form of portraiture. But we have anticipated events.

Soon came the startling realization that the daguerreotype was patented and that no one was allowed to take, demonstrate, exhibit, or sell daguerreotypes without a licence from the patentee, Miles Berry, who ordered M. de St Croix to cease his activities, but the latter, confident in the rightfulness of his position, soon resumed them. Miles Berry upon enquiry learned from Daguerre on 18 October:

"I consider it due to truth and to the Daguerreotype, which M. Sainte Croix injures considerably, to certify to you without loss of time, that this gentleman is totally unknown to me—that he left Paris before he knew how to execute the process, and, consequently, that the sketches he obtains can in no manner give an idea of the invention.

I avail myself of the same opportunity of stating as a fact, that none of the sketches taken by me have been sold, and that, consequently, such sketches as

have been offered for sale and represented as emanating from me, have been executed by other persons.''[174] The editor of *The Athenaeum* stated on 26 October 1839 that these daguerreotypes cost from £20 to £25.

The Polytechnic Institution continued their demonstrations without molestation, having previously been licensed.

Miles Berry's warning notices in the press aroused much indignation, for everyone considered that he was trying to exploit an invention which had been given freely to the world. When he made known that he was only acting upon the inventor's instructions, the legality and morality of Daguerre's patent was questioned, for the magnanimous gesture of the French Government did not seem to be at all consistent with a monopoly in England. Puzzled by this mercenary attitude in the face of the French Government statements, the English naturally wondered, ''Is Daguerre legally entitled to the patent?'' John Pye (1782–1874), the engraver of Turner's works and teacher of Landseer, wrote to Daguerre on 4 October:

<div align="right">

42 Cirencester Place,

Fitzroy Square, London.
</div>

Sir,

The invention of Daguerreotype will, no doubt, link your name with those of the distinguished men who have conferred great benefits on your country; and the French Government, in rewarding you and giving your discovery to the civilized world, has so dignified itself by the act, that your invention and the Government of your country form, at this moment, the most interesting and pleasureable subject of conversation amongst men of art and science in London.

Yet, whilst France is thus honored by you and its Government, Mr Berry, an Englishman, announces by daily advertisements in the London newspapers that he has taken out a Patent which gives to him exclusively the right of practising Daguerreotype in England, and that he is determined to prosecute all persons who may interfere with him by *making, using, exercising, or vending it*.

There appears something so very extraordinary in the pretensions of Mr Berry (he having laid no claim on the ground of being the inventor, nor in right of any moral authority vested in him by you) that there is growing amongst the admirers of your discovery in London, a determination to try by a Court of Law the value of those pretensions, and to publish the result in the French and English newspapers.

Before taking that step which may lead to an Action, it is deemed well to request that you will have the goodness to inform me whether you (having sold your invention, and your Government having given it to the world) have vested in Mr Berry, or any other Englishman, any exclusive right in it.

Congratulating you on the very honorable distinction you have acquired, and trusting that the importance attached to your invention in England will be deemed an apology for the trouble this communication may occasion you, I await the favour of your reply, and remain, Sir,

<div align="center">

Your very obedient servant,

JOHN PYE.[175]

</div>

Daguerre replied promptly on 7 October:

SIR,

In answer to your letter of the 4th instant, respecting the process of the Daguerreotype, and the Patent in England obtained for the same in the name of Mr Miles Berry, Chancery Lane, previous to any exposition thereof in France, I beg to state that it is with my full concurrence that the Patent has been so obtained, and that Mr Miles Berry has full authority to act as he thinks fit, under proper legal advice.

I would add, that if you will take the trouble to read attentively the articles of agreement between me and the French Government, you will see that the process has been sold, not to the civilized world, but to the Government of France, for the benefit of my fellow-countrymen.

With thanks for your good wishes and flattering letter, and esteem for your high talent as an artist, and with desire to have good will and assistance in England as well as in France,

<div align="center">

I remain, Sir,

Your obedient servant,

DAGUERRE.[176]

</div>

It was undeniable that Daguerre and Niépce had merely sold the invention to the French Government, but, equally unmistakably, the Minister of the Interior had announced that the State had acquired it for the benefit of the whole world. So the English wondered again, "When Arago and Duchâtel said that the invention did not admit of being secured by a patent, did they only mean a French patent? Or do Frenchmen really hyperbolically call France 'the whole world'?"—as the English patentee claimed some years later.[177] Repeated threats to overthrow the patent, accompanied by invective against patent agents in general, caused Miles Berry to publish a statement, dated Paris, 26 October, in the journal which his partner W. Newton edited.[178]

" . . . In purchasing the invention for herself, France did not intend gratuitously to give it to England and the whole world. This erroneous idea seems to have

taken possession of many of our countrymen, as well as foreigners. And why should France pay so large a remuneration as she has done to the proprietors of the Daguerreotype, for the empty honour of giving it to the people of England or any other nation? . . .

The facts are these: the French Government, under the advice and direction of that worthy and eminent philosopher, M. Arago, purchased the whole and sole right to exercise this invention of MM. Daguerre and Niépce, for the use of France and the French people; and these gentlemen, acting under the advice of their friends, took care to protect the discovery in England and Belgium*—and, I believe, elsewhere—before they made any exposition of it to the French nation.''

At the end of October Miles Berry was granted an injunction against de St Croix and the proprietors of the Adelaide Gallery who had supported him in his ''piratical attempt''.[179] This was the first lawsuit concerning photography—and there the matter rested for the time being. One thing is certain: Daguerre would not have dared to take out the patent without the knowledge of Arago and the French Government; he would not have risked a public scandal at the moment of his greatest triumph. It will be noticed that he was most careful to observe the *letter* of his agreement with the French Government: (article 3) ''The description of the process is not to be published until the draft of the Bill here discussed has been adopted.'' The Bill became law on 1 August, a fortnight before the patent was sealed (i.e. granted). Considering all the facts, it is impossible to avoid feeling that the French Government was guilty of hypocrisy.

From correspondence which—like the preceding letters—has hitherto remained unknown, it appears that some English people also attempted shady dealings. An English patent agent in Paris acting on behalf of a London patent agent named Delianson Clark threatened Isidore Niépce that Clark would have the patent put aside unless he were allowed a share in the profits.

<div align="right">

Paris, 5th October 1839.
24 Rue St Lazare.

</div>

To M. Niépce.
SIR,

I received an answer from Mr Delianson Clark, to whom I had communicated the proposals you said had been made to you.

His letter, I must confess, is far from expressing satisfaction. Having in a

* The authors are indebted to Gevaert Photo Producten, Antwerp, for kindly checking this point with the Belgian Patent Office, but no trace of such a patent could be found. Nor was the daguerreotype patented in any other country.

frank and loyal manner desisted from an opposition to your application for an English Patent, and sacrificed the first steps he had taken,* he considered he had a right to expect you would eagerly avail yourself of his services, and that a community of interests would thus secure to you advantages you could hardly obtain but through his mediation. Therefore, hurt as he is at seeing his offers rejected, and disbelieving those made to you, he threatens to throw in your way obstacles which your interest, better understood, would induce you to avoid. He mentions to me the difficulties he intends raising against you; and knowing, as I do, his resources, his position in London, and the turn of his mind, I assure you I do not exaggerate either his dissatisfaction, or the means he has of proving it.

Allow me therefore, Sir, to beg of you to pause before you take a decision, and to bear in mind that his dissatisfaction has a just cause, and that his co-operation may be as useful as his competition would be dangerous.

I remain, Sir, with due regard, &c.,

A. CANNING.

Niépce sent this letter to Miles Berry to deal with.

It is not unlikely that Miles Berry's attack on de St Croix was instigated by Antoine Claudet, who had bought the first licence to operate the daguerreotype direct from Daguerre himself, and not unreasonably wished to protect his newly acquired rights. Antoine François Jean Claudet, F.R.S. (1797–1867), a Frenchman who had settled in London in 1827 as an importer of sheet glass and cylindrical glass shades, had a shop at 89 High Holborn for the sale of those glass domes for covering clocks, statuettes, wax flowers, etc., so typical of Victorian interior decoration.

In the excitement which swept the world in January 1839 Claudet, a business-man with imagination, at once realized the commercial possibilities of the new invention if he were quick to exploit it. On the advice of his friend N. P. Lerebours, Claudet immediately went to Paris and obtained from Daguerre the agency for daguerreotype apparatus for England. In August, when Daguerre was free to divulge the secret of his process, Claudet received instruction in the manipulation from the inventor himself, and bought from him direct for £200 the first licence to practise the daguerreotype in England. It was stipulated, however, that if the British

* The editor of *The London Journal of Arts and Sciences*, 1840, p. 185, here added a footnote: "We presume he was obliged to abandon a caveat he had entered to catch this invention, not being in possession of such information as would enable him to raise an opposition against the Attorney-General's Report on Mr Berry's Petition for the Patent. . . . A party who obtained a Patent here in May last is about attempting to incorporate into his Specification the invention of MM. Daguerre and Niépce, though we have the most positive evidence that his invention in no one feature had any resemblance to the Daguerreotype, nor had any such idea entered his mind at the time he solicited his Patent."

Government or some public institution should later buy the patent and make the invention available to everyone, Daguerre would refund the purchase money of the licence. If a private purchaser for the patent should be forthcoming, Claudet was to be given the first option at the price offered.

At first Claudet restricted his activities to importing apparatus and pictures. During 1840 he bought from Lerebours several hundred surplus daguerreotypes taken for *Excursions Daguerriennes*. The first batch he submitted in April to Queen Victoria and Prince Albert, who selected some of the best. The remainder were exhibited at soirées of the Royal Society, and afterwards were put on sale at the business premises of Claudet and his partner George Houghton in High Holborn, at prices ranging from one to four guineas and upwards "according to their perfection, and the expense attending their production by travelling to the distant countries from which many of the views are taken."[180] Another selection of one hundred views of France, Greece and Italy were put on sale by Claudet at the Polytechnic Institution in June. For some months the daguerreotypes on sale were continental views, but on 18 July 1840 London views were mentioned for the first time, and these were doubtless taken by Claudet himself. The same advertisement announces "portraits from nature", "figures from the living model" (nudes) and "microscopic objects immensely magnified". A daguerreotype *portrait* was such a curiosity before March 1841, when the first public studio was opened in London, that people were willing to buy portraits of strangers—professional artists' models able to endure the necessary 10 to 15 minutes' exposure.

Meanwhile on 19 February 1840 Daguerre and Isidore Niépce had arranged to send to England a special agent, Elzeard Désiré Létault, with the object of selling the daguerreotype patent to the British Government or some public institution. The price Daguerre expected to obtain was about half the sum he claimed had been offered to him by England before the French Government acquired the invention. Létault's commission was to be 1,500 francs if the sale price should be less than 100,000 francs (£4,000). Should he obtain that sum he was to receive 2,000 francs commission, and of any amount which exceeded 100,000 francs he was to receive half (see terms of agreement in the appendix). Létault's expense account of £1 a day was generous considering the value of money at that period. However, Létault returned to Paris within the specified period (15 April 1840) without having achieved his object, no doubt because the English Government and public institutions did not want to have anything to do with an invention which had been first grandly given to the entire world and then patented in England only. The whole affair betrays a complete lack of understanding of English psychology.

In 1839–40 the daguerreotype process was too slow to allow of its application

to portraiture, and this was the case in England no less than in France and other continental countries, where chemists and opticians were trying to reduce the exposure to reasonable limits, either by increasing the sensitivity of the plate or by optical improvements. Only in America, as we have seen, were satisfactory portraits achieved, partly by the use of small cameras, and partly by the adoption of reflectors (see p. 135). Realizing that there was nothing like his mirror camera in Europe, which offered a wide field for its exploitation, Wolcott in February 1840 sent William S. Johnson, his partner's father, to England in order to sell the invention. Soon after his arrival he met in London through a patent agent named William Carpmael, Richard Beard, a coal merchant in Earl Street, Blackfriars, who speculated in patents. A somewhat complicated financial arrangement was arrived at. "Beard paid Johnson £200 and expenses for one-half of the American invention: the remaining half, with all profits, he purchased for £7,000 at twelve months from the issuing of the patent" [181] which Beard took out for the mirror camera on 13 June 1840.

As neither Beard nor Johnson senior knew anything about photography, they immediately engaged John Frederick Goddard (c. 1795–1866), a science lecturer at the Adelaide Gallery, "to apply his scientific knowledge to the improvement of the process". This refers to the use of bromine as an accelerator, with which, according to John Johnson, Alexander Wolcott had (unsuccessfully) experimented early in 1840. As a matter of fact, this important accelerating agent was included in Beard's patent of 13 June 1840 as: "An improved mode of treating the surfaces of prepared silver plates by submitting them to the chemical action of iodine and bromine or bromic acid combined, instead of treating them with iodine only. By the employment of this combination of iodine and bromine the surfaces of the silver plates are *said to be* [authors' italics] rendered more sensitive to the action of light, and the operation of obtaining perfect images greatly facilitated, whether performed by reflection from a mirror or through a lens."*

During the summer and autumn of 1840 Goddard and "other gentlemen of high scientific attainment" experimented with portraits from life at an establishment at Medical Hall, near Furnival's Inn, Holborn—on the site of the Prudential Assurance

* As there are several claimants to the honour of having first observed the superior sensitivity of silver bromide, it should be mentioned that priority in every respect, including that of publication, belongs to Dr J. W. Draper in the *Journal of the Franklin Institute*, Vol. XX, July 1837. However, whilst Draper was not concerned with photography but merely stated the results of his experiments on solar light, Fox Talbot mentioned the superior sensitivity of silver bromide for his Photogenic Drawing process in his communications to the Académie des Sciences on 18 March 1839 and to the Royal Society three days later. Sir John Herschel confirmed Talbot's observation in his communication to the Royal Society on 20 February 1840, when he stated that a glass plate coated with bromide of silver plus nitrate of silver is far more rapid than when coated with iodide of silver.

Co. In a studio with reflectors and blue glass screens, similar to Wolcott's Daguerrean Parlor (see p. 135), Goddard took the first (experimental) portraits in Britain —small pictures varying in size from that of a sixpence (for fitting in bracelets, lockets, etc.) to that of an ordinary miniature. In August the exposure averaged 5 to 6 minutes, but was reduced the next month to 1 to 4 minutes, according to size. "The features are admirably marked out, and are perfectly correct whatever may be the size in which they are taken, as they are all reduced in proportion. The eyes appear beautifully marked and expressive, and the iris is delineated with a peculiar sharpness, as well as the white dot of light on it."[182]

When Miles Berry heard of these activities he threatened legal action. Beard's and Johnson's argument that this was not Daguerre's invention but "the American photographic process" was of no avail. They had to give in and pay a licence fee of £150 p.a. for the right to daguerreotype with their mirror camera, and this did not include the use of Daguerre's apparatus.

As the days drew in and became darker Goddard redoubled his efforts. Eventually he succeeded in shortening the exposure by subjecting the plate to the fumes of bromine, as well as iodine. He may have been assisted by John Johnson, who was sent for by his father and arrived in London early in November, but all the available evidence points to Goddard's achievement, published by him in a letter to the *Literary Gazette* of 12 December 1840. Good portraits of William Johnson and Goddard's father taken on 12 and 16 February 1841 respectively were shown at a meeting of the Royal Society on the 18th. The exposures were 2 minutes 10 seconds for $1\frac{1}{2}$ in. × 2 in. pictures in very dark and rainy weather.[183]

Confident that exposures would be shorter in the brighter spring and summer weather, John Johnson went ahead in arranging the first *public* studio, which was erected on the roof of the Royal Polytechnic Institution, and overlooked Cavendish Square. It was opened on 23 March 1841 with J. T. Cooper and Goddard as operators; exposures varied from 3 seconds to 2 minutes, according to the weather.[184] Francis S. Beatty, an Irish engraver who was taken on as temporary operator in October 1841, said the exposure was 3 to 5 minutes.[185]

Great was the excitement caused in London by the novelty of having one's likeness taken by "the sacred radiance of the Sun" and crowds flocked to Beard's establishment. "In the waiting rooms you would see, awaiting their turn to enter the blue glass roofed room, the nobility and beauty of England, accommodating each other as well as the limited space would allow, during hours of tedious delay."[186]

The studio was circular so that the sitter could be made to face the sun at any time of day, and the posing-chair was on a raised platform, to bring him closer to the light from the blue glass windows which superseded the interposition of a screen.

"All the objects in the room have a bluish colour, which at first seems strange to the eye, but one soon gets used to it", wrote a reporter. "The person wanting to be portrayed is seated on a high comfortable chair, with his face turned towards the sun. The head is fixed with a kind of neck-iron. Opposite the sitter stands a big square box in which Mr Wolcott is hidden with his daguerreotype. He calls out to the 'patient' to put on a cheerful expression, and hardly is the latter ready with his grimace, than his image is already fixed on the silver plate with a surprising likeness. Before you have recovered from your astonishment at the wonder of physics, the picture is fixed by a chemical process; beautiful frames of every size and price are in stock, and before five minutes have passed, the visitor receives his *cara imagine* excellently carried out and nicely framed."[187]

"Do you know anything about that wonderful invention of the day, called the Daguerrotype [sic] ?" wrote Elizabeth Barrett to Mary Russell Mitford in 1843, "that is have you seen any portraits produced by means of it ? Think of a man sitting down in the sun and leaving his facsimile in all its full completion of outline and shadow, stedfast on a plate, at the end of a minute and a half! The Mesmeric disembodiment of spirits strikes one as a degree less marvellous. And several of these wonderful portraits . . . like engravings—only exquisite and delicate beyond the work of graver—have I seen lately—longing to have such a memorial of every Being dear to me in the world. It is not merely the likeness which is precious in such cases— but the association and the sense of nearness involved in the thing . . . the fact of the *very shadow of the person* lying there fixed for ever! It is the very sanctification of portraits I think—and it is not at all monstrous in me to say what my brothers cry out against so vehemently . . . that I would rather have such a memorial of one I dearly loved, than the noblest artist's work ever produced. I do not say so in respect (or disrespect) to Art, but for Love's sake. Will you understand ?—even if you will not agree ?"[188]

The earliest Beard photographs measure $1\frac{1}{2}$ in. \times 2 in. Each daguerreotype is protected by glass, with an oval or rectangular gilt matt—usually bearing the words "Beard Patentee"—interposed. The matt has the double function of preventing the glass from rubbing on the daguerreotype, and framing the portrait. The whole "sandwich" is set in a Pinchbeck case, the edges of which are turned over, sealing the daguerreotype from dust, and air which would oxidize the silver. The Pinchbeck case in turn is inserted in a dark red morocco leather case lined with red velvet. Early specimens are embossed on the back of the case with the royal coat-of-arms (signifying the Royal Polytechnic Institution, for Beard was never appointed photographer to the Queen) and the name of the case-maker and date of his patent,

"T. Wharton. No. 791, 24 August 1841". (Plate 115.) Occasionally they are in black
papier-mâché hanging frames of the kind used for silhouettes; these are considerably
rarer. They too bear a distinctive mark of their origin: the words "Beard Patentee"
are embossed on the setting of the hanging ring, and on the back of the frame is
affixed Beard's label. The earliest British daguerreotype which we have so far been
able to find is dated 1842 and shows a lady with low-cut bertha. (Plate 74.)

George Cruikshank caricatured Beard's studio in a woodcut (Plate 108) illus-
trating an amusing poem of several hundred lines on "The New School of Portrait-
painting" by S. L. Blanchard.[189]

> Like the crowds who repair
> To old Cavendish Square,
> And mount up a mile and a quarter of stair
> In procession that beggars the Lord Mayor's show.
> And all are on tiptoe, the high and the low,
> To sit in that glass-cover'd blue studio;
> In front of those boxes, wherein when you look
> Your image reversed will minutely appear,
> So delicate, forcible, brilliant and clear,
> So small, full, and round, with a life so profound,
> As none ever wore
> In a mirror before . . .
>
> His [Apollo's] agent on earth, when your attitude's right,
> Your collar adjusted, your locks in their place,
> Just seizes one moment of favouring light,
> And utters three sentences—"Now it's begun"—
> "It's going on now, sir"—and "Now it is done".
> And lo! as I live, there's the cut of your face
> On a silvery plate
> Unerring as fate,
> Worked off in celestial and strange mezzotint
> A little resembling an elderly print.
> "Well, I *never*!" all cry; "it is cruelly like you!"
> But Truth is unpleasant
> To prince and to peasant.
> You recollect Lawrence, and think of the graces
> That Chalon and Company give to their faces;
> The face you have worn fifty years doesn't strike you!

Excited though the crowds were, Beard was still more so. Business was beyond his wildest dreams; the average takings each day are said to have amounted to something like £150.[190] This figure, however, in all probability refers only to the enthusiastic onrush of the first few months, when a daguerreotype portrait was a great novelty, for N. P. Lerebours in November 1841 remarked[191] that the receipts at Beard's and Claudet's establishments in the early days "several times amounted to £60 in one day". Whatever the exact amount, the takings were undoubtedly very high, and Beard, realizing the fortune that lay within his grasp could he secure a monopoly in photographing "the human face divine", on 23 June 1841 purchased from Miles Berry the whole of the daguerreotype patent for £800, thus becoming the sole patentee in England, Wales and the Colonies. £800 seems a trifling sum for the monopoly of the daguerreotype for the remaining twelve years of the patent when we remember that only the previous year Daguerre had expected to obtain five times that amount, and considering that Beard had paid over £7,000 for the right to use Wolcott's camera, which was to be abandoned within two years.

In accordance with the arrangement made between Daguerre and Claudet in 1839, the patent was first offered to Claudet, but he could not afford it, and his partner, sceptical about the value of the investment, could not be persuaded to finance the project. In years to come, George Houghton must often have greatly regretted his shortsightedness, for Beard is said to have taken between £25,000[192] and £36,000 [193] in the second business year alone from the sale of licences and fees from his professional studios.

Since the summer of 1840 Claudet, like Beard, had been trying to speed up the daguerreotype process, but unable to avail himself of either Wolcott's camera or Goddard's accelerator bromine, both of which were patented, Claudet found a solution to the problem only two months after Beard had started business. It was in May 1841 that he made the discovery that a combination of chlorine and iodine vapour greatly increased the sensitivity of the plate. He communicated this accelerating process to the Royal Society on 10 June, a report to the Académie des Sciences in Paris having been read three days earlier.[194] The exposure was comparable with Beard's, varying between 10 seconds and 2 minutes according to the strength of the sunlight, the time of day, and the season of the year. It is astonishing how greatly the exposure varied from one month to another. "In June I operated in 10–20 sec., in July in 20–40 sec., in August in 40–60 sec., and now in September in 60–90 sec."[195] Whereas Goddard's accelerator was patented, Claudet made his freely available and thus provided perhaps the most important chemical advance in perfecting the daguerreotype, after Fizeau's gold toning (see p. 121).

The same month (June 1841) Claudet began taking portraits professionally in

the "glass-house" he had erected for experimental work some time in 1840 on the
roof of the Adelaide Gallery, just behind St Martin's-in-the-Fields.* Glazed with
blue glass, the studio was only used in cold or rainy weather; on fine days the sitter
was posed in the open air under an awning to screen the face from the glare of
sunlight.

"In that year (1841) I remember having my daguerreotype portrait taken by
M. Claudet on the roof of the Adelaide Gallery", wrote Thomas Sutton. "I was
seated one sultry summer afternoon at about three o'clock, in the full blazing
sunshine, and after an exposure of about a minute the plate was developed and
fixed with hypo. My eyes were made to stare steadily at the light until the tears
streamed from them and the portrait was of course a caricature. It has since
faded. I paid a guinea for it. M. Claudet himself superintended the pose, and an
assistant, a mere youth, prepared and developed the plate. . . . In conversation
with M. Claudet about the wonderful art which he practised, he informed me,
with the utmost gravity, that to achieve anything like success or eminence in it
required the chemical knowledge of a Faraday, the optical knowledge of a Hers-
chel, the artistic talent of a Reynolds or a Rembrandt, and the indomitable pluck
and energy of a Hannibal; and under these circumstances he strongly dissuaded
anyone from taking it up as an amusement."[196]

As soon as Beard heard of Claudet's activities he tried to get rid of his rival, and
on 15 July obtained an injunction restraining him from taking daguerreotypes.
Beard based his case on the clause in Claudet's agreement according to which he was
to receive back the value of his licence in the event of the patent being sold outright
to another party. In court Beard stated that Miles Berry had tendered Claudet £200
for the repurchase of his licence and had called upon him to assign it to Beard.
Claudet refused, contending that the wording of the clause did not make it com-
pulsory on him to *resell* his interest, though it did impose an obligation on the
patentee to tender the £200 for its *repurchase*. It is difficult to judge whether Claudet
was morally bound to relinquish his licence even though the wording of the agree-
ment left him a loophole, or whether he was indeed only insisting on his rights.
However that may be, the High Court of Chancery accepted Claudet's plea and
exactly a week later the injunction was dissolved. Beard appealed against this
judgment at the Court of Queen's Bench in June 1842, and at the Court of Ex-
chequer in 1843, but each time the High Court's decision was upheld. So the anom-
alous situation existed that although Beard was sole patentee of the daguerreotype,

* Better known to the present generation as Gatti's Restaurant, it became the Nuffield Centre in July
1948.

he had no control over Claudet's roof, which established itself as a new meeting place for friends, families and parties. "By his improved process Mr A. Claudet is enabled to take groups of three to six persons either engaged at tea, cards, chess, or in conversation, affording whole-length family portraits, or of friends, arranged in any manner most agreeable to the parties."[197] The possibility of taking several portraits simultaneously was a novelty to people who, thinking in terms of miniatures and silhouettes, believed that it would take several times longer than a single portrait.

Nevertheless, for the first ten months or so Claudet's portraits were inferior to Beard's, one of the chief drawbacks being the lateral reversal of the portrait, which did not occur with Wolcott's mirror camera. Having the advantages of the practical experience gained by Wolcott and Johnson in New York, and many months of Goddard's experimental work at Medical Hall, the pictures taken in Beard's studio were considered superior "in fidelity of resemblance, delicacy of marking, and clearness of effect". Fully aware of the defects of his pictures, Claudet later advertised "Having always adopted the practice of exchanging for better portraits those which have not been satisfactory, all persons exhibiting first portraits taken at this establishment will be entitled to duplicates at half price."[198] The price of a single portrait was one guinea for a $2\frac{1}{2}$ in. × 3 in. picture and more for larger sizes.

In August 1841 Claudet announced that "By a new application M. Claudet is enabled, *without any additional charge*, to fix the portraits and render them so durable that they will not fade or turn black."[199] One wonders what the earlier portraits were like!

With the intention of distinguishing his establishment from Claudet's in the public mind, Beard designated his pictures: "Patent photographic likenesses taken by Wolcott's reflecting apparatus", and adopted the term "photography" on the grounds that this is "a name better suited to the principles of English nomenclature than that of daguerreotype, which, although a favourite word on the Continent, is by no means suited to our views, as it has no reference whatever to the principles of the subject."[200]

Meanwhile in July 1841 Alexander Wolcott also arrived in London to superintend the manufacture of equipment required for other projected studios, and for this purpose a factory at 1 Wharf Road, City Road, was taken over. Encouraged by the excellent business at the Polytechnic Institution, during 1842 Beard opened two more studios in London, at 34 Parliament Street, Westminster, on 29 March, and a month later at 85 King William Street, City.[201] Simultaneously with the opening of the new London studios began the establishment of a number of studios in the provinces: at Liverpool (Mount Gardens, St James's Walk) in September 1841. According to the *Liverpool Mercury* of 10 September 1841 "the photographic com-

pany gave £2,500 for the patent [licence] for Liverpool and ten miles round, and erected an elegant building on land granted by the Corporation." John Relph was manager of the studio, and the price for each portrait was one guinea. Later a second establishment was opened at 34 Church Street, Liverpool. Photographic institutions were opened at Southampton in October 1841, [202] and at Brighton on 8 November 1841.[202a] The proprietor of the latter, on the Marine Parade, was William Constable, who took the earliest photographic portrait of Prince Albert on 6 March 1842. William Constable remained the only professional photographer in Brighton for the next ten years, and during this period many distinguished people sat to him, including the Duke of Devonshire and the Duke of Parma. In Manchester a studio was opened at the Exchange on 18 November 1841.[203] Lastly, we know of one at the Royal Bazaar, Norwich. Beard's name does not, however, appear in connection with these provincial studios for he sold each business when completed, with the licence which was sometimes for a town only, and at others extended to one or several counties. In this way Beard assigned to John Johnson the sole and exclusive right for the counties of Lancashire, Cheshire and Derbyshire on 9 November 1842.[204]

Photography had become big business for the former coal merchant. Yet at first, few people considered it worth while to pay the high licence fees asked for. To induce them to take up photography as a profession Beard explained to enquirers the very large gains that lay within their grasp, basing his figures on his own experience.

Charge	Profit
1 guinea (for a bust)	about 18s.
30s. (slightly larger size)	about 25s.
2 guineas (full length)	about 34s.
4 guineas (a miniature painted *from* a daguerreotype)	about 70s.

exclusive of the charge of 5s. for colouring each portrait, "the cost of which is not a penny".[205]

The reference to colouring probably meant that Beard charged no extra licence fee for colouring daguerreotypes, which he had also patented, on 10 March 1842.

Though amateurs could buy a licence for five guineas, the process was evidently too complicated and the outfit too expensive for anyone to daguerreotype for amusement only. We have in fact not seen any English daguerreotypes other than professional portraits, apart from the daguerreotype views of Rome and other Italian cities taken in 1840–41 by Dr Alexander John Ellis and his assistants Achille Morelli and Lorenzo Suscipi. They were intended for a publication, "Italy Daguerreotyped", which did not materialize on account of the expense of engraving the pictures.

One hundred fifty-eight wholeplate daguerreotypes by Dr Ellis are preserved at the Science Museum, London.

Scotland and Ireland were not included in the patent but amateurs there mostly used Fox Talbot's Calotype process, which besides being simpler and cheaper was not patented there either. However, Dr George Skene Keith, brother of Dr Thomas Keith the calotypist, accompanying his father on his second visit to Palestine and Syria in 1844, took about thirty daguerreotype views, including some of Petra. Eighteen of them were published as engravings in the thirty-sixth edition of the Rev. Dr Alexander Keith's (his father's) book *Evidence of the Truth of the Christian Religion* (Edinburgh, 1848). This is the first, and as far as we know the only, British book to be illustrated with engravings copied from daguerreotypes.

It is most probable that Beard bought the method of colouring daguerreotypes from the Swiss painter and daguerreotypist J. B. Isenring (see p. 178), who was the first to perfect a process and then immediately sold it to an English chemist, Robert Porret(?), on 17 January 1842. A condition of the contract was that Isenring must refrain from using his method for the next eight months.[206] Accustomed to miniatures, people had from the first been disappointed that daguerreotypes were not in colour, and understandably also objected to their metallic glare: hand-colouring gave them that charm and warmth they lacked. High-class miniature painters found a new lease of life by deftly combining the old art with the new. Sometimes "the likeness taken by the photographic process serves merely as a sketch for the miniature. . . . They have, when finished, all the delicacy of an elaborate miniature with the infallible accuracy of expression only obtained by the photographic process." More often the daguerreotype itself was coloured, a procedure which demanded great skill. A tracing of the portrait was made on glass, and from this a tracing-paper stencil was cut for each different colour. Dry powder colour, containing a little gum arabic, was then shaken on over the stencil. Alternatively, the powder could be applied with a fine camel-hair brush. The colours adhered to the metal when gently breathed upon to dissolve the gum arabic.

Another way of relieving the plainness of daguerreotypes was the introduction by Claudet of backgrounds of painted scenery representing trees, architecture or a library.

Claudet was also the originator of the photographic darkroom light. Finding the need for a more satisfactory way of observing the progress of development than occasionally peeping at the plate in the mercury box by the light of a taper, Claudet patented the idea that all operations upon the daguerreotype plate should be performed in a room illuminated by a red light, the colour of which did not affect the sensitive plate. He also constructed a camera in which the development with mercury vapour was carried out *inside* the camera box itself, which had a red window,

instead of having to resort to a darkroom. Claudet does not seem to have enforced his patent rights, however, for both darkroom light and painted backgrounds, included in the same patent of 18 December 1841, soon became general.

Though for the first ten months or so Claudet's daguerreotypes were inferior to those of his rival Beard, by the middle of 1842 they were generally considered to have surpassed them technically as well as artistically. In July 1842 he photographed some of the dancers at the Italian Opera "in postures that could be retained but for an instant, such as poising on one toe with the other leg extended, and resting on the points of both feet",[207] and these pictures aroused much interest as being the first "instantaneous" portraits.

Early the following year Claudet spent several months in Paris, where he photographed Louis-Philippe and a number of other notabilities. When he returned to London he brought with him a Petzval lens, which was much faster than any previous lens (see p. 174) and consequently permitted the taking of larger portraits than before, and announced that "M. Claudet is now enabled to take likenesses of a much larger size upon plates $6\frac{1}{2} \times 8\frac{1}{2}$ in. and even of the extraordinary dimensions of 16×13 in. [against the previous limit of $2\frac{1}{2}$ in. \times 3 in.]; and nothing can be more striking than the effect produced by these enlarged portraits. M. Daguerre has personally communicated to M. Claudet his latest discoveries, by which the process is much improved."[208] To hold his own, Beard also was now obliged to employ the Petzval lens, and Wolcott's mirror camera, the rights of which had been so expensively acquired, was abandoned.

The fact that the daguerreotype was a unique picture had from the earliest days been regarded as a drawback which could be only partially overcome by taking several portraits at a sitting. This was not an altogether satisfactory solution, since the pictures were never exactly the same. Some clients, too, wanted portraits of larger dimensions. Claudet solved the problem by having a camera made in 1842 which was fitted with a repeating back containing a large daguerreotype plate. By means of this he was able to take "multiple portraits", as he called them, on one plate, which was cut up afterwards into the several separate portraits. He showed some of these at the Exhibition of the Products of French Industry in Paris, 1844. Alexander Wolcott and John Johnson found a different solution. They devised an apparatus for copying daguerreotypes, either on a daguerreotype plate or on sensitized paper, for which purpose Beard acquired a Calotype licence from Talbot in 1842. With this enlarger, which was patented in March 1843 and is the first to be constructed anywhere, copies could be made in the original size, diminished, or enlarged to "life-size". Though the apparatus was installed in all Beard's studios, the complete absence of any Beard daguerreotypes larger than $3\frac{1}{2}$ in. \times $4\frac{1}{2}$ in. would

indicate that it was chiefly used for making additional copies, or for enlargements of the very small portraits taken during the first two years with the mirror camera.

In 1844 Claudet abandoned his glass-house on top of the Adelaide Gallery and moved to more commodious premises on the top floor of the adjoining house, which communicated with the Adelaide Gallery and also had a private entrance at 18 King William Street (now William IV Street). Here he followed Beard's example in providing a waiting-room "specially for ladies, who can avail themselves of the attendance and attention of a respectable female". Since the artistic effect of daguerreotype portraits depended to a large extent on the sitter's dress, garments suitable in shape and colour were provided at Beard's and Claudet's establishments, but fastidiousness and individual taste caused most sitters to refuse to wear dresses that had clothed others before. Preliminary advice on what to wear was therefore desirable:

"Avoid pure white as much as possible. Some ladies dress themselves out in snowy berthas and spotless wristbands; but many a good picture is spoiled by the spottiness occasioned by the powerful action of this colour upon the plate. Violets have also the same effect upon it. A lady takes her sitting in a purple dress and is astonished to find herself in a white muslin in her portrait, this particular colour acting even more intensely than the pure white upon the prepared silver. The very best kind of dress to wear on any such occasions is a satin or a shot-silk, or any material, in fact, upon which there is a play of light and shade. Plaids always look well; and an old tartan shawl thrown across the shoulders and well composed as to folds would form an admirable drapery, but this is an artistic liberty which ladies are very loath to submit to. . . .

We wish ladies would be a little less prim on such occasions. It is quite melancholy to see the care they take to brush their hair, and apply that *abomination* fixiture [sic] to make it 'look nice'; whereas if a good breeze had broken it up into a hundred waves, the effect in the daguerreotype would have been infinitely more beautiful. And let them by all means abjure the system of making up a face for the occasion. The effect is painfully transparent. The mouth, so expressive in all faces, in these portraits is nearly always alike; and for the simple reason, that we put its muscles into attitudes which are not at all natural to it—we substitute a voluntary for an involuntary action; and of course stiffness is the result. If ladies, however, *must* study for a bit of effect, we will give them a recipe for a pretty expression of mouth—let them place it as if they were going to say *prunes*."[209]

Among the many distinguished people whom Claudet photographed in the mid-forties were the inventors of photography Talbot (1844) (Plate 77) and Daguerre (1846), the Dowager Queen Adelaide and the Duke of Wellington (both in 1844), the Duke and Duchess of Northumberland, and the Duke of Richmond. The Duke of Wellington's portrait (Plate 83)—the only photograph for which he ever sat—was by general consent the best likeness of him, and was copied in several engravings and miniatures. Ryall's engraving (Plate 82) published on the Duke's birthday the following year is a good example both of the licence engravers took in copying photographs, and of the untrustworthiness of their results in general; the reversal of the portrait probably rectified Claudet's failure in not employing a reversing prism at that time. In later years he did, and in his anxiety to connect two important points in an advertisement, he unintentionally produced this humorous result: "Mr Claudet's Coloured and Non-inverted Daguerreotype Establishment is open every day."[210]

On 5 April 1847 Claudet opened another portrait studio at the Colosseum in Regent's Park. This establishment, reopened in 1845 with a 400-ft.-long × 115-ft.-high panorama of London* by E. T. Parris, and a permanent exhibition of sculpture, soon became popular, and seemed, therefore, to provide a most favourable place for a portrait studio, expecially since "the atmosphere of that locality being free from smoke will greatly facilitate the photographic operations".

It is difficult to describe the general resentment which the daguerreotype patent —and the Calotype patent—aroused, and the retarding influence they had on the progress of photography in England. Like Fox Talbot, the patentee of the daguerreotype was constantly involved in lawsuits against infringers. Warnings threatening to prosecute unlicensed daguerreotypists usually bore the additional remark "Information, with necessary proofs, relating to infringement, will be liberally rewarded", and those who made it their business to snoop had a busy time as *agents provocateurs*.

The most important of Beard's lawsuits, and the longest in the history of British photography, was that against John Egerton, which occupied the courts on and off for five and a half years, from February 1845 to June 1849.[211] In this lawsuit Egerton was able to rally to his side all the indignation and contempt in which Daguerre's patent had been held by a large section of the public for years, and this fact may be responsible both for the long duration of the case and the final verdict. For though

* The preliminary sketches for this panorama were made in 1821–22 by the land surveyor Thomas Horner, working in a small wooden cabin that had been constructed for this purpose above the cross on the dome of St Paul's Cathedral. When the panorama painted by E. T. Parris from these sketches was first exhibited in 1829 it was considered one of the wonders of the world. Covering over an acre of canvas, it was the largest painting in the world.

Beard won in the end* he was not awarded damages, and the high legal costs, as well as the loss of licence fees which had brought in large sums in the first few years of the patent, proved his ruination. Just over three months after winning the action, on 8 October 1849, Beard applied for a certificate of bankruptcy, which was granted on 5 June 1850.

Bankruptcy did not bring Beard's photographic activity to a sudden conclusion, but gradually, one by one, his London studios were disposed of, beginning with the first at the Polytechnic Institution in 1852, until in the end Beard retained only his establishment in King William Street, London Bridge, which had from its opening in 1842 been under the management of his son Henry.

While Beard gradually moved down in the world, Claudet's reputation was yearly increasing. In 1851 he set up a "Temple to Photography" at 107 Regent Street, the southern end of which, round Vigo Street and the Quadrant, was almost monopolized by photographers, whose "glass-houses" are still commemorated in the name Glasshouse Street. Sir Charles Barry, architect of the new Houses of Parliament, reconstructed the existing building in Renaissance style, while the interior decoration was entrusted to Hervieu, a then well-known French artist. Paintings illustrating the history of photography and the various photographic processes, and medallion portraits of men who promoted the science of photography and stereoscopy surrounded the visitors in the waiting rooms and studios. By general consent it was the most elegant and luxurious establishment of its kind in Britain.

"What Lawrence did with his brush, M. Claudet appears to do with his lens; he catches the best aspect of his sitter, and does full justice to nature. His female portraits have a grace and a delicacy which we have never seen before in Sun-portraits, his men too, show blood; and these advantages are secured without loss of likeness or naturalness. . . . What can the miniature painter—the painter of real portraits, not ideal or poetic images—do against the Sun?"[212]

In 1853 Claudet was commanded to take portraits of Queen Victoria and other members of the royal family, and this led to his appointment as "Photographer-in-ordinary to the Queen".

Claudet prided himself on being not only the first in England to practise the daguerreotype but also the last to abandon the process.† He was in addition the first person successfully to apply photography to the stereoscope, in 1851, and during the following years produced a large number of stereoscopic daguerreotypes. Though Claudet, Beard and others had in 1842 attempted to take some stereo

* The daguerreotype patent was *not* set aside, as has been erroneously stated by Sir David Brewster and others: it ran its normal course of fourteen years, expiring on 14 August 1853.

† One in the Gernsheim Collection is dated as late as 1858.

photos for Sir Charles Wheatstone's reflecting stereoscope, daguerreotypes proved unsuitable for examination in this instrument which admitted light from all directions, on account of the reflections from their highly polished surface. In 1850 a Parisian optician, Jules Duboscq, undertook to manufacture a closed form of refracting or lenticular stereoscope devised by Sir David Brewster the previous year. In this box-form stereoscope the previous disadvantage did not occur, and when displayed at the Great Exhibition it attracted the curiosity of Queen Victoria. The Queen's immense interest in any photographic novelty proved very beneficial for the progress of British photography in the nineteenth century. In this case it resulted in a universal craze for "3D" pictures, to use the term of the modern revival. Half a million stereoscopes were sold within the next five years.[213]

Claudet, Beard, Mayall and Williams at once began taking stereoscopic views of the interior of the Crystal Palace and of the exhibits. Claudet succeeded also in taking portraits and even groups such as the charming "Geography Lesson" (Plate 84). These pictures had to be taken with two cameras set up side by side, for a twin-lens camera had not yet been constructed. Claudet sent a selection of these photographs to the Emperor of Russia, who, unable to come to London personally, was so delighted to be able to obtain a lifelike impression of the exhibition that he presented Claudet with a magnificent diamond ring, accompanied by a letter complimenting him on the marvellous effect of relief obtained in the stereoscope. The proud owner promptly made a stereoscopic daguerreotype of the ring, an engraving of which was published in *The Illustrated London News* in April 1852.[214]

After 1851 Claudet devoted much of his time to improving and developing stereoscopic photography and was largely instrumental in making it popular. Apart from devising an improved viewing instrument with eye-pieces adaptable to various sights, he patented in 1853 a folding pocket stereoscope, similar to the one registered by W. E. Kilburn (Plate 112), and invented a large revolving stereoscope (1855) in which one hundred stereoscopic slides were mounted on an endless band and rotated by knobs.

Other London Studios.

Until June 1846 there were only four daguerreotype portrait studios in London —three of Beard's, and Claudet's. The mounting costs of the protracted lawsuit against Egerton and the uncertainty of its outcome forced Beard eventually to relax his hold on the monopoly in the capital. During the latter part of 1846 and in 1847 three new daguerreotypists, all licensed by Beard, opened studios in London.

First on the scene was an American, John Jabez Edwin Mayall (1810–1901), who arrived in London towards the end of 1846 from Philadelphia, where he had

87. "Le talent vient en dormant", lithograph by Gérard Fontallard, March 1840

86. "La Patience est la vertue des ânes", lithograph by Honoré Daumier, July 1840

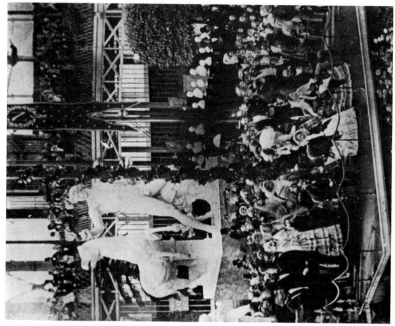

89. Queen Victoria, Prince Albert, Napoleon III and the Empress Eugénie at the Crystal Palace, 20 April 1855. Stereoscopic daguerreotype by T. R. Williams

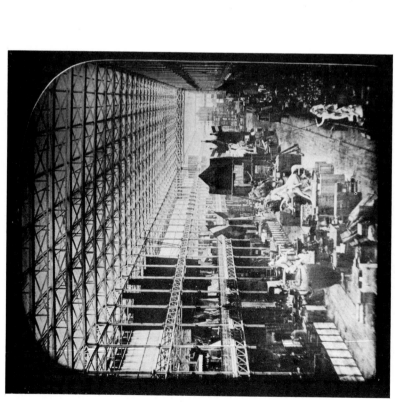

88. Interior of the Crystal Palace, 1851. Stereoscopic daguerreotype by T. R. Williams

91. Mrs. Glanville and her daughter Mrs. Harriet Spencer. Stereoscopic daguerreotype by A. Claudet, 1857

90. Victorian interior. Stereoscopic daguerreotype by A. Claudet, 1855

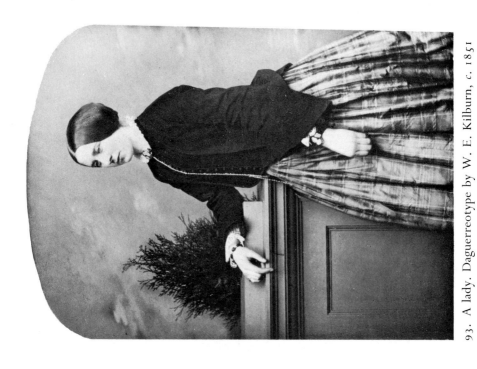

92. A Lieut.-Colonel of the 65th Foot. Stereoscopic daguerreo-
type by T. R. Williams, c. 1855

93. A lady. Daguerreotype by W. E. Kilburn, c. 1851

95. An odalisque. French stereoscopic daguerreotype, c. 1853

94. An artist's model. French stereoscopic daguerreotype, c. 1853

96. Ruins around the Alster after the great fire of Hamburg, 1842. Daguerreotype by C. F. Stelzner. The earliest surviving news photograph

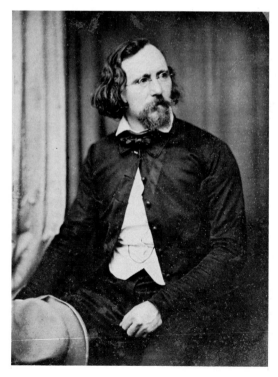

97. Jacob Venedey, Member of Parliament for Homburg. Daguerreotype by Hermann Biow, 1848

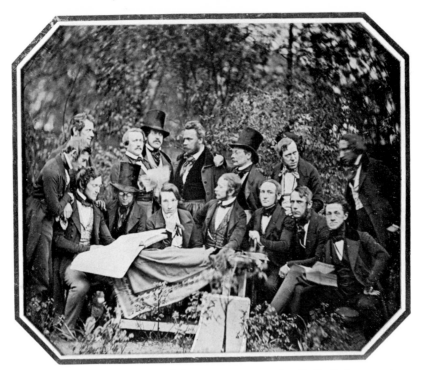

98. Outing of Hamburg art club. Daguerreotype by C. F. Stelzner, 1843

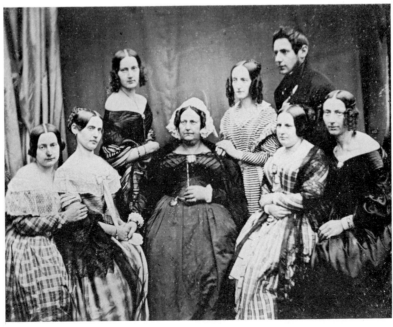

99. Family group. Daguerreotype by Hermann Biow, c. 1845

101. A gentleman. Daguerreotype by C. F. Stelzner,
c. 1850

100. Frau von Braunschweig (left) and Frau C. F. Stelzner.
Daguerreotype by C. F. Stelzner, c. 1849

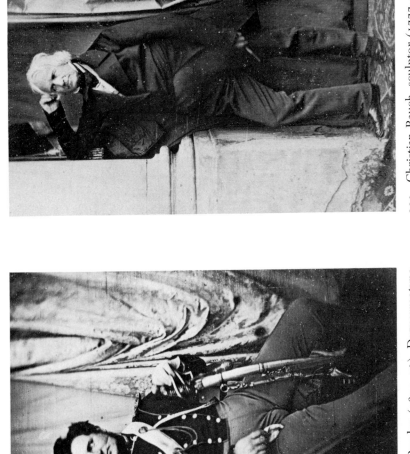

103. Christian Rauch, sculptor (1777–1857). Daguerreotype by Hermann Biow taken in Berlin, 1847

102. Dr H. Nicolaus von Beseler (1803–52). Daguerreotype by Hermann Biow, 1843

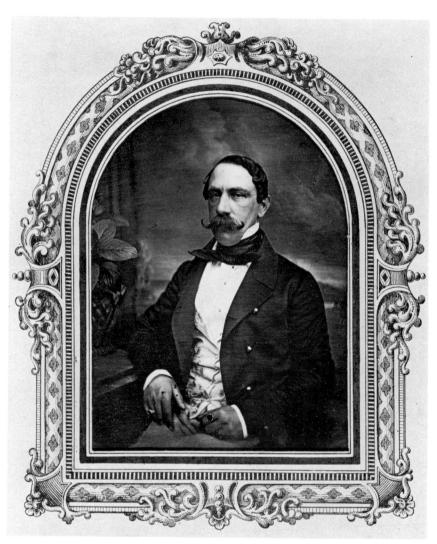

104. A gentleman. Daguerreotype by C. F. Stelzner, c. 1848

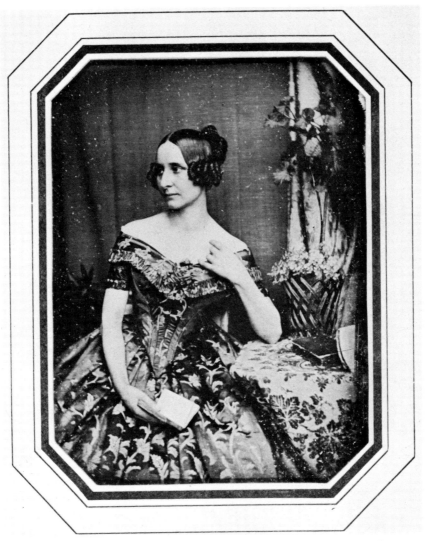

105. Caroline Stelzner, miniature painter (1808–75). Daguerreotype by C. F.
Stelzner, c. 1843

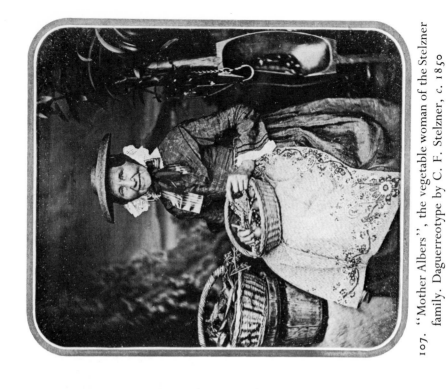

107. "Mother Albers", the vegetable woman of the Stelzner family. Daguerreotype by C. F. Stelzner, c. 1850

106. A dancer. Daguerreotype by C. F. Stelzner, c. 1850

109. Joint meeting of the Académies des Sciences et des Beaux-Arts on 19 August 1839. On the platform from L. to R.: Arago, Daguerre, Isidore Niépce

PHOTOGRAPHIC PHENOMENA, OR THE NEW SCHOOL
OF PORTRAIT-PAINTING.

" Sit, cousin Percy ; sit, good cousin Hotspur !"—HENRY IV.
" My lords, be seated.''—*Speech from the Throne.*

108. Beard's studio. Woodcut of drawing by George Cruikshank, 1842

110. "La Daguerréotypomanie", lithograph by Théodore Maurisset, December 1839

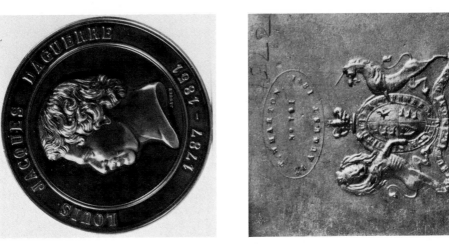

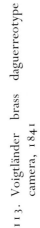

113. Voiglländer brass daguerreotype camera, 1841

114. Daguerre medal given as a prize by the Club of Amateur Photographers, Vienna, 1888

115. Metal frame of early Beard daguerreotypes embossed with the Royal coat-of-arms of the Royal Polytechnic Institution, and the name of the frame-maker T. Wharton and the number and date of the patent for the frame, 24 August 1841

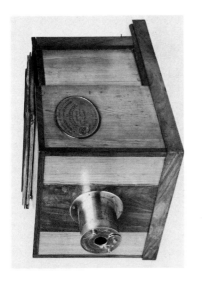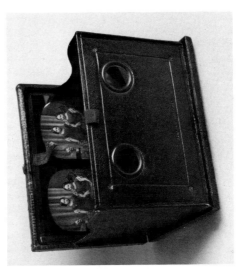

111. Daguerre camera, 1839, with Giroux's seal and Daguerre's signature

112. W. E. Kilburn's folding pocket stereoscope, January 1853

PUBLISHED SEMI-MONTHLY, AT THREE DOLLARS PER ANNUM, IN ADVANCE.

THE
DAGUERREIAN JOURNAL :

Devoted to the Daguerreian and Photogenic Art.

Also, embracing the Sciences, Arts, and Literature.

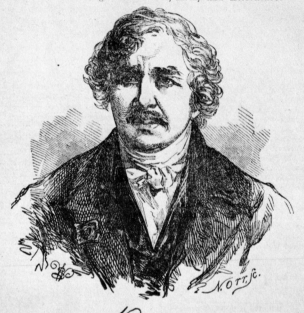

NOVEMBER 1, 1850.

NEW-YORK:

S. D. HUMPHREY, EDITOR AND PUBLISHER,
NO. 235 BROADWAY.

SINGLE NUMBERS TWENTY-FIVE CENTS SUBJECT TO NEWSPAPER POSTAGE.

116. Title-page of *The Daguerreian Journal*, 1 November 1850. New York. With woodcut of Daguerre. The first photographic journal

originally been a lecturer in chemistry, and running a daguerreotype studio since
1842. For a time he seems to have managed Claudet's business at King William
Street, Strand, while the latter was establishing his new studio at the Colosseum;
but by early March 1847 Mayall had his own establishment, "The American Daguer-
reotype Institution", 433 West Strand, where he was known as "Professor High-
school", a pseudonym which he had used in Philadelphia. From the first moment
his business flourished for, like all American daguerreotypes, Mayall's were distin-
guished by their superior polish and clarity, and were larger than English ones. A
"life-size" portrait shown in the photographic section of the Birmingham Exhibi-
tion of Manufactures and Art, 1849, was described as "the largest picture which
the pure pencil of the sunbeam has ever painted."[215] Another "largest-ever"
daguerreotype was a "Bacchus and Ariadne" (probably a copy of a painting) measur-
ing 24 in. × 15 in.—a great technical feat. Mayall may be considered one of the
earliest exponents of pictorial photography. A series of ten daguerreotypes illustrat-
ing the Lord's Prayer which he had taken in Philadelphia in 1845, a set of six
pictures (1848) illustrating Campbell's poem "The Soldier's Dream", and "The
Venerable Bede blessing an Anglo-Saxon child" were described in the catalogue of
the Great Exhibition, 1851, as "Daguerreotype pictures to illustrate poetry and
sentiment."[216] In some of these, painted landscape backgrounds were used; in
others, a landscape was painted in on the photograph. Though full of praise for
Mayall's portraits, The Athenaeum did not approve of these compositions. "It seems
to us a mistake. At best, we can only hope to get a mere naturalistic rendering.
Ideality is unattainable—and imagination supplanted by the presence of fact."[217]

Mayall probably realized the validity of this criticism, for he abandoned this
hybrid mixture of "art photography" in spite of Prince Albert's encouragement,
who "took him by the hand, consulting him now and again upon the rapid strides
which photography began to take".

Mayall took daguerreotypes of many famous people including Daguerre himself,
Herschel, Faraday, Brewster, Bulwer Lytton, and Turner (all between 1846–49).
Turner was fascinated by the daguerreotype and used to visit Mayall frequently.
He sat watching him at work, and they often experimented together with different
lighting effects.[218]

Mayall seems to have been the first "at home" photographer, for his catalogue
of 1848 announces "Invalids are waited upon at their own residence." His charges
in this year for portraits, complete in morocco leather case, ranged from 10s. 6d. to
£2 10s. for plain daguerreotypes, and from 15s. to £3 3s. coloured, according to
size. For groups, the charges were higher, according to the number of people in the
picture.

Portrait photography, then as now, called for patience and tact on the part of the photographer. As mentioned by Lerebours in 1843 (see p. 118) vanity is manifest to every portraitist, whether painter or photographer. Mayall had his share of difficult sitters, but not all were as obstinate as a lady who had sat for her portrait in his absence.

"In turn every possible view of the face had been tried: right-side, and left-side, front, three-quarters, and profile, and almost every modification between; but the lady was dissatisfied. . . . Presenting herself next morning, and explaining the case, she was blandly received by Mr M., who had heard all particulars from his operator.

'Be so good as to take a seat here, madam,' placing a chair with its back to the camera.

The lady, wondering, did as she was desired; Mr M. then proceeded gravely to place the head-rest to the forehead instead of as usual to the back of the head. Having focused, and put the plate in the camera, he said, 'Now, madam, if you will be so good as to remain quite still for a few moments——'

'Why, Mr M., you are about to take the back of my head!' exclaimed the lady.

'Precisely so, madam. That is the only change now left for us. I have seen the pictures taken, they are all excellent Daguerreotypes, and very good likenesses. Every possible view of the face has been tried; our only chance of pleasing now, is by trying a portrait in which the face will be entirely absent.'"[219]

Mayall was polite and good tempered, and the lady, not entirely unreasonable, was struck with the ludicrous position: with a laugh she asked permission to see the rejected pictures of yesterday once more, and eventually selected several of them to be finished and paid for.

About 1852 Mayall opened a second studio at 224 Regent Street (Argyll Place) under the management of a Dr Bushnell, also formerly of Philadelphia; in June 1855 he sold the American Daguerreotype Institution in the Strand to Jabez Hughes, who had been trained by him in this studio.

William Edward Kilburn opened his daguerreotype studio at 234 Regent Street towards the end of 1846. He soon counted as one of the three leading daguerreotypists (Plate 93), the others being Claudet and Mayall. In April 1847 the Queen and Prince Albert sat to Kilburn for their portraits in the conservatory at Buckingham Palace, and in acknowledgment of his success he was appointed "Her Majesty's Daguerreotypist".

Archibald Lewis Cocke did not open his business until the spring of 1847. His first studio was on top of an elegant draper's shop (possibly Swan & Edgar's) at 44 Regent Street.

William Telfer's "Royal Photographic Establishment" at 194 Regent Street, opened about 1848, also turned out some exquisite daguerreotypes. (Plate 78.)

A year or two later T. R. Williams (1825–71), originally Claudet's assistant and later employed by Beard, set up his own business at 236 Regent Street. Williams may be credited with having taken one of the earliest news photographs—the opening ceremony of the rebuilt Crystal Palace at Sydenham on 10 June 1854. During the prayer of the Archbishop of Canterbury he took three daguerreotypes 3 in. × 5 in., which he exhibited the same evening at Lord Rosse's soirée. "The portraits of the Queen and the brilliant cortège which surrounded her at the moment were strikingly effective."[220] Williams took a similar photograph during the state visit of Napoleon III and the Empress Eugénie with Queen Victoria and Prince Albert to the Crystal Palace on 20 April 1855 (Plate 89). Working from a platform erected in the gallery opposite the royal dais, he succeeded, in spite of the comparatively long exposure necessary, in taking the picture by choosing a quiet moment in the proceedings, a speech of welcome. The sculpture in the background of this historical photograph is a copy of one of the Horse-Tamers outside the Quirinale in Rome. Also worth noting is the large N in honour of Napoleon on the banner at the right.

Apart from the fashionable West End daguerreotypists enumerated, there were a much larger number whose portraits bear no sign of origin, indicating that not a few may have traded "black". The Fleet Street region seems to have been favoured for such operations. It was here that Egerton worked until served with an injunction by Beard; we also hear of a Miss Wigley of 108 Fleet Street, the first woman photographer in Britain, and of another daguerreotypist whose establishment appears in loftier regions in "Cuthbert Bede's" amusing account than it probably was in reality.

"A placard informed us that the Daguerreotype and Photographic Rooms were upstairs ☞. So we passed down a dark passage, and tumbled onto a still darker staircase, to the great damage of our shins, and the needless outlay of inelegant expressions. With a little difficulty, we got up a flight of steep stairs, kicking against each stair as we went, to keep ourselves on the right track; and at length we found ourselves on a small landing, of a size calculated to hold one uncomfortably. We looked about us, and, by the light that dimly straggled through a half-glass door, we saw before our nose—indeed, against it—another ☞ as

though pointing out to us an upward path. We silently took it; the way was steep and sterile—for the carpeting had ceased at the first *plateau*—and we began to feel fatigued. We arrived at another landing, as shrunken in its dimensions as the previous one; and there, on the wall, gleamed the mystic ☞. Gloomy thoughts took possession of our mind; but the faint sound of 'Cheer, boys, cheer!' played on an organ in the street below encouraged us to proceed. We staggered up another steep and sterile flight, and, by a toilsome route, gained another *plateau*. Still the mystic ☞ was there, and still it urged us upwards—upwards!

We went on. The air from the organ in the street below became fainter, and fainter; the air from the attics and the rooms above grew denser and denser. We staggered, and would have fallen; but we recovered ourselves by a strong effort, and pushed on. We reached another small landing, but the ☞ was there before us . . . and we continued the ascent. Again the light beamed upon us from a staircase window, but it served only to reveal the hazardous nature of our expedition. Shall we forego the interprise, and descend? No! the courage of an English heart forbids it, so long as there is a chance of success. We go on. Another landing, and another ☞. Is it a demon hand that is going before us, and luring us on to destruction? Horrible fancies fill our brain. A door is beside us, the handle towards our hand: Come, let us clutch it! and it opens. What do we see? A bald-headed woman in a semi-dressed state, who rushes behind some bed-curtains, and screams, 'It's upstairs! It's upstairs!' What is upstairs? let us go and see. We apologize to the bald-headed female, and go upstairs. . . . Another landing is gained; and still the demon ☞ is urging us upwards. We faintly sing the National Anthem (with our hat off) and, after the third verse, feel sufficiently invigorated to pursue our upward path. A few more moments of toil, and our exertions are crowned with success; we sink down exhausted at the door of the Daguerreotype Room. No need now for the demon ☞ to point out what we have discovered. Ha! ha! We have discovered that Photography is, indeed, High Art.''[221]

THE DAGUERREOTYPE IN SCOTLAND

Thomas Davidson, an Edinburgh optician, was the first to experiment with the daguerreotype in Scotland, with a view to applying it to portraiture. In a paper communicated to the Society of Arts for Scotland on 23 November 1840[222] he states that ''in taking miniature [size] portraits, the lens requires to be more like that of a telescope than for a daguerreotype [camera], as in this case the rays require to be rather concentrated in a small space, than spread over a large surface.'' He devised a concave-convex lens which for taking landscapes was inserted with its concave surface towards the object, and a small stop used. For portraits, the lens was reversed,

and presented its convex side to the object (as in a telescope), and a diaphragm double the diameter of the landscape one was used. The larger stop and consequent increase of light reduced the exposure for portraiture to 6 to 10 minutes, according to the intensity of light. Davidson was aware that this was not yet short enough, and occupied himself with improving the lens. He succeeded during the second half of 1841 in making a good double combination portrait lens similar in design to, though not as fast as, Petzval's (see p. 174). Indeed, he even constructed a conical brass camera very much on the lines of Voigtländer's, though with some improvements: the pictures were larger ($2\frac{3}{4}$ in. square) and the camera did not have to be taken into a dark room for reloading.*

It is difficult to determine whether Davidson's camera is an independent invention or an imitation of Voigtländer's, nor can the date be established beyond the fact that it was after 22 March 1841 when Davidson presented to the Society of Arts, Edinburgh, an 8-page brochure entitled "The Art of Daguerreotyping, with the improvements of the process and camera", which does *not* contain anything about this brass camera.

Davidson's improved lens may have been originally designed for a Mr Howie, who began taking portraits on the roof of a house in Princes Street in the autumn of 1841, and was the first professional portraitist in Scotland.

"Mr Howie's arrangements were at first of the simplest kind. His sitters had to climb three flights of stairs, and then by a kind of ladder reached a skylight, through which they got access to the roof of the house. The posing chair, with something in the shape of a head-rest fixed to its back, was placed against the gable of the adjoining building, and the operator used to take the sitter by the shoulders and press him down with the observation: 'There! now sit as still as death!' Of course, under such circumstances with the sun shining brilliantly and the exposure counted by minutes, artistic portraiture was not to be expected; but Mr Howie did very well, notwithstanding, and gathered about him large numbers of those interested in the new art from all parts of the country."[223]

Howie and Davidson were intimate friends, and on one occasion they went in company with Sir David Brewster, Sheriff Cosmo Innes, and a Captain Scott, to East Princes Gardens to test a new lens. A typical Edinburgh wind was blowing, which did not exactly assist the operation. Captain Scott was posed, and his hat, by way of aiding the composition, was placed on the ground at his side.

* Davidson's camera was noticed by Helmut Gernsheim in July 1952 at the Royal Scottish Museum, Edinburgh, where its peculiar shape had prevented its recognition as a camera. It is described and illustrated in the authors' *History of Photography*.

"The tripod being somewhat rickety, a long window sash-weight was laid across the camera to keep it steady. Mr Davidson—whose temper had been sorely tried both by the wind and the desire of the sitter to move at inconvenient times—was the operator, and just at the critical moment the Captain cried, 'Oh, stop! the wind is moving my hat!' whereupon Mr Davidson seized the sash-weight and pitched it into the hat, through the crown of which it went, sinking several inches into the ground, and exclaimed, 'There! No fear of movement now!'."[224]

In Ireland, the first "Daguerreotype Portrait Institution" was opened in 1842 by "Professor" Glückman, a Hungarian, at 13 Lower Sackville Street, Dublin. Early daguerreotypists often gave themselves the title of professor.

As already mentioned, the daguerreotype patent did not cover Scotland and Ireland, and daguerreotypists there not infrequently made profitable raids into England. An itinerant Irish daguerreotypist named McGhee is said to have toured the North of England with his photographic wagon for a considerable time without being noticed by the patentee.

Wolcott's mirror camera as patented by
Richard Beard on 13 June 1840

Chapter VII

THE INTRODUCTION OF THE DAGUERREOTYPE IN GERMAN-SPEAKING COUNTRIES

IMMEDIATELY after the publication of the daguerreotype Giroux despatched six outfits, with instruction manuals, to Louis Sachse (1798–1877), art-dealer and proprietor of a lithographic establishment at 30–31 Jägerstrasse, Berlin. These had been on order since July, for Sachse, who had been in Paris on business in April 1839, had been able to arrange with Daguerre personally that he should be the first person in Germany to receive the apparatus. The first full reports of the manipulation appeared in the *Vossische Zeitung* and other Berlin papers on 26 August, and Sachse's anxiety grew daily lest somebody else should forestall him in spite of his careful arrangements, which had cost him a good deal of money. He had paid 425 francs for each outfit, plus 600 francs freight on the consignment. At last on 6 September the long-awaited apparatus arrived. Great was Sachse's horror and indignation when on opening the cases he found everything in a terrible mess. The consignment had been so badly packed that the bottles were smashed, the iodine had stained everything, the mercury had run into the plate-boxes and spoiled the silver plates. Many days' repair work was necessary before he could despatch five of the outfits to his customers. With the sixth Sachse started daguerreotyping himself. His dream of being the first person in Germany to receive daguerreotype apparatus had come true, but Giroux's negligence had deprived him of the initial advantage. On 15 September he had the mortification of seeing a locally made apparatus exhibited at the premises of the optician Theodor Dörffel in Unter den Linden, with a notice that orders for it could be accepted at the low price of 25 Thalers (75 Marks) without lens, according to quality. Some half-plate and one-sixth plate daguerreotypes Dörffel had taken were exhibited at the same time; others by him—views of the New Museum, the Armoury, and some statues—were shown in the gallery of George Gropius at the Bauschule, and, although their general effect was not considered artistic, they were the first to be seen in Berlin (if not in Germany).

It was not until five days later that Sachse was able to display at his shop a daguerreotype which he had taken himself, together with one by Mme Giroux which had

been sent with the apparatus. It was the first to reach Berlin, and represented a picturesque arrangement of statues, sculptured columns, and drapery. Mme Giroux took many of the specimen pictures which were sold with the apparatus, and deserves to be remembered as the first woman photographer. Sachse's subject was a view of the Jägerstrasse with one of the Gendarme-towers, and he had the satisfaction of reading that it was considered a perfect picture and not merely a scientific experiment—implying that Dörffel's productions were inferior.

Sachse was enthusiastic. "What a wonderful, heavenly invention Daguerre has made!" he wrote to a customer in Königsberg. "I tell you, one could lose one's senses when one sees such a picture, made to a certain extent by Nature alone." Making daguerreotypes was indeed a heavenly gift—Sachse made them as fast as he could, for the demand always outstripped the supply. He claimed to have taken and sold over 600 quarter-plate pictures in the first six weeks, at 1–2 *Friedrichd'or* a time! (17*s*. 6*d*. to 35*s*.). Imported French daguerreotypes, mostly by Giroux and his wife, found eager purchasers at 60–120 francs. On 30 September Sachse was commanded to Charlottenburg, where he took five views in the presence of King Frederick William III.

About 20 September Eduard Petitpierre (1789–1862), a Swiss who had settled in Berlin and had been appointed optician to the King, also received a Giroux outfit. One of his first daguerreotypes aroused some amusement because it revealed a loving couple in the Lustgarten who had been gazing at each other entranced so that they appeared quite distinctly on the plate although the exposure had lasted 23 minutes! In another picture, the guard at the Museum appeared in the picture twice, having changed his position during the exposure. In appreciation of three daguerreotypes which the enterprising photographer sent the Emperor of Russia soon after, he was rewarded with a diamond ring.

Petitpierre intended to use his Giroux outfit as a model for the construction of others, which he announced would cost only about half the French price (18 Fr.d'or, = 306 Marks). But neither he nor Dörffel, who had taken orders for cheap cameras of his own design, was able to produce any within the first two months because suitable achromatic lenses were difficult to obtain in Germany. In the end, Dörffel was obliged to grind his own.

The only person in Berlin who could make silvered copper plates was the court goldsmith, J. G. Hossauer, who had also taken up photography.

George Gropius, brother of Carl Gropius of the Diorama, and other amateurs, frequently exhibited their pictures at his bookshop and art gallery. These early Berlin daguerreotypists used to meet at the newly founded Polytechnic Society for the exchange of "tips", and discussions.

The keen interest of the Germans in the daguerreotype is evinced by the surprisingly large number of publications (ten) on the process which appeared within the first two months in Berlin, Stuttgart, Karlsruhe, Hamburg, Halle and Leipzig. In fact more brochures appeared in Germany than in any other country, though some of the earlier ones were mere compilations or translations of Donné's report in the *Journal des Débats*, the first of these appearing in Berlin before the end of August. One manual purporting to give instructions on Daguerre's process— *Vollständige Anweisung zur Verfertigung Daguerre'scher Lichtbilder auf Papier* * . . . —confusingly described a paper method akin to Talbot's.

During the autumn, Carl August von Steinheil (1801–70), professor of mathematics at Munich—who with Franz von Kobell (1803–75) had in March 1839 devised a process of photography on paper similar to Fox Talbot's—tried to simplify the daguerreotype apparatus. On 31 December 1839 the *Münchner Politische Zeitung* announced that he had constructed a pocket camera which had several advantages over Daguerre's apparatus, in addition to its portability. Near and distant objects could be rendered sharp in the same picture, and photographs could be taken even on dull days, owing to the short focal length (25 mm.) and large opening (F 2·5) of the three-lens object-glass (plano-convex, plano-concave, and bi-convex, cemented together). In fact, Steinheil's camera had some of the characteristics of the modern miniature camera, but since enlarging was not practicable, the tiny 8 mm. × 11 mm. plates had to be viewed through a magnifying glass, and this drawback proved the stumbling-block to the introduction of the apparatus. It was an invention that had come long before its time.[225]

Sachse took the first portrait in Germany in April 1840, but the attempt cannot have been very successful, for little was said about it beyond "the sitter is as easily recognizable as in a freehand drawing"[226]—hollow praise for a photograph. Portraiture, in fact, made no progress in Germany until well after the introduction of the portrait lens designed by Professor Josef Max Petzval (1807–91) of Vienna. The idea of calculating a lens specially for portraiture had been suggested to the mathematician by his friend Professor A. von Ettinghausen, who happened to be in Paris at the time of the publication of the daguerreotype. Ettinghausen was as enthusiastic for the new invention as he was critical of the slow lenses with which the Giroux apparatus had been fitted. He had several discussions on the subject with Chevalier, and during one of his visits was shown the latter's double combination achromatic lens for the telescope. Whether or not this lens gave Ettinghausen the idea that a similar lens would be advantageous for photographic purposes, as Chevalier later complained, is difficult to establish. It is, however, certain that Petzval used a

* *Complete Directions for the Preparation of Daguerre's Light Images on Paper. . . .*

well-corrected telescope lens (right way round) for his front component, adding an air-spaced doublet behind it, which was mathematically designed to give sharp definition and to correct spherical aberration. Petzval's double combination lens was characterized by a large aperture (F 3·6), fairly short focal length (15 cm.) and gave excellent definition in the picture centre without the use of a stop. It could therefore be employed for portraiture at its full aperture, which made it twenty times faster than the Chevalier and Lerebours lenses in the Daguerre Giroux cameras. At Petzval's request Anton Martin of the Polytechnic Institute in Vienna made some experimental portraits with this lens in May 1840, and after further modifications the lens was put into production by the old-established Viennese opticians Voigtländer & Sohn, and put on the market in November. To enhance its efficiency Voigtländer introduced on 1 January 1841 a conical-shaped camera (Plate 113) specially designed for it, and taking small circular pictures 9 cm. (3½ in.) in diameter. After the sitter had been focused through the magnifying-glass which was fixed behind the ground-glass, the camera had to be removed from its stand and taken to the dark-room, where its whole rear portion was unscrewed and replaced by a sensitized plate in a circular holder. This unpractical arrangement was a drawback to the otherwise ingenious design (a fault avoided in the similar camera of the Edinburgh optician Davidson), and for this reason, perhaps, only seventy cameras were sold during 1841, at a price of 95 or 120 Austrian gulden (1 gulden = about 2s.) according to whether they were made of wood or brass.* The Petzval-Voigtländer lens, however, which was produced in different focal lengths† for use in any camera, immediately established itself as the *sine qua non* for portraiture, and was exported all over the world. Best proof of its excellence were the many "Petzval type" imitations that were made in every country, and traded in France as "système allemand". In 1862, Voigtländer made the 10,000th lens, and throughout the nineteenth century it remained the most widely used portrait lens in every country. With it, the ascendancy of German optical equipment may be said to have begun.

According to Voigtländer's instruction booklet[227] (January 1841), exposures in the open air were "on a dark day in winter 3½ minutes, on a sunny day in the shade 1½ to 2 minutes, in direct sunshine 40 to 45 seconds". In other words, exposure and picture size were comparable to Draper's in New York the previous summer. Soon after the publication of the brochure the daguerreotype was speeded up by chemical means, and in an addendum dated 1 August 1841 the manufacturers stated

* Only the brass camera was conical-shaped. The walnut camera was the usual shape for plates 2⅔ × 3 in. or 3 × 4 in. In each case the price included the whole outfit.

† In spring 1842 Voigtländer introduced cameras for pictures up to 5½ in. at a price of 144 gulden, the lens having a focal length of 12 in. and an opening of 3 in.

that 4 to 15 seconds in the shade, or one second in sunshine, was now sufficient.

The chemical acceleration referred to was due to the Viennese civil servant Franz Kratochwila, who found that by exposing the iodized plate to the combined vapours of chlorine and bromine its sensitivity was increased five times. Kratochwila published the process in the *Wiener Zeitung* on 19 January 1841, five weeks after J. F. Goddard's publication in London of bromine as an accelerator (see p. 152). Early in March[228] the brothers Johann and Joseph Natterer, Viennese students, were reported to have taken portraits with the Voigtländer camera on plates subjected to the action of iodine and chlorine vapour, in 5 to 6 seconds in clear weather, and in 10 seconds in dull weather, reinforced with ordinary lamp-light. According to Professor Berres[229] the Natterer brothers must also be credited with having taken the first instantaneous street views depicting people and traffic in motion. Thus chemical acceleration and the Petzval lens had combined to reduce exposures to a second—the time it took to remove and replace the lens cap.

About this time was formed the Freie Vereinigung von Freunden der Daguerreotypie, an informal association of about a dozen amateur daguerreotypists who met fiom time to time at the Fürstenhof on the Landstrasse, Vienna, bringing the results of their experiments for discussion.[230] The leading spirits of the group were the Professors von Ettinghausen, Petzval, and Berres, others being Voigtländer, the Natterer brothers, Kratochwila, Anton Martin, librarian at the Polytechnic Institute, who later wrote several photographic handbooks, Regierungsrat Schultner, a civil servant, Dr Joseph Johann Pohl, the apothecary Endlicher, and the photographers Carl Reiser and Karl Schuh. The latter, a Berliner, is said to have been the first professional portrait photographer in Vienna, with a studio at the Fürstenhof. The date would be some time in the second half of 1841. In October 1841 Reiser daguerreotyped several members of the Bavarian royal family in Munich, and for a short time daguerreotyped members of the public in a glass-house put at his disposal in the botanical gardens. Some daguerreotypes which he exhibited at the Kunstverein (Art Society) were considered better than any hitherto seen in Munich.[231]

The first Petzval-Voigtländer apparatus was imported into Berlin by Sachse on 6 October 1841, and during that month Joseph Wawra, a Viennese painter, availing himself of the latest improvements took (for a few weeks) the first really satisfactory and artistic portraits in Berlin.

Strangely enough it is not until August of the following year that we hear of the first professional portrait studio in Berlin. This was opened at 41 Zimmerstrasse by J. C. Schall (1805–85), a portrait painter whose earliest traceable advertisement appeared on 16 August 1842. Within three weeks competition arose from the portrait painter Julius Stiba (d. 1851) who originally taught "quick painting" on paper,

wood, glass, and porcelain in six lessons (success guaranteed) at 64 Friedrichstrasse. For a while Stiba included daguerreotype in his art courses, but when he found photographic portraiture more profitable he abandoned teaching altogether.

Schall's and Stiba's studios were very primitive. Their sitters were posed in the open courtyard, a sheet serving as background. The exposure time was usually a minute in clear fine weather. After two o'clock operations stopped and on dull or rainy days the "studio" was closed.

With the approaching Christmas season more artists turned photographer, attracted by the prospect of lively business. As the weather became colder, they were driven indoors, but from 17 December on Schall was able to invite clients to his heated glass-house—the first of its kind in Berlin. Berliners had apparently also their share of "black portraits" due to under-exposure, and Schall's announcement may not have seemed so quaint then as it does now: "I will refrain from praising my own pictures, which are sufficiently known to my valued clients for their good likenesses, strong effect, and sharpness. I will only permit myself to remark that my portraits are not like Moors, as is usually the case with those taken indoors, but are clear and white, that is to say, truly European."[232] In April 1843 Schall added another attraction—colouring daguerreotypes, which he had patented.

The most artistic daguerreotype portraits in Germany, and some of the finest in the world, were taken by two Hamburg photographers, the artists Hermann Biow (1810–50) and C. F. Stelzner.

Biow's "heliographic studio" at 163 Königstrasse, Altona, opened on 15 September 1841, preceded any in Berlin, if not in Germany. The following summer he installed himself temporarily in the Belvedere of the Baumhaus, Hamburg, and from the beginning of September 1842 on, he and Stelzner collaborated for seven months in a specially built glass-house at 32 Caffamacherreihe. After this, Biow set up an independent studio again at 52 Neuerwall, where he introduced hand-coloured daguerreotypes.

It is an ironic circumstance that the earliest news photographs were taken at the very moment when the world's first illustrated paper, *The Illustrated London News*, was going to press with its first issue—yet neither the photographers nor the proprietors of the paper knew of the existence of the other. Biow and Stelzner took a large number of daguerreotypes of the ruins of the Alster district of Hamburg after a terrible conflagration on 5–8 May 1842. Unaware of these authentic pictures, *The Illustrated London News* published an imaginary view of the fire based on an old print of Hamburg in the British Museum, on the front page of its first issue on 14 May. Biow recorded the devastation in a series of forty daguerreotypes which he offered to the Hamburg Historical Society at his usual charge of 1 *Friedrichd'or*

(17s. 6d.) each, but the Society, perhaps afraid of buying "vanishing pictures", did not avail themselves of this opportunity, and so these irreplaceable historical documents were lost to posterity. Today only one by Stelzner (Plate 96) remains in existence.

In July 1843 the whole of Hamburg was kept amused by a quarrel between Biow and the famous satirist M. G. Saphir, who had sat to the photographer for several free portraits. When the latter sent a messenger inviting Saphir to call to select the one he liked best, the humorist became abusive because the pictures had not been delivered to him. In revenge, the photographer delivered the portraits cut up. It was a declaration of war which Saphir repaid with a vitriolic attack on the daguerreo-typist. "Cephir" then joined the battle with a counter-attack on Saphir, and "The Daguerreotype War in Hamburg" was in full swing.[233]

Biow was never short of a reason for enticing clients to his studio. Even foggy November weather was turned to advantage: "The cold foggy days to be expected now are even more favourable to the certain effect of the light than the clearest sunshine."

Between 1846 and his early death in 1850 Biow was much away from Hamburg, daguerreotyping royalty and celebrities in Dresden, Berlin and Frankfurt, where the work of the Hamburg portraitist was preferred to local talent. In Berlin a studio was set up for him in the Rittersaal of the Schloss, where he daguerreotyped King Frederick William IV, princes, ministers, the court and all the famous men in art and science such as Alexander von Humboldt and the sculptors Christian Rauch (Plate 103) and Schadow. Ambition now began to haunt Biow. He planned (like Brady in America) a National Gallery of Photographic Portraits. For this reason he travelled to Frankfurt in 1848 to photograph Archduke Johann, who had been appointed Administrator of the Empire, and the members of the National Assembly (Plate 97). One hundred and twenty-six of these portraits were published in Frank-furt the following year as lithographs.[234]

Carl Ferdinand Stelzner (1808–94), who had studied under Isabey and other well-known artists in Paris, was originally a miniature painter. His photographs of the Hamburg fire (Plate 96) and his first studio in partnership with Biow have already been mentioned. Stelzner's art training comes out unmistakably in his photographs. They are exquisite miniatures in photography and were frequently tinted by his wife, who as a professional miniature painter often used her husband's photographs to copy from. Stelzner's portraits cannot help impressing one by their high artistic quality.

Many miniature painters had turned to photography when their own art was ousted by the daguerreotype, and their portraits are still steeped in the traditions of

the older art. Newcomers, on the other hand, brought a new outlook to photography, a freedom of pose and snapshot-like casualness (Plate 59) which is truly photographic.

In Leipzig the first to take portraits professionally was Joseph Weninger, an artist who came from Vienna and was active in Leipzig from January to May 1842, before going on to Copenhagen and Stockholm. In the summer of that year Carl Dauthendey (1819–96) took portraits in Leipzig in his garden-house, before moving on to Dessau and St Petersburg, where he became the first professional daguerreotypist in the autumn of 1843. The first permanent public studio in Leipzig was opened by the instrument-maker Wehnert about August 1842.[235]

A special niche in the history of early daguerreotypists must be given to Johann Baptist Isenring (1796–1860) of St Gallen, Switzerland, a well-known copperplate engraver of topographical views. He ordered a daguerreotype outfit from Giroux in October 1839, and, undaunted by Arago's opinion, immediately set to work to solve the problem of portraiture. Finding it impossible to arrive at shorter exposures than about 20 minutes in full sunshine—particularly as he used plates up to 10 in. × 8 in.—Isenring overpainted the image and scratched in on the silvered plate the pupils of the eyes to correct the unsharpness caused by the sitter's blinking. Whatever the merit of these portraits may have been—and they were far from pure photography—Isenring deserves at least to be remembered as the first person to retouch photographs, and to attempt to give daguerreotypes a more lifelike appearance by colouring them—a fact to which reference has already been made in another chapter (see p. 159). Isenring also held the first public exhibition of portrait photographs in Europe. This was at St Gallen in August 1840, and his four-page catalogue listing thirty-nine portraits, besides eight still-lifes, architecture, etc., was preceded only by Gouraud's in New York, December 1839.

Up to that time Isenring had only practised on relations and friends—the only victims willing to endure the long exposure—but after learning of Kratochwila's chemical acceleration he accepted orders from the public. In July 1841 he was in Munich, where for a short time he operated in a room in the Maximiliansplatz,[236] the exposure being one minute and the price of the portrait 2 Kronenthaler (1 Kr.T. = 4·60 Marks). At the Munich fair the same summer Isenring's portrait booth proved a great attraction, too: "By the time you have said three paternosters —if you are still capable—your face is printed, however ugly it may be." From a published aquatint of the Wittelsbacher Platz "photographiert von J. B. Isenring in St Gallen" it is clear that he also daguerreotyped views in Munich, which served him as subjects for copper-plate engravings.

By April of the following year Isenring was the proud owner of a "Sonnenwagen"—the earliest photographic carriage we know of, fitted up as living and

sleeping quarters as well as studio and darkroom. This enabled him to extend his business activities as an itinerant daguerreotypist to Southern Germany, Upper Austria and Northern Switzerland. It was probably Isenring's daguerreotype portraits that Hans Andersen saw on a journey to Southern Germany about 1841. They were the first daguerreotype portraits he had seen, "made in ten minutes. . . . It seemed to me like magic. . . . The daguerreotype and the railway, these two new flowers of the present age, were to me already a benefit of the journey."[237]

Franziska Möllinger (1817–80) of Solothurn travelled all over Switzerland taking views, fifteen of which she published copied as lithographs in 1844–45 under the title "Daguerreotypierte Ansichten der Hauptstädte und der schönsten Gegenden der Schweiz."

About this time Carl Durheim (1810–90), a lithographer in Berne, learned the daguerreotype process from a visiting Frenchman. In 1845 he opened a daguerreotype studio there, but in 1849 changed to the paper process—as did also J. B. Isenring.

Conclusion

In tracing the history of the introduction of the daguerreotype in France, America, England, and German-speaking countries, we have concentrated on the nations which made important contributions both to the technique and aesthetics of the new art. To describe the introduction of the daguerreotype in other countries would be monotonous and add nothing essential to the understanding of its history and development. By 1842–43 all European capitals and large towns had one or more portrait studios, or at least were visited by itinerant photographers. With the exception of England and France, daguerreotype portraiture in Europe continued until about 1860. In these countries, the life of the daguerreotype was shorter on account of the advantages offered by the collodion process published by Frederick Scott Archer in 1851.

APPENDICES

DAGUERRE'S GRAPHIC ART

OIL PAINTINGS

"Interior of a chapel in the church of the Feuillants, Paris." Exhibited at the Salon of 1814. Whereabouts unknown; engraved by A. F. Lemaître in 1827 and published by Liébert in *Galerie du Luxembourg, des Musées, Palais et Châteaux Royaux de France.*

"Ruins of Holyrood Chapel." 2·08 m. × 2·54 m. Exhibited at the Salon of 1824. (Walker Art Gallery, Liverpool.) A diorama of the same subject opened in Paris on 20 October 1823.

"The Interior of Roslyn Abbey [Chapel]." Exhibited at the Salon of 1824. Whereabouts unknown. A diorama of the same subject opened in Paris on 24 September 1824.

"View of the Village of Unterseen." Exhibited at the Salon of 1827. Whereabouts unknown, but a pen and wash drawing of the same subject dated 1826 is at the Société Française de Photographie. A diorama of this subject opened in Paris on 24 August 1826.

"View of Montmartre, Paris." Oil on canvas, 23 cm. × 37 cm. c. 1830. (Musée Carnavalet.)

"View of Mont Blanc", 1831. Probably the same subject as the diorama entitled "The Valley of Chamonix" which opened in Paris on 19 November 1831. In 1924 the painting was in the possession of Mentienne, jnr., at Bry. Potonniée described it as "a mediocre work, lacking interest, but of an agreeable design and good aerial perspective." It was not exhibited at the Salon.

"Landscape" (subject not specified). Exhibited at the Salon of 1834. Probably it is the landscape with ruin at George Eastman House.

"Landscape with Ruin", 1834. 19 cm. × 25·5 cm. Signed. (George Eastman House.)

"The Rise of the Deluge." 94 cm. × 122 cm. including frame. Exhibited at the British Institution in 1838 and at the Salon of 1840. A diorama of same subject opened in Paris on 4 November 1829.

Painting in oil on brown velvet, "Night effect in a Forest", 13 cm. × 19 cm. (George Eastman House.) It may have been a sketch for the diorama of the Black Forest, first shown in Paris on 17 April 1833.

"View of the Environs of Naples." A sketch (in oils?) in the possession of one of Mme Daguerre's nieces. If this niece were Mme de Sainville, the picture was destroyed in 1870.

DRAWINGS

"The Village of Unterseen." Pen and wash drawing, 1826. (Société Française de Photographie.) Same subject as the diorama which opened in Paris on 24 August 1826.

"Effect of Moon on a Lake." Pastel. (Whereabouts unknown.)

"A Hollow Path." Pastel dated 1850. These two pastels were shown by Gabriel Cromer at the Société Française de Photographie in 1925. (Whereabouts unknown.)

"Solomon's Temple." Sepia drawing 25·5 cm. × 35 cm. Signed. (George Eastman House.) Sketch for the diorama "The Temple of Solomon" which opened in Paris on 15 September 1836.

A tree. Pencil sketch 7·5 cm. × 9 cm. Signed. 1820s. (George Eastman House.)

Study of trees. Pencil sketch 7·5 cm. × 9 cm. Signed. 1820s. (George Eastman House.)

A ruined Gothic church. Dessin-fumée 6 cm. × 8 cm. Signed. 1826. (George Eastman House.) A label on the back reads "Dessin-fumée. Fantaisie par Daguerre."

A slightly different version of the above entitled "Londres, 1826". (Collection of P. Naudot.)

A Gothic arch. Sepia drawing 5·7 cm. × 9 cm. Signed "D". (George Eastman House.)

A ruined Gothic church with figures. Sepia drawing 15 cm. × 11 cm. Signed and dated 1821. (George Eastman House.)

Landscape with distant tower. Pencil sketch 19·5 cm. × 26·8 cm., oval. Signed. (George Eastman House.)

Tower. Pencil sketch 11·5 cm. × 7·7 cm. Signed. (George Eastman House.)

A church interior. Pen and wash drawing 14·9 cm. × 11·7 cm. 1820s. (Besançon Museum.)

A ruined arch. Water colour 18·7 cm. × 13·4 cm. 1820s. (Besançon Museum.)

Design for a proscenium. Water colour 20·5 cm. × 18·2 cm. 1820s. (Besançon Museum.)

Note. This list does not claim to be complete, but we can state that the Bibliothèque Nationale, the Conservatoire des Arts et Métiers, the British Museum, the Victoria & Albert Museum, and the Tate Gallery, possess no original works by Daguerre.

CONTEMPORARY REPRODUCTIONS OF DAGUERRE'S WORKS

(a) Lithographs from *Voyages pittoresques*:

Ancienne Normandie. 1820.

Plate 12. Ruins of the Abbey of Jumièges. North side. Daguerre del. 1820. Lith. by G. Engelmann. 24 cm. × 30·5 cm. Shown at the Salon of 1822.

Plate 45. Church of Harfleur. Daguerre del. Schmit sculp. 10 cm. × 16·4 cm.

Ancienne Normandie. 1825.

Plate 165. Great Hall of the Palais de Justice [Rouen]. Daguerre del. Figures by Xavier Le Prince. Arnout sculp. 20·3 cm. × 15·7 cm.

Franche-Comté. 1825.

Plate 26. General view of the interior of the church of Brou. Daguerre del. Courtin sculp. Lith. by G. Engelmann. 35 cm. × 27·5 cm. Exhibited at the Salon of 1827. This subject was used by Gropius as a diorama which opened on 29 October 1827 in Berlin.

Auvergne Vol. 1. 1829.

Plate 25. Château de Tournoël, gallery leading to the chapel. Daguerre del. Courtin sculp. Lith. by Engelmann. 27 cm. × 21·5 cm.

Plate 26. Entrance to the gallery leading to the chapel. Château de Tournoël. Daguerre del. 1829. Courtin sculp. Lith. by Engelmann. 19·5 cm. × 22·3 cm.

Plate 30. Interior of the apse of the church of Volvic. Daguerre del. Courtin sculp. 21 cm. × 31 cm.

Plate 46. Interior of the ruins of the Château de Blot-le-Rocher. Daguerre del. Arnout sculp. 19·5 cm. × 18·8 cm.

Auvergne Vol. 2. 1833.

Plate 120. Bridge of Thiers. Daguerre del. L. Haghe lith. Printed by C. Hullmandel. 29·5 cm. × 21 cm. Diorama subject, first shown in Paris on 11 November 1827.

Plate 216. Entrance to the palace of Cardinal d'Amboise at Gaillon. Daguerre del. Bichebons sculp. Lith. by G. Engelmann. 25·5 cm. × 19·3 cm.

(b) Other reproductions:

"Interior of the Chapel of the Feuillants." Engraving 21 cm. × 16 cm. by Lemaître, 1827, after Daguerre's first painting (1814). Exhibited by Lemaître, at the Salon of 1827, and published by Liébert in *Galerie du Luxembourg, des Musées, Palais et Châteaux Royaux de France.*

"Citerne en ruines à Montmartre." Daguerre del. 1818, lith. probably by Engelmann. 12·9 cm. × 16·6 cm.

"Souterrain." Daguerre del. 1818, lith. probably by Engelmann. 12·9 cm. × 16·6 cm.

　　Both these lithographs bear the printed remark: "Exécutées pour le Théâtre de l'Ambigu-Comique."

"Entrance to the Church of the Holy Sepulchre." Daguerre del. Lith. by Engelmann 21·5 cm. × 26·8 cm. (from an unknown publication). Shown at the Salon of 1819.

　　There is a copy of each of these contemporary reproductions of Daguerre's pictures at George Eastman House and in the Gernsheim Collection. In addition, George Eastman House possesses a lithograph of a church interior, from an unknown publication issued by Sazerac & Duval, Passage de l'Opéra, Paris.

PARIS DIORAMA

The valley of Sarnen in Switzerland, by Daguerre. (Sent to London)	11 July 1822 to 18 Feb. 1823
The Chapel of the Trinity in Canterbury Cathedral, by Bouton. (Sent to London)	11 July 1822 to 27 July 1823
The port of Brest, from the Rose Battery, by Daguerre. (Sent to London)	19 Feb. 1823 to 19 Oct. 1823
Interior of Chartres Cathedral, by Bouton. (Sent to London)	27 July 1823 to 21 Feb. 1824
Interior of the Chapel of Holyroodhouse, Edinburgh, effect of moonlight, by Daguerre. (Sent to London)	20 Oct. 1823 to 23 Sept. 1824
The port and town of Sta. Maria in Spain (Meeting of the duc	21 Feb. 1824 to

d'Angoulême and the King of Spain)—sometimes called "View of the Trocadéro" or "Cadiz", by Bouton and Daguerre.	19 Apr. 1825
Roslyn Chapel near Edinburgh, effect of sun, by Daguerre. (Sent to London)	24 Sept. 1824 to 14 Aug. 1825
The City of Rouen, taken from the Côte Sainte-Catherine, by Bouton. (Sent to London)	20 Apr. 1825 to 30 Nov. 1825
Effect of fog and snow seen through a ruined Gothic colonnade, by Daguerre. (Sent to London)	15 Aug. 1825 to 4 May 1826
The surroundings of Paris, taken from Bas-Meudon, by Bouton. (This may be the same as the picture called "St Cloud" which was shown in London in 1827)	27 Nov. 1825 to 23 Aug. 1826
The ruined cloisters of the monastery of Saint-Wandrille, Normandy, by Bouton. (Sent to London)	4 May 1826 to 20 Dec. 1826
The village of Unterseen in Switzerland, by Daguerre. (Sent to London)	24 Aug. 1826 to 21 Aug. 1827
Edinburgh during the fire of 15 November 1824 (by moonlight), by Daguerre.	21 Dec. 1826 to 13 Nov. 1827
Interior of the Basilica of Saint Peter in Rome, by Bouton. (Sent to London)	19 Aug. 1827 to 14 May 1828
The village of Thiers, near the Saint-Jean bridge, by Daguerre. (Sent to London)	11 Nov. 1827 to 26 July 1828
Interior of Rheims Cathedral, by Bouton. (Sent to London)	15 May 1828 to 27 Oct. 1828
Mount St Gothard, from Faido (Canton Ticino), by Daguerre. (Sent to London)	27 July 1828 to 3 Aug. 1829
The Grand Canal, Venice, by Bouton	25 Oct. 1828 to 3 Nov. 1829
The Campo Santo, Pisa, by Bouton. (Sent to London)	1 Aug. 1829 to 14 May 1830
The beginning of the Deluge, by Daguerre.	4 Nov. 1829 to 31 Jan. 1831
View of Paris from Montmartre, by Daguerre. (Sent to London)	12 May 1830 to 13 May 1831
The 28 July 1830 at the Hôtel de Ville (The July Revolution), by Daguerre.	23 Jan. 1831 to 20 Jan. 1832
The tomb of Napoleon at St Helena, at sunset, by Daguerre.	1 May 1831 to 1 June 1834
The valley of Chamonix, by Daguerre.	19 Nov. 1831 to 1 Dec. 1833
Edinburgh during the fire (2nd showing)	20 Jan. 1832 to 27 Dec. 1832

The Black Forest: assassination of the countess of Hartzfeld and her servant in 1804, by Daguerre.	7 Apr. 1833 to 1 Mar. 1835
The central basin of commerce at Ghent (double effect), by Daguerre and Sébron.	20 Mar. 1834 to 14 Sept. 1836
A midnight mass at the church of Saint-Etienne-du-Mont (double effect), by Daguerre and Sébron.	11 Oct. 1834 to 13 Oct. 1837
Landslide in the valley of Goldau, Switzerland, on 2 September 1806 (double effect), by Daguerre and Sébron.	20 Sept. 1835 to 8 Mar. 1839
Inauguration of the Temple of Solomon (double effect), by Daguerre and Sébron.	15 Sept. 1836 to 8 Mar. 1839
A sermon in the royal church of Santa Maria Nuova at Monreale, Sicily (double effect), by Daguerre and Sébron.	25 Mar. 1838 to 8 Mar. 1839

At the time of the fire Daguerre is said to have been working on a new diorama of Sta Maria Maggiore.

A *small* diorama of the interior of the church at Méry near Pontoise was shown in the small gallery at the Diorama.

The above is the complete timetable of the dioramas shown at Daguerre's Paris establishment. Readers who may come across other titles should be warned that Bouton's later dioramas and those imported by him (after 1842) are sometimes ascribed to Daguerre. In addition, new titles have been created by writers from their faulty recollections: e.g. "The Valley of Unterwalden" (either the Valley of Sarnen which is in Canton Unterwalden, or the Village of Unterseen); "The Tomb of Charles X at Holyrood" is an impossible title since he died and was buried in Austria; "The Basilica at Montreal" (not Canada, but Monreale in Sicily); "View of Naples with Vesuvius in eruption" is no doubt Diosse's "Mount Etna", shown in Paris by Bouton; "The church of Saint-Germain-l'Auxerrois" (Saint-Etienne-du-Mont), etc.

In all the seventeen years of its existence the Paris Diorama was only closed on 17, 18 and 19 September 1835, in preparation for the diorama of the valley of Goldau.

LONDON DIORAMA

The valley of Sarnen, Switzerland, by Daguerre The Chapel of the Trinity in Canterbury Cathedral, by Bouton.	} 29 Sept. 1823 to Aug. or Sept. 1824
The port of Brest, from the Rose Battery, by Daguerre Interior of Chartres Cathedral, by Bouton	} Opened end of Sept. 1824
Ruins of Holyrood Chapel, Edinburgh, by moonlight, by Daguerre Interior of Chartres Cathedral, by Bouton	} Opened middle of Mar. 1825
Roslyn Chapel near Edinburgh, effect of sun, by Daguerre The city of Rouen, taken from the Côte Sainte-Catherine, by Bouton	} Opened 20 Feb. 1826

Effect of fog and snow seen through a ruined Gothic colonnade,
 by Daguerre
 Opened early
St Cloud and the environs of Paris (probably the same as the
 June 1827
 view of Paris from Bas-Meudon, near St Cloud), by Bouton

The village of Unterseen, Switzerland, by Daguerre — Opened 24 Mar.
Cloisters of St Wandrille, Normandy, by Bouton — 1828

The village of Thiers, by Daguerre — Opened end of
Interior of the Basilica of St Peter, Rome, by Bouton — May 1829

Mount St Gotthard, from Faido (Ticino), by Daguerre — Opened 21 Apr.
Interior of Rheims Cathedral, by Bouton — 1830, closed 1832

1831 as above

View of Paris from Montmartre, by Daguerre — Opened 16 July
The Campo Santo, Pisa, by Bouton — 1832

1833 no information

Ruins of Fountains Abbey by moonlight, by Bouton — Opened end of
Crypt of the Cathedral of St Denis, by Bouton — Feb. 1834

Interior of the Church of Santa Croce, Florence (double effect),
 by Bouton
 Opened early
 June 1835
The Campo Vaccino, Rome, by Bouton

Interior of the Church of Santa Croce, by Bouton (2nd showing) — Opened 4 Apr.
The village of Alagna, Piedmont (double effect) by Bouton — 1836

The port of Brest, by Daguerre, (2nd showing) — Opened Feb.
Chartres Cathedral, by Bouton (2nd showing) — 1837

The Basilica of St Paul-without-the-walls, Rome (double effect),
 by Bouton
 Opened Apr.
(The second picture was probably Brest harbour, in order to
 1837
 avoid showing two churches at the same time)

The Basilica of St Paul-without-the-walls (2nd showing) — Opened end of
Cascades of Tivoli (double effect) by Bouton — Mar. 1838

The Basilica of St Paul-without-the-walls, Rome — Later in 1838
The village of Alagna (2nd showing)

The Coronation of Queen Victoria, by Bouton — Opened end of
The Church of Santa Croce (3rd showing) — Apr. 1839, closed
 on 28 Dec.

The Shrine of the Nativity, Bethlehem, by Rénoux from sketches — Opened
 by David Roberts — Sept. 1840
(Second picture not known)

The Shrine of the Nativity (2nd showing) } 5 Apr. 1841 to
The Cathedral of Auch near Toulouse, by Rénoux } 31 Dec. 1841

The village of Alagna (3rd showing) } Early Mar. 1842
The Shrine of the Nativity (3rd showing) } to 31 Dec. 1842

The Cathedral of Notre-Dame, Paris (double effect), by Rénoux } 24 Apr. 1843 to
St Paul's-without-the-walls, Rome (3rd showing) } early Mar. 1844

The Cathedral of Notre-Dame, Paris (2nd showing) }
The interior of the Abbey Church of St Ouen at Rouen (double } Early Apr. 1844
 effect), by Rénoux } to 31 Jan. 1845

The Cathedral of Notre-Dame, Paris (3rd showing) } Opened 12 Apr.
View of Heidelberg (double effect), by Rénoux } 1845
Heidelberg and Notre-Dame were again shown during 1846,
 closing soon after 19 Dec. 1846.

The interior of St Mark's, Venice (double effect), by Diosse } Opened 31 Mar.
Cascades of Tivoli, by Bouton (2nd showing) } 1847
Shortly after 9 Oct. 1847 Tivoli was removed and St Mark's
 shown alone until 11 Mar. 1848

The interior of St Mark's, Venice (2nd showing) } Opened end of
Mount Etna (double effect), by Diosse } Apr. 1848
St Mark's was removed on 18 Nov. 1848, the Diorama reopened
 with Mount Etna alone on 27 Nov. 1848, closed 31 Jan. 1849.

The valley of Rosenlaui, Switzerland, by Diosse } Early Apr. 1849 to
The interior of the Church of Santa Croce (4th showing) } mid-Nov. 1849

The Castle of Stolzenfels (double effect), by Nicholas Meister } Early Mar. 1850,
Shrine of the Nativity, Bethlehem (4th showing) } closed early Nov.
 } 1850
The Diorama reopened mid-December 1850 showing Stolzenfels
 and Mount Etna until April 1851.

BASIS OF THE PROVISIONAL AGREEMENT

Between Nicéphore Niépce and Daguerre

The undersigned, Monsieur Joseph-Nicéphore Niépce, landowner, residing at
Châlon-sur-Saône, Department of Saône-et-Loire, on the one hand, and Monsieur
Louis-Jacques-Mandé Daguerre, painter, member of the Legion of Honour, and manager
of the Diorama, residing in Paris at the Diorama, on the other hand, hereby enter into
the following provisional agreement for the purpose of forming a partnership.

Monsieur Niépce has made certain researches with the purpose of fixing by a new
method, without the aid of a draughtsman, the views of nature, resulting in numerous
experiments substantiating this discovery. This discovery consists in the spontaneous repro-

duction of the images received in the camera obscura.

Monsieur Daguerre, whom he has informed of his discovery, realizing its great interest, especially since it is capable of great improvement, offers to associate himself with Monsieur Niépce in order to achieve perfection and for securing all the benefits which may be derived from this new kind of art-manufacture.

In view of these facts the parties hereto have agreed to the following provisional and fundamental articles of association.

Art. 1. A firm shall be founded by MM. Niépce and Daguerre under the commercial title of *Niépce–Daguerre*, for the purpose of perfecting the said discovery invented by Monsieur Niépce and [to be] improved by Monsieur Daguerre.

Art. 2. This partnership shall be for the term of ten years dating from this 14th December; it cannot be dissolved before this term without the mutual consent of the interested parties. In case of death of either of the partners his heir shall succeed to the said partnership for the remainder of the unexpired term of the ten years. Furthermore, in event of the death of either of the partners, the said discovery may only be published under the joint name designated in article 1.

Art. 3. Upon signature of this agreement, Monsieur Niépce shall disclose to Monsieur Daguerre, under the seal of secrecy which shall be preserved under penalty of all costs, damages, and interests, the principle on which his discovery rests, and shall furnish him with a full and exact written statement on the nature, manipulation, and different methods of applying the processes connected therewith, in order that the experiments for improving and utilizing the discovery may be carried out as completely and quickly as possible.

Art. 4. Monsieur Daguerre undertakes, under the same penalties, to preserve absolute secrecy regarding the fundamental principle of the discovery, and the nature, use, and explanations of the processes which will be disclosed to him, and will co-operate as much as possible in the necessary improvements, to the best of his ability and talents.

Art. 5. Monsieur Niépce gives and cedes to the partnership his invention, representing the value of half the profits which may be derived from it, and Monsieur Daguerre contributes a new design of camera obscura, his talents, and his industry, equivalent to the other half of the said profits.

Art. 6. Upon signature of this agreement, Monsieur Daguerre shall disclose to Monsieur Niépce, under the seal of secrecy, which shall be preserved under penalty of all costs, damages and interests, the principle upon which the improvement he has made to the camera obscura depends, and shall furnish him with precise documents on the nature of the said improvement.

Art. 7. MM. Niépce and Daguerre will each contribute one-half of the cash capital necessary for the establishment of the firm.

Art. 8. When the partners consider the invention sufficiently perfected to apply it to the process of engraving, in order to find out what advantages an engraver would derive from the application of the process, which would provide him with a ready-made sketch, MM Niépce and Daguerre agree not to choose any other person than Monsieur Lemaître to make the said application.

Art. 9. At the time of the final agreement, the partners will mutually appoint the manager

and accountant of the firm, which will have its offices in Paris. The manager shall conduct the business as decided by the partners, and the accountant will receive and make payments as ordered by the manager in the interests of the firm.

Art. 10. The services of the manager and accountant will be for the duration of the present agreement, but these officials shall be eligible for re-appointment. Their services will be gratuitous, or a portion of the profits may be awarded them, as the partners may think fit at the time of signing the final agreement.

Art. 11. Every month the book-keeper shall render his accounts to the manager, showing the position of the firm; and every six months the partners shall divide the profits as stated below.

Art. 12. The accounts showing the position of the firm shall be balanced, signed and attested each half-year by both partners.

Art. 13. The improvements and perfections made to the said invention, and to the camera obscura, shall be the property and for the benefit of both partners, and when they have attained the object in view, they will make a final agreement on the basis of the present one.

Art. 14. The net profits of the firm shall be shared equally between Monsieur Niépce as inventor and Monsieur Daguerre for his improvements.

Art. 15. Any dispute which may arise between the partners in regard to this agreement shall be decided by arbitrators appointed by each party privately, according to article 51 of the Code of Commerce, and their decision shall be final and irrevocable.

Art. 16. If it should be decided to wind up the firm, the liquidation shall be undertaken privately by the accountant, or by both partners together, or by a third person to be appointed privately or by a competent tribunal at the instigation of the more active partner.

The whole of this agreement has been entered into provisionally by the parties, who, for its execution, give as address their respective residences as specified above.

Executed and signed in duplicate at Châlon-sur-Saône this fourteenth day of December one thousand eight hundred and twenty-nine.

Approved by me though not written
by my hand
 J.-N. NIÉPCE

Approved by me though not written
by my hand
 DAGUERRE

(See Plate 31.)

Registered at Châlon-sur-Saône the 13th March 1830, folio 32, Vol. C.9 and following. Received five francs fifty centimes, 10% [tax] included.

DUCORDEAUX

Niépce's copy of the agreement is preserved by the Niépce family. Daguerre gave his copy to Arago in 1839 for study before making his report on the daguerreotype, and he retained it. In 1890 Dr Pedro N. Arata of Buenos Aires bought from a Frankfurt book-dealer Arago's collected works and found in the volumes documents used by the editor J. A. Barral—among them the Niépce–Daguerre contract, two letters from Niépce to Daguerre and the two later contracts with Isidore Niépce.

ADDITIONAL AGREEMENT on the basis of the Provisional Agreement between MM. Joseph-Nicéphore Niépce and Louis-Jacques-Mandé Daguerre the fourteenth December one thousand eight hundred and twenty-nine at Châlon-sur-Saône.

Between the undersigned Louis-Jacques-Mandé Daguerre, painter, member of the Legion of Honour, manager of the Diorama, residing in Paris, and Marie-Joseph-Isidore Niépce, landowner, residing at Châlon-sur-Saône, son of the late M. Joseph-Nicéphore Niépce, in his capacity as sole heir, conforming to Article 2 of the provisional agreement dated 14 December 1829: the following has been agreed upon. To wit

1. That the discovery with which this contract is concerned, having undergone great improvements through the collaboration of M. Daguerre, the said partners recognize that it has reached the point which they desired to attain, and that further improvements are almost impossible.

2. That M. Daguerre having, after numerous experiments, recognized the possibility of obtaining a more speedy result by the aid of a process which he has discovered, and which (taking success for granted) will replace the basis of the invention set out in the provisional agreement of 14 December 1829: the first article of the said provisional agreement shall be annulled and replaced as follows:

First Article. MM. Daguerre and Isidore Niépce form a partnership under the commercial title *Daguerre et Isidore Niépce*, for the exploitation of the discovery invented by M. Daguerre and the late Nicéphore Niépce.

All the other articles of the provisional agreement are and remain the same.

Made and passed in duplicate between the undersigned this ninth day of May one thousand eight hundred and thirty-five at Paris.

Approved by me though not written Approved by me though not written
by my hand by my hand

 I. NIÉPCE DAGUERRE

Daguerre's copy is at Buenos Aires. Niépce's copy is preserved at the Musée Denon, Châlon.

CONTRACT BETWEEN DAGUERRE, I. NIÉPCE, AND ALPHONSE GIROUX

It is agreed between the undersigned, MM. Daguerre and Niépce on the one hand, and Messrs Alphonse Giroux et Cie on the other hand, as follows:

Article 1. M. Daguerre hereby undertakes to deliver to Messrs Alphonse Giroux et Cie, and to them alone, the models and information necessary for the manufacture of the various equipment which makes up the daguerreotype apparatus.

Art. 2. MM. Daguerre and Niépce undertake not to deliver abroad, with the exception of England, any model or the permission to manufacture their apparatus. Messrs Alphonse Giroux et Cie are the only persons authorized to sell or manufacture in France and abroad; MM. Daguerre and Niépce transfer all their rights to Messrs Alphonse Giroux et Cie, in return for a share in the profits as described in Article 8.

Art. 3. Messrs Alphonse Giroux et Cie are authorized by M. Daguerre to announce that the apparatus is manufactured under his direction.

Art. 4. Each apparatus will bear a printed label or signature of MM. Daguerre and Giroux. If, however, in the course of competition Messrs A. Giroux et Cie were obliged to manufacture these instruments at a lower price—and therefore were forced to fall short of the desired perfection—M. Daguerre could not attach his name to them.

Art. 5. Messrs Alphonse Giroux et Cie are authorized to manufacture the apparatus in different sizes, in order to expand the scope of this article for artists, if they find this advisable in the interest of all the parties. In this case M. Daguerre must be consulted.

Art. 6. MM. Daguerre and Niépce undertake not to manufacture or sell any apparatus at their own place or elsewhere, but M. Daguerre reserves the right to manufacture them for his own personal use.

Art. 7. M. Daguerre undertakes to inform M. Giroux of any improvements or perfection which he may make to his invention (after having first communicated these to the Government).

Art. 8. Messrs Giroux et Cie undertake for their part to divide with MM. Daguerre and Niépce half the profits resulting from the sale of each Daguerreotype [outfit]; this means that MM. Daguerre and Niépce are to receive one-quarter each, and Messrs Giroux et Cie the two other quarters.

Art. 9. Immediately after the Bill has been passed by the Chambers of Deputies and of Peers, M. Daguerre will entrust to Messrs Alphonse Giroux et Cie on loan two of the specimen pictures he has obtained, in order that the latter may collect subscriptions for the sale of apparatus. This article [i.e. the choice of pictures] is left to the discretion of M. Daguerre.

Art. 10. Immediately after the acceptance of the Bill by the Chambers, M. Daguerre undertakes to initiate M. Giroux personally into the secret of his invention in all its details. M. Giroux, for his part, promises to keep the secret and not to supply any apparatus nor any pictures until the day the King's ordinance has been published [i.e. the day the process is published by the King's decree—19 August].

Art. 11. A special list will be kept showing the exact number of apparatus sold.

Art. 12. As sales proceed accounts shall be rendered to MM. Daguerre and Niépce of their share of the profits as stipulated in Article 8.

Art. 13. It is understood that the sale of accessories necessary for the daguerreotype apparatus and replacements [of chemicals and plates, etc.] do not enter into this agreement and the profits therefrom accrue solely to Messrs Giroux et Cie. MM. Daguerre and Niépce shall be presented with a statement of the cost of manufacture, after which the selling price of the apparatus will be determined.

Art. 14. It is agreed that until such date as the King's ordinance shall have been made public, MM. Daguerre and Niépce cannot present without payment any apparatus to anyone, with the exception of one outfit for M. Arago.

Art. 15. It is also agreed that the arrangements which MM. Daguerre and Niépce will make in England will be such that the introduction of the daguerreotype [apparatus] in

that country must be in agreement with that made by the firm of Alphonse Giroux et Cie and must on no account precede it.

Art. 16. In the case of unforeseen circumstances, if the publication of the process is not authorized by the Government [i.e. if the Bill is not passed] Messrs Alphonse Giroux et Cie undertake not to derive any benefit from their knowledge of the process with which they have become acquainted, and to keep it secret.

Art. 17. The cost of manufacturing the said apparatus is to be borne solely by Messrs Giroux et Cie.

Art. 18. Messrs Giroux et Cie do not deny themselves the right to profit from any later discoveries which may be made with an analogous object in view.

Art. 19. The constructional parts of the outfit [i.e. mercury and iodizing boxes, etc.] shall not be shown to Messrs Alphonse Giroux et Cie until the Bill has been passed by the Chamber of Deputies.

Made in triplicate between us this twenty-second day of June, one thousand eight hundred and thirty-nine.

Approved the above	Approved the above	Approved the above
Iʳᵉ NIÉPCE	DAGUERRE	A. GIROUX ET CIE

Contract found by Georges Potonniée among the papers of the Niépce family, and published by him in the *Bulletin de la Société française de Photographie*, August 1937. The English translation by Edward Epstean published in the *Photographic Journal*, January 1938, fails to convey the correct meaning of articles 9, 18 and 19.

CONTRACT BETWEEN DAGUERRE, I. NIÉPCE AND LÉTAULT

Between the undersigned:

1. M. Louis-Jacques-Mandé Daguerre, painter, living at No. 17, Boulevard Saint-Martin, Paris, party of the first part;
2. M. Jacques-Marie-Joseph-Isidore Niépce, living at Châlons-(sic) sur-Saône, Saône et Loire, party of the second part;
3. and M. Elzeard Désiré Létault, living at No. 13 rue de L'Echiquier, Paris, party of the third part.

It is agreed as follows:

According to the proceedings of this day before M. Bonnaire, notary of Paris, Messrs Daguerre and Niépce have made M. Létault their agent and representative in England for the purpose of pursuing, dealing and concluding whatever is necessary for their interest. In conformity with the foregoing and in order to indemnify him and recompense him for his labour, expenses and time, Messrs Daguerre and Niépce undertake, each separately and both collectively, to grant to, and M. Létault on his part agrees to accept, a commission or remuneration, starting from this day, amounting to 1,500 francs in case the sale, assignment or offer for the patent or licence for the daguerreotype taken out in England about August the 14th by Mr Milleberry [i.e. Miles Berry] and having become their

property, does not reach the amount of 100,000 francs or 4,000 pounds sterling; on the other hand, he shall receive a remuneration of 2,000 francs if the amount tendered for the sale, offer or assignment reaches the above-mentioned sum of 100,000 francs, or 4,000 pounds sterling. In addition, they grant to M. Létault the ownership of the entire half of all that sum which may exceed the said sum of 100,000 francs, or 4,000 pounds sterling, realized from the said patent or licence for the daguerreotype in its sale, offer or assignment.

Finally, Messrs Daguerre and Niépce agree to pay M. Létault, during his stay in England, one pound sterling per day, plus fifteen pounds sterling for the expenses of the journey, going and coming, which journey must not be prolonged beyond the 15th of April next; if the trip is extended beyond this date, the expenses allowed by Messrs Daguerre and Niépce are not required to be paid without prejudice notwithstanding the agreed indemnities set out herein.

Made in triplicate in Paris on the nineteenth day of February one thousand eight hundred and forty.

<div align="center">

NIÉPCE DAGUERRE LÉTAULT

</div>

Contract found by Georges Potonniée among the papers of the Niépce family, and published by him in the *Bulletin de la Société française de Photographie*, August 1937.

DAGUERREOTYPES BY DAGUERRE

<div align="center">

(on plates 21·5 cm. × 16·5 cm. unless otherwise stated)

</div>

Still-life in his studio, 1837 (Plate 37). (Société Française de Photographie.) Presented by Daguerre to M. de Cailleux, Curator at the Louvre. On the back: "Épreuve ayant servi à constater la découverte du Daguerréotype, offerte à Monsieur de Cailleux par son très devoué serviteur Daguerre."

View of the Tuileries and the Seine from the balcony of the Ministry of the Interior, Quai d'Orsay, 7 September 1839. (Conservatoire national des Arts et Métiers.) (Plate 38.)

A similar picture (said to be poor) taken on a rainy day in September 1839, and several others. (Société Française de Photographie.)

An arrangement of fossil shells, 1837–39. (Conservatoire national des Arts et Métiers.) (Plate 41.)

Group of casts and capitals 1837–39. (Conservatoire national des Arts et Métiers.)

Notre-Dame from the Pont des Tournelles, 1838–39. (Gernsheim Collection.) (Plate 39.)

The same subject, sent to the Emperor Ferdinand I of Austria in 1839 (lost).

Group of casts from antique sculpture including Hercules, sent to Metternich in 1839. (Schloss Königswart, Bohemia.)

The Palais Royal, Paris, 1838–39. Sent to Berlin; formerly at the Technische Hoch-

schule. (Plate 42.) Evacuated during World War II to Brno, now at the National Technical Museum, Prague.

> Group of casts, including faun and nymph, *c.* 1838–39.
>
> Boulevard du Temple taken from Daguerre's laboratory in the Diorama by mid-day light, 1838. (Plate 40.)
>
> Another, with a man having his shoes cleaned, taken at 8 a.m.

(The three last pictures were sent to Ludwig I of Bavaria. They were described by Daguerre as "Épreuves ayant servi à constater la découverte du Daguerréotype, offertes à sa Majesté le Roi de Bavière par son très humble et très obéissant serviteur Daguerre." They were damaged in World War II.) (National Museum, Munich.)

> A Bacchus and other plaster casts, 1838–39. 12 cm. × 15 cm.
>
> View from Daguerre's third-floor flat at 17 Boulevard Saint-Martin: a few houses and a leafless tree, March 1839. 12 cm. × 15 cm. (Plate 56.)
>
> A crouching Venus and another plaster cast of a nude female figure, 1838–39. 12 cm. × 15 cm.
>
> A bust of Homer and other plaster casts, with a carpet showing texture of weaving (shown on 19 August 1839), 1838–39. 12 cm. × 15 cm.

(The above four daguerreotypes were given by Daguerre to Arago and by him to the Perpignan Museum. Arago, who was born at Estagel near Perpignan, was Deputy for the East Pyrenees.)

Cast of Venus and bas-reliefs, 1838–39. Illustrated by Lécuyer in his *Histoire de la Photographie*.

The Quai Voltaire, Paris, 1838–39. Supposed to have been given by Daguerre to Isidore Niépce. (Musée Denon, Châlon-sur-Saône.) (A view of the Pantheon at this museum is not by Daguerre but by Isidore Niépce, 1839.)

Portrait of an artist (possibly Charles Arrowsmith) (Plate 61), *c.* 1842–43. 8·3 cm. × 10·5 cm. Daguerre's signature is scratched on the plate. (George Eastman House.)

Portrait of the painter de Gosse, one-time collaborator on the Diorama. This daguerreotype, shown by Aimé Girard to members of the Société Française de Photographie on 6 May 1864, bears the following inscription on the back (translation): "To my friend Gosse. Daguerre. Made in six seconds in hazy weather, in 1843." (Whereabouts unknown.)

Family group of the Marquis de Virieu, said to have been taken by Daguerre in March 1843. Reproduced in *The Photographic Journal*, London, March 1905. (Whereabouts unknown.)

Mme Daguerre, taken at Bry, *c.* 1845. 5 cm. × 6·5 cm. (Science Museum.) (Plate 60.)

Mme Daguerre's niece Georgina Arrowsmith, taken at Bry. *c.* 1845. (Société Française de Photographie.)

Daguerre's cook, at Bry. *c.* 1845 (French collection). Illustrated in Lécuyer's *Histoire.*

View of Bry from the tower of Daguerre's house, 1845. (Société Française de Photographie.)

The following daguerreotypes by Daguerre were referred to by Arago or in newspapers during 1839, but the originals have not been traced.

Several of the Boulevard du Temple, some showing horses which had partly moved (shown to Samuel Morse).

Ile de la Cité and Notre-Dame.

The long gallery joining the Louvre and the Tuileries.

Some views of the Seine and several of its bridges.

Some views of the (Customs) barriers.

} Mentioned by Arago 7 Jan. 1839

Pont-Marie, 1837. Mentioned in the *Gazette de France*, 6 January 1839. Shown on 19 August 1839.

A spider taken through a microscope.

View of Paris from the Pont des Arts.

Three views of the Luxor obelisk in the Place de la Concorde taken by morning, noon, and evening light. Reported in *The Spectator*, 2 February 1839.

Several groups of busts from the Musée des Antiques, including the one with bust of Homer and carpet now at the Perpignan Museum.

View from Daguerre's flat at 17 Boulevard Saint-Martin taken end of August 1839, when demonstrating to Jules Janin.

The Institut de France.

Pont-Neuf and statue of Henri IV.

The Grève (a square in Paris where executions used to take place).

PORTRAITS OF DAGUERRE

Miniature by Millet du Charlieu, 1827. (Louvre.) The only portrait of Daguerre without a moustache; he looks very young for forty. (Plate 29.) Also photogravure of it by Dujardin printed by Charles Wittmann.

Lithograph by Henri Grevedon, 1837 (facing left). (Société Française de Photographie.)

Lithograph of the same portrait but without Grevedon's name, printed by Aubert & Cie and published in *Galerie de la Presse, de la Littérature et des Beaux-Arts*, 1840. (George Eastman House and Gernsheim Collection.)

Several versions of Grevedon's portrait were published:

Lithograph of Daguerre (facing right) signed "Julien", *c.* 1837. Printed by Aubert & Cie, published in *Galerie du Valeur* (No. 61). (George Eastman House and Gernsheim Collection.)

Another version, in which the clothes are slightly different, printed by Lemercier, Bénard & Cie, forms the frontispiece of Alphonse Giroux's second edition of Daguerre's Manual, 1839. In some copies of this portrait the signature "Julien" is still faintly legible.

A very poor copy of this portrait, signed "F. Jules Collignon" and lithographed by E. Thierry Frères was published by Susse Frères and forms the frontispiece of the edition of Daguerre's Manual published by Lerebours and Susse, 1839.

Another very poor copy signed "J. Vitou" appears as frontispiece to Mentienne's *La Découverte de la Photographie en 1839*, Paris, 1892.

(The lithographs published in 1839 were all old portraits and bear little resemblance to the daguerreotypes taken in the mid-forties. They all make Daguerre look too young.)

Caricature bust by Jean Pierre Dantan, 1838–39. One bronze and one plaster, 17 cm. high at the Musée Carnavalet, one plaster at George Eastman House and one terracotta at the Conservatoire des Arts et Métiers. Daguerre's head is represented coming out of the roof of the Diorama. On the base, which is in the form of a camera, is "Diorama" in rebus form (Di os rat mât). Daguerre's freckles figure prominently. The bust was published as a woodcut by Théodore Maurisset in *Musée Dantan. Galerie des charges et croquis des célébrités de l'époque*, H. Delloye, Paris, 1839. The 100 woodcuts are by Théodore Maurisset. (George Eastman House and Gernsheim Collection.) (Page 13.)

Monochrome painting by Paul Carpentier, 1851 (shortly after Daguerre's death) at the Société Française de Photographie. It was copied from Meade's daguerreotype. Published as a photogravure by Adolphe Braun in the Society's Bulletin, November 1891.

Bust by Paul Carpentier, c. 1851 (?) at the Société Française de Photographie. Illustrated in the *Annales de la Société libre des Beaux-Arts*, 1855. Made after Daguerre's death, from a daguerreotype by Meade.

Relief medallion by Husson on Daguerre's tomb at Bry-sur-Marne, erected November 1852 by the Société libre des Beaux-Arts.

Plaster medallion 43 cm. diameter by an unknown sculptor. (Musée Carnavalet.) This may be the model for the one on the tomb.

Plaster bust by P. Cuypers, exhibited at the Photographic Exhibition, Vienna, 1864 (No. 859).

Sculpture on the Beuth monument, Berlin, by P. C. H. Wilhelm.

Marble bust four to five times life size by Mathieu Meusnier, 1876, at the entrance to the photographic department at the Conservatoire des Arts et Métiers.

Bust by Capellaro on monument at Cormeilles erected August 1883 by the Société Française des Archives photographiques.

Bust on monument in Washington erected August 1890 by the Photographic Association of America.

Bust by Mme Élise Bloch on monument erected at Bry, June 1897, by the Société Française de Photographie.

Prize medal (together with Niépce) of the Société Française de Photographie, 1854, designed by E. Soldi.

Prize medal of the Viennese Amateur Photographers Club, 1888, designed by Jauner. (Plate 114.)

Niépce's and Daguerre's portraits on French postage stamp commemorating the centenary of photography in 1939. The text reads "Arago annonce la découverte de la photographie le 7 janvier, 1839", but the illustration is copied from the woodcut (Plate 109) of the meeting of 19 August 1839—an anachronism which has escaped notice up to now.

Daguerreotypes of Daguerre:

Daguerreotype by J. B. Sabatier-Blot, 1844. (Plate 1.) (Original at George Eastman House.) Published as a photogravure (detail of head) by the Société Française de Photographie by subscription (n.d.).

Daguerreotype by E. Thiésson, 1844. 9 cm. × 7 cm. (Frontispiece). (Original at the Musée Carnavalet.)

Daguerreotype by A. Claudet, 1846.* (Whereabouts of original not known.) Published as a woodcut in the *Illustrated London News*, 26 July 1851.

Daguerreotype by William England, 1846.* (Original at the Société Française de Photographie to whom it was presented by England in 1905.)

Daguerreotype by J. E. Mayall, 1846.* (Whereabouts of original not known.) Published as a carbon print in the *Photographic News Almanac*, 1882.

Five or six daguerreotypes by Charles R. Meade, 1848. (Two originals at Smithsonian Institution, Washington.) One or more were published as lithographs by F. D'Avignon, New York. (George Eastman House.)

Some by Vaillat taken at the same time as Meade's. (Formerly collection of Paul Nadar. Whereabouts not known.)

Daguerreotype by Richebourg (n.d.). (Whereabouts of original not known.) Nadar reproduced this daguerreotype and signed his reproduction with his name (a print is at the Royal Photographic Society, London). Published as a photogravure by Dujardin in *Paris Photographe*, c. 1891.

Daguerreotype by Warren Thompson. (Whereabouts of original not known.) Gustave Janet used it for a woodcut illustrating an article by Francis Wey in *Musée des Familles*, 1853.

BOOKS ILLUSTRATED WITH LITHOGRAPHS OR ENGRAVINGS AFTER DAGUERREOTYPES, OR WITH PRINTS FROM ETCHED DAGUERREOTYPES &c.

Album du Daguerréotype réproduit, orné de vues de Paris, en épreuves de luxe avec texte. Printed by Bruneau, rue Montmartre 39, and sold by the publisher (name not stated), Place de la Bourse 12, Paris. Entered in the *Bibliographie de la France* on 11

* The three daguerreotypes by Claudet, England and Mayall show Daguerre in the same pose, and it may be assumed they were taken at the same sitting.

January 1840. This is the first publication with reproductions from daguerreotypes. 4 lithographs on silver paper simulating daguerreotypes. (George Eastman House.)

Daguerreotyp-Panorama över Stockholm och dess omgifning. Daguerreotyped by L. Benzelstjerna, lithographed by J. C. Boklund. 12 parts announced, but probably no more than two parts (8 plates) published by Thomas S. Müller, Stockholm, in 1840. Printed by L. J. Hjerta. (Royal Library and City Museum, Stockholm.)

Paris et ses environs réproduits par le Daguerréotype. Edited by Charles Philipon, published by Aubert & Cie, Paris, 1840. 60 plates lithographed by 14 different artists. (Gernsheim Collection and George Eastman House.)

Excursions Daguerriennes: vues et monuments les plus remarquables du globe. 111 plates engraved by various artists after daguerreotypes, including prints from two actual daguerreotypes etched by H. Fizeau. Published in parts containing 4 plates each, 1841–43. Parts 1–8 published during 1841, parts 9–15 during 1842, the remaining parts totalling another 51 plates were published during 1843 and announced to be completed by 30 October 1843. Parts 1–15 comprising 60 plates were issued as Vol. I in 1842, and the remaining 51 plates as Vol. II at an unspecified date (1843 or 1844). Albums containing special selections were also published. Edited and published by N. P. Lerebours, Place du Pont-Neuf 13. Also sold by Rittner et Goupil, Boulevard Montmartre 15, and Hr Bossange, Quai Voltaire 11. (George Eastman House and Gernsheim Collection.)

Anatomie microscopique et physiologie des fluides de l'économie. Atlas éxécuté d'aprés Nature au Microscope-Daguerréotype. By Alfred Donné and Léon Foucault. Contains 86 engraved illustrations on 20 plates, copied from daguerreotypes by Oudet. Published by J. B. Baillière, rue de l'Ecole-de-Médicine 17, Paris, 1845. (British Museum.)

Vues de Paris prises au Daguerréotype: gravures en taille douce sur acier. 25 engravings edited and published by Chamouin, Paris, n.d. (c. 1845). (George Eastman House and Gernsheim Collection.)

Evidence of the Truth of the Christian Religion etc. By Alexander Keith. 36th edition much enlarged. Edinburgh 1848. Illustrated with 18 engravings from daguerreotypes by George S. Keith taken in Palestine and Syria in 1844. The engravings are by W. Miller and W. Forrest. (Gernsheim Collection.)

Album de Touraine d'aprés le Daguerréotype. Plessis-Les-Tours & Maison Tristan. Published by Clarey-Martineau, Rue de la Harpe 14 & 16, Tours; also sold by Guilland-Verger, Rue Royale 43, n.d. (c. 1854). 6 lithographs by Clarey-Martineau, one dated 1854. (George Eastman House.)

Promenades poétiques et daguerriennes. Bellevue (Seine-et-Oise). Avec sept vues prises au Daguerréotype et reportées sur papier photographique. By Louis-Auguste Martin. Paris, 1850.

Promenades poétiques et daguerriennes. Chantilly. Avec six vues prises au Daguerréotype et reportées sur papier photographique. By Louis-Auguste Martin. Paris, 1850.

These small guide-books were the earliest photographically illustrated books published in France. The daguerreotypes must have been rephotographed by Blanquart-Evrard's modification of the Calotype process.

LOOSE LITHOGRAPHS AND ENGRAVINGS COPIED FROM DAGUERREOTYPES

Le Daguerréo-Lithographe. Lithographic views of Paris copied from daguerreotypes by Lerebours, Soleil, and others. Lithographed by L. Marquier. Published by Hautecœur, rue du Coq Saint-Honoré. (3 plates at George Eastman House.)

Daguerrian Excursions in Jamaica. An unspecified number of lithographic views copied from daguerreotypes by A. Duperley (a photographer in Kingston, Jamaica) and printed in Paris by Thierry Brothers. Published by Duperley in Kingston, 1844. Several coloured plates are in the possession of M. D. Harrell.

Daguerreotypierte Ansichten der Hauptstädte und der schönsten Gegenden der Schweiz. (Title also in French: *Vues Daguerréotypées des villes capitales de la Suisse ainsi que des contrées les plus intérressantes de ce pays.*) Taken and published by Franziska Möllinger. Solothurn, 1844–45. 15 lithographs in 4 parts. (The entire series is in the Stenger Collection at Agfa, Leverkusen.)

Daguerreotyp-Ansichten. Lithographs by Waage of views of Vienna (no photographer mentioned), printed by Reiffenstein & Roesch, c. 1845. (2 plates in Gernsheim Collection.)

A series of Italian views were published in Milan with French titles, of which the following are examples:

La Cathédrale, Milan, éxécuté d'après le daguerréotype. Steel engraving by L. Cherbuin. 1840s. (Gernsheim Collection.)

Recueil de vues principales de la Toscane, éxécutées d'après les originaux du Daguerréotype et gravées par J. J. Falkeisen et L. Cherbuin. Published by Ferdinand Artaria et Fils, Rue Ste. Marguerite No. 111, Milan, n.d. 1840s. 18 exquisite aquatints, fully equal to those in *Excursions Daguerriennes.* (George Eastman House.)

BIBLIOGRAPHY OF DAGUERRE'S INSTRUCTION MANUALS
Compiled by Beaumont Newhall

Daguerre's instruction manual, *Historique et description du procédé nommé le Daguerréotype,* immediately became a best seller. Before the eventful year of 1839 had run its course it appeared not only in French but also in English, German, Swedish and Spanish, and by 1840 was translated into Italian, Hungarian and Polish as well.

All known copies of these translations and variant issues are listed here. To Erich Stenger, whose *Daguerre-Schriften,* Berlin, 1936, was the pioneer bibliography, and to Helmut Gernsheim, who described the English editions in the *Photographic Journal,* XC, Section A (September 1950), pp. 308–310, I am indebted for valuable assistance.

Orthography, punctuation and order have been strictly followed in transcribing the title pages, but no attempt has been made to furnish a complete bibliographical description. The French issues appear in a bewildering variety of forms, because the same printed

sheets were bound with different title pages and with various inserts of advertising material.

(As an indication of the rapidity with which the various manuals succeeded one another, the authors have whenever possible added the month of publication in brackets.)

1. HISTORIQUE ET DESCRIPTION DES PROCÉDÉS DU DAGUERRÉOTYPE ET DU DIORAMA, PAR DAGUERRE, Peintre, inventeur du Diorama, officier de la Légion-d'Honneur, membre de plusieurs Académies, etc., etc. Paris. Alphonse Giroux et Cie, Rue du Coq-Saint-Honoré, 7, Où se fabriquent les Appareils; Delloye, Libraire, Place de la Bourse, 13. 1839.

> *False title, title, 79 pp. plus VI plates. Printed by Béthune et Plon. For a detailed discussion of this first issue of the first edition, see* Photographic Journal, XC, Section A (*July* 1950), *pp. 233–34. Only two copies are known; both are in the George Eastman House Collection. One of the copies was presented by Daguerre to his friend Mentienne, the mayor of Bry-sur-Marne.*
>
> (*Published on or about 20 August. Not listed in the* Bibliographie de la France.)

2. (*Same*) Paris. Susse Frères, Éditeurs, Place de la Bourse, 31. Delloye, Libraire, Place de la Bourse, 13. 1839.

> *Except for inserts and change in title page identical to* 1. *Entered in* Bibliographie de la France *on 14 September* 1839.

3. (*Same*) Paris. Molteni et Fils Aîné, Rue du Petit-Lion-Saint-Sauveur, 22, Où se fabriquent les Appareils; Delloye, Libraire, Place de la Bourse, 13. 1839.

> *Except for advertising inserts and change in title page identical to* 1.

4. (*Same*) Paris. Lerebours, Opticien de l'Observatoire, Place du Pont-Neuf, 13; Susse Frères, Éditeurs, Place de la Bourse, 31. 1839.

> *Except for advertising inserts and change in title page identical to* 1.

5. HISTORIQUE ET DESCRIPTION DES PROCÉDÉS DU DAGUÉRREOTYPE ET DU DIORAMA, rédigés par Daguerre. Deuxième edition augmentée et corrigée par l'Auteur. Paris. Susse Frères, Éditeurs, Place de la Bourse, 31. Delloye, Libraire, Place de la Bourse, 13. 1839.

> *Despite the statement on the title page, this is not a second edition. Except for the title page and advertising inserts it is identical to* 1. *Entered in* Bibliographie de la France, 19 *October* 1839.

6. HISTORIQUE ET DESCRIPTION DES PROCÉDÉS DU DAGUERRÉOTYPE ET DU DIORAMA, rédigés par Daguerre, ornés du portrait de l'auteur, et augmentés de notes et d'observations par MM. Lerebours et Susse Frères. Paris. Susse Frères, Éditeurs, Place de la Bourse, 31. Lerebours, Opticien de l'Observatoire, Place du Pont-Neuf, 13. 1839.

> *False title, title, 88 pp., front. (portrait of Daguerre), VI plates. Pages 1–79 are identical to preceding issues. The added matter, a signature of 4 leaves, contains* "Observations sur le Procédé Nommé le Daguerréotype" *by Lerebours,* "Nouvelle Préparation des Plaques au Tripoli", *and* "Observations pour les Intérieurs et pour faire les Portraits", *by Susse Frères.* (*Evidence of advertisements indicates November as the month of publication.*)

7. *(Same)* Paris. Lerebours, Opticien de l'Observatoire, Place du Pont-Neuf, 13. Susse Frères, Éditeurs, Place de la Bourse, 31. 1839.

Identical to 6 except for the change in the position of the publishers' names on the title page, for advertising inserts, and lack of imprint on the engraved plates. In all preceding issues the words "Susse Frères, Edit. Place de la Bourse, 31" appear at the foot of the page. In this issue the words do not appear, although the plates are printed from the same engraved plates.

(Evidence of advertisements indicates November as the month of publication.)

8. HISTORIQUE ET DESCRIPTION DES PROCÉDÉS DU DAGUERRÉOTYPE ET DU DIORAMA, par Daguerre, Peintre, inventeur du Diorama, Officier de la Légion-d'Honneur, membre de plusieurs Académies, etc. Nouvelle Edition, corrigée et augmentée du portrait de l'auteur. Paris, Alphonse Giroux et Cie, Éditeurs, Rue du Coq-Saint-Honoré, No. 7, où se Fabriquent les Appareils; et chez les Principaux Libraires, Papetiers, Marchands d'Estampes et Opticiens. 1839.

False title, title, 76 pp., front. (portrait of Daguerre), VI plates. The plates are re-engraved and an extra figure, numbered 7, has been added to Plate I, showing a wooden spatula. Printed by Felix Malteste et Cie, Paris. Entered in Bibliographie de la France, 28 September 1839. A variant exists, differing only by the inclusion of the printer's colophon on p. 76.

9. HISTORY AND PRACTICE OF PHOTOGENIC DRAWING ON THE TRUE PRINCIPLES OF THE DAGUERRÉOTYPE, WITH THE NEW METHOD OF DIORAMIC PAINTING; published by order of the French Government. By the inventor, L. J. M. Daguerre, Officer of the Legion of Honour, and member of various academies. Translated from the original by J. S. Memes, LL.D., Hon. Mem. of the Royal Scottish Academy of Fine Arts, etc. London: Smith, Elder and Co., Cornhill; and Adam Black and Co., Edinburgh. 1839.

xii, 76 pp., VI plates. Printed by Stewart and Murray. Preface dated 13 September 1839. (Date of first review in The Literary Gazette, *21 September.)*

10. HISTORY AND PRACTICE OF PHOTOGENIC DRAWING ON THE TRUE PRINCIPLES OF THE DAGUERRÉOTYPE, WITH THE NEW METHOD OF DIORAMIC PAINTING; secrets purchased by the French Government, and by their command published for the benefit of the arts and manufactures: by the inventor L. J. M. Daguerre, Officer of the Legion of Honour, and member of various academies. Translated from the original by J. S. Memes, LL.D., Hon. Mem. of the Royal Scottish Academy of Fine Arts, etc. London; Smith, Elder and Co., Cornhill; and Adam Black and Co., Edinburgh. 1839.

Except for change in title page, identical to 9.

11. *(Same)* Second Edition. London: Smith, Elder and Co., Cornhill; and Adam Black and Co., Edinburgh. 1839.

Except for statement "Second Edition" on title page, identical to 9 and 10. (British Museum copy dated 19 October.)

12 (*Same*) Third Edition. London: Smith, Elder and Co., Cornhill; and Adam Black and Co., Edinburgh. 1839.

> *Except for statement "Third Edition" on title page, identical to 9, 10 and 11. (Published before 28 October.)*

13 HISTORY AND PROCESS OF PHOTOGENIC DRAWING BY MEANS OF THE DAGUERRÉOTYPE. Published by order of the French Government. By L. J. M. Daguerre, Officer of the Legion of Honour, etc. With notes and explanations by M. Arago, Member of the Chamber of Deputies, etc. Illustrated by six engravings. London: William Strange, 21, Paternoster Row. MDCCCXXXIX.

> *46 pp., VI plates. Printed by R. MacDonald. (British Museum copy dated 19 October.)*

14. AN HISTORICAL AND DESCRIPTIVE ACCOUNT OF THE VARIOUS PROCESSES OF THE DAGUERRÉOTYPE AND THE DIORAMA. By Daguerre, Painter, Inventor of the Diorama, a knight of the Legion of Honour, and a Member of several Academies. London, McLean, 26 Haymarket; —Nutt, Bookseller, Fleet Street. 1839.

> *False title, title, 86 pp., VI plates. Printed by Belin and Co., Paris. Entered in Bibliographie de la France, 2 November 1839.*

15. A PRACTICAL DESCRIPTION OF THAT PROCESS CALLED THE DAGUERREOTYPE; this process consists in the spontaneous reproduction of the images of nature, received in the camera obscura, not with their colours, but with great nicety in the gradation of shades, by M. Daguerre, painter, inventor of the Diorama, Officer of the Legion of Honour, etc. Translated by J. P. Simon, M.D., a native of France . . . London: John Churchill, Prince's Street, Soho. Edinburgh: Carfrae and Son. Dublin: Fannin and Co. Southampton: Fletcher and Son. 1839.

> *38 pp., II plates on one leaf. Printed by J. Green & Co., London. Preface dated 30 October 1839. A translation of pp. 57–74 of the basic edition (Nos. 1–6) plus 5 pages (34–38) of self-advertisement in which Dr Simon gives details of his medical qualifications, in particular his experiments with a stomach pump of his invention, and seeking employment. Published before 16 November when it was reviewed in* The Literary Gazette.

16. (*Same*) Second Edition. London: W, Waller, 188, Fleet Street, Edinburgh: Carfrae and Son. Dublin: Fannin and Co. Southampton: Fletcher and Son. 1839.

> *Identical to 15 except for title page with misprint "calle" instead of "called".*

17. A FULL DESCRIPTION OF THE DAGUERREOTYPE PROCESS: as published by M. Daguerre. Illustrated by numerous woodcuts. Extracted from the American Repository, edited by Prof. J. J. Mapes. New York: For sale by J. R. Chilton, 263 Broadway. 1840.

> *Cover-title, 16 pp. A reprint of pp. 55–68 of the Memes translation (Nos. 9–12). (Only pp. 1–8 are from Memes. Pp. 9–16 contain Chilton's explanation of the apparatus, some French improvements reprinted from* The Athenaeum, London, *of 30 November 1839, some observations by Chilton, and the first exposure-table by D. W. Seager.)*

18. DESCRIPTION PRATIQUE DES PROCÉDÉS DU DAGUERRÉOTYPE ET DU DIORAMA, par Daguerre, Peintre, inventeur du Diorama, officier de la Légion d'Honneur, membre de plusieurs Académies, etc., etc. Le procédé du Daguerréotype consiste dans la

reproduction spontanée des images de la nature reçues dans la chambre noire, non avec leurs couleurs, mais avec une grande finesse de dégradation de teintes. Berlin, Libraire de Ad. Mt. Schlesinger, Linden No. 31. Paris, chez Susse frères. St Petersbourg, chez Grueff.

23 pp. (*This is one of the manuals printed in Paris for sale abroad.*)

19. PRAKTISCHE BESCHREIBUNG DES DAGUERREOTYP's von Daguerre, Maler, Erfinder des Diorama, Offizier der Ehrenlegion, Mitglied mehrerer Akademien u.s.w. Treu übersetzt nach der den Pariser Daguerreotypen beigelegten Originalbeschreibung des Herrn Daguerre und begleitet von sechs Tafeln Abbildungen der einzelnen Theile des Original-Instruments. Berlin 1839. Verlag von George Gropius.

24 pp., VI plates. (*First advertised on 30 September in the* Vossische Zeitung.)

20. DAGUERRE'S AUSFÜHRLICHE BESCHREIBUNG SEINER GROSSEN ERFINDUNG, oder die Kunst, auf die beste Art die so höchst merkwürdigen Lichtbilder zu verfertigen. Gemeinfasslich von Daguerre selbst mitgetheilt, nebst den neuesten Berichten darüber von mehreren berühmten Naturforschern. Aus dem Französischen frei übersetzt von einem deutschen Physiker. Mit 6 Tafeln Abbildungen. Stuttgart: J. Scheible's Buchhandlung. 1839.

108 pp., VI plates.

21. DAS DAGUERREOTYP UND DAS DIORAMA, oder genaue und authentische Beschreibung meines Verfahrens und meiner Apparate zu Fixirung der Bilder der Camera obscura und der von mir bei dem Diorama angewendeten Art und Weise der Malerei und der Beleuchtung, von Louis Jacq. Mandé Daguerre. Mit zwei Tafeln Abbildungen. Stuttgart. Verlag der J. B. Metzler'schen Buchhandlung. 1839.

68 pp. II folding plates. (*First advertised in the* Vossische Zeitung, *Berlin, on 5 October.*)
A correction slip pasted in some early copies is dated "September 1839."

22. DAS DAGUERRÉOTYP. Geschichte und Beschreibung des Verfahrens von Daguerre, Maler, Erfinder des Diorama, Officier der Ehrenlegion, Mitglied mehrerer Academien ec. Nach dem Französischen. Hamburg 1839. Gedruckt bei Wilh. Ludwig Anthes. Adolphs-Platz No. 9.

40 pp., *folding plate.*

23. GESCHICHTE UND BESCHREIBUNG DES VERFAHRENS DER DAGUERREOTYPIE UND DES DIORAMAS von Louis Jaques [sic] Mandé Daguerre. Nach dem Original aus dem Französischen übersetzt. Mit 6 lithographischen Tafeln und 2 Tabellen, die Vergleichung des 100theiligen und Reaumur'schen Thermometers und des französischen mit einigen deutschen Maassen enthaltend. Carlsruhe. Verlag von A. Bielefeld. 1839.

118 pp., VI plates.

24. DAGUERREOTYPEN. BESKRIFNING A DEN MÄRKVÄRDIGA UPPFINNINGEN ATT FIXERA FRAMSTÄLLDA BILDER &C. af L.J.M. Daguerre. Öfversättning; tillika med de af Professor Arago uti Kongl. Franska Vetenskaps-Academien lemnade upplysningar, jemte en korrt beskrifning om det, jemväl af Daguerre upfunna, Dioramat. Med 6 Plancher. Stockholm, 1839, A. Bonniers förlag.

xxiv, 44 pp., VI plates.

25. DESCRIPTION PRATIQUE DU PROCÉDÉ NOMMÉ LE DAGUERRÉOTYPE. Ce procédé consiste dans la reproduction spontanée des images de la nature reçues dans la chambre noire, non avec leurs couleurs, mais avec une grande finesse de dégradation de teintes; par Daguerre, Peintre, inventeur du Diorama, officier de la Légion-d'Honneur, member de plusieurs Académies, etc., etc. A Gênes, Chez Antoine Beuf, Libraire et Cabinet de Lecture, rue Nuovissima No. 784. 1839.

 45 [1] pp., VI plates. Printed by Yves Gravier, Genoa.

26. DESCRIZIONE PRATICA DEL NUOVO ISTROMENTO CHIAMATO IL DAGUERROTIPO coll'aiuto del quale si riproducono spontaneamente le immagini della natura ricevute nella camera oscura, non gia con i colori, ma bensì con una estreme finezza di gradazioni di tinte Nuova scoperta del Sig. Daguerre pittore, inventore del Diorama, ufficiale della Legione d'Onore, membro di varie accademie ec. ec. Prima traduzione italiana Roma 1840 Per Alessandro Monaldi Tipografo

 30 pp., VI plates. Printed by Alessandro Monaldi.

27. EL DAGUEROTIPO. EXPLICACION DEL DESCUBRIMIENTO QUE ACABA DF HACER, Y A QUE HA DADO NOMBRE M. DAGUERRE, publicada por el mismo y traducida por D. Eugenio de Ochoa . . . Madrid: Imprenta de I.Sancha. 1839.

 xxxviii, 52 pp., VI plates.

28. ESPOSICION HISTORICA Y DESCRIPCION DE LOS PROCEDIMENTOS DEL DAGUERREOTIPO Y DEL DIORAMA. Traducida de la última edicion francesa, corregida y considerable-mente aumentada con notas, adiciones y aclaraciones que la ponen al alcance de todos. Con siete laminas. Por D. Joaquin Hysern y Molleras . . . Publicada por el Doctor Don Juan Maria Pou y Camps, etc. . . . Madrid: Imprenta de D. Ignacio Boix. 1839.

 xvi, 119 pp., VII plates.

29. HISTORIA Y DESCRIPCION DE LOS PROCEDERES DEL DAGUERREOTIPO Y DIORAMA. Por Daguerre, Pintor, inventor del Diorama, official de la legion de honor, miembro de varias academias, etc. etc. Traducido al Castellano por Pedro Mata . . . Barcelona: Por Don Juan Francisco Piferrer, Impressor de S. M. Plaza del Angel. 1839.

 Title, xiii [2] 50 pp., folding plate.

30. DAGUERRE KEPEI ELKÉSZÍTÉSÉ MÓDJÁNAK LEIRASA Nemet utan kózli D. Zimmermann Jakab. Becsben [i.e. Vienna] 1840. Hagenauer Fridr. Özvegye's tarsai betürvel, es köllse eivel.

 27 pp. with illus. (Practical manipulation only.)

31. DAGUERREOTYP I DIJORAMA czyli dokladny i autentyczny opis postepowania i aparatu mojego, do utrwalenia obrazów ciemnicy optycznéj (camera obscura), przytém o rodzaju i sposobie malowani i oswietlenia w Dijoramie przet Ludw. Jakóba Mandé Daguerra. Wraz z dwoma tablicami rycm Poznan (Posen), naktadem braci Szerkow 1840.

 56 pp. with 2 plates. (Contains daguerreotype manipulation, heliography, Daguerre's improvements on heliography, and description of Diorama painting.)

32. OPISANIE PRAKTYCSNE SPOSOBU WYRABIANIA DAGUERROTYPÓW przez DAGUERRA Malarza, Wynalarza Dyoramy, Kawalera Legii Honorowéj, Czlonka Wielu Akademi etc. etc. Z 6 Tablicami. Przelozone z Francuzhiego. Warszawa, 1840.

NOTES BY THE AUTHORS

The following, known only from an advertisement, may be another Daguerre edition, and is therefore added with reserve.

DAS DAGUERREOTYPE [sic] oder authentische Beschreibung des von Niepce und Daguerre erfundenen Verfahrens und der Apparate zur Fixierung von Bildern der Camera Obscura von Daguerre. Verlag der J.B. Metzler'schen Buchhandlung, Stuttgart, 1839.

It will be noted that it was issued by the same publisher as No. 21, differing from it in title and preceding it, according to an advertisement in the *Spenersche Zeitung* of 2 September, by over a month. If the manual were what its title claims, it would be the first German edition. It is not mentioned in Stenger's *Daguerre-Schriften*.

Some brochures are sometimes incorrectly listed as Daguerre manuals although they are in fact only summaries or descriptions by other people. The following are a few titles of this kind:

DAS GEHEIMNISS DER DAGUERROTYPIE, oder die Kunst: Lichtbilder durch die Camera Obscura zu erzeugen. Mit einer Anweisung zur Bereitung des photogenischen Papieres nach Talbot und Daguerre. Leipzig, 1839. Paul Baumgärtner. (Ludewig's Verlag in Grätz.)

 68 pp. July 1839.

The foreword of this brochure, which was published simultaneously by Baumgärtner in Leipzig and by Ludewig in Graz, Austria, in July 1839, is signed "F-n", which probably stands for the Graz writer of technical brochures Karl von Frankenstein. He was obviously in a great hurry to be the first to publish, and it is in fact the first separate publication in the world concerning Daguerre's invention, and the information in the text is largely guesswork, for Daguerre's method was not revealed until 19 August. In a postscript the author mentions the meeting in the Chamber of Deputies on 9 July (a mistake for 3 July), proving that the text itself was already written in June.

DAGUERREOTIPO SCOPERTA OTTICO-PITTORICA per ottenere le immagini degli oggetti col mezzo della luce Metodo dei signori Daguerre e Niepce con note sul metodo di Talbot per preparare le carte fotogeniche Bologna pei tipi del Nobili e Comp. 1839.

 8 pp. Censor's date 4 September 1839.

DAS DAGUERREOTYP oder die Erfindung des Daguerre, die mittelst der Camera obscura und des Sonnenmikroskops auf Flächen dargestellten Lichtbilder zu fixiren. Beschrieben von dem berühmten Physiker Arago. Aus dem Französischen frei übersetzt von einem deutschen Physiker. Stuttgart: J. Scheible's Buchhandlung. 1839.

 Advertised in the Vossische Zeitung, Berlin, 5 October.

DAS DAGUERROTYP. Eine ausführliche Beschreibung der Daguerre'schen Methode, die Bilder der Camera obscura zu fixiren, nebst Abbildung aller dazu gehörigen Apparate. Von Prof. Dr Ferd. Lüdgers in Paris. Diese Schrift lehrt das ganze Verfahren mit allen den Details, welche bis jetzt noch nicht publicirt sind, und ist mit den nöthigen Abbildungen begleitet, wonach man sich die erforderlichen Apparate verfertigen lassen kann. Quedlinburg und Leipzig. Druck und Verlag von Gottfr. Basse. 1839.

22 pp. Illus. Advertised in the Vossische Zeitung, *30 September. Compiled from Dr Donné's report in the* Journal des Débats.

VOLLSTÄNDIGE ANWEISUNG ZUR VERFERTIGUNG DAGUERRE'SCHER LICHTBILDER auf Papier, Malertuch und Metallplatten durch Bedeckung oder durch die Camera obscura und durch das Sonnenmicroscop. Mit Beschreibung und Abbildung der dazu brauchbaren Camera obscura. Nach eigenen Versuchen von F. A. W. Netto . . . Zweite Auflage. Mit einer Kupfertafel. Halle, 1839. C. A. Kümmel's Sortiments-Buchhandlung. G. C. Knapp.

20 pp., 1 plate. Advertised in the Gewerbeblatt für Sachsen *on 22 August.*

DESCRIPTION OF THE DAGUERREOTYPE PROCESS or a summary of M. Gouraud's public lectures, according to the principles of M. Daguerre. With a description of a provisory method for taking human portraits. Boston: Dutton and Wentworth's Print. 1840.

16 pp. End of March 1840.

ON THE PRESERVATION OF DAGUERREOTYPES

Daguerreotypes are not yet regarded as antiques, the limiting date for which is 1830. Consequently these, and other photographs, are frequently thrown away, and the beautiful cases sold for other purposes: this is especially the case when small portraits are contained in lockets, brooches, and other jewellery. The first and most essential factor for the preservation of daguerreotypes is, therefore, a greater appreciation of their rarity by antique dealers and the public in general. Remember each daguerreotype is a unique picture.

Daguerreotypes have often formed the subject of special collections, but not infrequently those who collect them lack the necessary care and knowledge which their preservation requires. During the 125 years or so which have elapsed since their production, many of them have become tarnished with oxidation round the edges, and, if the glass has not been properly sealed to the plate, it may well be covered with dust particles as well. The first thing to do after acquiring a daguerreotype is to take it out of its case and clean the cover-glass on both sides. Dust on the plate itself must be removed with the utmost care, either by gently blowing on it, or by picking up each dust speck separately with the twisted corner of a linen handkerchief. On no account must the image be brushed over with cotton wool or a camel-hair brush, or touched with the fingers. This amount of

cleaning is all a well-preserved daguerreotype needs. Immediately afterwards, the cover-glass should be replaced, not forgetting to put the gilt matt in between, the purpose of which is not so much to frame the picture as to prevent the glass from rubbing against it. Cover-glass and picture must then be sealed with sellotape or any other adhesive tape to prevent any further oxidation.

Restoring daguerreotypes chemically should only be attempted after sufficient experience has been gained on poor specimens. Chemical restoration is sometimes successful, and sometimes not, without any apparent reason, and this applies in particular to pictures taken before 1843 which may not have been toned with chloride of gold. Chemical restoration should only be applied to untinted and uncoloured daguerreotypes, and any especially valued specimen should first be rephotographed.

Until 1958, when Mrs Ruth K. Field, an assistant at the Missouri Historical Society, St Louis, published her discovery of cleaning daguerreotypes with a liquid dip for silver-ware,[238] the tarnish on daguerreotypes could only be removed by a solution of potassium cyanide, which is one of the most dangerous poisons and could enter the bloodstream through a small cut in the skin. Mrs Field's method is extremely simple and effective, and has been successfully used by Helmut Gernsheim on several occasions.

After the picture has been carefully removed from its frame, avoiding touching any part of the surface, cold water (preferably distilled) is allowed to run gently over it to remove any dust particles. The plate is then placed in a shallow dish containing Goddard's "Silver Dip" and gently rocked until the tarnish has disappeared, which may take five minutes. Certain parts, usually around the edges, that are more oxidized can be separately gone over with a piece of best-quality cottonwool soaked in the solution. Rinsing, first with tap water and then with distilled water, precedes the drying which is done by holding the plate at one corner with a pair of pliers over the flame of a spirit-lamp, or over an electric fire, picture side uppermost, of course. While this is being done, one should blow gently and ceaselessly over the surface of the picture so that the water evaporates evenly and quickly without leaving a mark. The picture is then reframed as described above.

Laymen, and even photographers, often speak incorrectly of *faded* daguerreotypes. These pictures cannot fade, but just as a paper print may be weak or strong, a daguerreotype may bear a faint or a strong image—yet this it did from the day it was made. Sometimes it is possible to intensify the image by using the following solutions:

A.	Gold chloride	1 grain
	Water	1 ounce
B.	Sodium hyposulphite	4 grains
	Water	1 ounce

After the daguerreotype has been rinsed in distilled water, the two solutions are well mixed together and flowed over the plate, which is then heated by a spirit-lamp. The action of the intensifier will be noted in a marked manner as the gold is deposited, and the more rapidly the action takes place the more satisfactory will be the result. Rinsing and drying follow as above.

Before rephotographing a daguerreotype it is essential to clean the cover-glass on

both sides, otherwise every speck of dust will show in the photograph. Many ways have been tested, but the following daylight method, resulting in a positive picture, proved the simplest. The picture is laid on the floor near a window, preferably with north light, and photographed with the camera in a vertical position, and using a lens of normal focal length. To avoid reflections in the daguerreotype, the tripod legs should be draped with black cloth, and a piece of black cardboard fixed over the camera front with a hole cut for the lens to project through. Should any reflections remain, a larger piece of cardboard is called for, projecting well over the camera front, but a slight alteration in the angle of the daguerreotype made by placing a piece of cardboard or a match under a corner is sometimes all that is necessary to avoid glare.

BIBLIOGRAPHY

In addition to the many articles in journals and newspapers indicated in footnotes, the following sources were used. The French and English sections being largely based on original research, our statements sometimes differ from those made by previous writers, a fact which should be borne in mind when discrepancies are noticed, to which attention has not been drawn in the text.

Semi-mechanical portraiture before photography :

René Hennequin. *Edme Quenedey: un "photographe" de l'époque de la Révolution et de l'Empire*. Troyes, 1926.

René Hennequin. *Avant les photographies: les portraits au physionotrace*. Troyes, 1932.

J. C. Lavater. *Physiognomische Fragmente*. Zürich, 1775-76.

E. Nevill Jackson. *The history of silhouettes*. London, 1911.

E. Nevill Jackson. *Silhouette*. London, 1938.

Max von Boehn. *Miniaturen und Silhouetten: ein Kapitel aus Kulturgeschichte und Kunst*. Munich, 1917 (1918).

The Diorama :

Les spectacles de Paris et de toute la France, ou calendrier historique et chronologique des théâtres pour l'année 1822, and following. Paris.

Specification of the Patent granted to John Arrowsmith on 10 February 1824 for the Diorama. Published in *The Repertory of Arts, Manufactures and Agriculture*, Vol. 46, April 1825.

Various Diorama programmes in the Gernsheim Collection.

Germain Bapst. *Essai sur l'histoire des Panoramas et des Dioramas*. Paris, 1891.

Erich Stenger. *Daguerre's Diorama in Berlin*. Berlin, 1925.

Georges Pontonniée. *Daguerre, peintre et décorateur*. Paris, 1935.

A. Auerbach. *Panorama und Diorama*. Pirna, 1942.

Helmer Bäckström. *G. A. Müller's Diorama in Stockholm in the 1840s*. Article in Swedish published in *Nordisk Tidskrift för Fotografi*, No. 7, 1943.

The daguerreotype:

Comptes rendus hebdomadaires des Séances de l'Académie des Sciences. Paris, 1839–44.

François Arago. *Rapport de M. Arago sur le Daguerréotype.* Paris, 1839.

L. J. M. Daguerre. *Historique et description des procédés du Daguerréotype et du Diorama.* Paris, 1839.

J. B. Isenring. *Kunstausstellung enthaltend eine Sammlung von Lichtbildern, meistens Porträts nach dem Leben.* St Gallen, 1840.

Un amateur [Hubert]. *Le Daguerreotype considéré sous un point de vue artistique, mécanique et pittoresque.* Paris (June), 1840.

Buron. *Description des nouveaux Daguerréotypes perfectionnés et portatifs, avec l'instruction de M. Daguerre, annotée.* Paris (July), 1841.

Gaudin & N. P. Lerebours. *Derniers perfectionnements apportés au Daguerréotype.* Paris (December), 1841.

Charles Chevalier. *Nouvelles instructions sur l'usage du Daguerréotype. Description d'un nouveau photographe, etc.* Paris, 1841.

Isidore Niépce. *Historique de la découverte improprement nomée Daguerréotype.* Paris, August, 1841.

Friedrich Voigtländer. *Anweisung zum Gebrauche des neuen Daguerreotyp-Apparates zum Portraitieren, nach der Berechnung des Herrn Prof. Petzval.* Vienna, 1841.

Friedrich Voigtländer. *Beschreibung des Voigtländer'schen Apparates zur Darstellung photographischer Porträte nach der Berechnung des Herrn Prof. Dr Petzval.* Vienna, 1842.

N. P. Lerebours. *Traité de Photographie: derniers perfectionnements apportés au Daguerréotype.* Paris (July), 1843. (Also English translation by J. Egerton. London, 1843.)

L. J. M. Daguerre. *Nouveau moyen de préparer la couche sensible des plaques destinées à recevoir les images photographiques.* Paris (May), 1844.

A. Gaudin. *Traité pratique de Photographie, exposé complèt des procédés relatifs au Daguerréotype.* Paris (September), 1844.

J. Thierry. *Nouveaux élements de Photographie, avec des notes détaillées sur diverses améliorations apportées aux opérations daguerriennes.* Paris (June), 1844.

Charles Chevalier. *Mélanges photographiques. Complément des nouvelles instructions sur l'usage du Daguerréotype.* Paris (March), 1844.

J. Thierry. *Daguerréotypie.* Paris, 1847.

Charles Chevalier. *Guide du Photographe. Troisième partie: éloge de Daguerre—documents historiques.* Paris, 1854.

Paul Carpentier. *Notice sur Daguerre.* Paris, 1855. This Notice is a reprint of Carpentier's article of the same title published in the *Annales de la Société libre des Beaux-Arts,* Vol. XVIII, 1855.

Mayer & Pierson. *La Photographie considérée comme art et comme industrie. Histoire de sa découverte.* Paris, 1862.

Alfred Delvau. *Les Lions du Jour: Physionomies Parisiennes.* Paris, 1867. Article on Daguerre, pp. 118–120.

Victor Fouque. *La vérité sur l'invention de la Photographie. Nicéphore Niépce sa vie, ses essais, ses travaux.* Paris, 1867.

Louis Figuier. *Les merveilles de la science*, Vol. III, Part 1, "La Photographie". Paris, 1869.

E. Chevreul. "La vérité sur l'invention de la Photographie", *Journal des Savants*, 1873.

Baron Ernouf. *Les inventeurs du Gaz et de la Photographie*. Paris, 1877.

Louis Sachse. "Zur Geschichte der Daguerreotypie in Deutschland" (correspondence between Sachse and Giroux and others), in *Photographische Mitteilungen*. Berlin, 1889. Reprinted in "120 Jahre Photographie", in *Allgemeine Photographische Zeitung*, Vienna, 1959.

Mentienne. *La découverte de la Photographie en 1839*. Paris, 1892.

Pedro N. Arata. "Documentos historicos relativos al Descubrimiento de la Fotografia", in *Anales del Museo de la Plata*, Vol. I, Buenos Aires, 1892.

Wilhelm Weimar. *Die Daguerreotypie in Hamburg 1839–1860*. Hamburg, 1915.

Wilhelm Dost and Erich Stenger. *Die Daguerreotypie in Berlin 1839–1860*. Berlin, 1922.

Georges Potonniée. *Histoire de la découverte de la Photographie*. Paris, 1925. (*History of the Discovery of Photography*, translated by Edward Epstean, New York, 1936.)

J. M. Eder. *Geschichte der Photographie*. 4th edition, Halle, 1932. (English translation by Edward Epstean. New York, 1945.)

Erich Stenger. *Die Photographie in München 1839–1860*. Berlin, 1939.

Erich Stenger. *Daguerre-Schriften*. Berlin, 1936.

Robert Taft. *Photography and the American Scene*. New York, 1938 (New York, Dover Publications, Inc., 1964).

Erich Stenger. *Die beginnende Photographie im Spiegel von Tageszeitungen und Tagebüchern*. Würzburg, 1943.

Helmer Bäckström. The Daguerreotype in Sweden. Article in Swedish in *Tekniska Museets Arsbok Daedalus*, Stockholm, 1943.

Raymond Lécuyer. *Histoire de la Photographie*. Paris, 1945.

T. P. Krawza. *Documents on the History of Photography*, original correspondence of Niépce, Daguerre, and others at the Academy of Sciences, Moscow, published in Russian and French. Moscow, 1949. It contains 49 letters of Daguerre to Niépce, 30 from Niépce to Daguerre, 14 by Vincent Chevalier, also others. Altogether 150 letters and documents dating from 1787 to 1841.

Julio F. Riobó. *La Daguerrotipia y los Daguerrotipos en Buenos Aires*. Buenos Aires, 1949.

Julio F. Riobó. *Primera Exposicion de Daguerrotipos realizada en Chascomus, Prov. de Buenos Aires*. 2nd illus. edn., Buenos Aires, 1950.

Helmut and Alison Gernsheim. *History of Photography*. London, 1955.

Beaumont Newhall. *The Daguerreotype in America*. New York, 1961.

Wolfgang Baier. *Quellendarstellungen zur Geschichte der Fotografie*. Halle & London, 1965.

REFERENCES

1 This story was related by J. B. Dumas soon after Daguerre's death. *The Illustrated London News*, 26 July, 1851.
2 Quoted by Max Dauthendey in *Der Geist meines Vaters*, Munich, 1912.
3 Sir Robert Robertson, President of the Royal Society, on the occasion of the centenary of the Royal Photographic Society in 1953.
4 Max von Boehn, *Das Empire*, Berlin, 1925.
5 In later panoramas, foreground objects were sometimes added, after Colonel Langlois had successfully introduced them in his panorama of the Battle of Navarino in 1830 (see p. 30).
6 *Magasin Encyclopédique*, Paris, 1800, No. 33.
7 Daly, *Revue générale de l'Architecture*, Vol. 2, Paris, 1841.
8 Ackermann, *Repository of Art*, Vol. II, No. 11, 1823, p. 305.
9 Patent relating to the Diorama granted to John Arrowsmith, London.
10 John Lewis Roget, *A History of the Old Water-Colour Society*, London, 1891. Article on Augustus Charles Pugin.
11 A number of Daguerre's stage designs were published as lithographs about 1822 by Engelmann & Schmitt in the series *Recueil des principales décorations des divers théâtres de la capitale*, but we have been unable to trace any in this country. One, from *Elodie*, is at the Conservatoire des Arts et Métiers, another is at the Societé Française de Photographie.
12 Georges Potonniée, *Daguerre, Peintre et Décorateur*, Paris, 1935.
13 Frederick C. Bakewell, *Great Facts*, London, 1859.
14 Ackermann, *Repository of Art*, November 1823.
15 *The Times*, 4 October 1823.
16 Ackermann, *Repository of Art*, November, 1823.
17 *Le Miroir des Spectacles*, 12 July 1822.
18 *Journal des Théâtres*, 14 July 1822.
19 *Journal de Paris*, 22 July 1822.
20 *La Quotidienne*, 4 August 1822.
21 *Almanach des Spectacles*, 1823, p. 240.
22 *The Mechanics' Magazine*, 31 January 1824.
23 John Imison, *Elements of Science and Art*. New edition, London, 1803, Vol. II, p. 330. See also E. Orme, *An Essay on Transparent Prints and on Transparencies in General*, London, 1807.
24 *The Mirror of Literature, Amusement and Instruction*, 26 March 1825.
25 Loc. cit.
26 *Ibid.*, 4 March 1826.
27 *Ibid.*, 30 June 1827.
28 *Ibid.*, 26 March 1825.
29 *Ibid.*, 4 March 1826.

30 *The Spectator*, 24 April 1830.

31 Review of "St Wandrille" by Bouton and "Unterseen" by Daguerre, in *The Mirror of Literature* etc., 29 March 1828.

32 Review of "Unterseen" by Daguerre in *The Athenaeum*, 25 March 1828.

33 Review of "Santa Croce" by Bouton in *The Athenaeum*, 6 June 1835.

34 Review of "Alagna" by Bouton in *The Athenaeum*, 2 April 1836.

35 Review of "The Village of Thiers" by Daguerre in *The Athenaeum*, 3 June 1829.

36 *The Mirror of Literature*, etc., 26 March 1825.

37 See Helmut Gernsheim, *The Times Educational Supplement*, 6 July 1951, and *The Photographic Journal*, Section A, July 1951.

38 Charles Chevalier, *Guide du Photographe*, Paris, 1854.

39 *The Athenaeum*, 3 June 1829.

40 Letter in the collection of the late General L. David.

41 Letter in the collection of the Photographic Society of Vienna.

42 They were all the same size.

43 August Lewald, *Gesammelte Schriften*, Part 7, Leipzig, 1845.

44 Quoted from a letter, dated 6 September 1824, to M. Sauvan, at George Eastman House.

45 *L'Artiste, Journal de la Littérature et des Beaux-Arts*, Paris, Vol. II (1831), p. 177.

46 *L'Artiste*, Vol. V (1833), p. 184.

47 Charles Maurice (Descombes), *Histoire anecdotique du Théâtre*, Paris, 1856.

48 *Journal des Artistes*, 8 February 1835, No. 6.

49 *L'Artiste*, Vol. X, No. 11, 1835.

50 *Journal des Artistes*, 18 September 1836.

51 *L'Artiste*, Vol. V (1833), p. 207.

52 *L'Artiste*, Vol. V (1833), p. 207.

53 *The Athenaeum*, 2 April 1836.

54 Edmond Texier, *Tableau de Paris*, Vol. II, 1853.

55 *The Mirror of Literature*, etc., 19 September 1840.

56 *London*, edited by Charles Knight, Vol. VI, 1844.

57 *The Athenaeum*, 6 April 1844.

58 *London*, edited by Charles Knight, Vol. VI, 1844.

59 *The Spectator*, 2 June 1832.

60 J. P. Simon, M.D., *A Practical Description of that Process called the Daguerreotype*, London, 1839. One of the first poems inspired by photography.

61 A. Mentienne, *La Découverte de la Photographie en 1839*, Paris, 1892.

62 Fox Talbot, *The Pencil of Nature*, Part I, London, 1844.

63 Charles Chevalier, *Guide du Photographe*, Paris, 1854.

64 Letter by Niépce dated Châlon, 17 September 1818, reproduced in L. David, *Photographisches Praktikum*, Halle, 1932.

65 Charles Chevalier, *Guide du Photographe*, Paris, 1854, Part III.

66 Georges Potonniée, *Daguerre, Peintre et Décorateur*, Paris, 1935.

67 Victor Fouque, *La Vérité sur l'Invention de la Photographie*, Paris, 1867, p. 126.

68 "Interior of the Chapel of the Feuillants", Plate 6.

69 Fouque, p. 129.

70 Isidore Niépce, *Historique de la Découverte improprement nommée Daguerréotype*, Paris, August 1841, p. 23.

71 Fouque, p. 132.

72 Isidore Niépce, p. 24.

73 Victor Fouque, pp. 140–144.

74 Arago quoted before the Académie des Sciences from Daguerre's notebook of 1824 these experiments with phosphorescent powder and a small disc of blue glass. *Comptes rendus*, 18 February 1839, p. 243.

75 *Journal des Artistes*, 27 September 1835.

76 Paul Carpentier, *Notice sur Daguerre*: Annales de la Société libre des Beaux-Arts, Vol. XVIII, 1855.

77 Quoted in Robert Hunt, *Researches on Light*, 1844, p. 29.

78 Niépce's letter of 23 October 1829 accepting Daguerre's offer of partnership and reminding him of his own offer during his stay in Paris. Letter at the Soviet Academy of Sciences, Moscow.

79 Fouque, p. 153.

80 Letter at the Soviet Academy of Sciences.

81 Five MS. synopses were found in 1929 at the Soviet Academy of Sciences. The Introduction is preserved at the Musée Denon, Châlon.

82 Letter from Daguerre to Niépce dated 12 October 1829, at the Soviet Academy of Sciences. Published in the *British Journal of Photography*, 14 November 1930.

83 *British Journal of Photography*, loc. cit.

84 Victor Fouque, p. 158.

85 Wolfgang Schade, "100 Jahre Photographie?" *Illustrierter Beobachter*, Berlin, 1937, p. 1804.

86 Letter from Niépce to Daguerre, 24 June 1831.

87 Daguerre's Manual, 1839, annotation to Niépce's letter of 29 January 1832.

88 M. A. Gaudin, *Traité pratique de Photographie*, Paris, 1844, p. 4.

89 Georges Potonniée, *History of the Discovery of Photography*, New York, 1936, p. 152, footnote.

90 *Comptes rendus*, 30 September 1839, p. 424.

91 *Comptes rendus*, loc. cit.

92 Mayer and Pierson, *La Photographie considérée comme Art et comme Industrie*, Paris, 1862.

93 *Journal des Artistes*, 27 September 1835. The paragraph is printed with the dots of omission which appear in the original.

94 *Ibid.*, 11 September 1836.

95 *Le daguerréotype considéré sous un point de vue artistique, mécanique et pittoresque par un amateur* [Hubert], Paris, 1840.

96 Isidore Niépcé, *Historique de la Découverte improprement nommée Daguerréotype*, Paris, 1841, p. 58.

97 Quoted in Daguerre's Manual, 1839.

98 A. Mentienne, *La Découverte de la Photographie en 1839*, Paris, 1892, p. 16, 137.

99 *Les Familles de France, les Hommes d'Etat, de Guerre, de Science et de l'Art*, Paris, 1851.

100 *Comptes rendus*, Vol. VIII, 7 January 1839.

101 J. S. Memes, in the preface to his translation of Daguerre's Manual, 1839.

102 *The Literary Gazette*, 12 January 1839.

103 *L'Artiste*, 2nd series, Vol. II (1839), pp. 145–148.

104 *Le Commerce*, 13 January 1839. Also *Le Moniteur Universel*, 14 January 1839.

105 *The Literary Gazette*, 2 March 1839: letter from Francis Bauer dated 26–27 February.

106 *Comptes rendus*, Vol. VIII, 4 February 1839, pp. 172–174.

107 *Comptes rendus*, 27 May 1839, p. 838.

108 Sir John Robison, "Notes on Daguerre's photography", *The Edinburgh New Philosophical Journal*, July 1839, pp. 155–157.

109 *Samuel Finley Breese Morse, His Letters and Journals*, ed. by Edward Lind Morse, New York, 1914.

110 *Courrier des Théâtres*, 9 March 1839. Owing to the difficulty of communication with U.S.S.R. it has unfortunately not been possible to follow up this indication of a Russian Diorama.

111 This poem by L. J. N. Lemercier, a writer of tragedies, was recited at the meeting of the Académie Française on 2 May 1839.

112 *Œuvres complètes de François Arago*, ed. by J. A. Barral, Paris and Leipzig, 1854–62, Vol. XII.

113 The full text of Duchâtel's speech and the reports by Arago and Gay-Lussac are given in Daguerre's Manual, 1839.

114 *Rapport de M. Arago sur le Daguerréotype*, Paris, 1839, p. 6 (published on 31 August); also *Comptes rendus*, 19 August 1839, p. 250.

115 *Rapport de M. Arago sur le Daguerréotype*, p. 50–51 (also in *Comptes rendus*).

116 Ludwig Pfau, *Kunst und Gewerbe*, Part I, Stuttgart, 1877, pp. 115–117.

117 M. A. Gaudin, *Traité pratique de Photographie*, Paris, 1844, p. 7.

118 Jules Janin, *L'Artiste*, Vol. IV, 1 September 1839.

119 *Comptes rendus*, 30 September 1839, pp. 426–427.

120 *The London Journal of Arts and Sciences*, Vol. XV, 1840, pp. 120–123.

121 *Le Daguerréotype considéré sous un point de vue artistique, mécanique et pittoresque*, par un amateur [Hubert], Paris, 1840.

122 *Le Charivari*, 10 September 1839.

123 Victor Fouque, *La Vérité sur l'Invention de la Photographie*, Paris, 1867.

124 Victor Fouque, op. cit.

125 *The Athenaeum*, 21 December 1839.

126 *Comptes rendus*, 30 September 1839, p. 423.

127 *Comptes rendus*, 4 November and 9 December 1839; advertisement in Lerebours and Susse Frères' edition of Daguerre Manual, November 1839.

128 *Comptes rendus*, 14 October 1839, p. 485.

129 *Spenersche Zeitung*, Berlin, 22 October 1839. The reference to an earlier portrait made by Daguerre is incorrect.

130 M. A. Gaudin, *Traité pratique de Photographie*, Paris, 1844.

131 N. P. Lerebours, *Traité de Photographie*, Paris, 1843, p. 70.

132 *The Woman at Home*, Vol. VIII, 1897, p. 812.

133 Letter at George Eastman House, published here for the first time by courtesy of Beaumont Newhall.

134 German newspaper report quoted by Prof. Dr. Erich Stenger in *Siegeszug der Photographie*, 1950, p. 86.

135 Georges Pontonniée, *Histoire de la Découverte de la Photographie*, Paris, 1925, p. 231. Potonniée does not mention the photographer's name.

136 *Comptes rendus*, 28 June 1841.

137 *The Art Union*, London, September 1841, p. 156. The authors have seen a similar daguerreotype taken by Girault de Prangey and dated 1841.

138 Robert Hunt, *Researches on Light*, London, 1844, p. 89.

139 N. P. Lerebours, *Derniers Perfectionnements apportés au Daguerréotype*, 2nd edition, Paris, May 1842.

140 Gaudin and N. P. Lerebours, *Derniers Perfectionnements apportés au Daguerréotype*, November 1841, p. 43.

141 M. A. Gaudin, *Traité pratique de Photographie*, Paris, 1844, p. 156.

142 N. P. Lerebours, *Traité de Photographie*, Paris, 1843.

143 The Abbé Moigno, *Répertoire d'Optique Moderne*, Paris, 1847.

144 Baron Gros, *Quelques Notes sur la Photographie*, Paris (January), 1850.

145 *Comptes rendus*, 22 April 1844, p. 756.

146 The letter and document are preserved at the Société Française de Photographie.

147 Published in *Image*, January 1952.

148 *Morning Herald*, New York, 30 September 1839.

149 The part relating to daguerreotype manipulation had been first reprinted in the States in the New York *Observer* on 2 November 1839.

150 Marcus A. Root, *The Camera and the Pencil*, Philadelphia, 1864.

151 Letter from Draper to the New York Mechanics' Institute, reprinted in Root's *Camera and the Pencil*.

152 *The United States Gazette*, Philadelphia, 24 October 1839.

153 *The Edinburgh New Philosophical Journal*, July 1839, p. 150. This paper was reprinted in various English journals.

154 Article by John Johnson in *Eureka*, Vol. I, p. 25, New York, 1846.

155 *Journal of the Society of Arts*, London, 18 August 1882, p. 932. By a slip, the date is given as "April 1839" instead of 1840.

156 John William Draper, M.D., "On the process of Daguerreotype, and its application to taking portraits from the life." *The London, Edinburgh and Dublin Philosophical Magazine and Journal of Science*, Vol. XVII, September 1840.

157 Published in the appendix of Draper's *Treatise on the force which produces the organization of plants*, New York, 1845.

158 *The Knickerbocker*, New York, Vol. XIV, 1839, p. 560.

159 *Evening Star*, New York, 21 February 1840.

160 *Ibid.*, 24 February 1840.

161 Beaumont Newhall. *Daguerre's Agent in America: François Gouraud*. Paper communicated to the International Conference on the Science and Applications of Photography, London, September, 1953.

162 Advertisement in the *Scientific American*, 11 September, 1845.

163 *Memoirs of John Quincy Adams*, Philadelphia, 1876.

164 Francis Wey, "Comment le soleil est devenu peintre", *Musée des Familles*, Paris, June–July, 1853.

165 John Werge, *The Evolution of Photography*, London, 1890, p. 143.

166 *The Art Journal*, London, November 1850.

167 Robert Taft, *Photography and the American Scene*, New York, 1938.

168 *The Art Journal*, March 1854.

169 Lawsuit *Beard* v. *Egerton*, 27 May 1846, reported in Court of Common Pleas, Vol. III, London, 1848.

170 *The Spectator*, 2 February 1839, p. 115.

171 *The Times*, 14 September 1839.

172 *The Literary Gazette*, 21 September 1839.

173 *The Athenaeum*, 14 September 1839, advertisement.

174 *The London Journal of Arts and Sciences and Repertory of Patent Inventions*, Vol. XV, 1840, p. 182.

175 and 176 Op. cit., pp. 183–184.

177 Lawsuit *Beard* v. *Egerton*, 2 June 1845, reported in *The Times*, 3 June.

178 *The London Journal of Arts and Sciences and Repertory of Patent Inventions*, Vol. XV, 1840, p. 181.

179 *The London Saturday Journal*, 2 November 1839.

180 Advertisement in *The Athenaeum*, 18 April 1840, and *Fraser's Advertiser*, 1840, p. 1979.

181 *The Photographic News*, 21 August 1868. Letter from John Johnson.

182 *The Morning Chronicle*, 12 September 1840.

183 Notes from J. F. Goddard's diary published in the *Photographic News*, 13 May 1864.

184 J. F. Goddard, *The Chemist*, Vol. II, May 1841, p. 143.

185 Francis S. Beatty, *The Year-book of Photography and Photographic News Almanac for 1884*, p. 77.

186 Loc. cit.

187 *Intelligenzblatt der Stadt Bern*, 10 November 1841. Quoted in Prof. Erich Stenger's *Die Beginnende Photographie*, Würzburg, 1943, p. 15. The reporter was probably mistaken in referring to Wolcott as the operator.

188 Betty Miller, *Elizabeth Barrett to Miss Mitford*, London, 1954.

189 *George Cruikshank's Omnibus*, London, 1842, pp. 29–32.

190 Francis S. Beatty, loc. cit.

191 Gaudin and N. P. Lerebours, *Derniers Perfectionnements apportés au Daguerréotype*, Paris, November 1841, p. 43.

192 [Jabez Hogg], *Photography Made Easy*, London, 1845.

193 A. Claudet, *British Journal of Photography*, 21 February 1868, p. 90.

194 *The Athenaeum*, 17 July 1841; also *Philosophical Magazine*, Vol. XIX, p. 167.

195 Letter from Claudet in *The Spectator*, 11 September 1841.

196 Thomas Sutton, "Reminiscences of an Old Photographer", *British Journal of Photography*, 30 August 1867, p. 413.

197 Advertisement in *The Athenaeum*, 26 June 1841.

198 Advertisement in *The Illustrated London News*, 27 May 1843.

199 Advertisement in *The Athenaeum*, 14 August 1841. The "new application" can only have been Fizeau's fixing with chloride of gold, though it is strange that a year passed by before Claudet availed himself of it.

200 J. F. Goddard, *The Polytechnic Journal*, Vol. IV, 1841, p. 248.

201 Advertisement in *The Illustrated London News*, 23 July, 1842.

202 Francis S. Beatty, *The Photographic News*, 8 August 1879.

202a "William Constable of Brighton", *The Times*, 22 December 1961.

203 *The Photographic News*, 1886, p. 370.

204 *The Manchester Guardian*, 29 June 1850.

205 [Jabez Hogg] *Photography Made Easy*, London, 1845.

206 *Münchener Morgenblatt*, 16 April 1842. The name of the chemist is there given as Poppett.

207 *The Spectator*, 30 July 1842.

208 Advertisement in *The Illustrated London News*, 27 May 1843.

209 Dr Andrew Wynter, *The People's Journal*, Vol. II, 1846, p. 288.

210 Advertisement in *The Art Union*, London, October 1846.

211 For details see the authors' *History of Photography*.

212 *The Athenaeum*, 30 August 1856.

213 Sir David Brewster, *The Stereoscope*, London, 1856, p. 36.

214 The daguerreotype, but unfortunately not the ring, is in the Gernsheim Collection.

215 *The Art Journal*, October 1849, p. 294.

216 Other fancy pictures listed by Mayall in 1848 include "Love me, love my dog", "101 in the Shade", "The May Queen", "The Young Arithmetician", "The Birth of Moses", "Alas, poor Yorick".

217 *The Athenaeum*, 17 April, 1847.

218 Walter Thornbury, *The Life of J. M. W. Turner, R.A.*, London, 1862.

219 *The Photographic News*, 16 August 1861, p. 383.

220 *Notes and Queries*, 17 June 1854, p. 571.

221 "Cuthbert Bede" (Rev. Edward Bradley), *Photographic Pleasures*, London, 1855, pp. 29–31.

222 "Description of the process of daguerreotype, and remarks on the action of light in that process, both in respect to landscapes and miniature portraits."

223 *The British Journal of Photography*, 22 August 1879, p. 400.

224 *Ibid.*

225 Dr Rudolf Loher, *Carl August von Steinheil*, Munich, n.d. (c. 1937).

226 *Spenersche Zeitung*, 29 April 1840.

227 *Anweisung zum Gebrauche des neuen Daguerreotyp-Apparates zum Portraitieren, nach der Berechnung des Herrn Prof. Petzval, ausgeführt von Voigtländer und Sohn*, Vienna (January 1841).

228 *Spenersche Zeitung*, 2 March 1841.

229 *Wiener Zeitung*, 24 March 1841. See also *Austria, oder Oesterreichischer Universal-Kalender für 1846*. Vienna, 1845. Article on photography by A. Martin, pp. 194–216.

230 J. M. Eder, *Geschichte der Photographie*, and *Allgemeine Photographische Zeitung*. Vienna, 1959.

231 *Münchener Tagblatt*, 21 October 1841.

232 Advertisement in *Vossische Zeitung*, 4 February 1843.

233 *Der Daguerreotypen-Krieg in Hamburg oder Saphir der Humorist, und Biow der Daguerreotypist vor dem Richterstuhl des Momus. Ein humoristisches Bulletin von "Cephir"*. Hamburg, 1843.

234 *Die Männer des deutschen Volks, besonders nach Biows Lichtbildern auf Stein gezeichnet, oder Deutsche National-Galerie*. Frankfurt, 1849.

235 *Praktische Anweisung zum Daguerreotypieren*, Leipzig, 1842, and Max Dauthendey, *Der Geist meines Vaters*, Munich, 1912.

236 *Correspondent*, Munich, 28 July 1841.

237 Bjørn Ochsner, *Fotografier af H. C. Andersen*, Copenhagen, 1960.

238 *Infinity*, New York, December 1958.

INDEX

Ние то испоручаме
по си свеки каде и кому
не шекаа шеда и кому
испракаа ие лица да се мисле...
каисида слонта неимаа
да та
од авгуота